THE HUMAN FIGURE

A PHOTOGRAPHIC REFERENCE
FOR ARTISTS

THE HUMAN FIGURE
A PHOTOGRAPHIC REFERENCE
FOR ARTISTS

E. A. RUBY

VNR **VAN NOSTRAND REINHOLD COMPANY**
NEW YORK CINCINNATI TORONTO LONDON MELBOURNE

Photographs by Sean Kerman

Copyright © 1974 by Litton Educational Publishing, Inc.
Library of Congress Catalog Card Number 74-5948
ISBN 0-442-27148-4

Published by Van Nostrand Reinhold Company
A Division of Litton Educational Publishing, Inc.
135 West 50th Street, New York, NY 10020

16 15 14 13 12 11 10 9 8 7 6 5 4 3

Note: The even-numbered pages in this book are printed
in several orientations to the odd-numbered pages
due to the spiral binding of the original edition. Students
may wish to detach the pages, punch holes in the top
margins, and insert rings to duplicate the original version.

Contents

Male | 1
walking | 1
running | 9
standing | 17
sitting | 59
lying | 83
head | 98
hands | 113
feet | 127

Female | 141
walking | 141
standing | 149
sitting | 173
lying | 195
head | 211
hands | 226
feet | 240

Details | 253
expressions | 253
heads | 263
hands | 279
eyes and noses | 293
mouths | 298
ears | 301

Two-year-old child | 309
standing | 309
sitting | 317
head | 324
hands | 329
feet | 334

Author

Erik Ruby was born into a creative family. He entered the Paier School of Art in Hamden, Connecticut, where he studied in advertising together with other related subjects such as fine arts and illustration. He now works as both an illustrator and designer and his work has been used by many large corporations and has appeared in national magazines. The idea for *The Human Figure* came to him when he searched for a good book on drawing anatomy and found that traditional sources were mostly text and therefore useless, since one cannot draw from words.

He believes his book is the most complete on the subject and that it will be very useful for artists since it shows—in photographs—the figure in its natural state.

Drawing by the author.

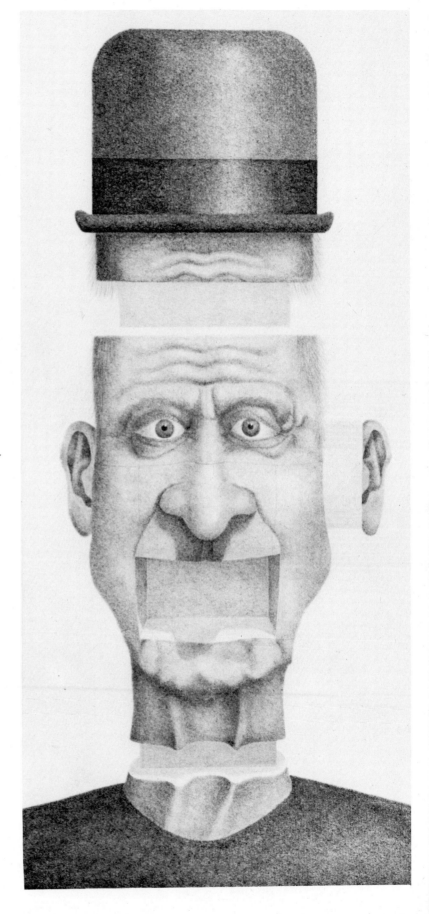

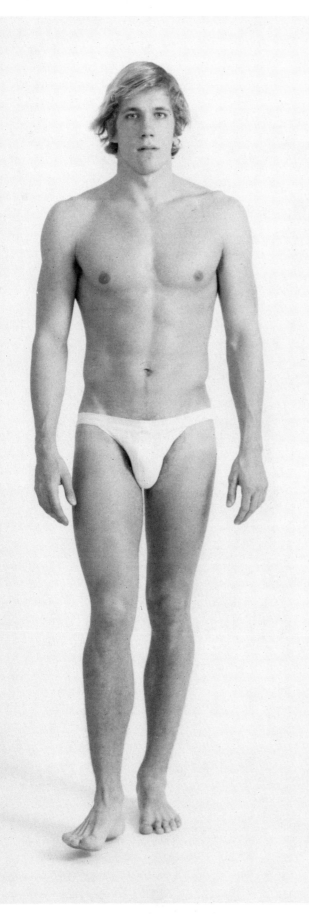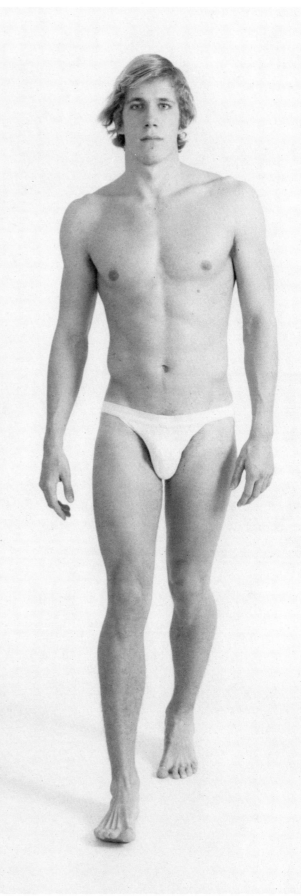

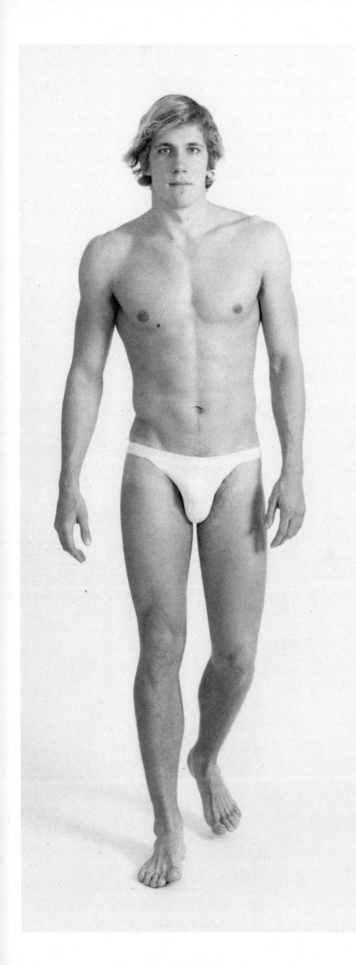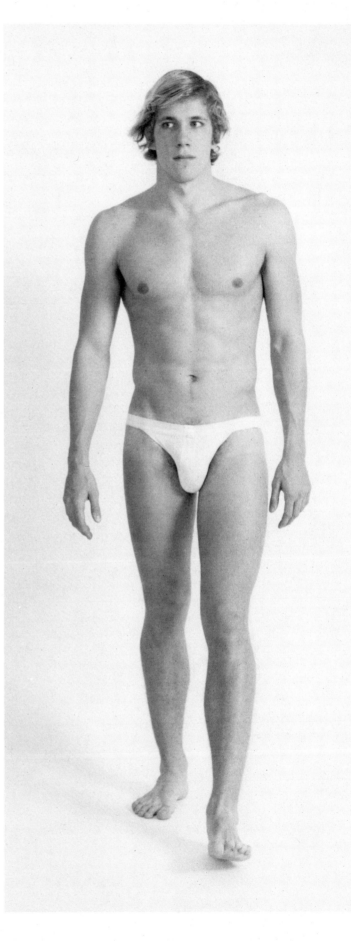

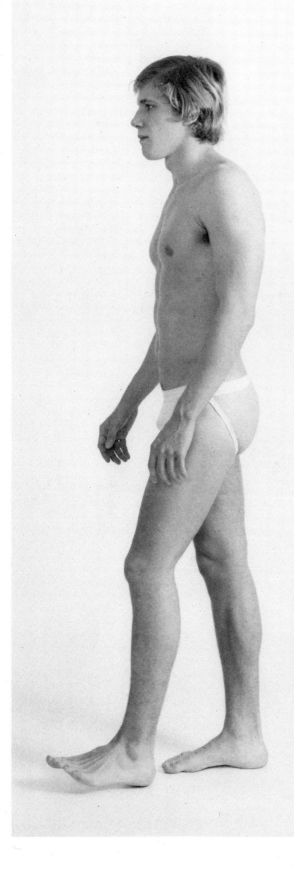
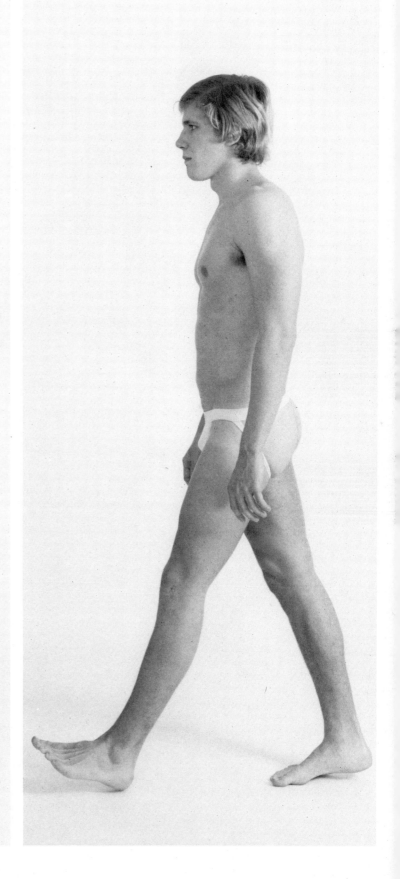

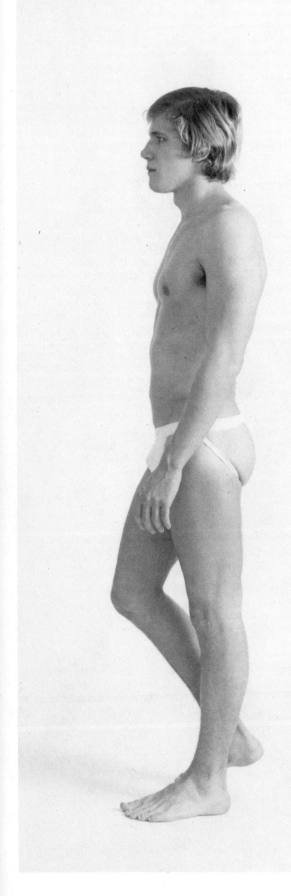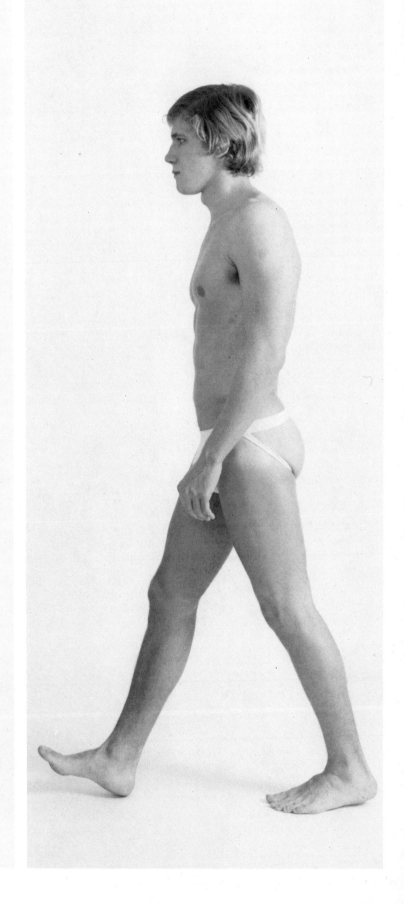

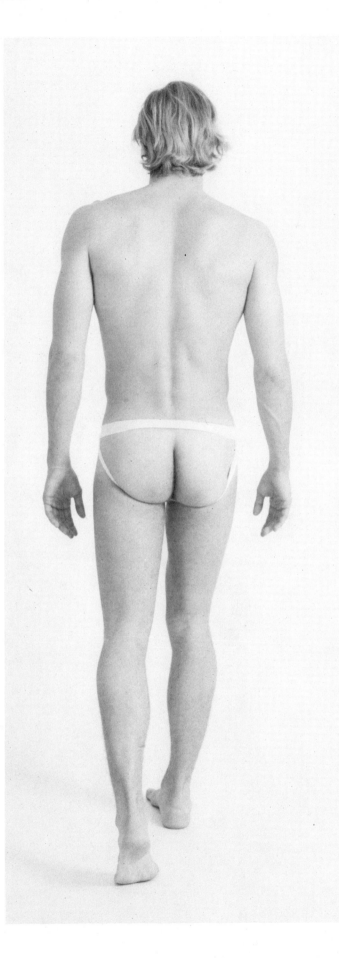
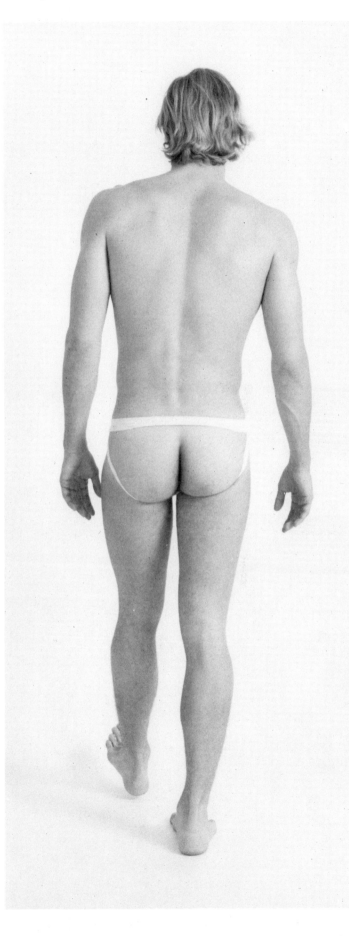

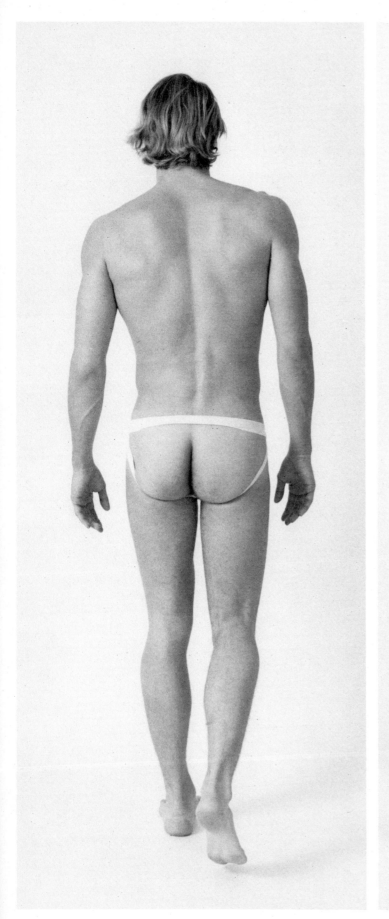
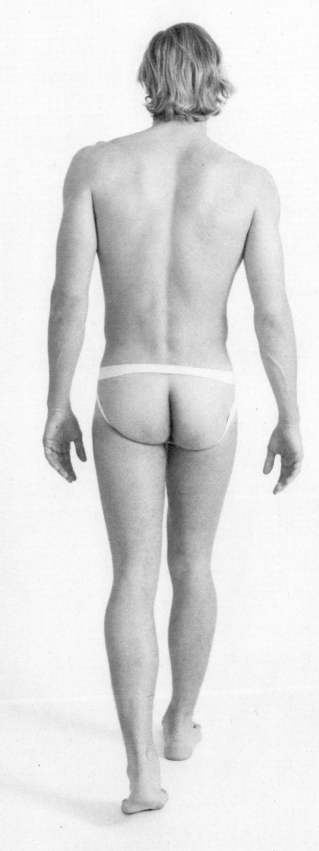

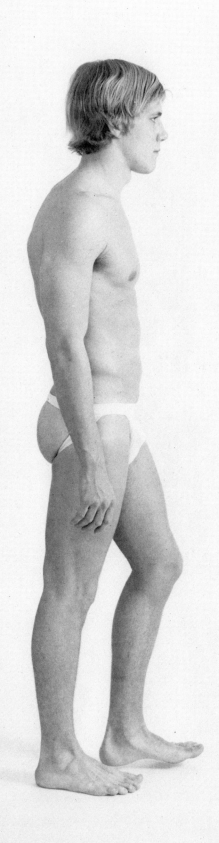

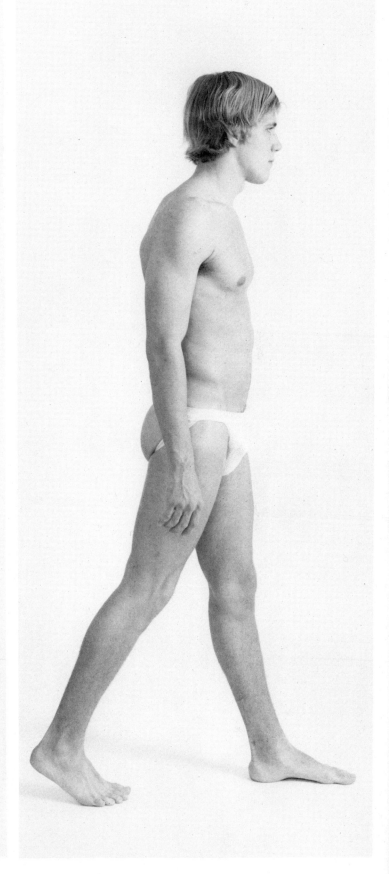

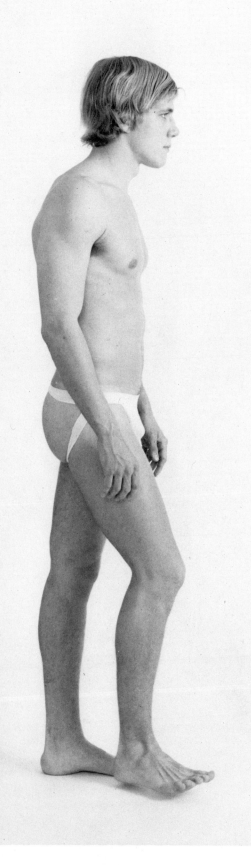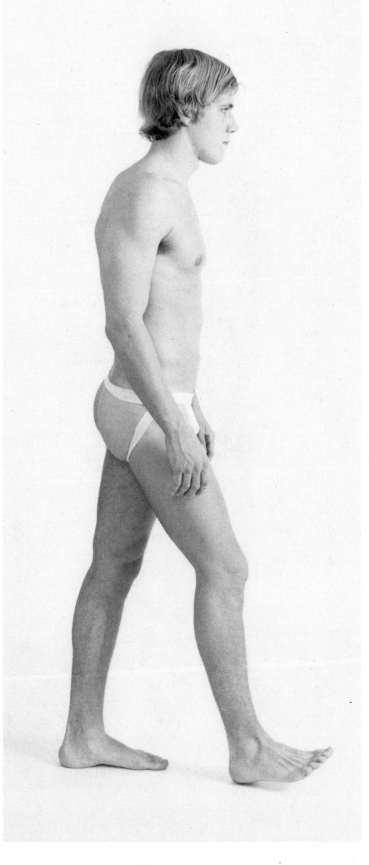

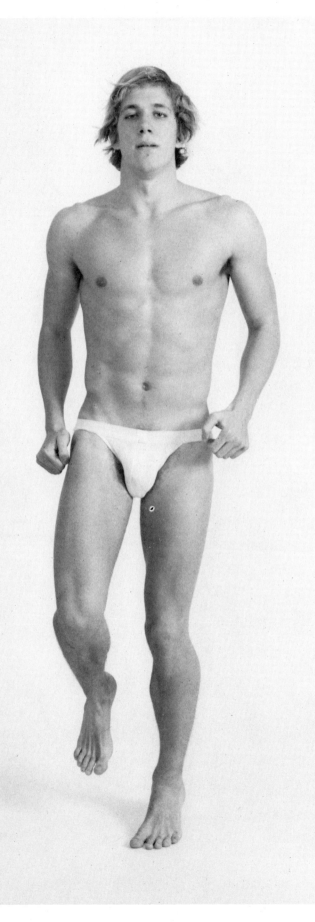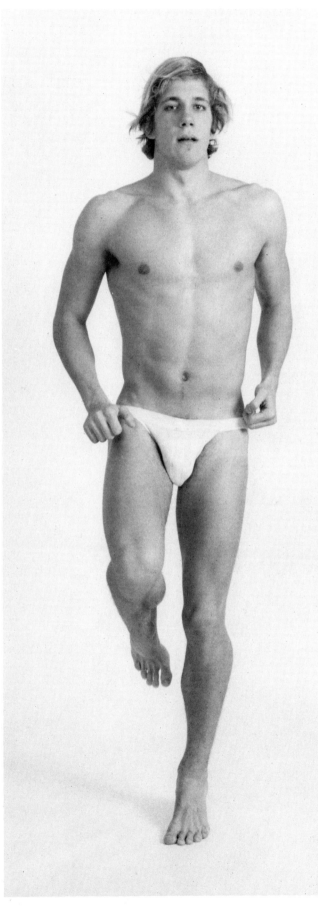

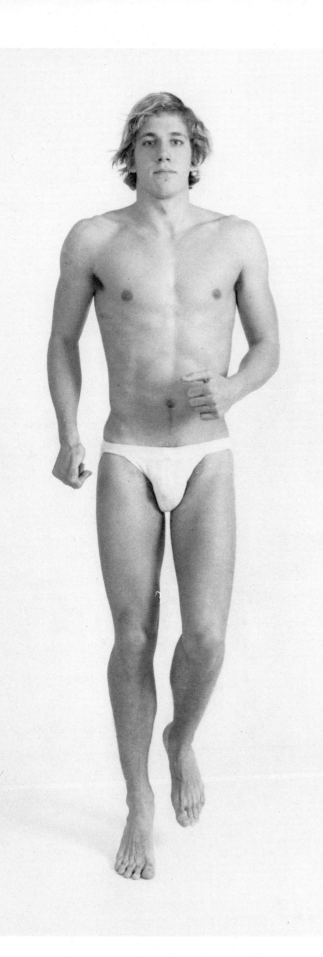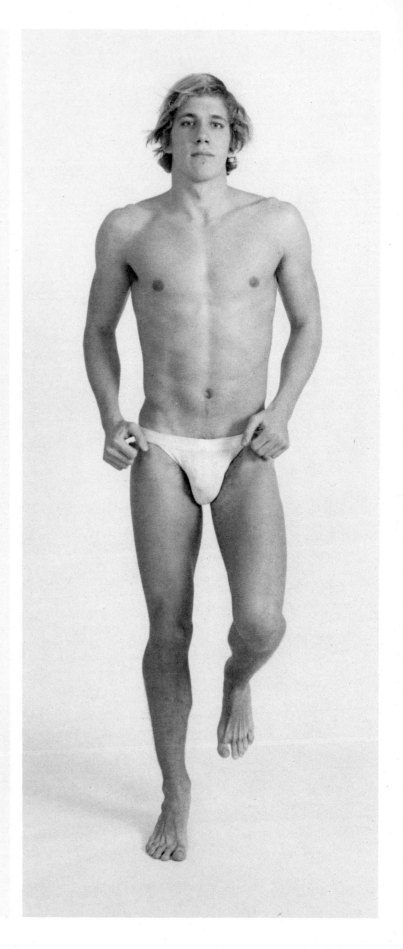

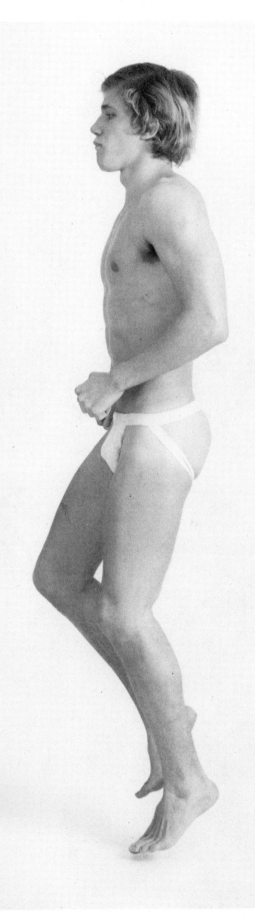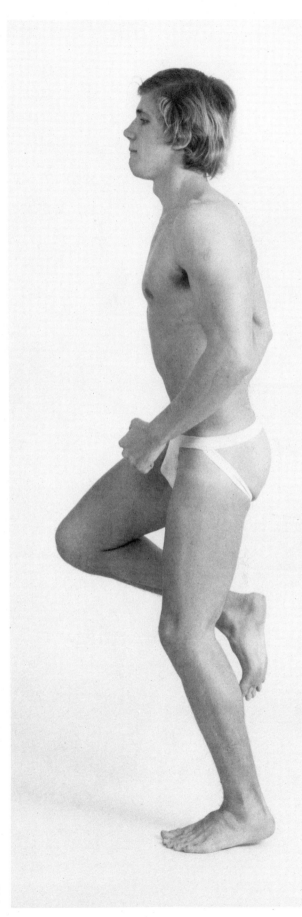

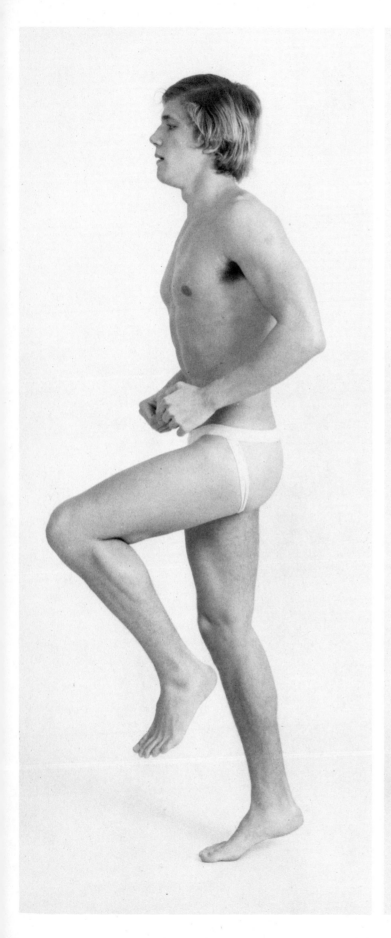
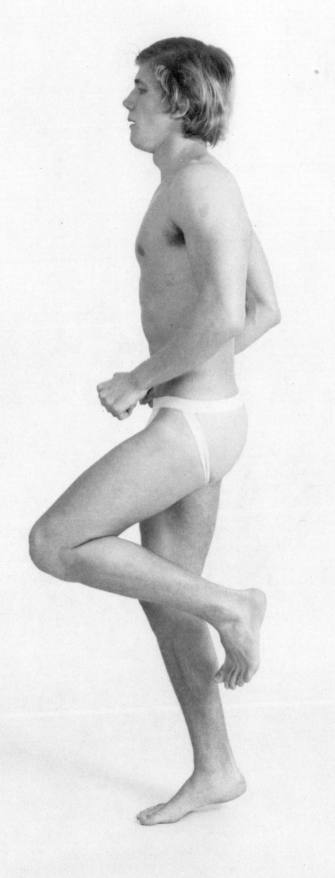

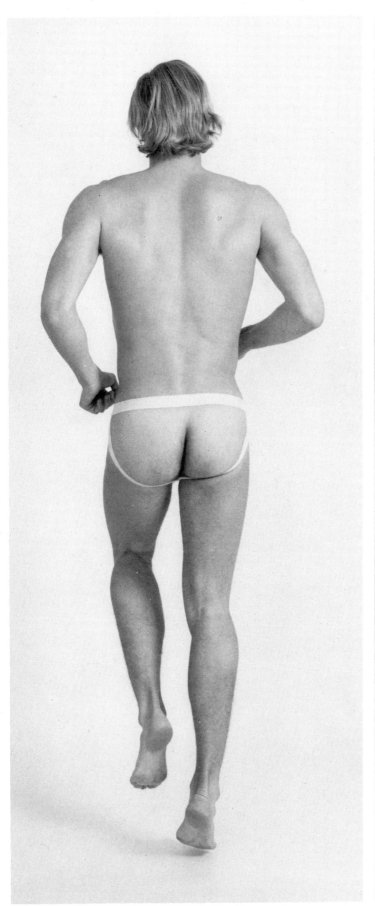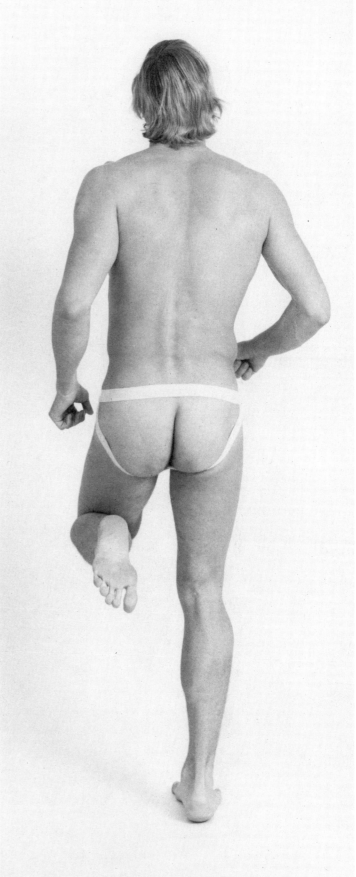

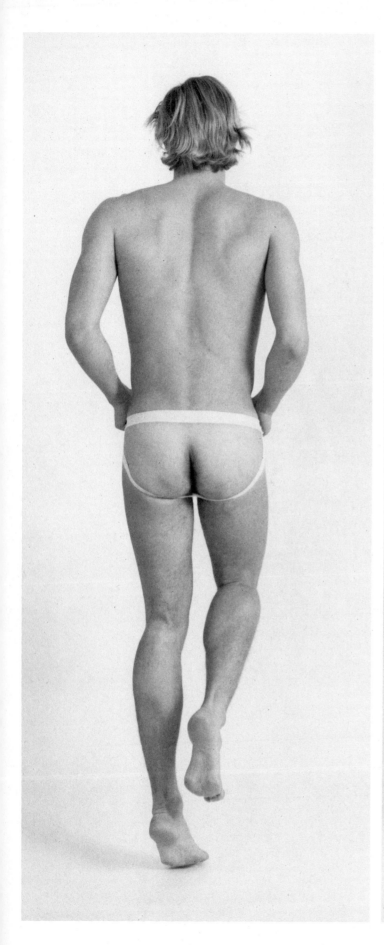
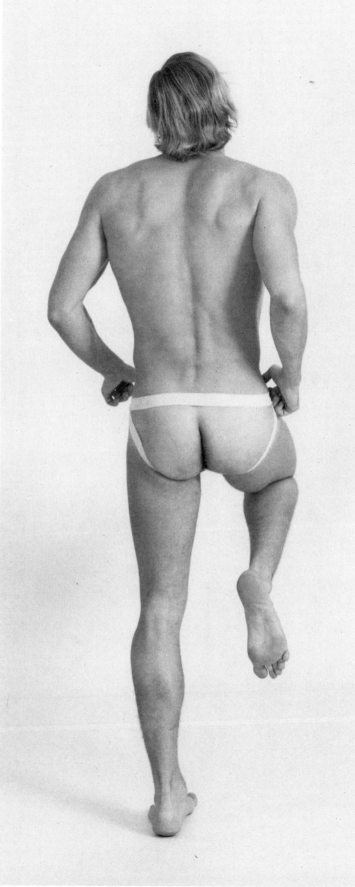

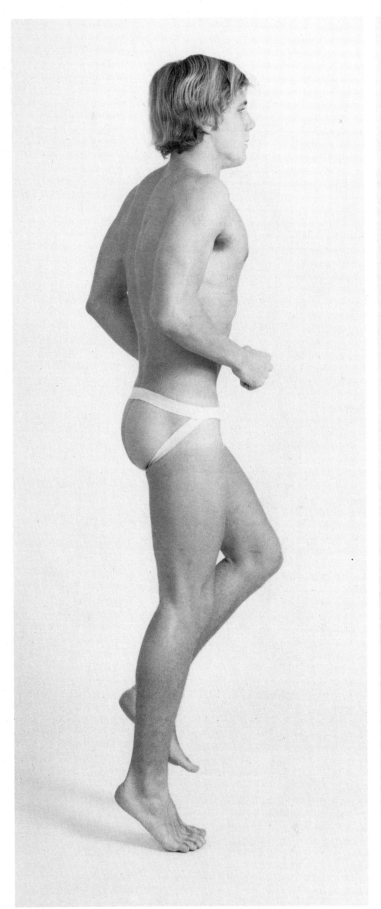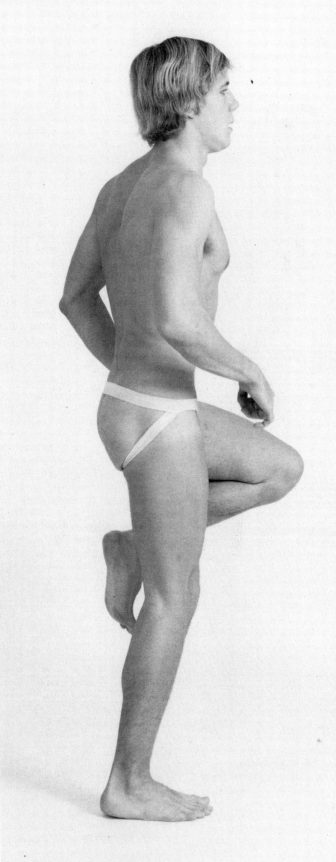

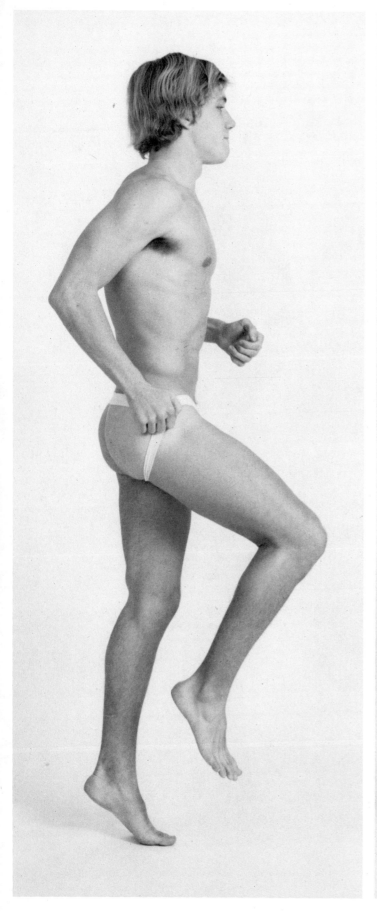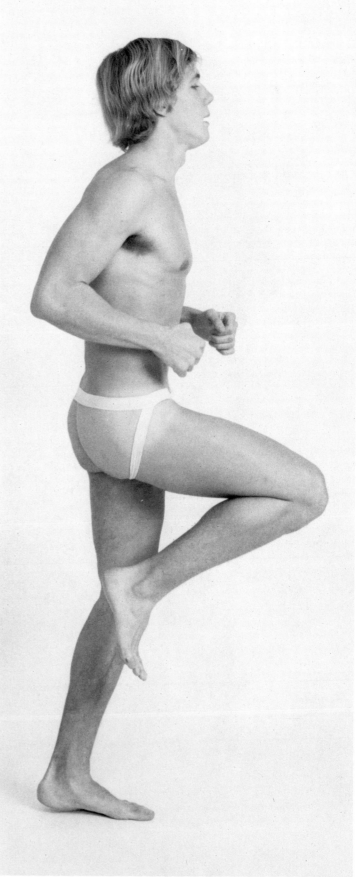

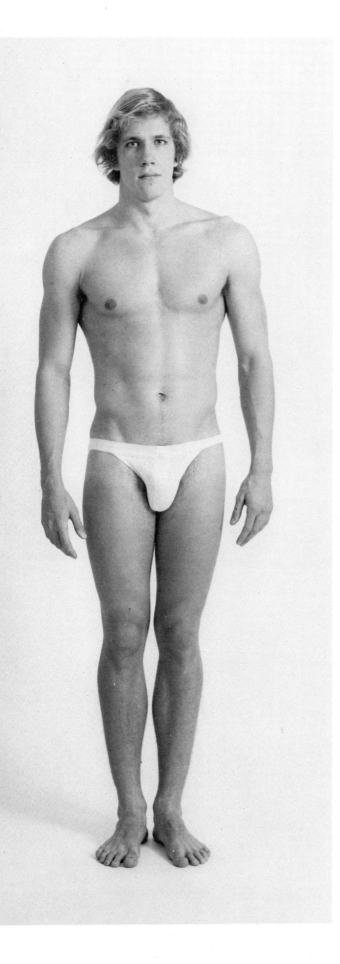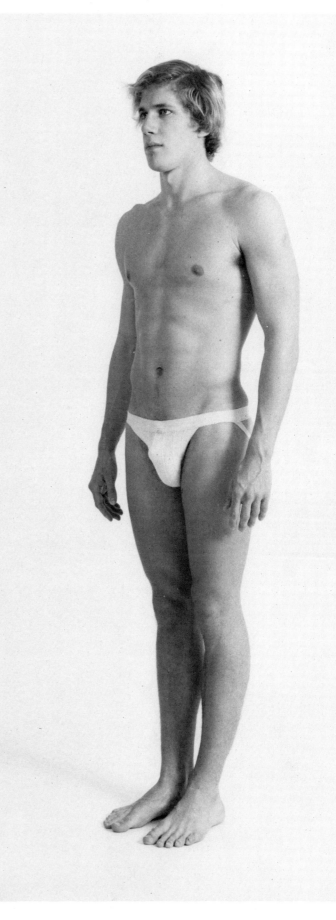

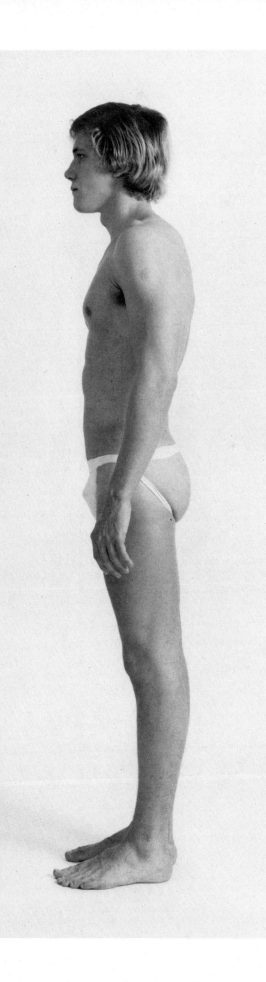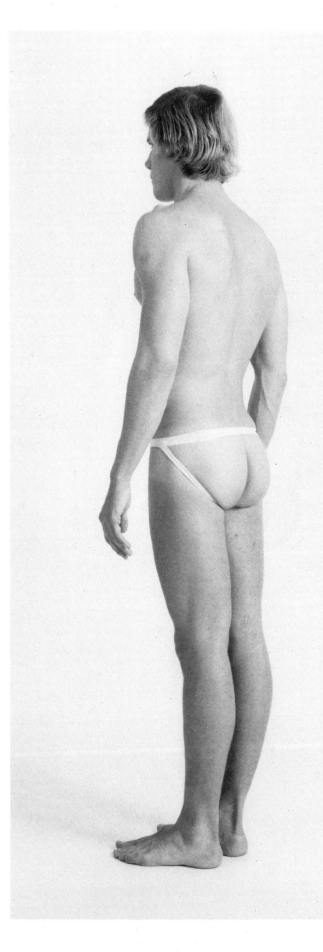

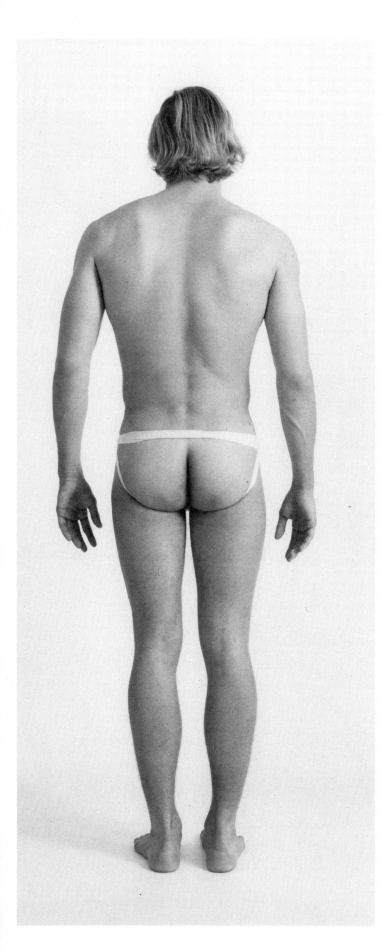
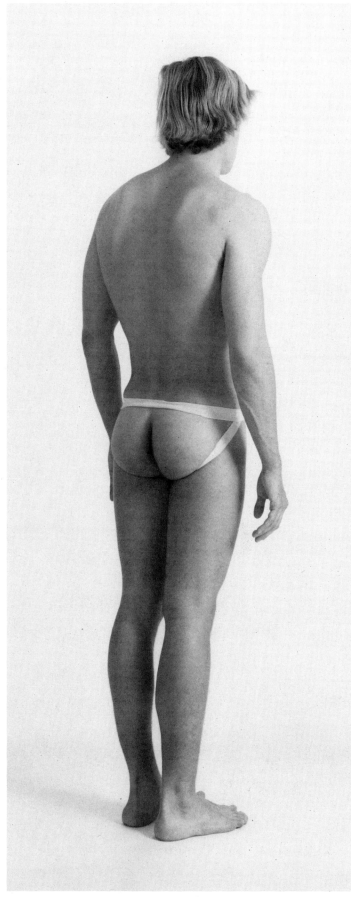

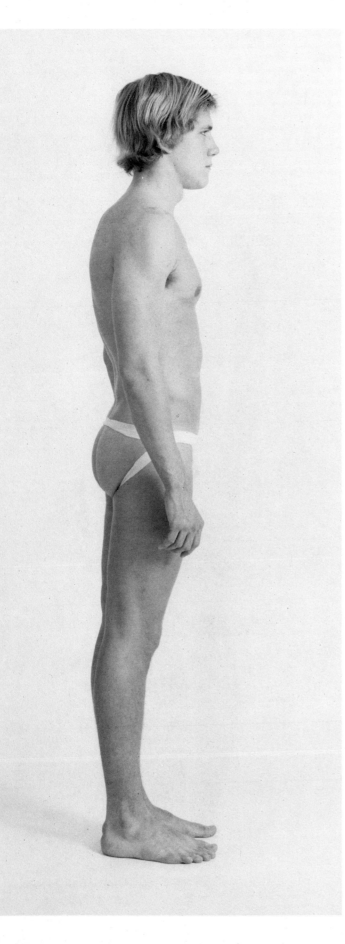
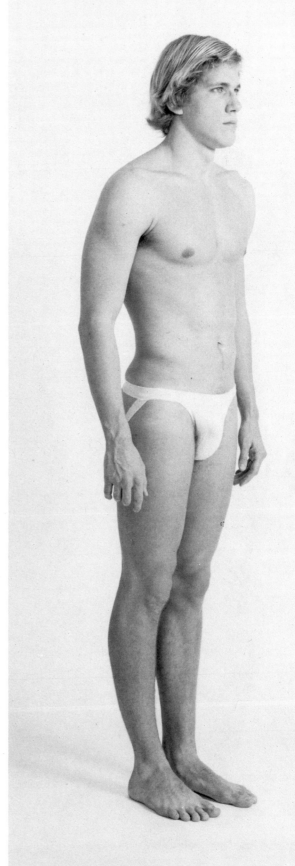

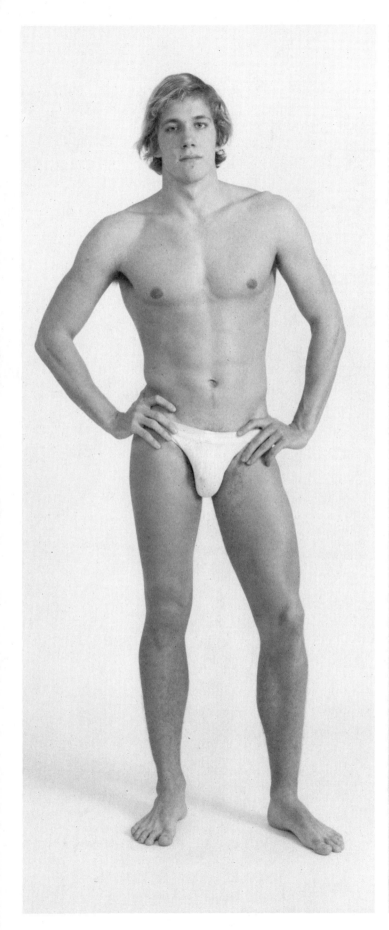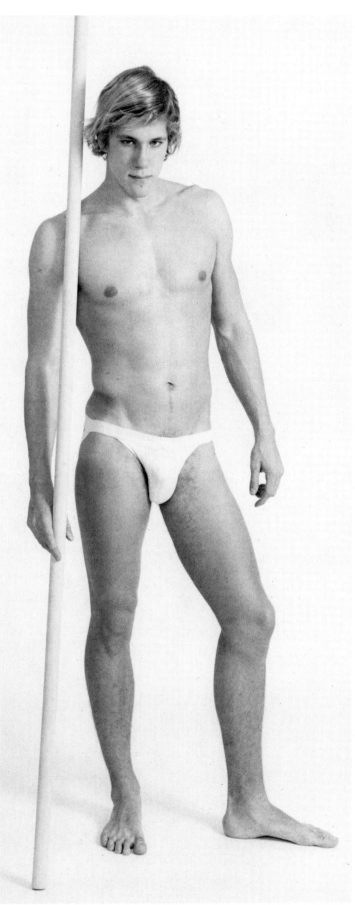

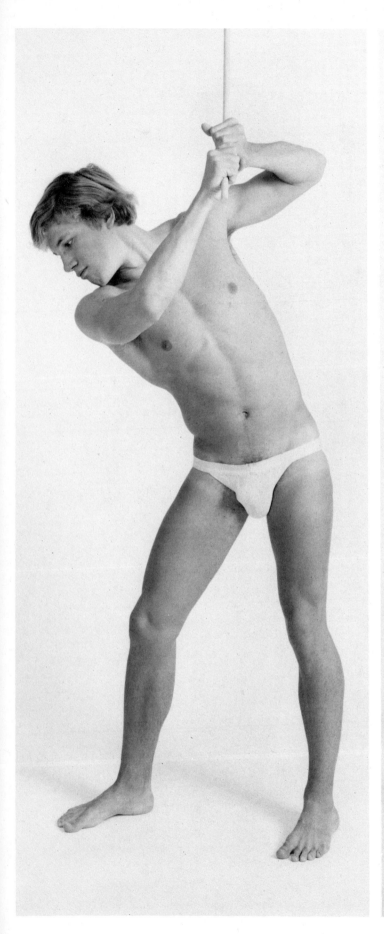
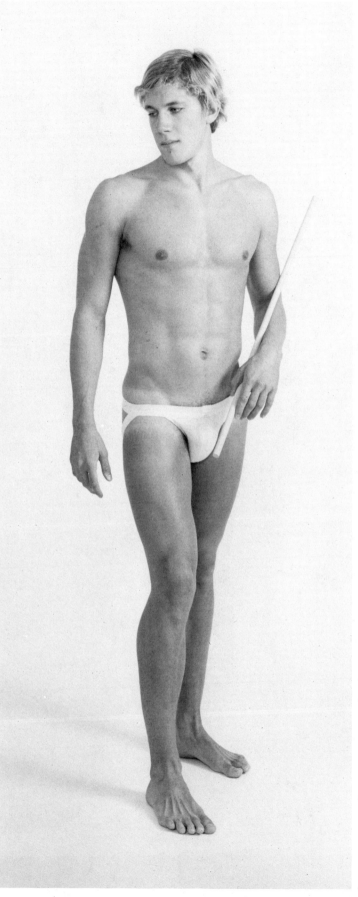

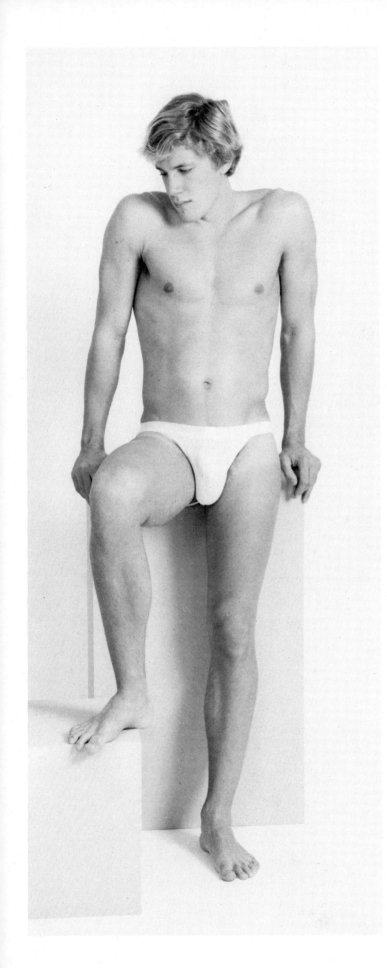
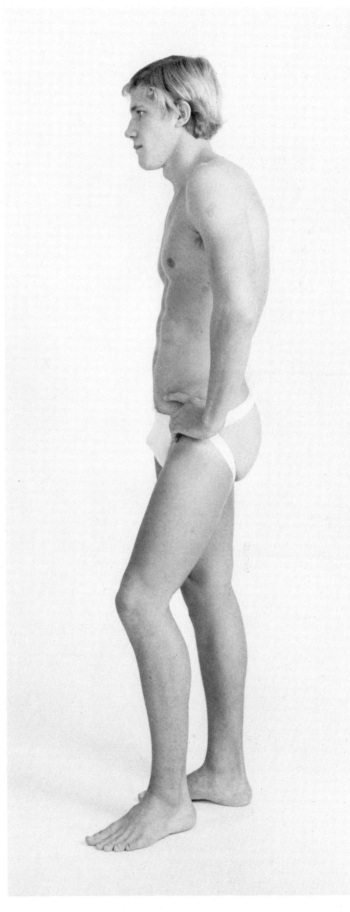

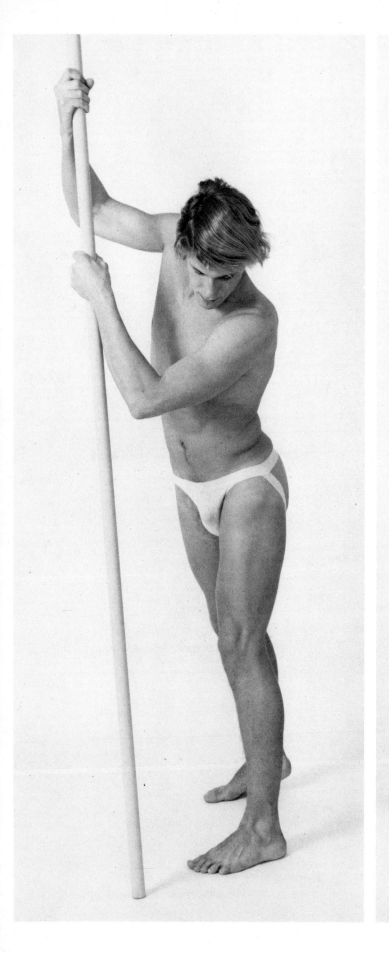
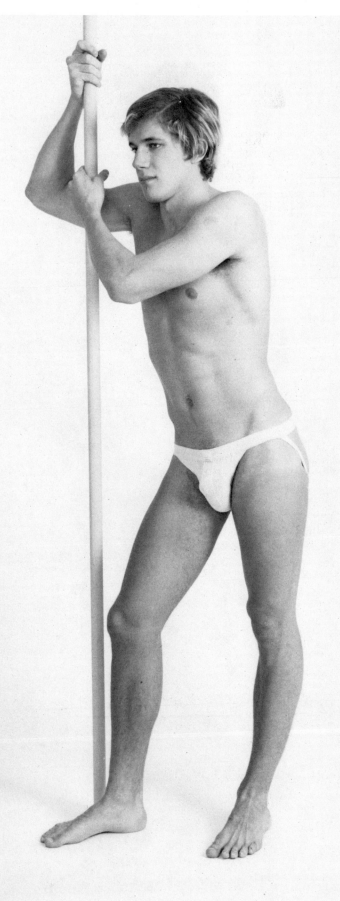

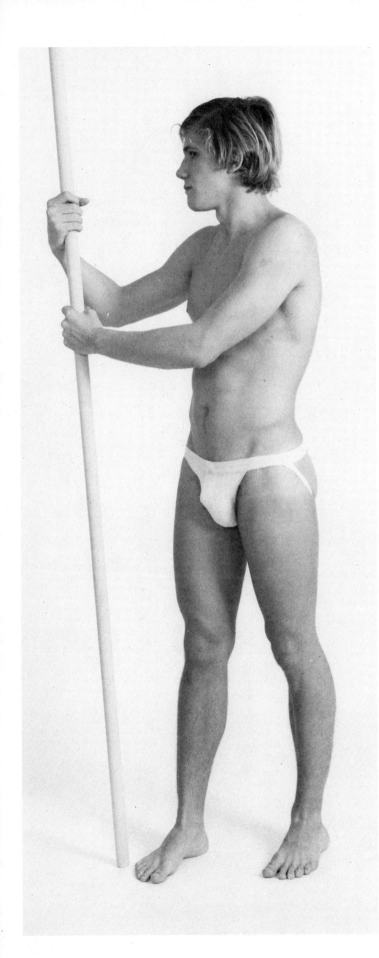
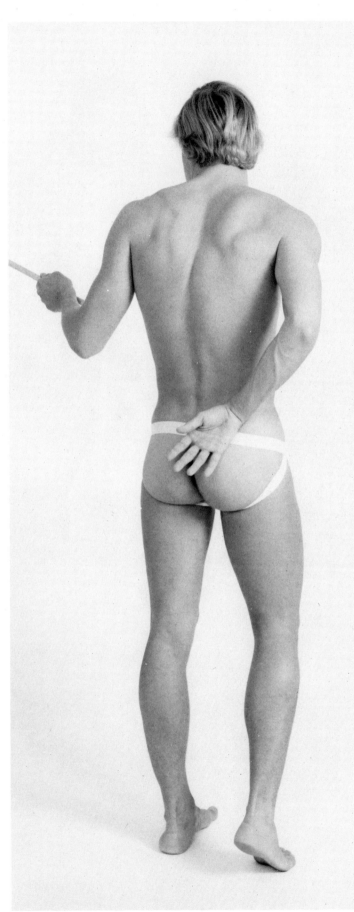

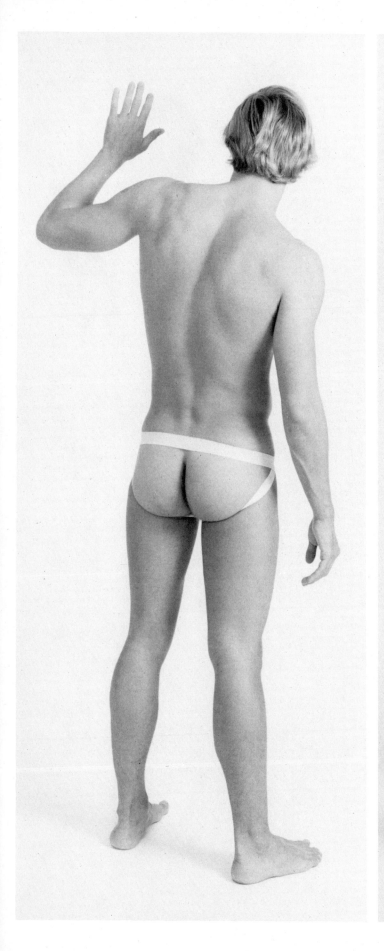
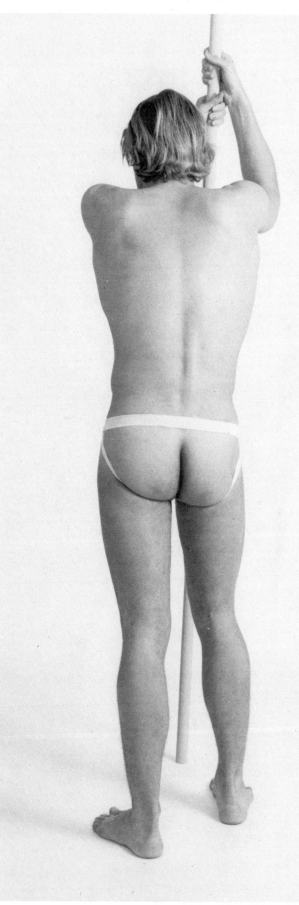

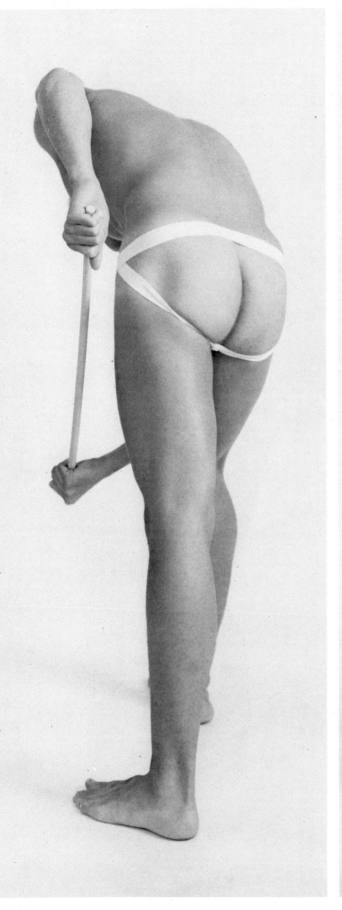
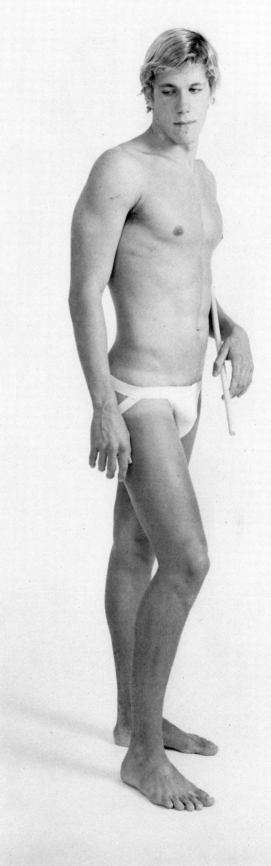

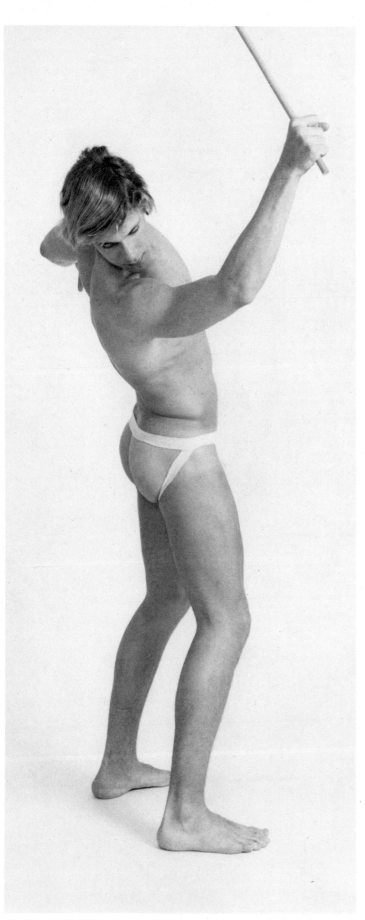
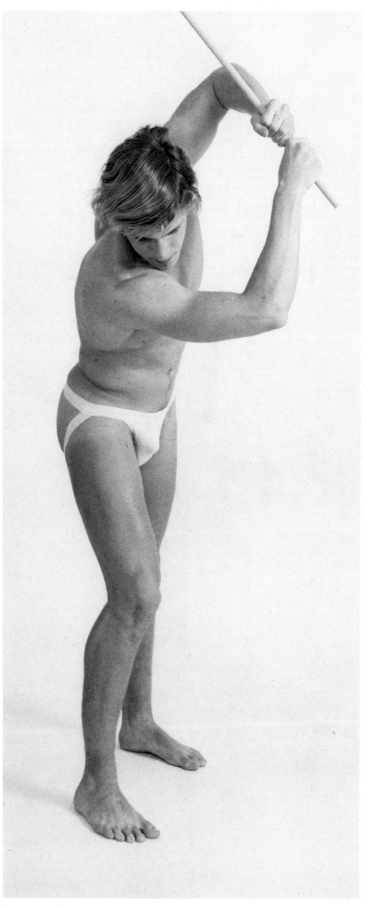

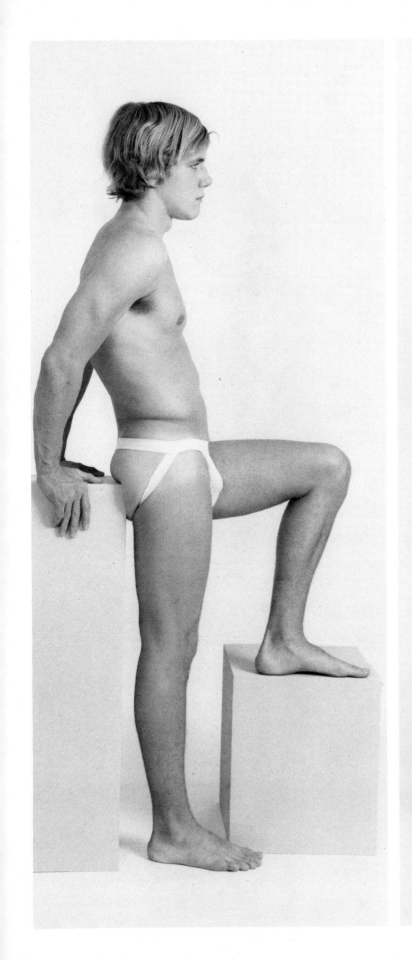
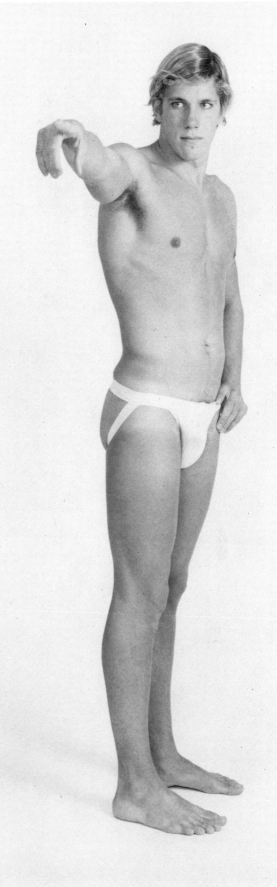

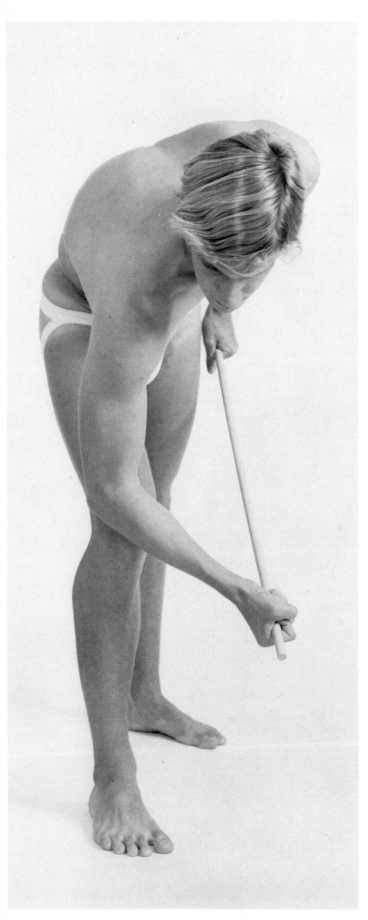
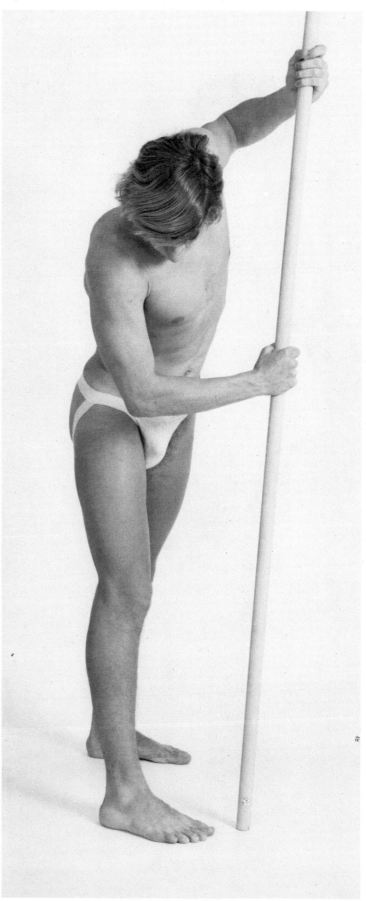

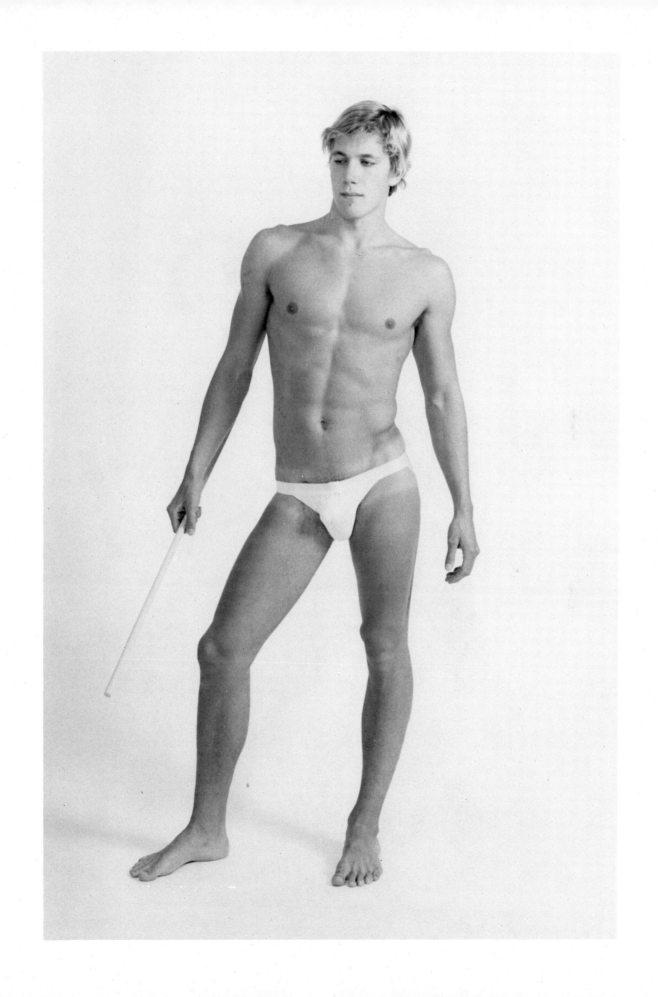

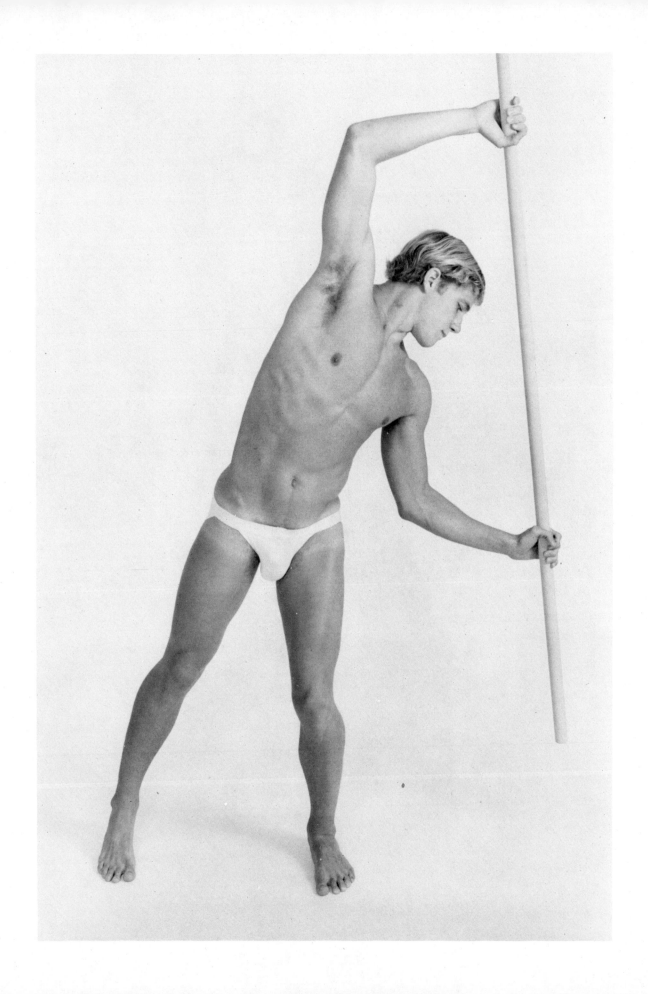

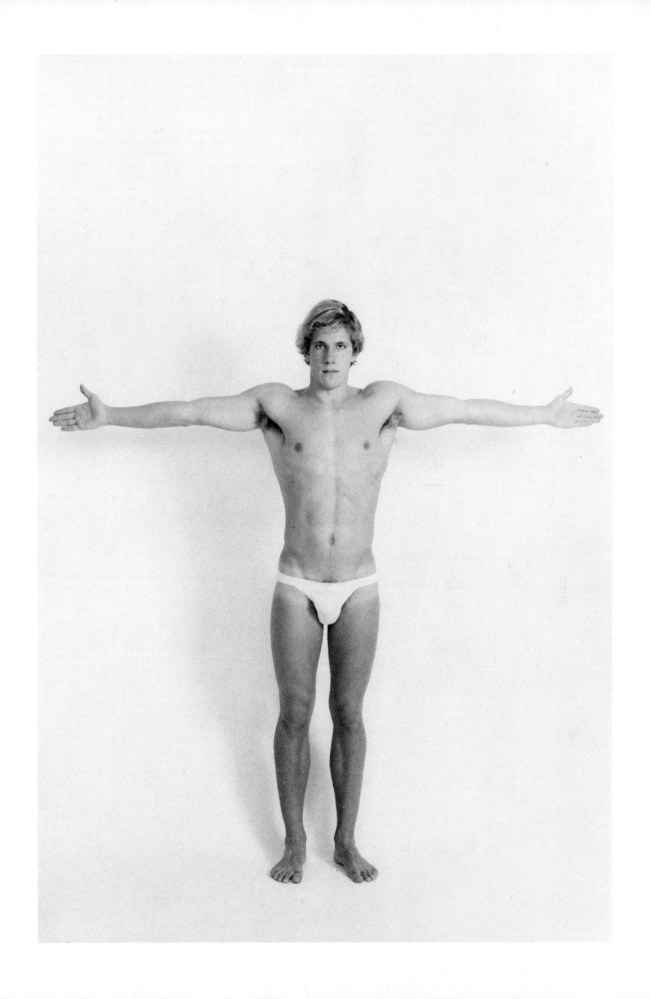

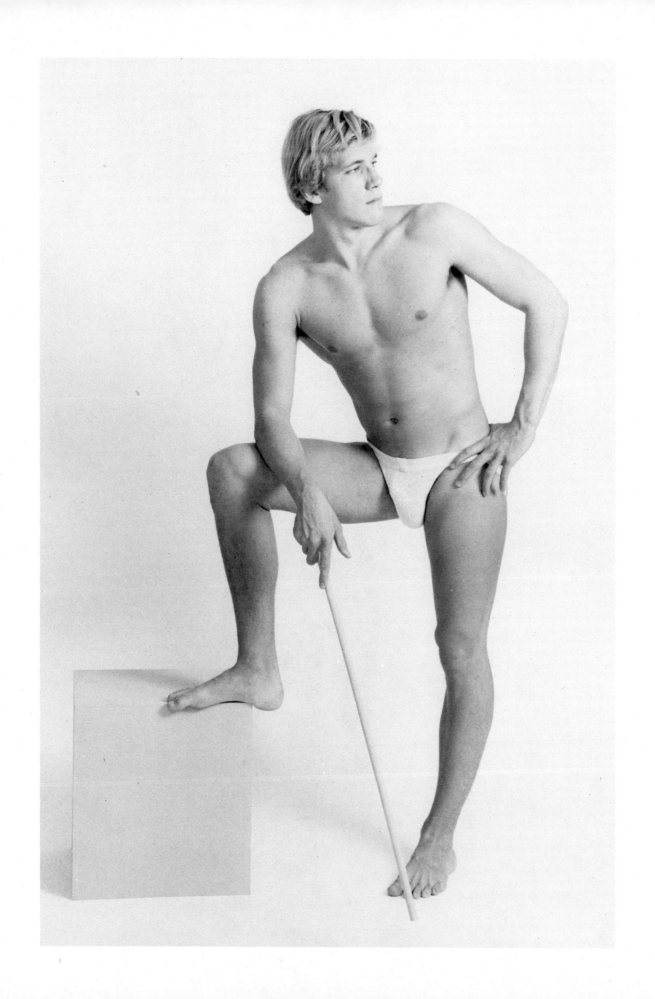

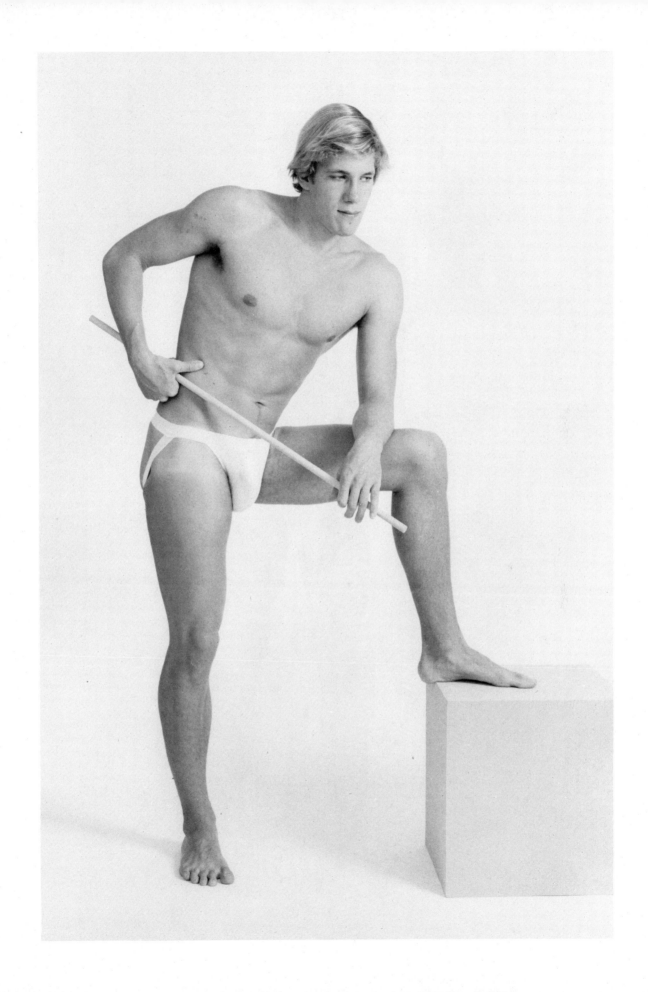

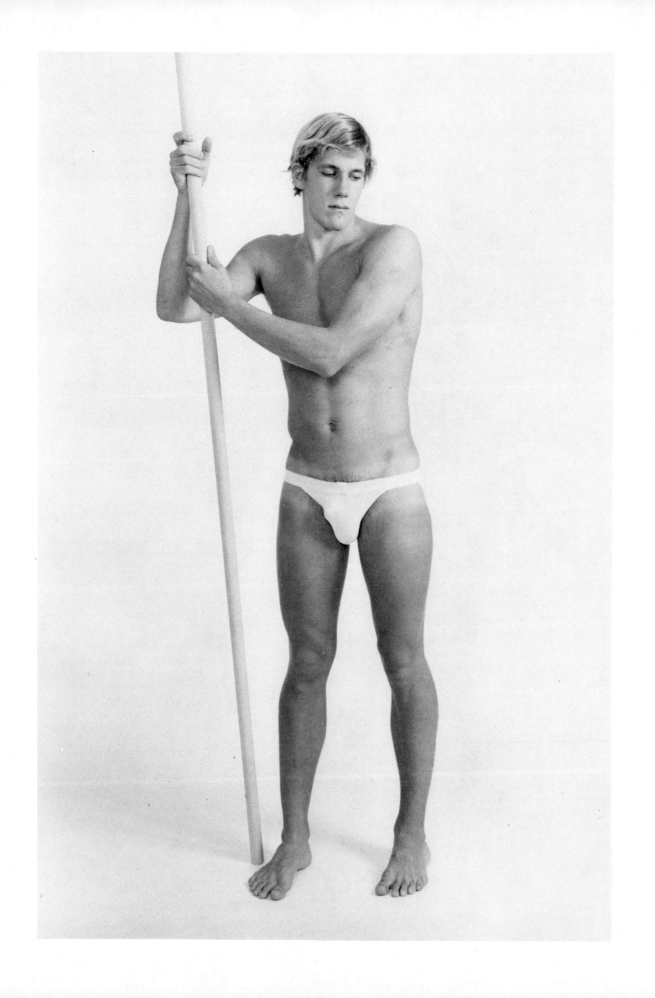

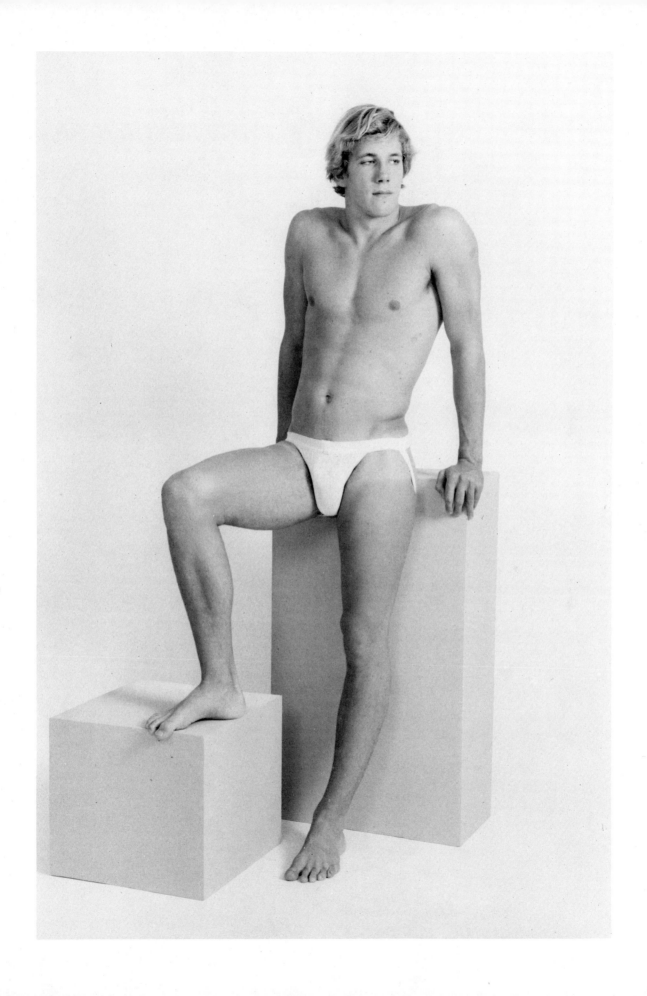

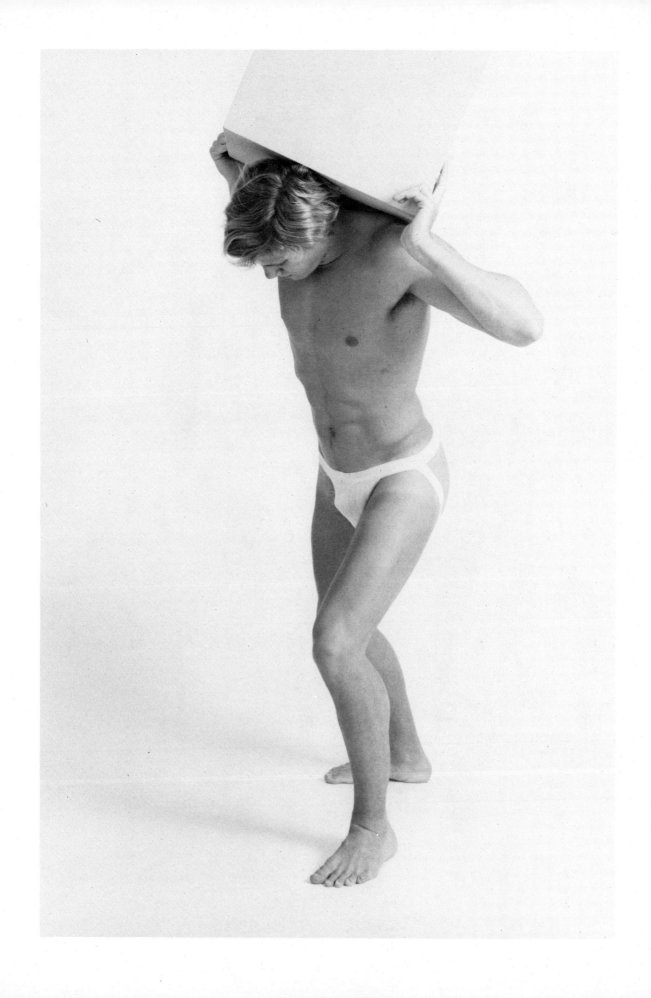

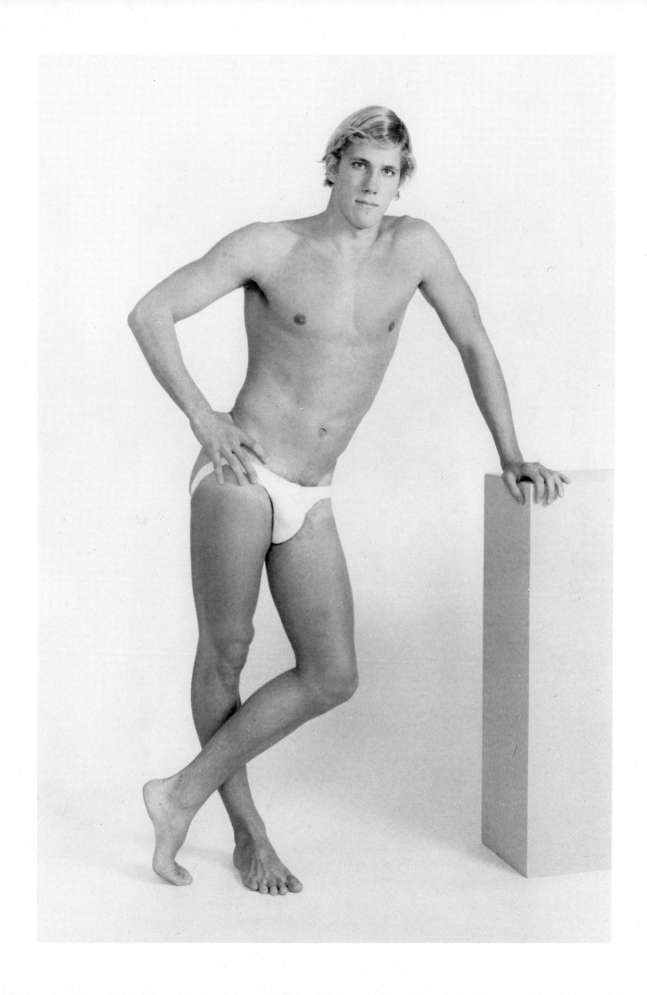

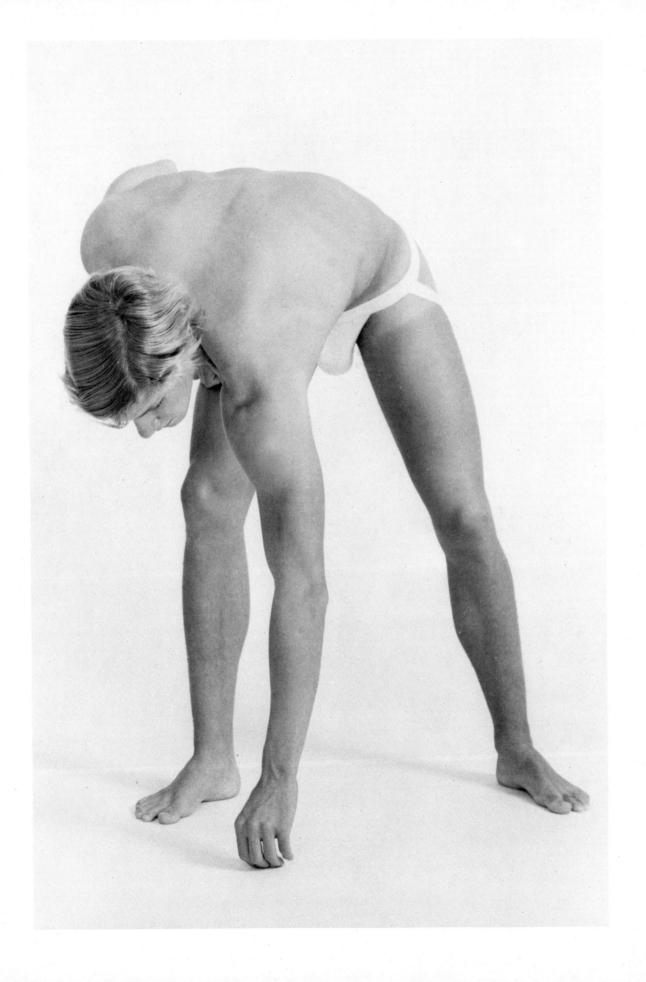

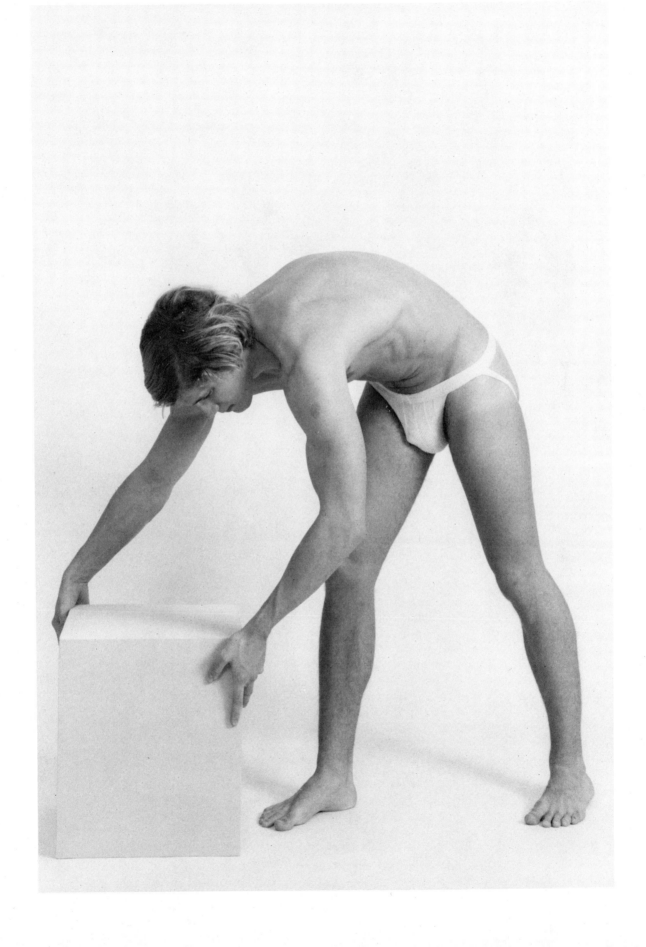

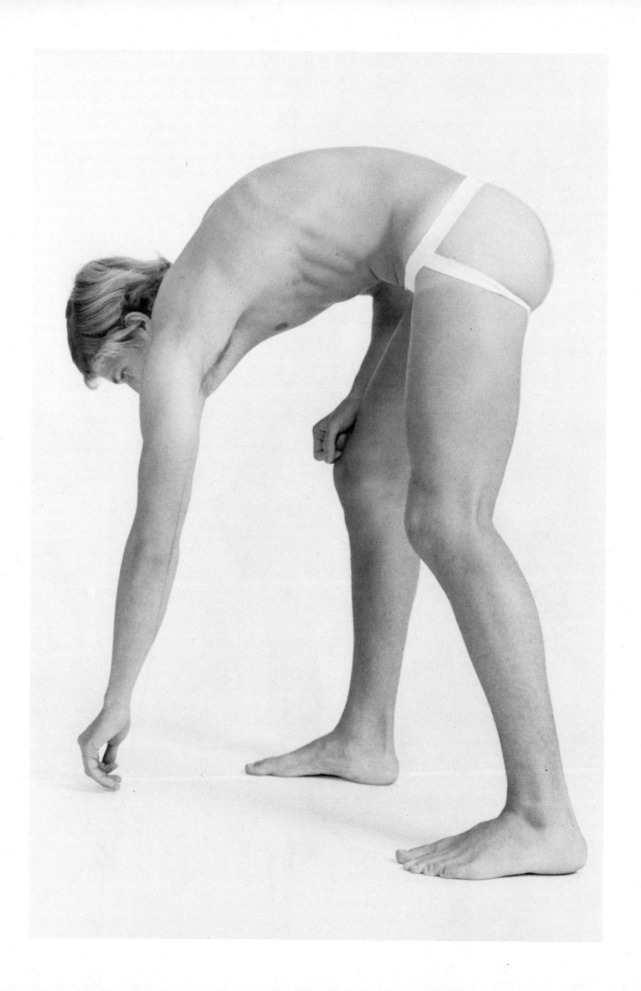

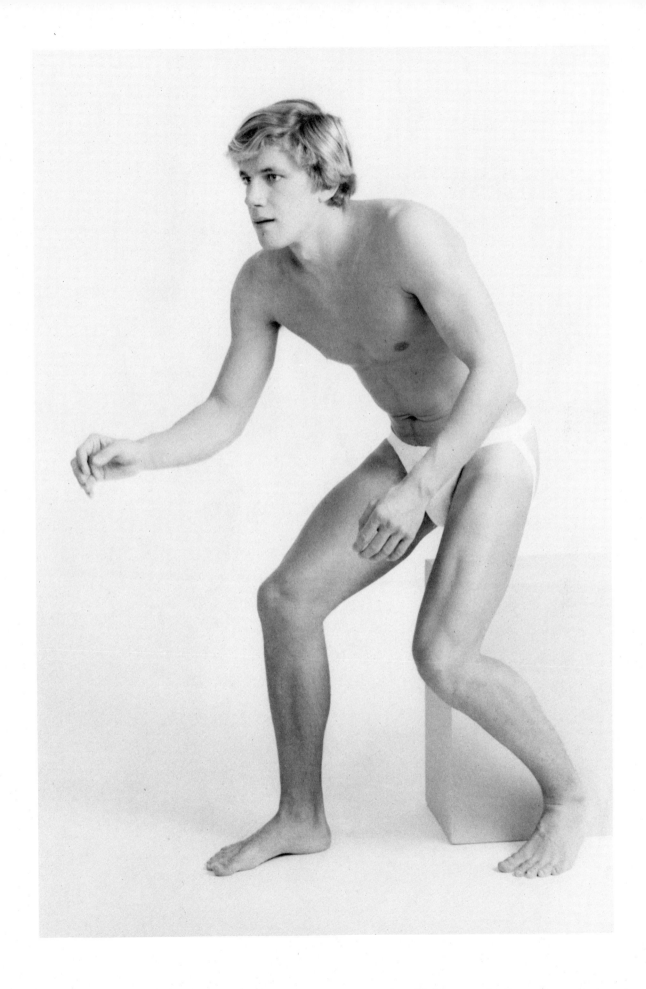

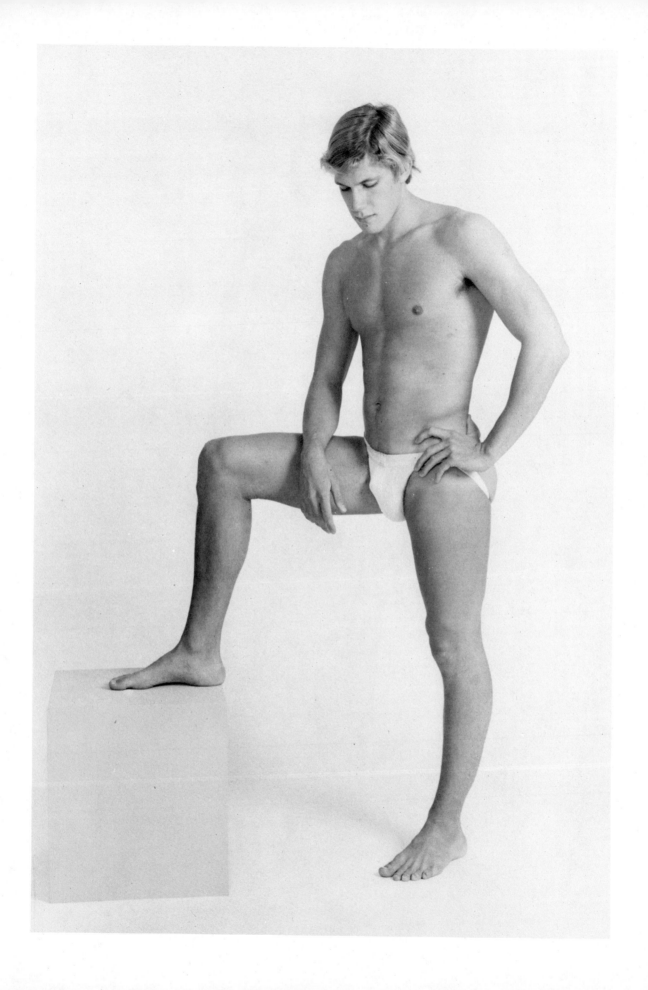

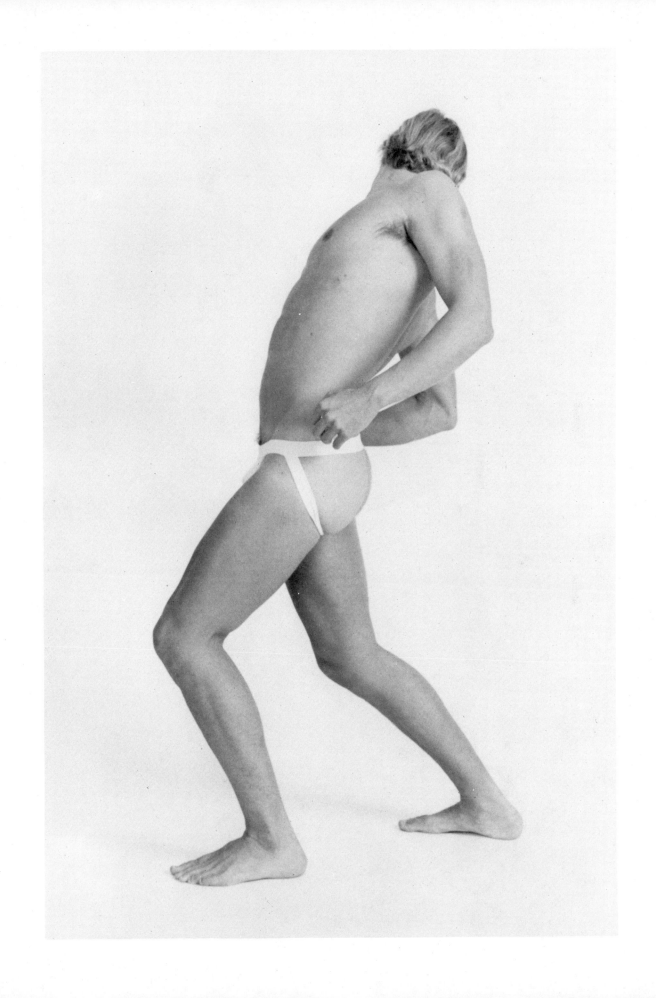

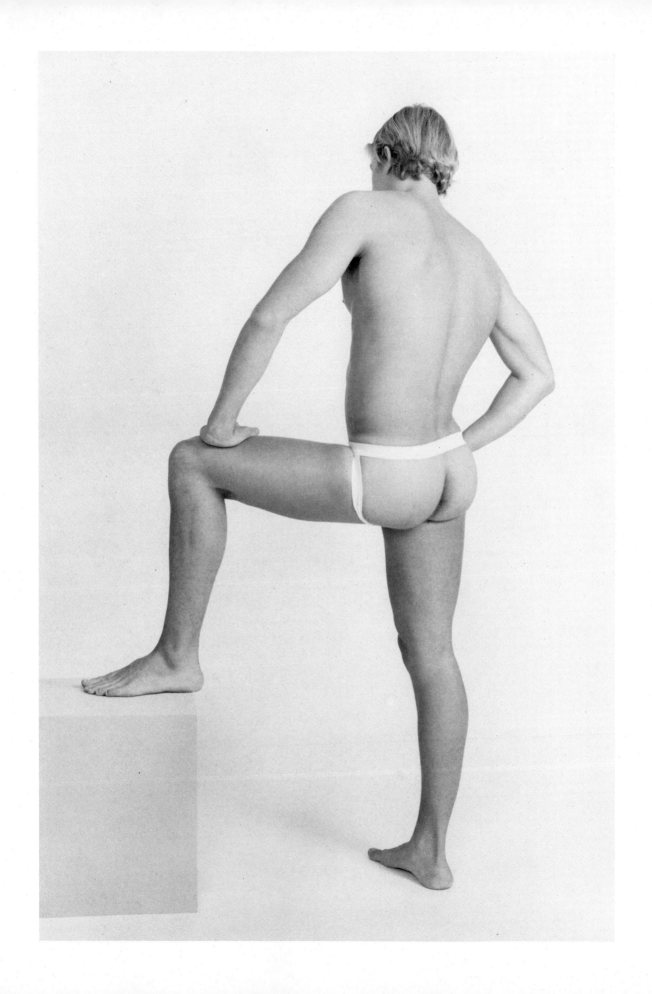

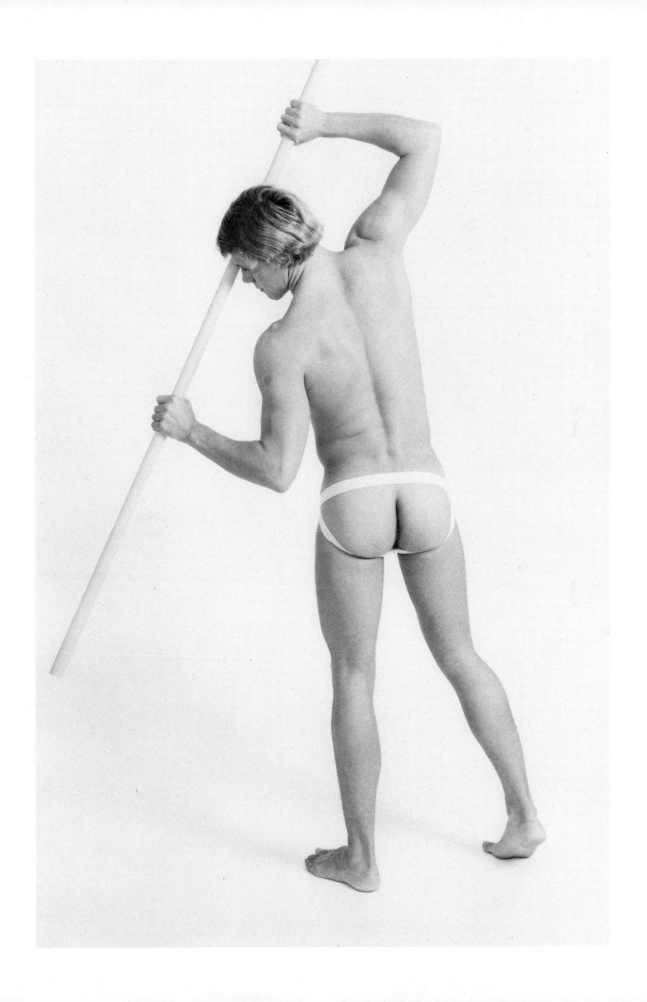

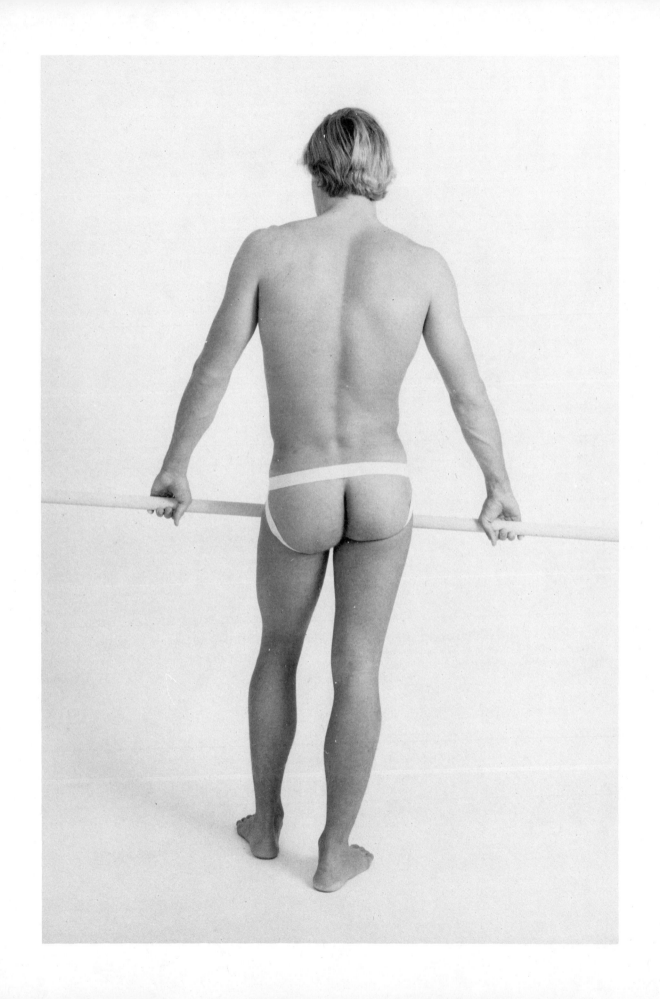

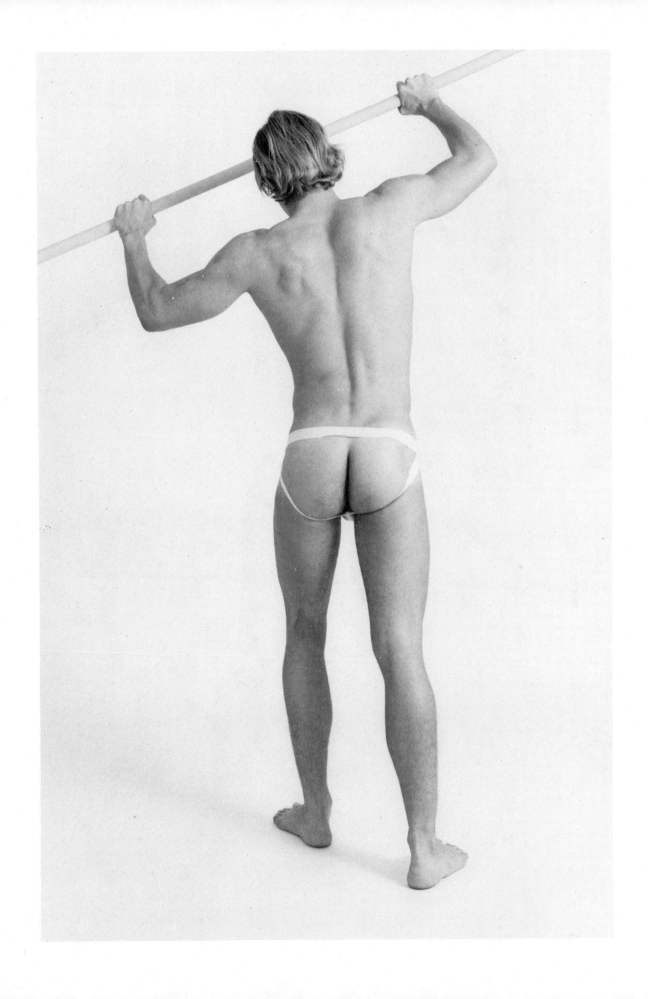

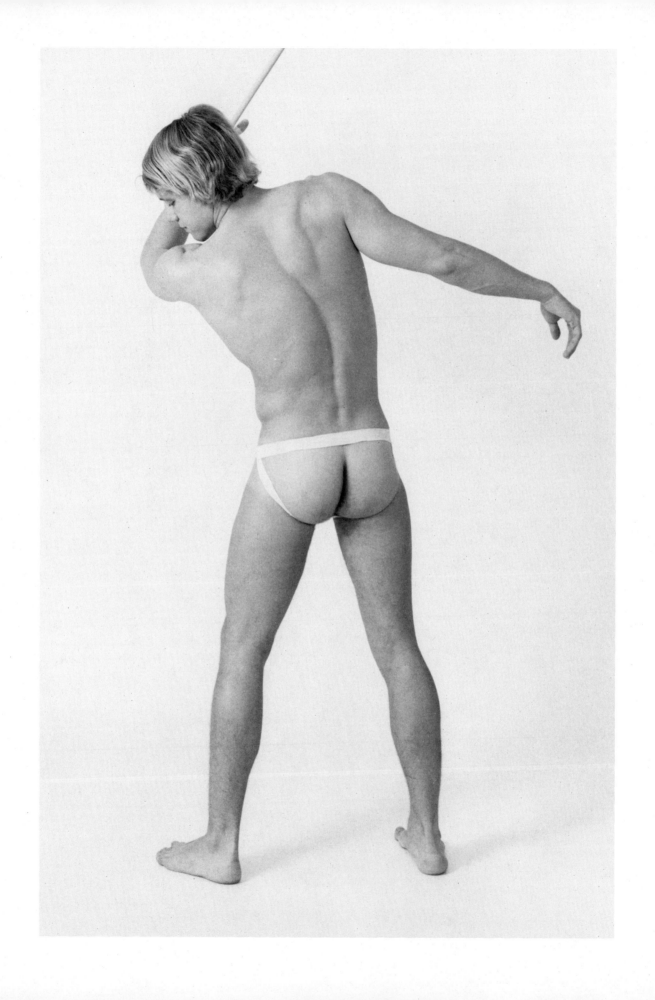

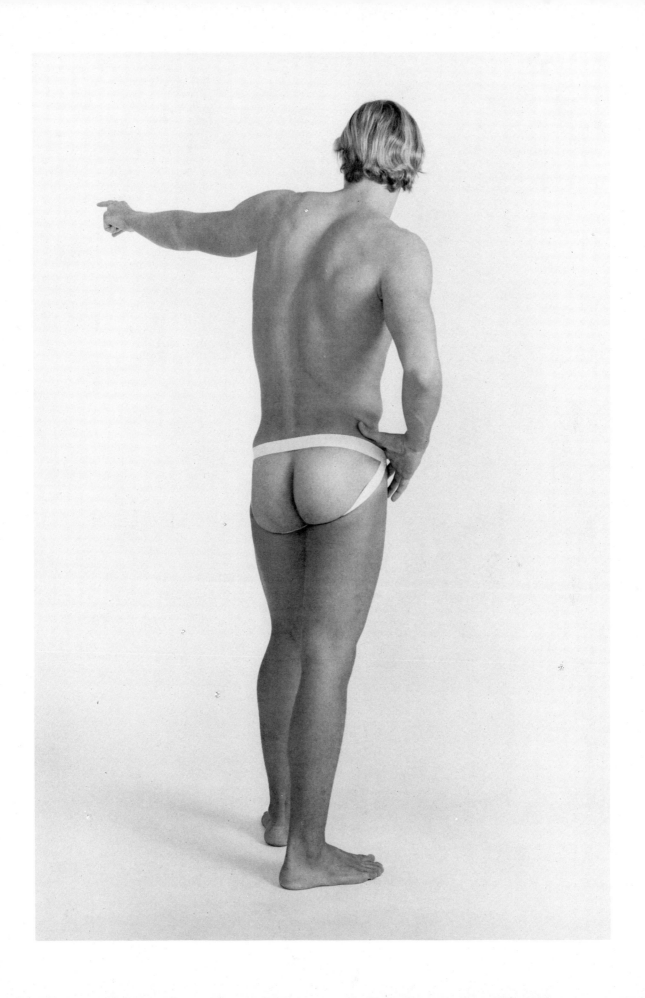

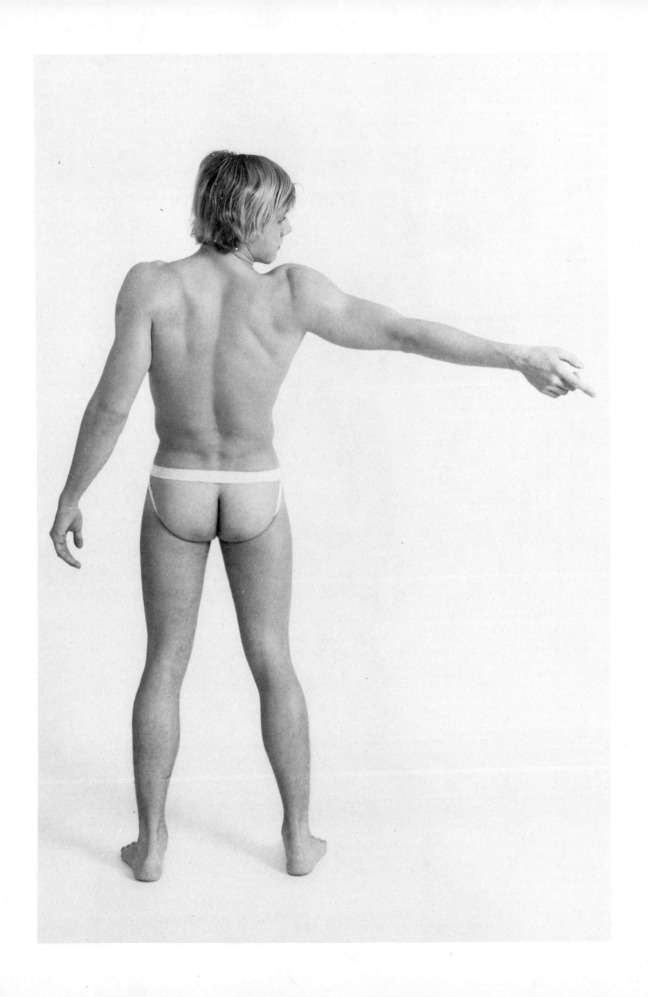

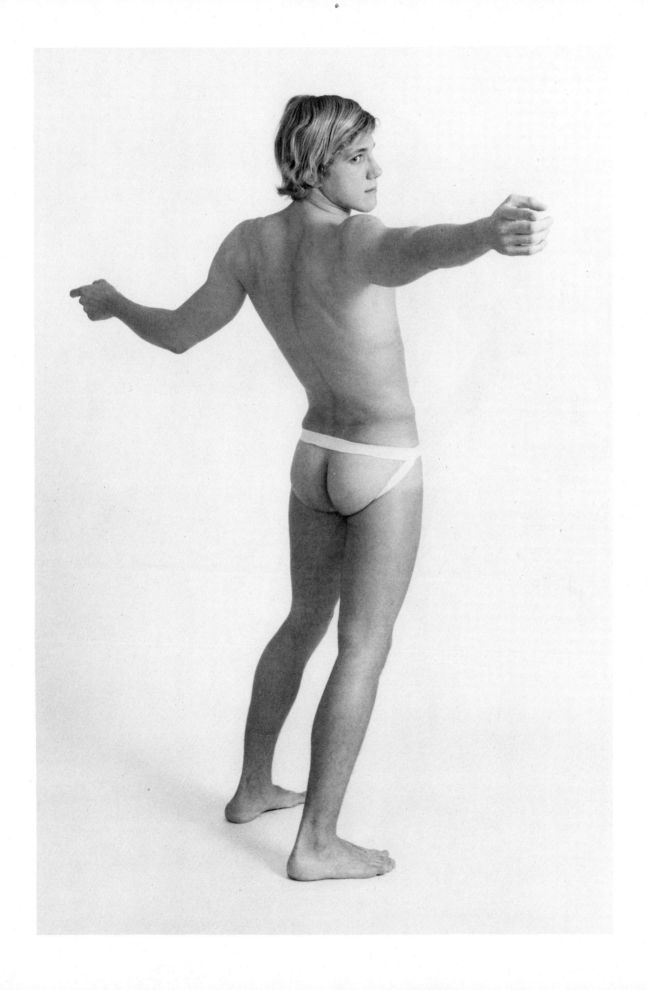

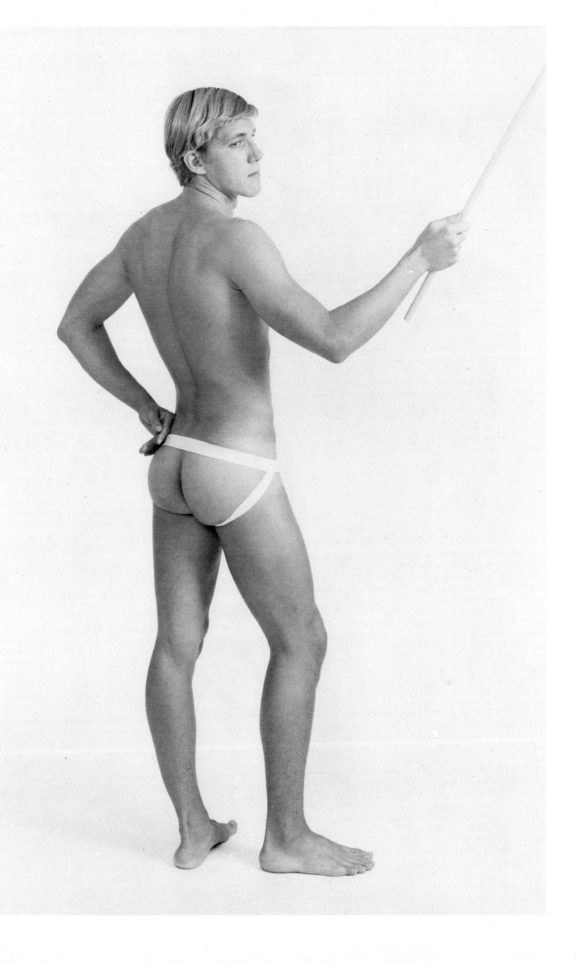

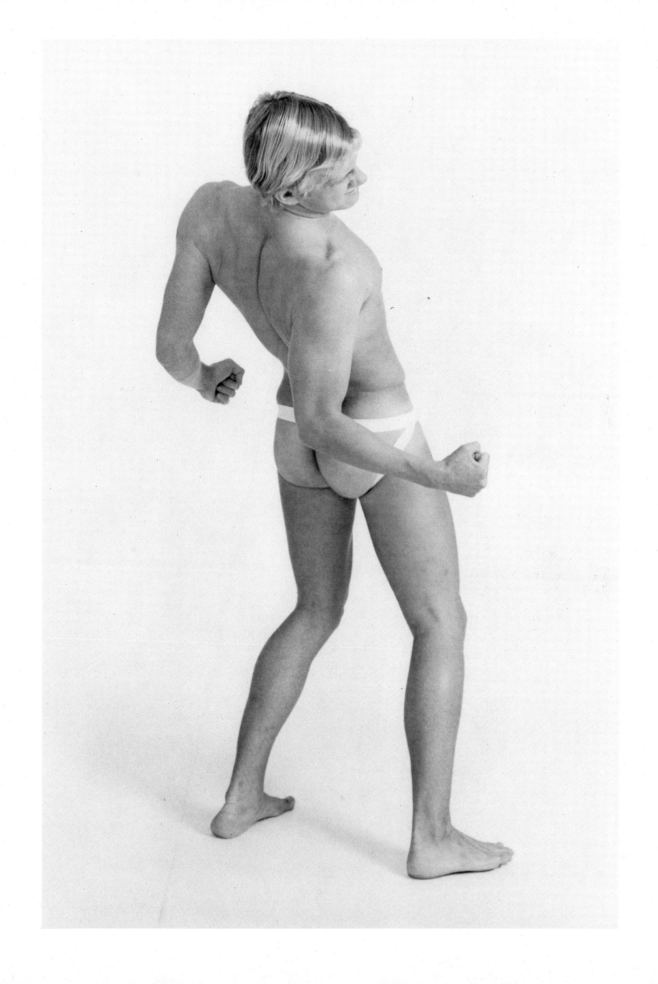

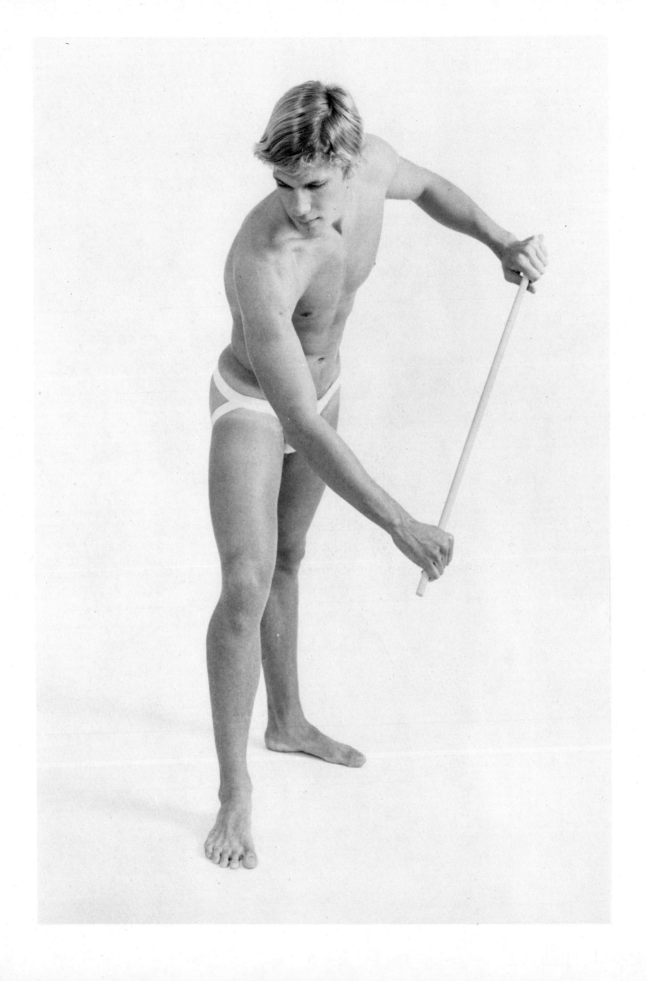

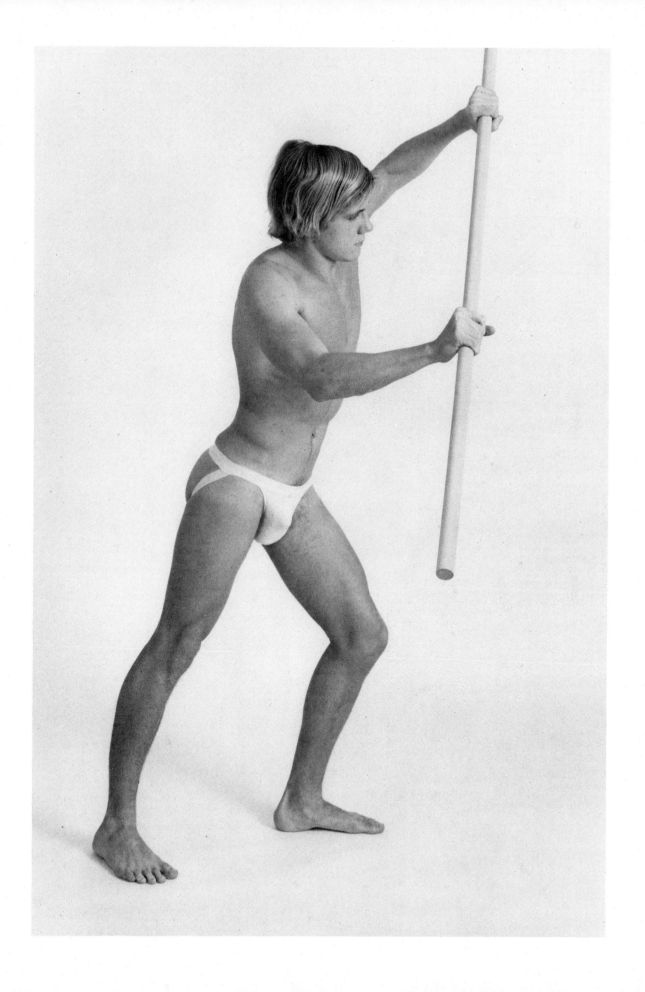

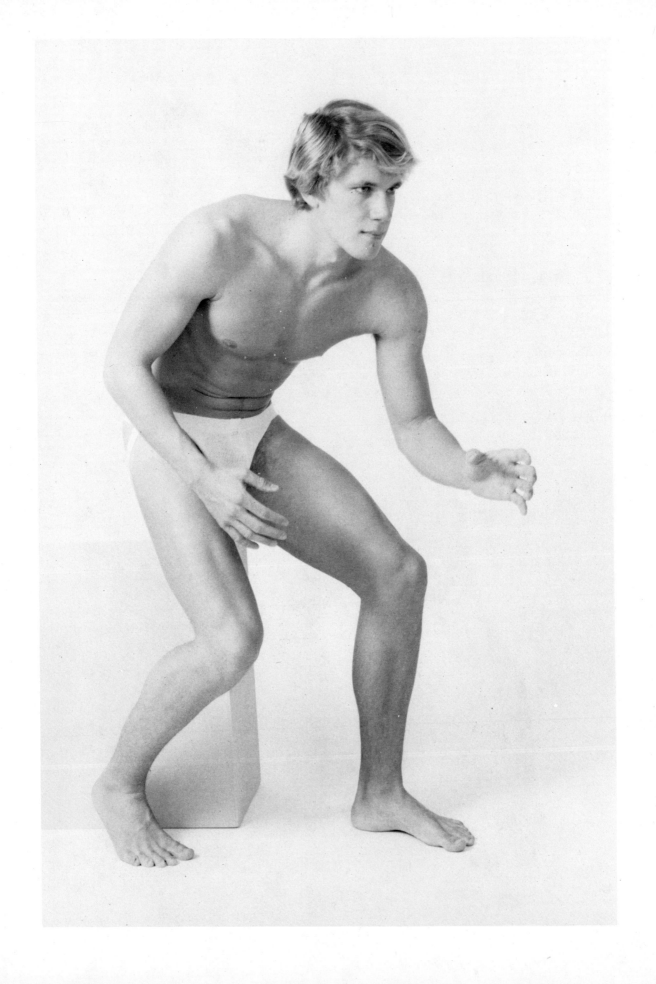

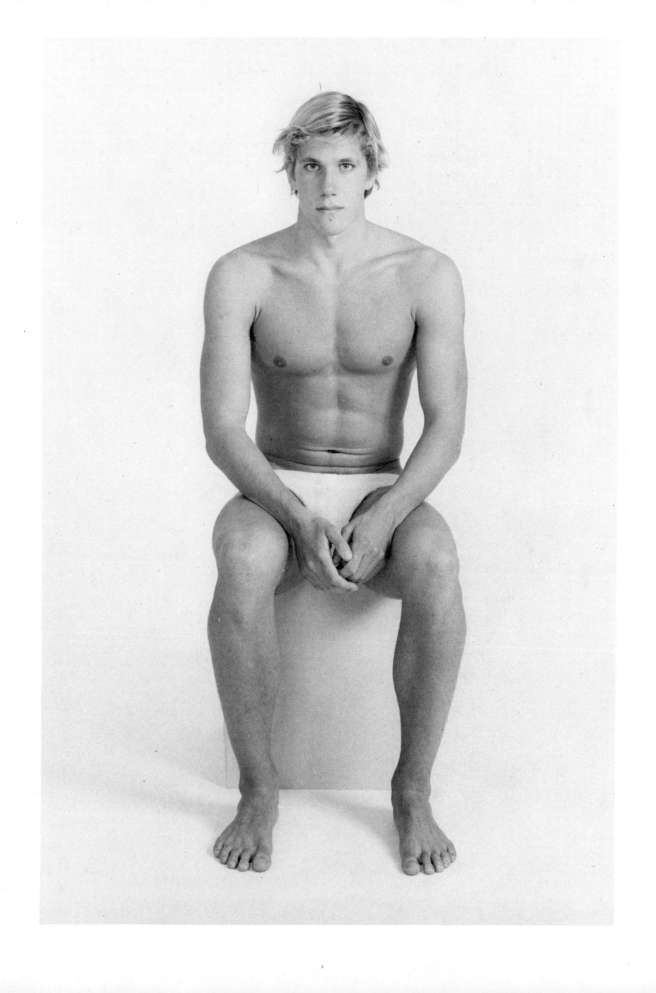

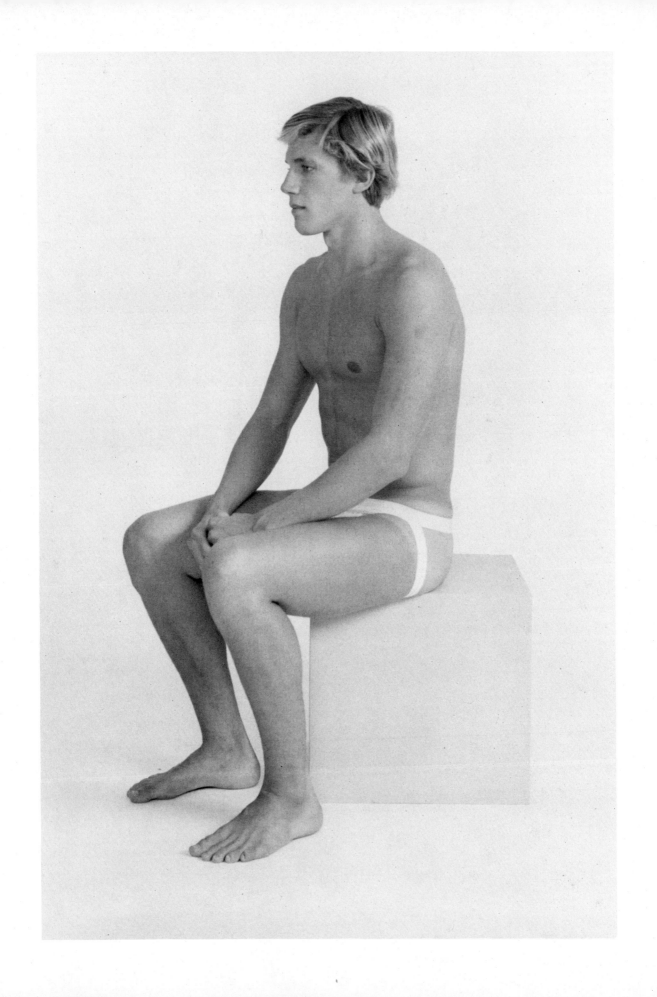

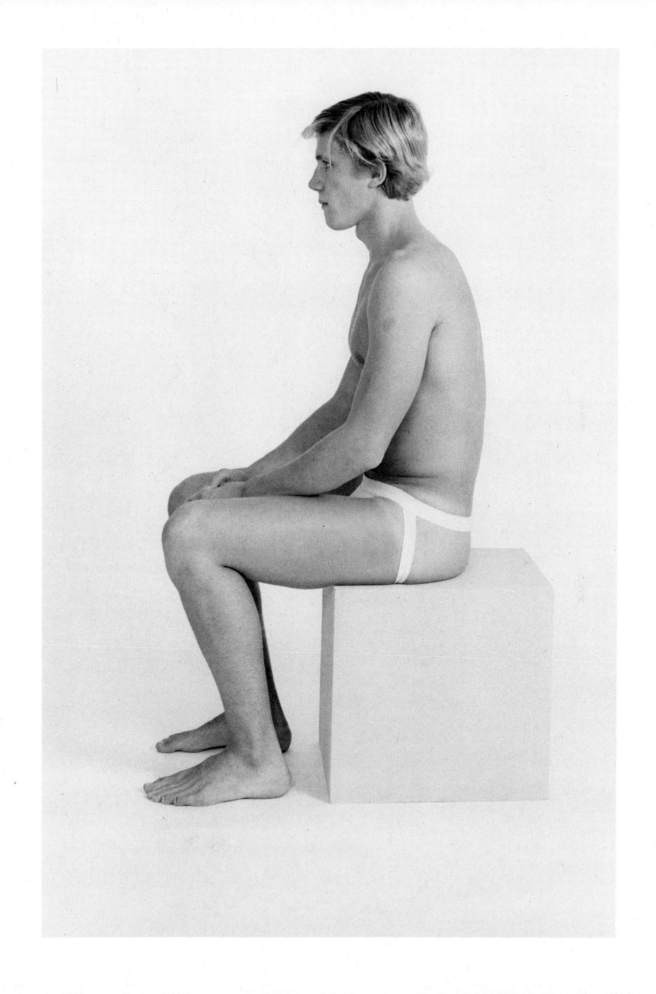

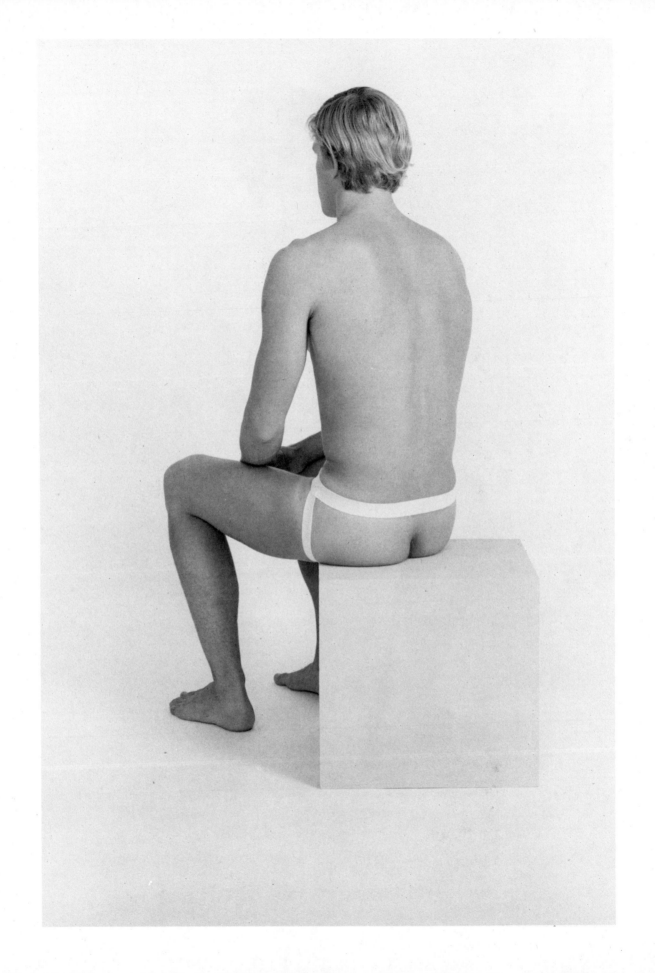

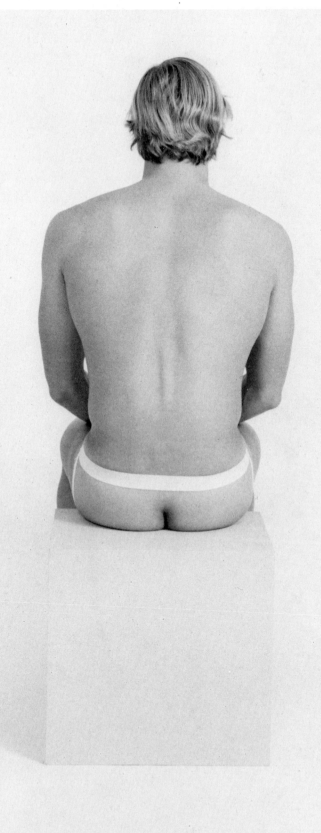

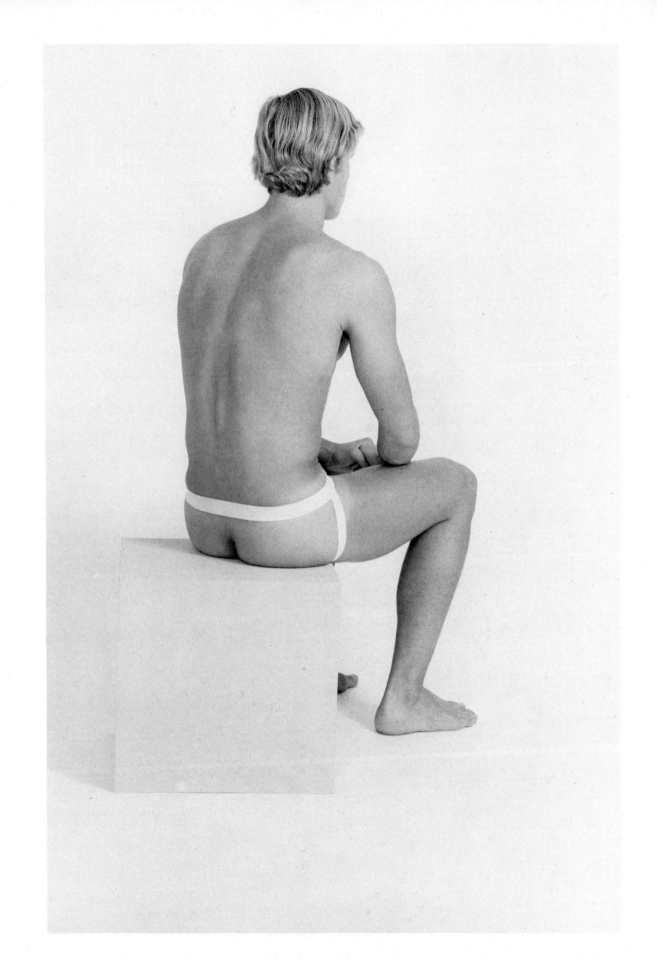

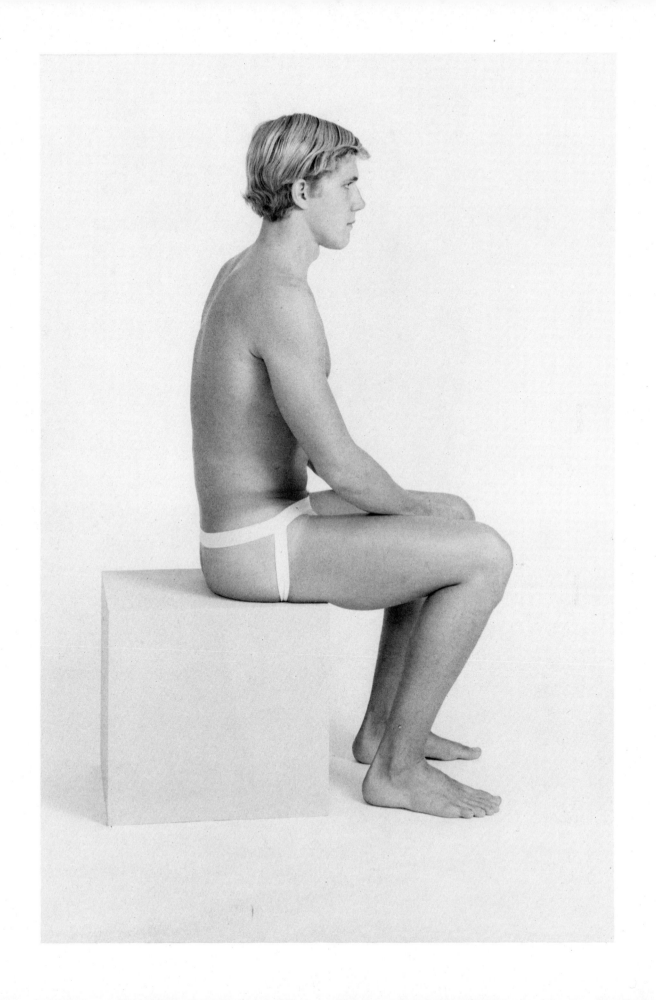

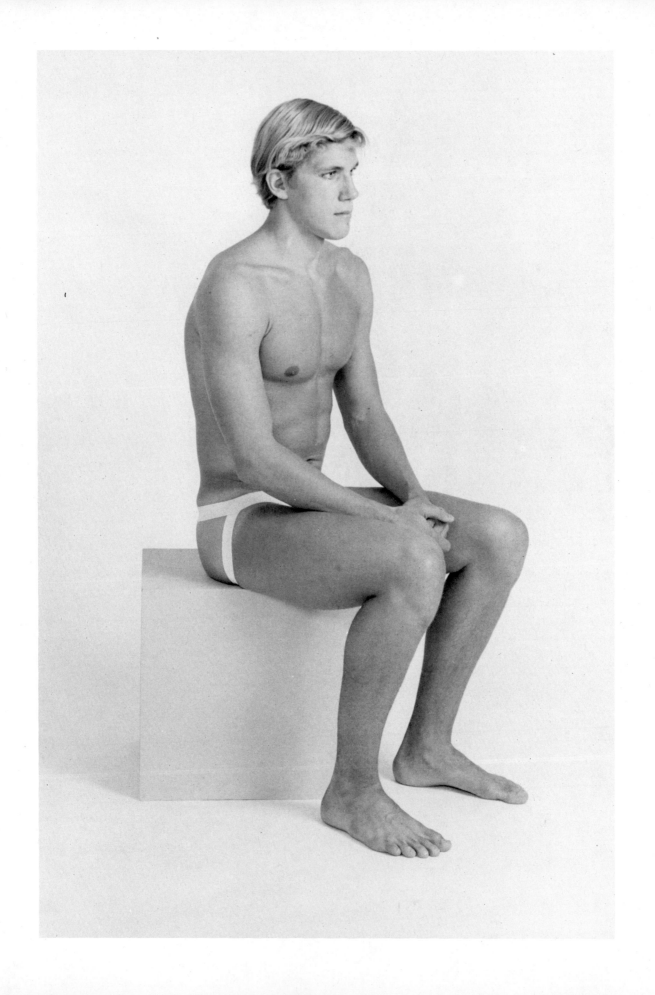

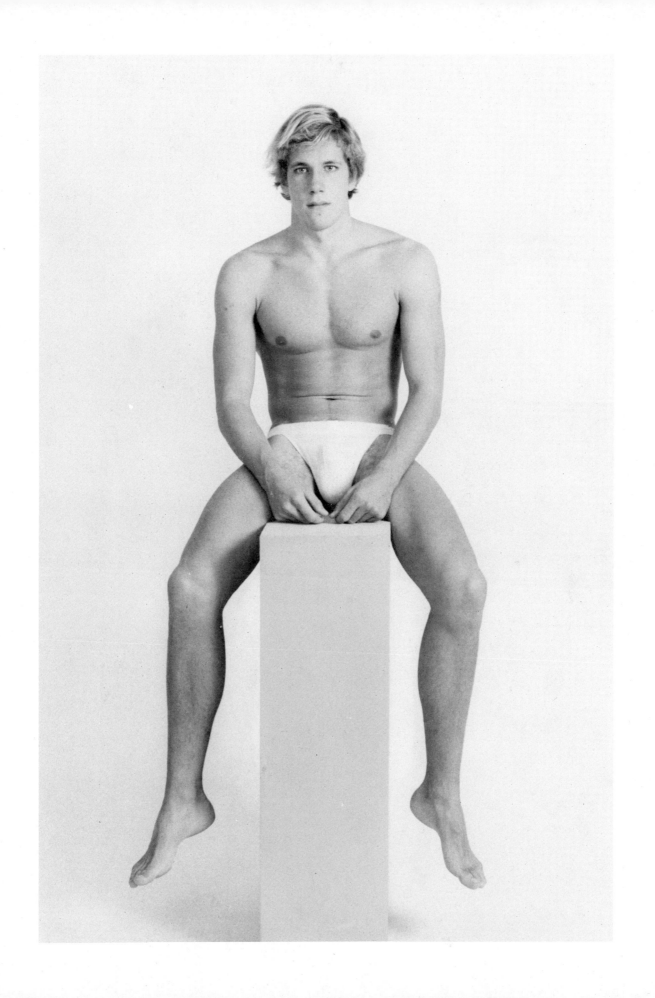

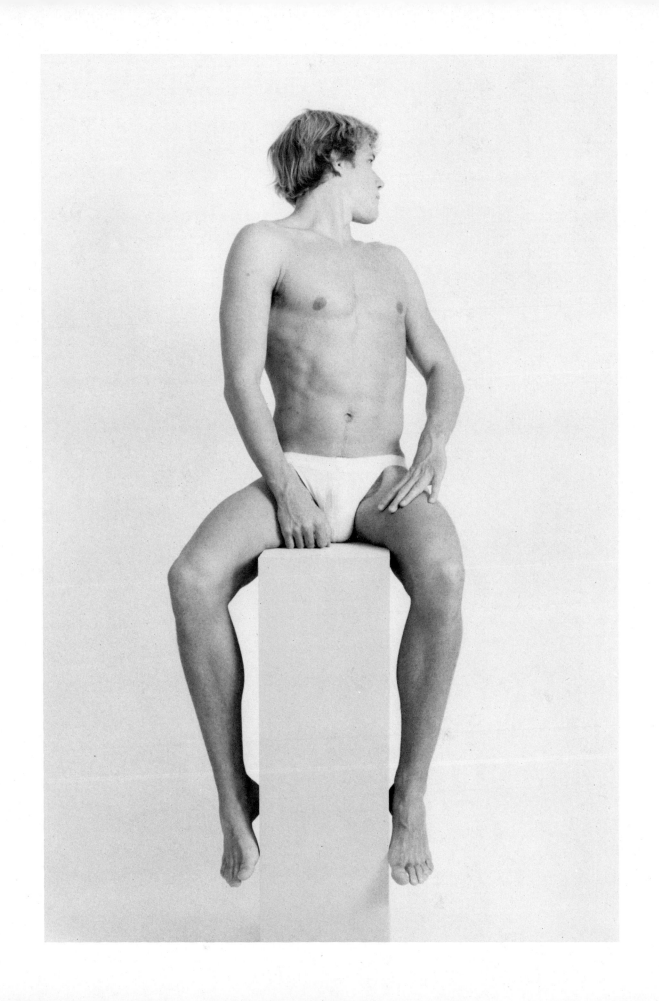

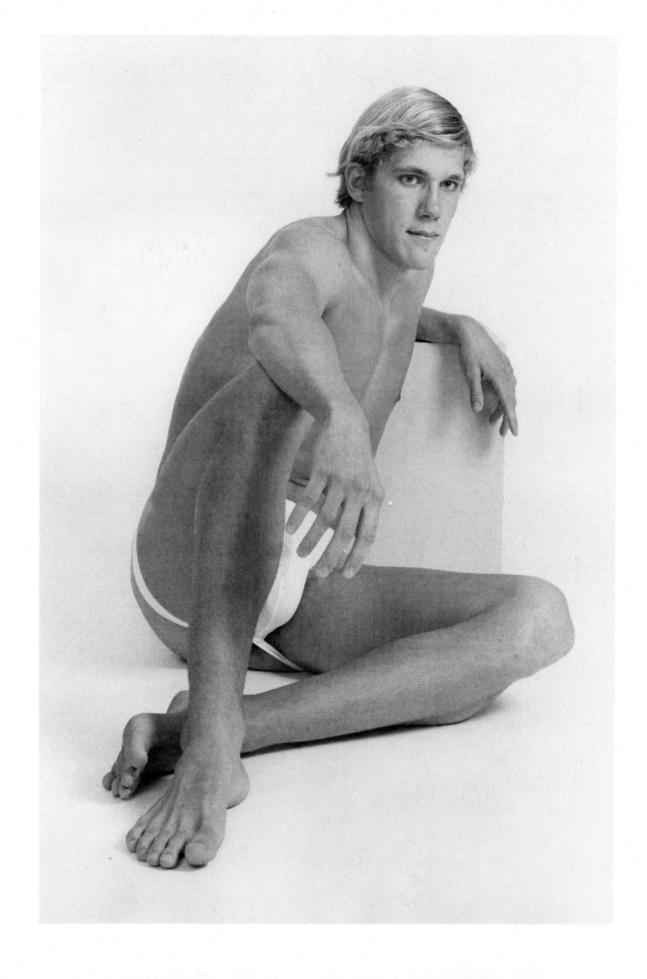

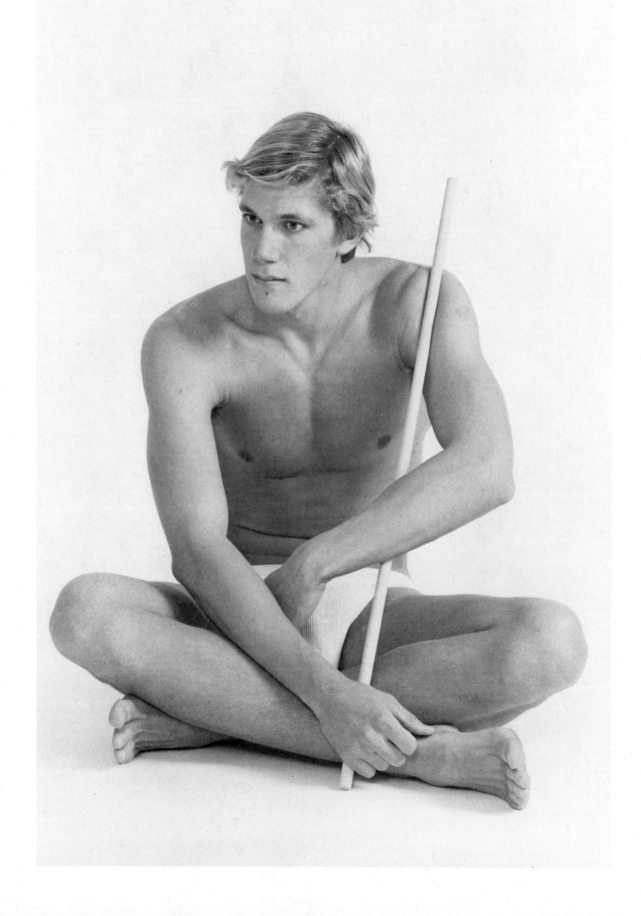

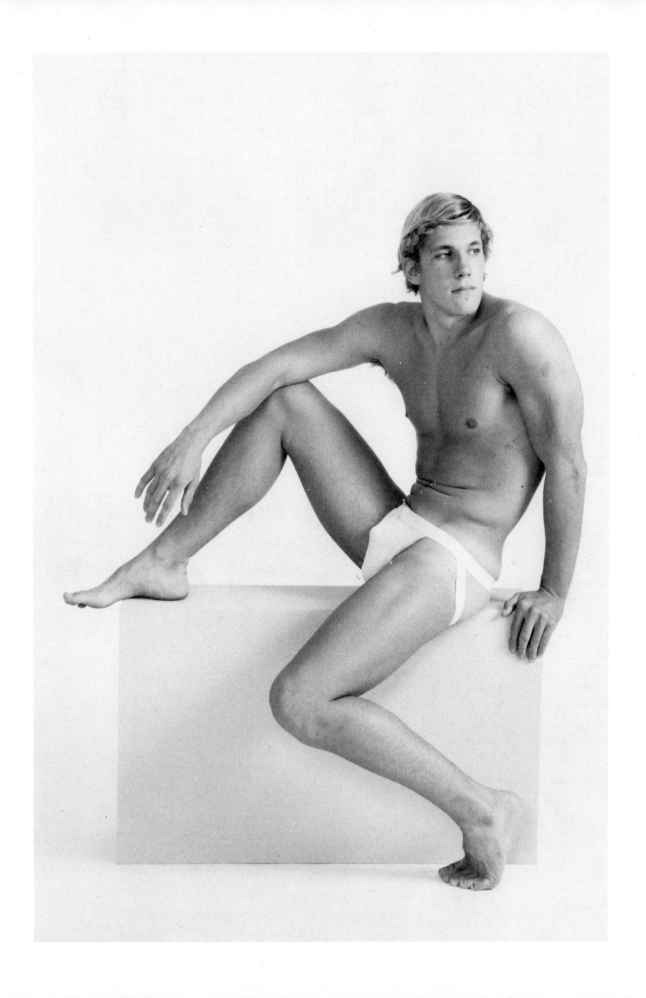

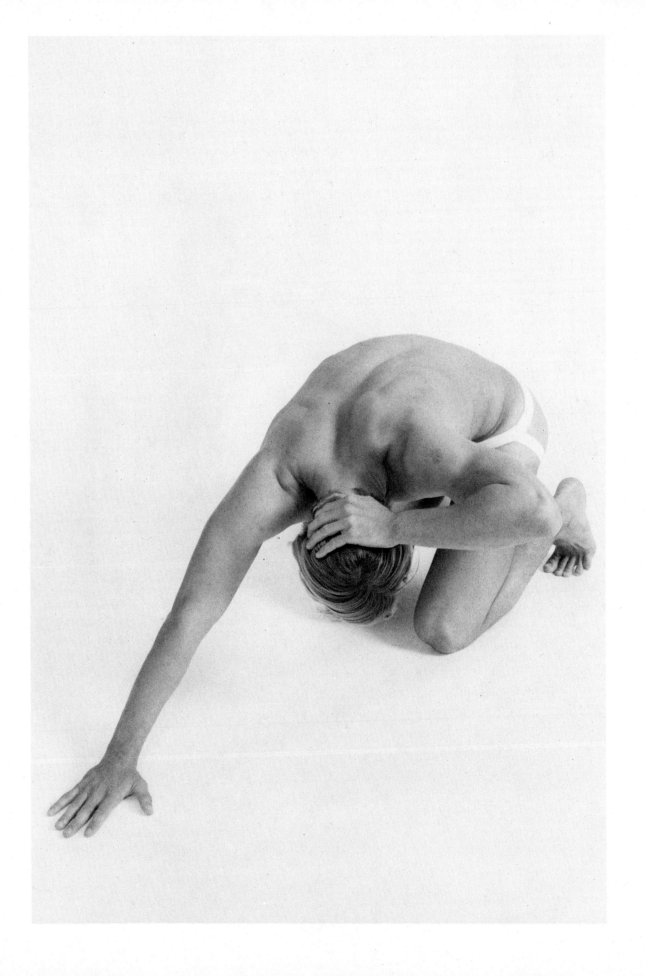

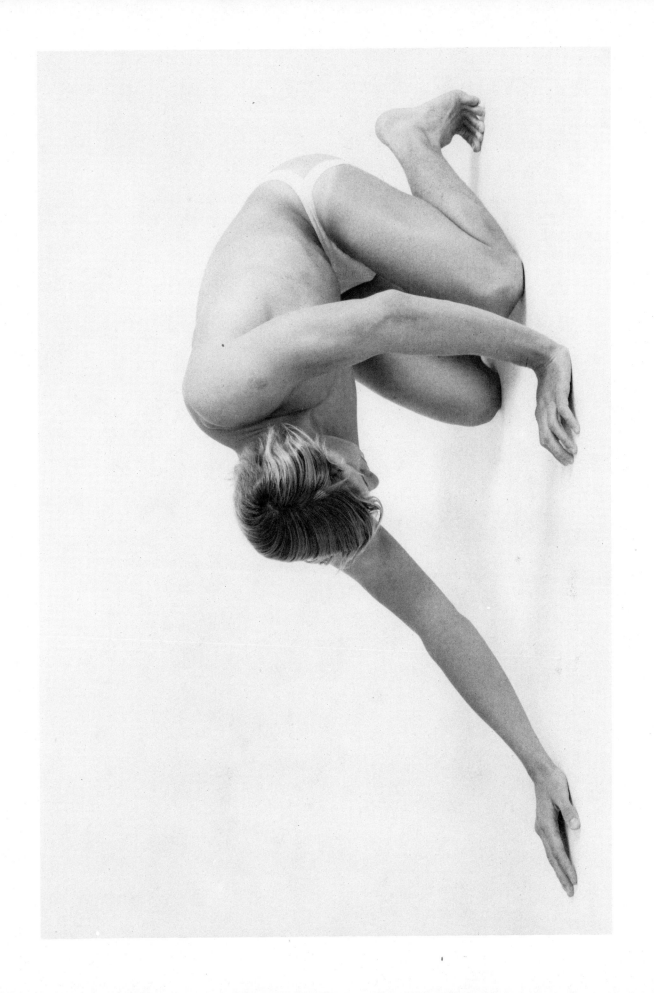

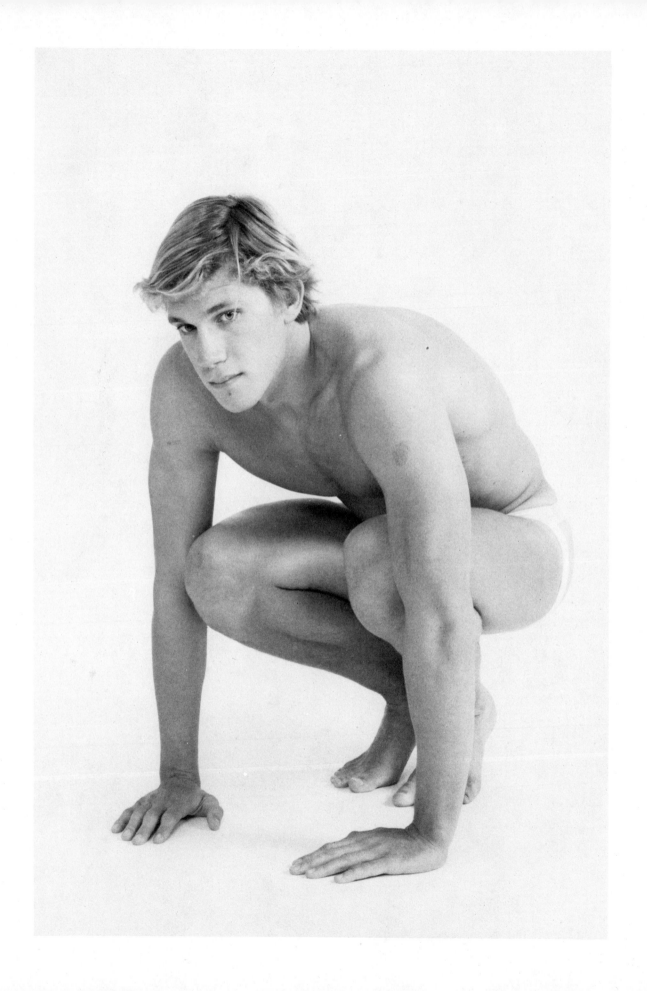

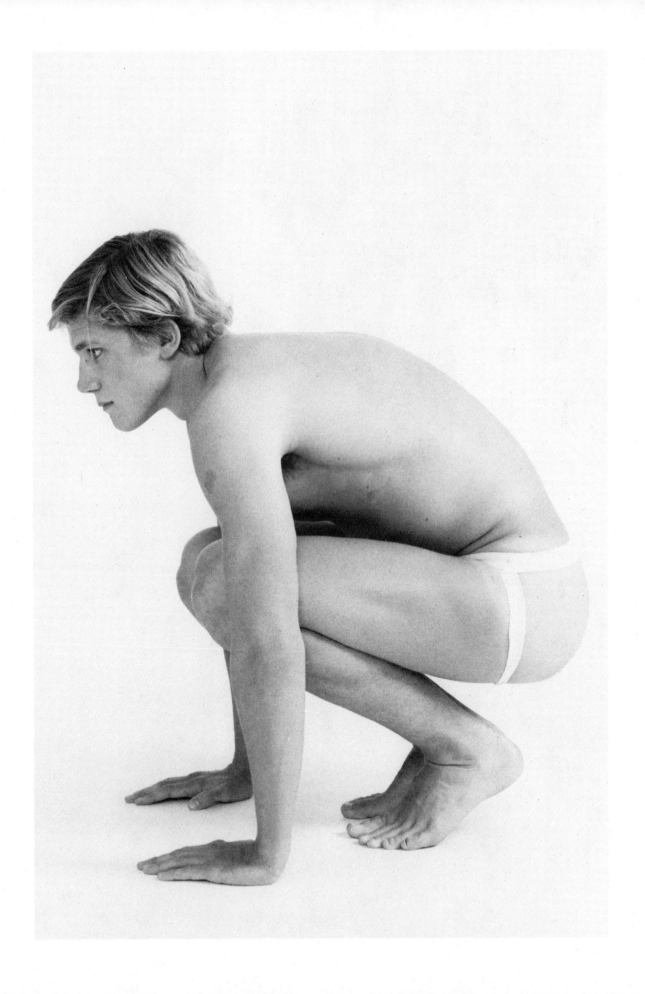

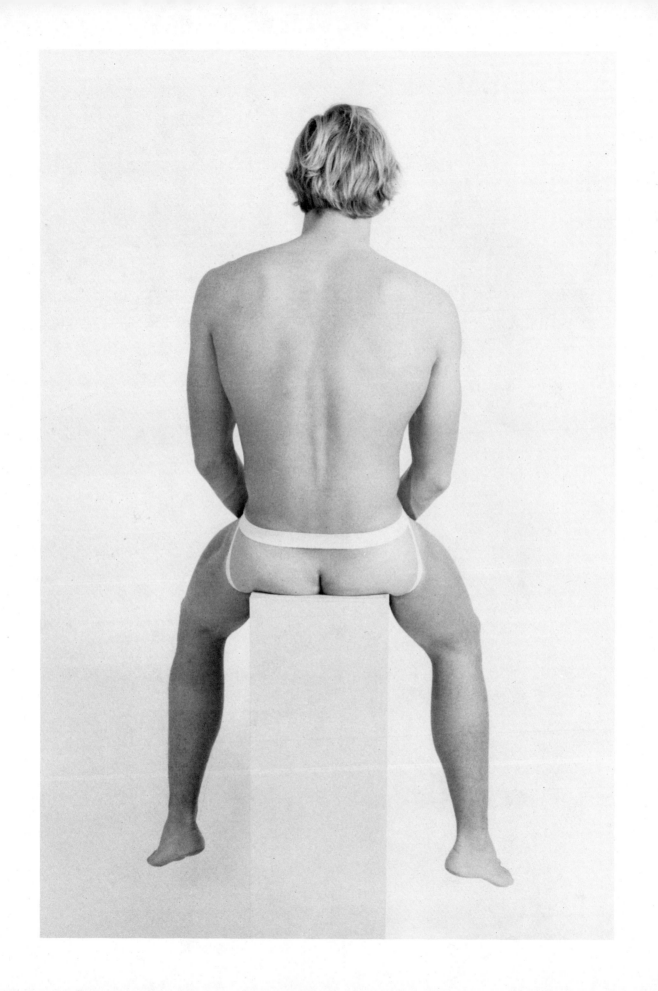

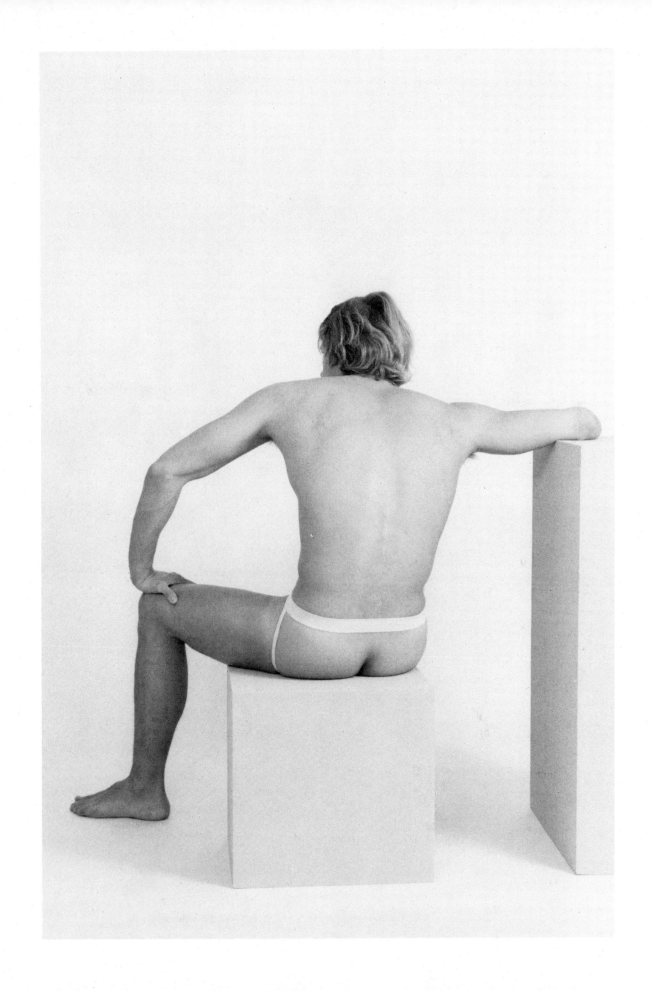

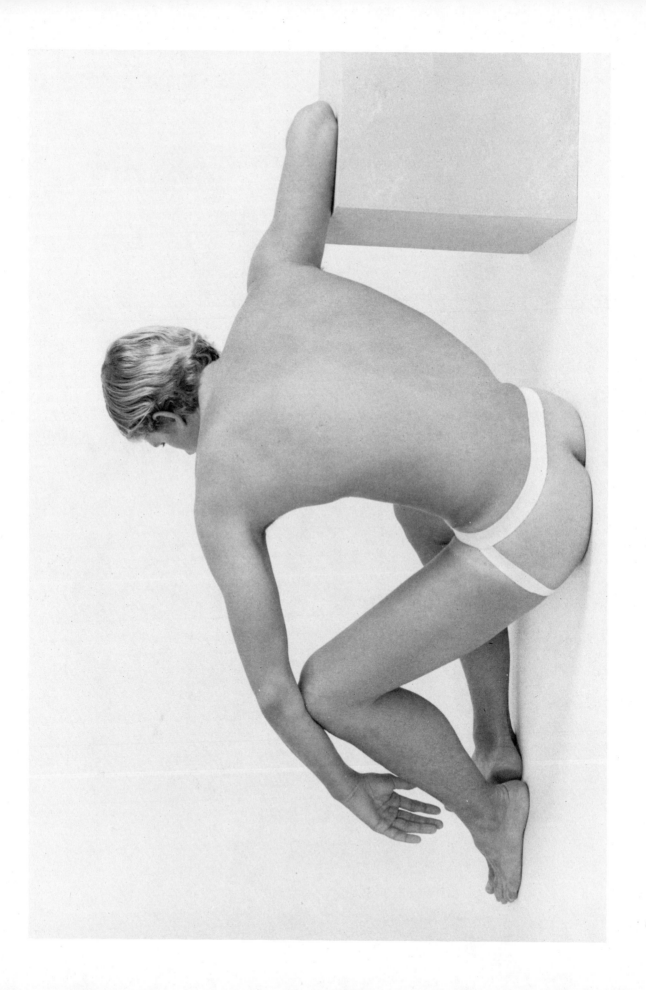

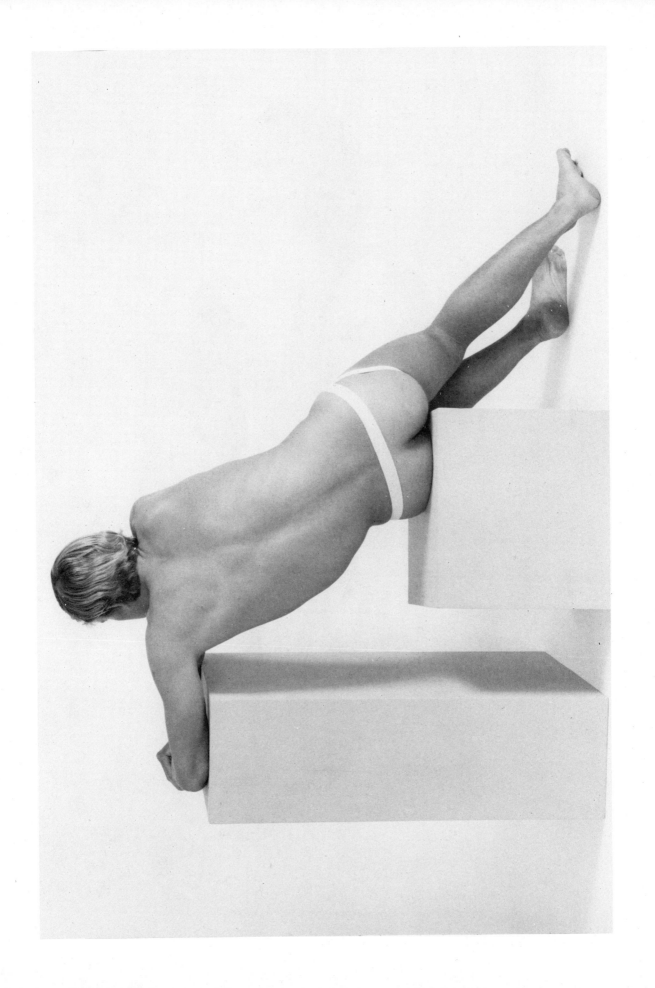

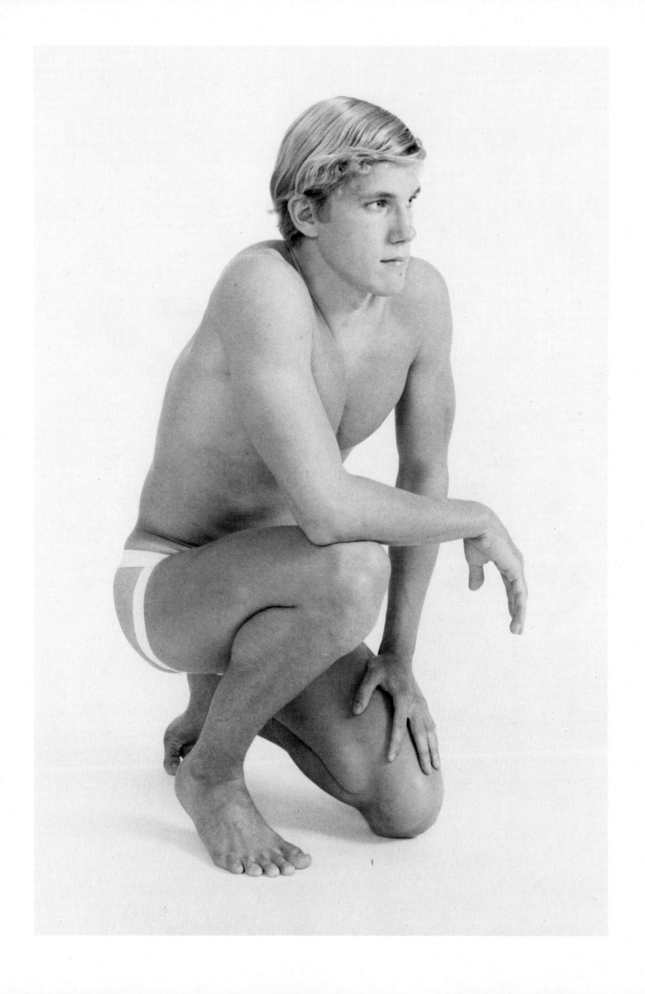

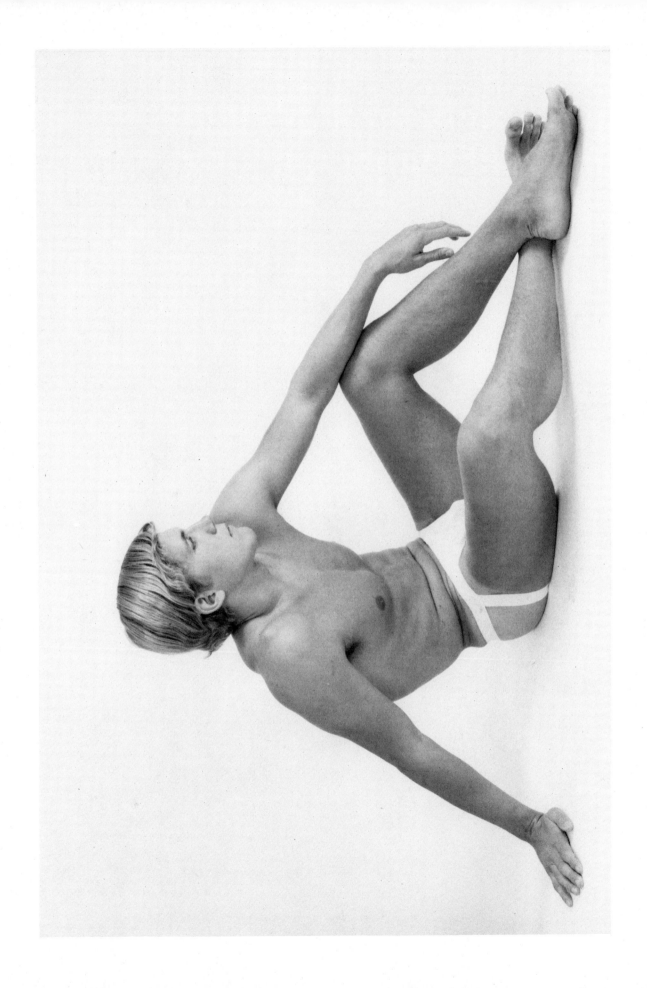

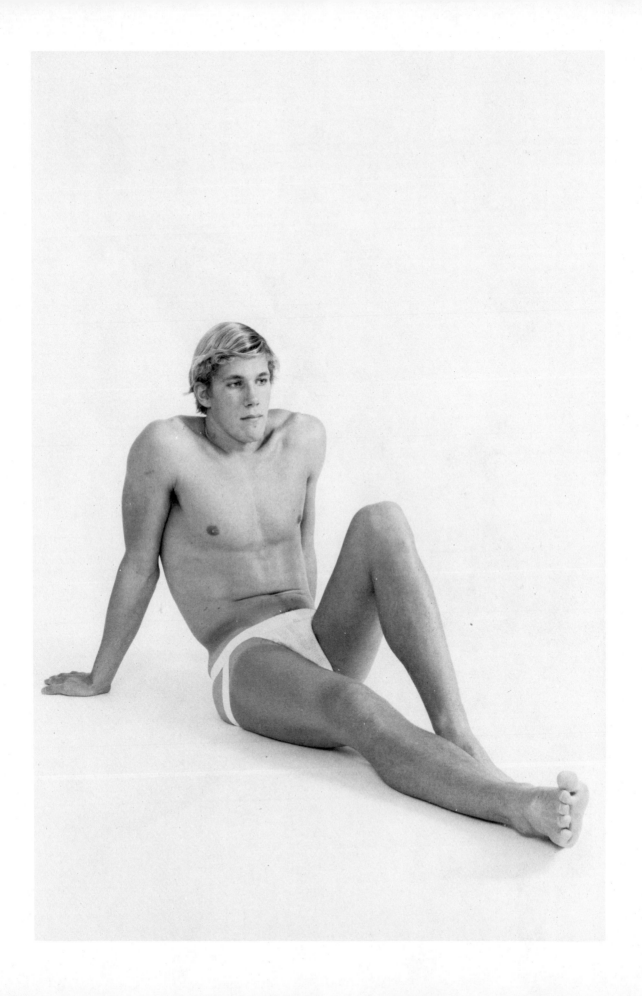

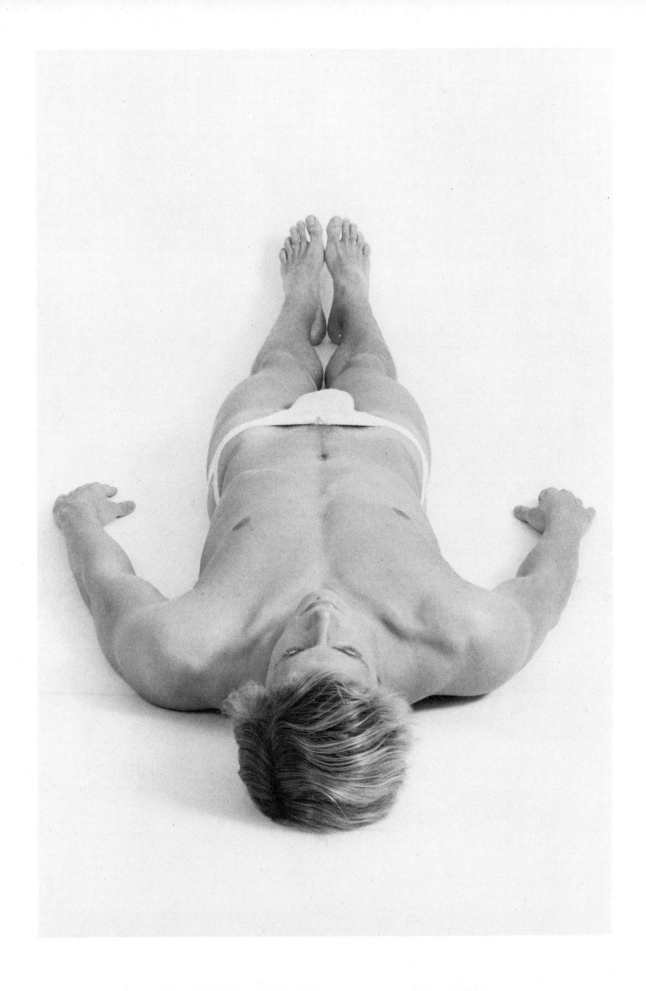

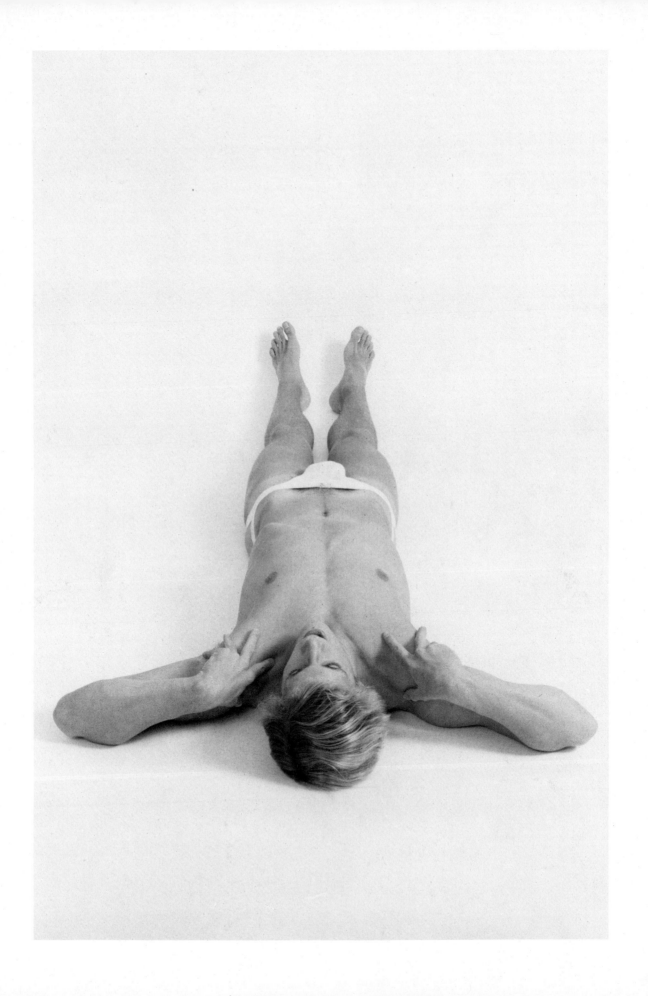

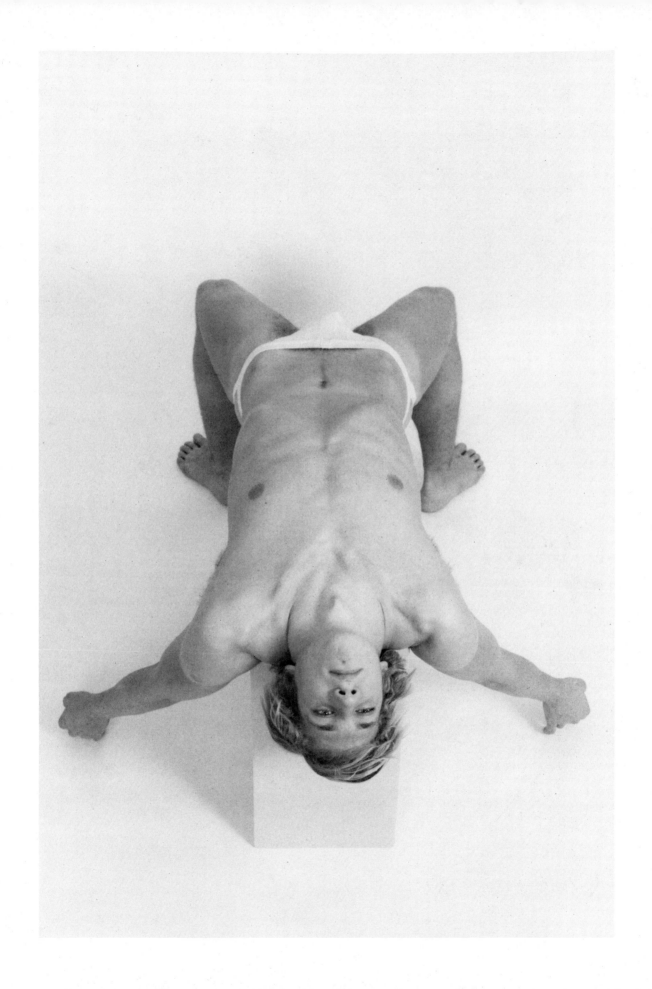

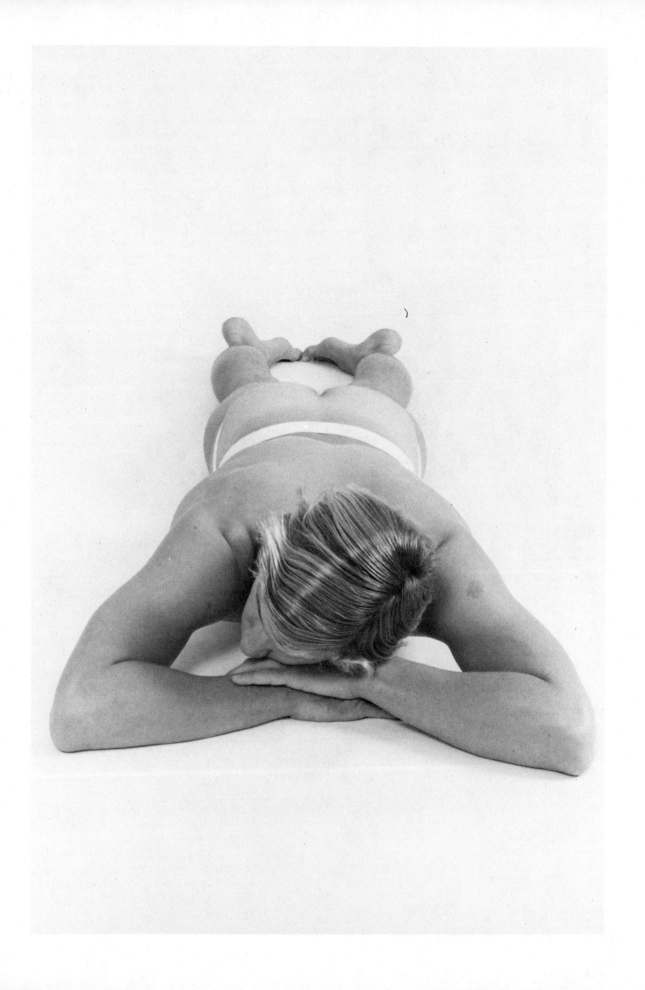

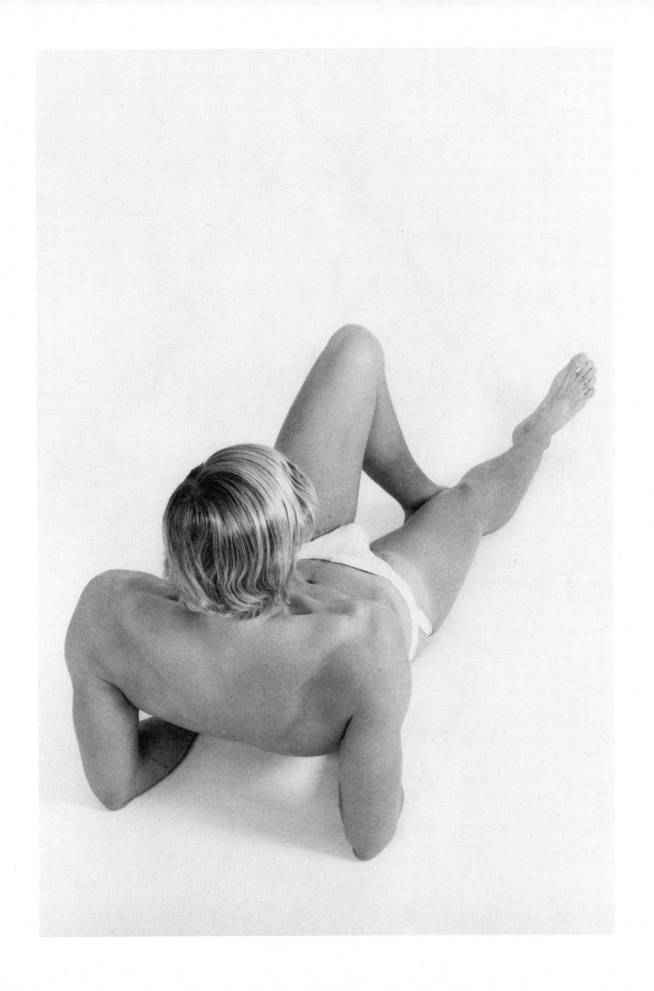

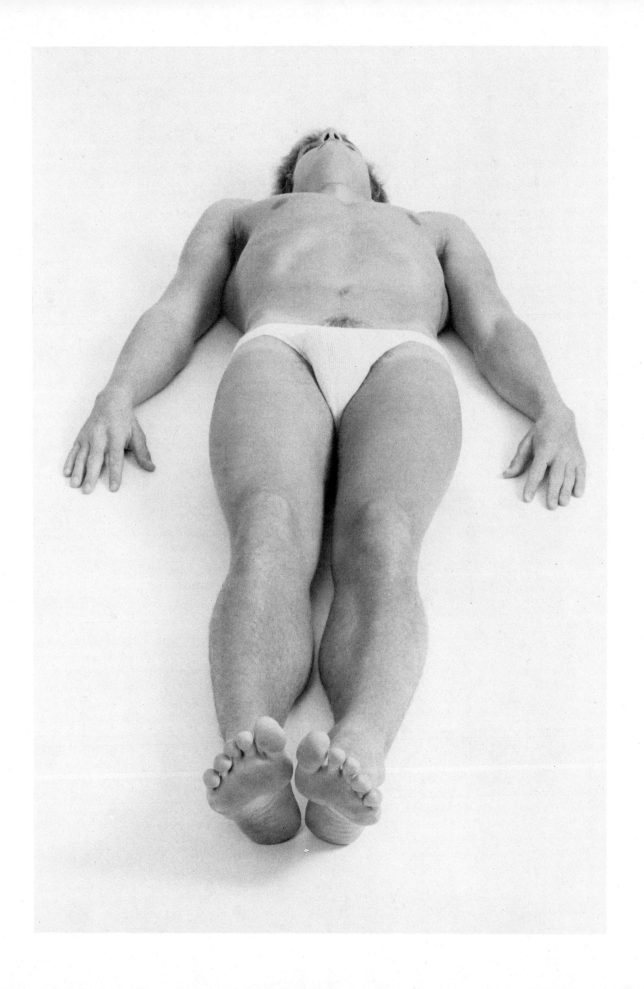

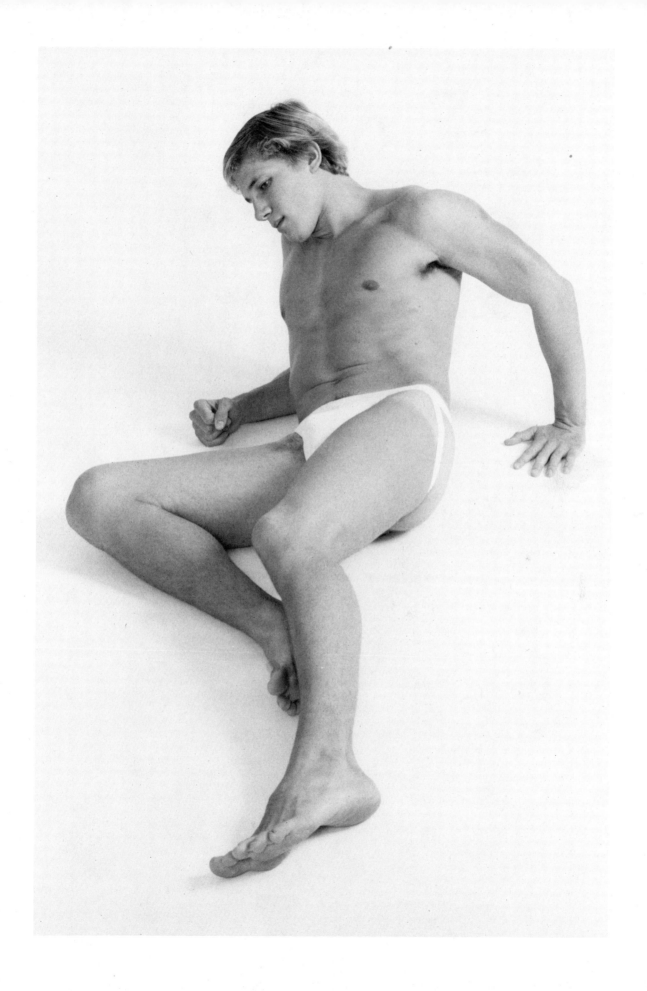

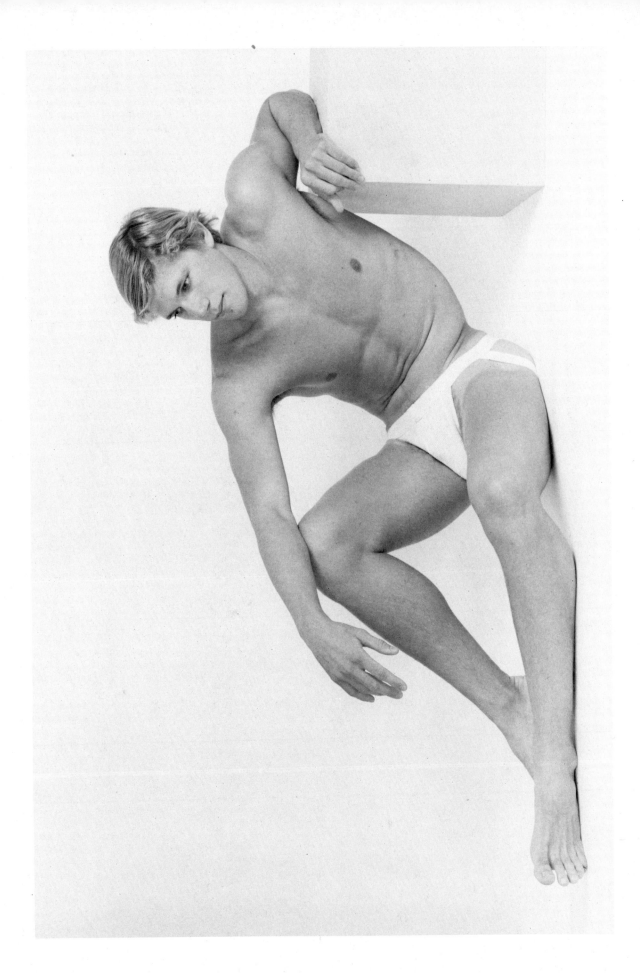

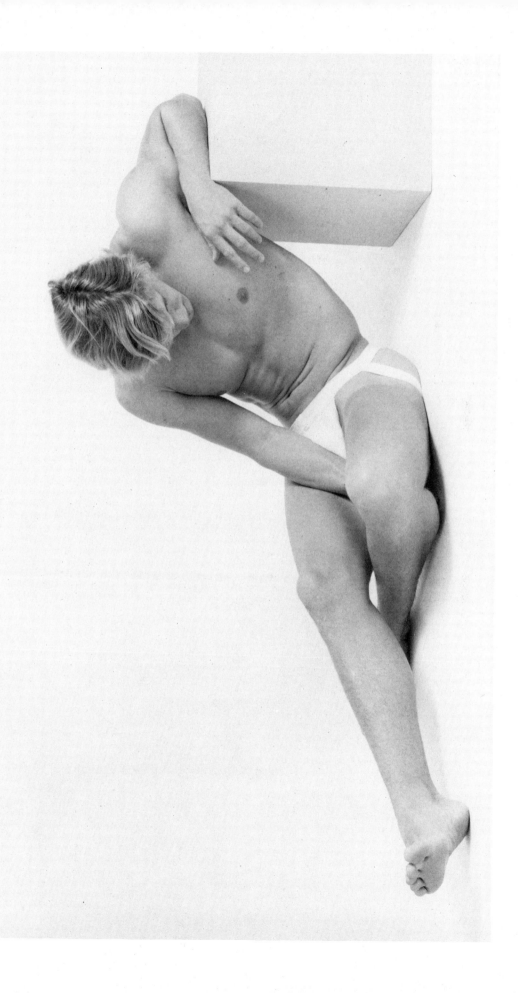

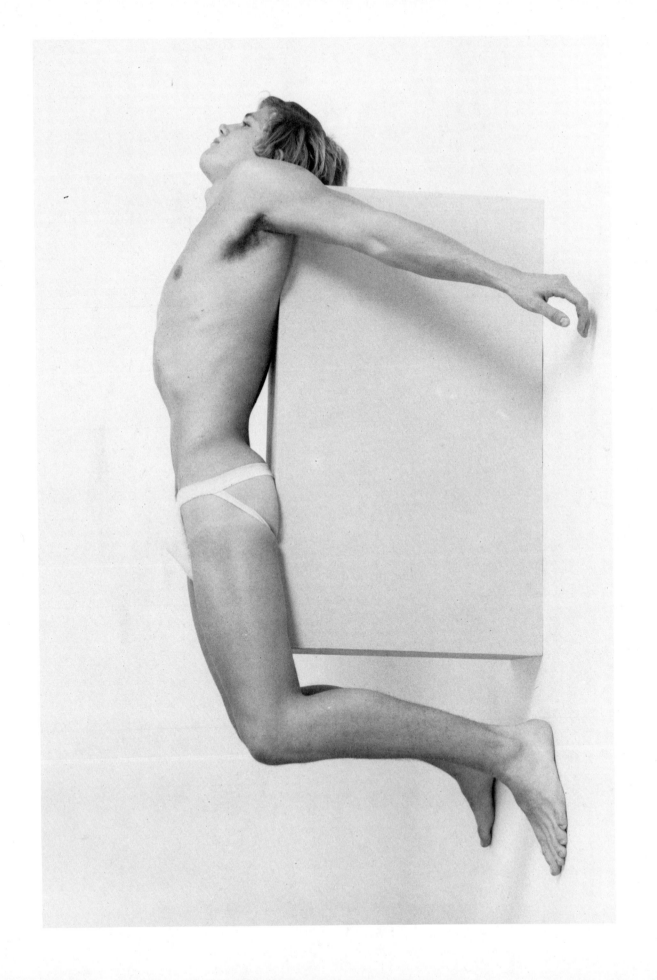

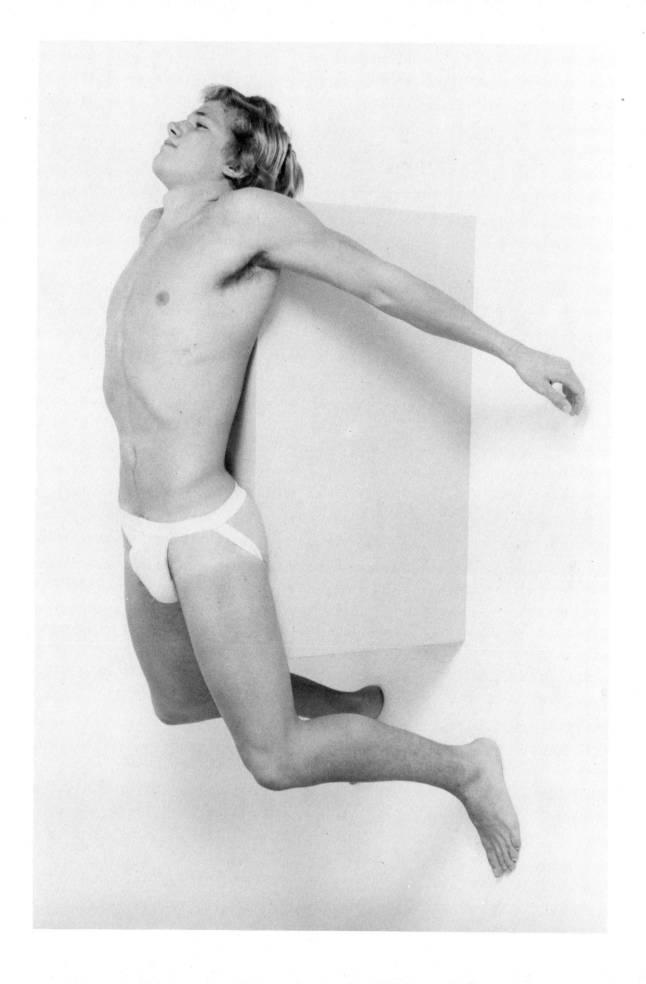

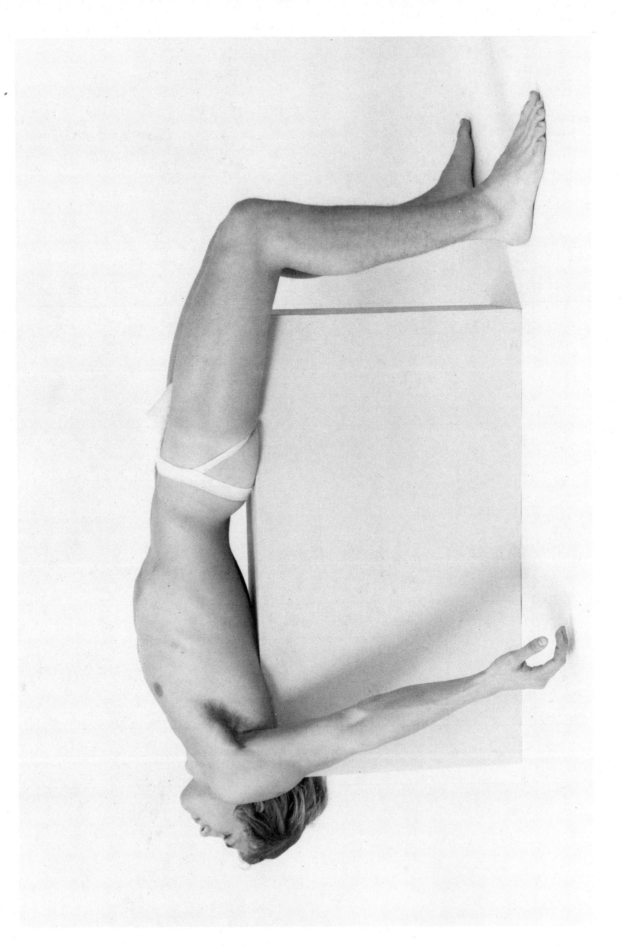

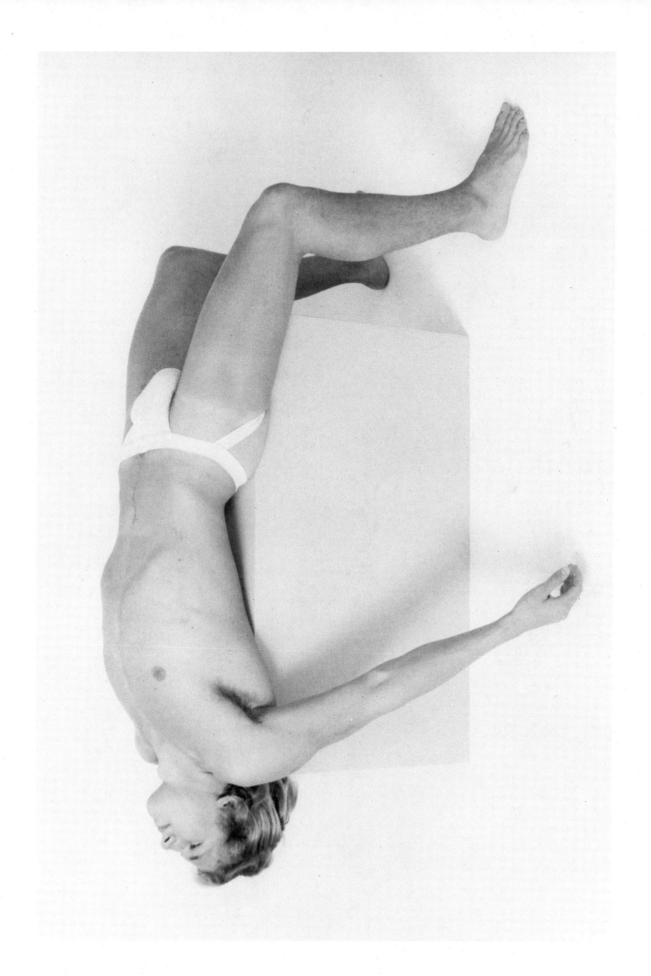

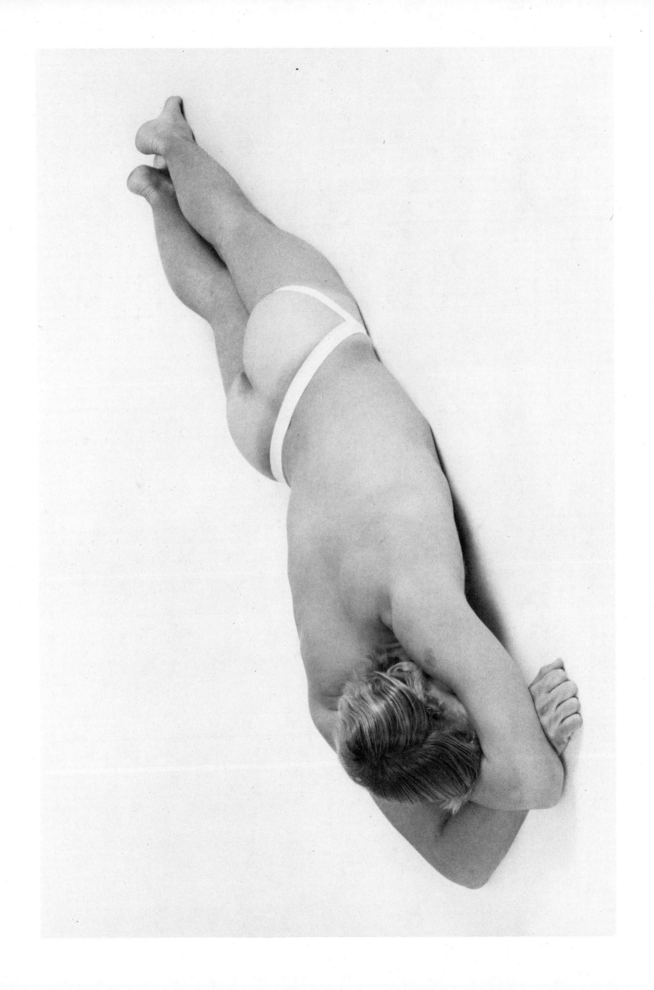

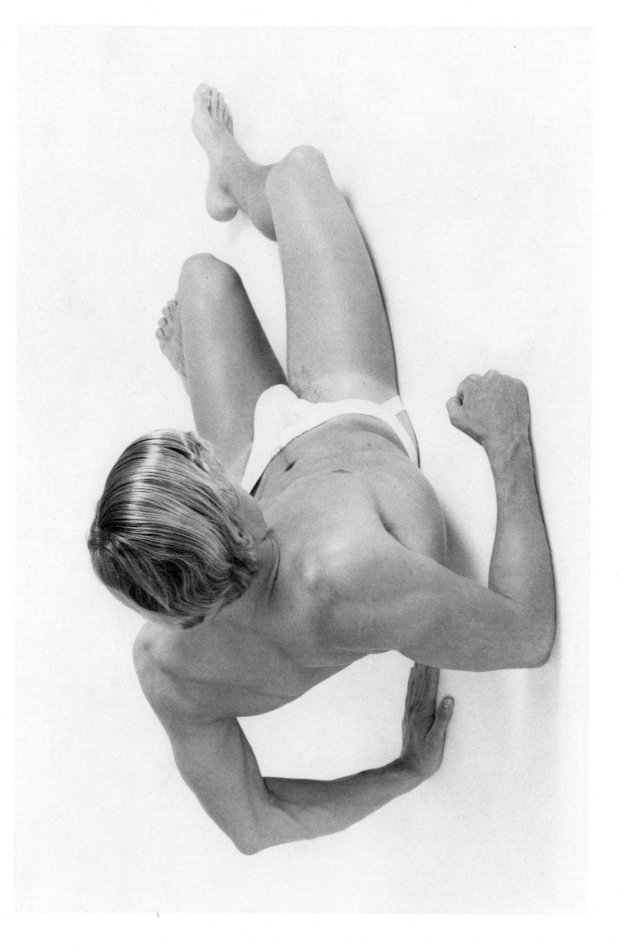

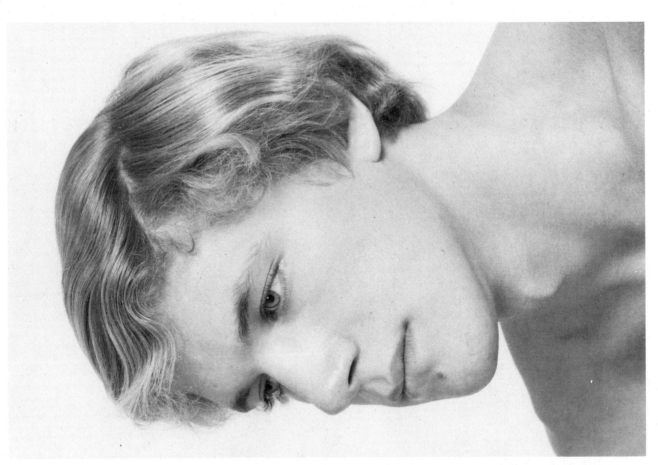

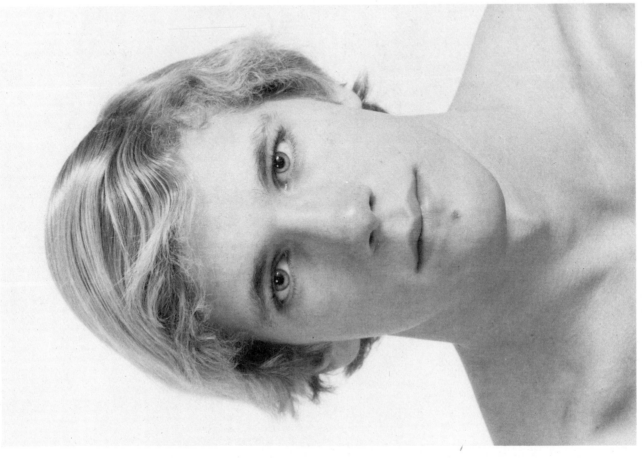

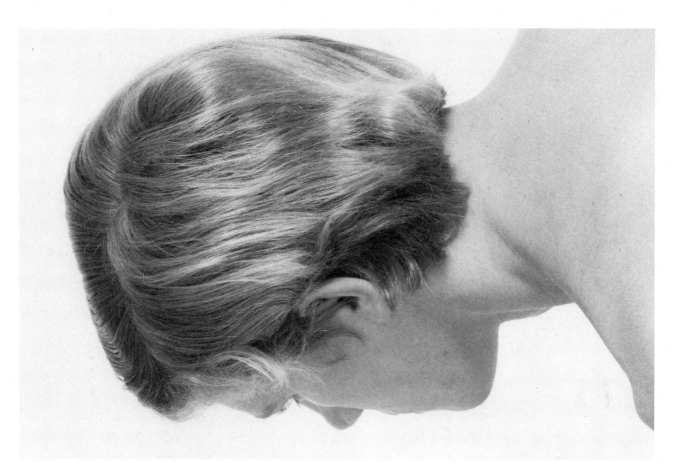

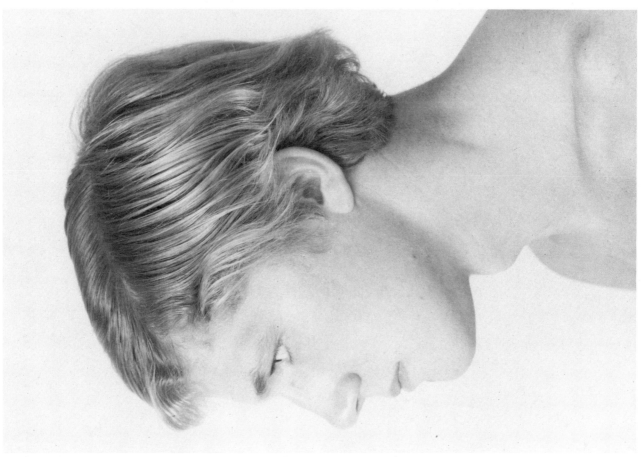

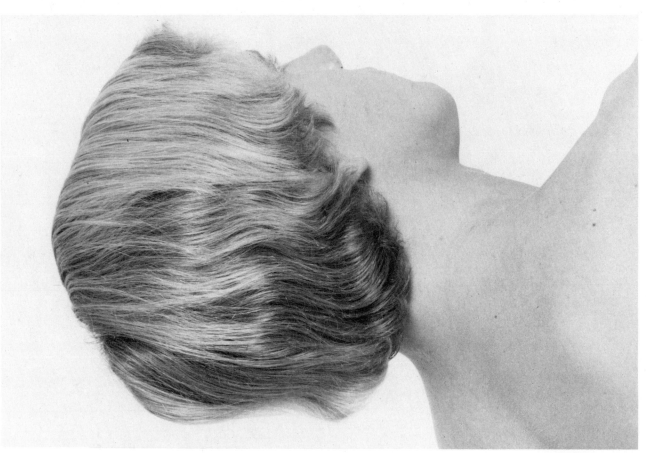

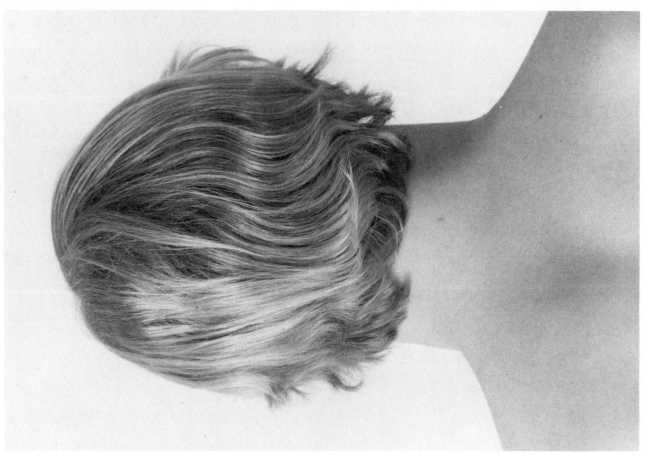

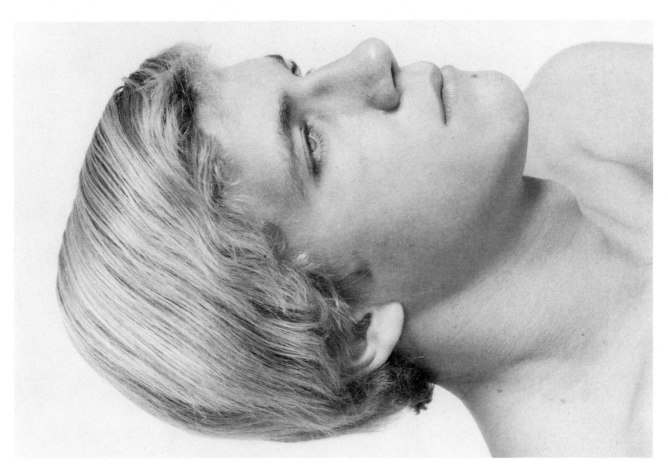

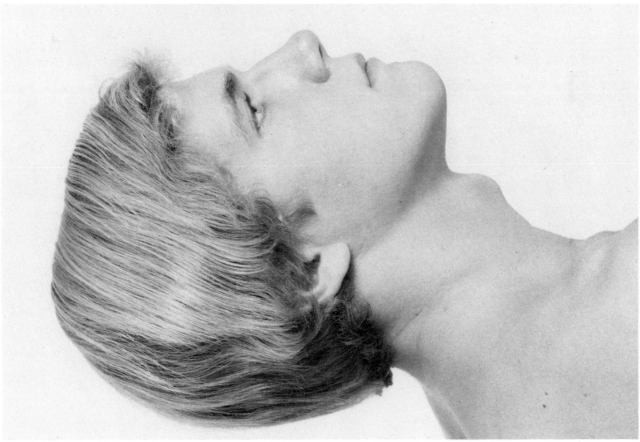

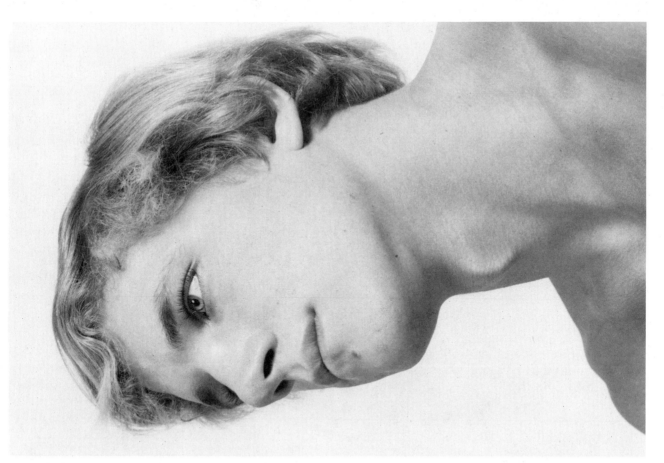

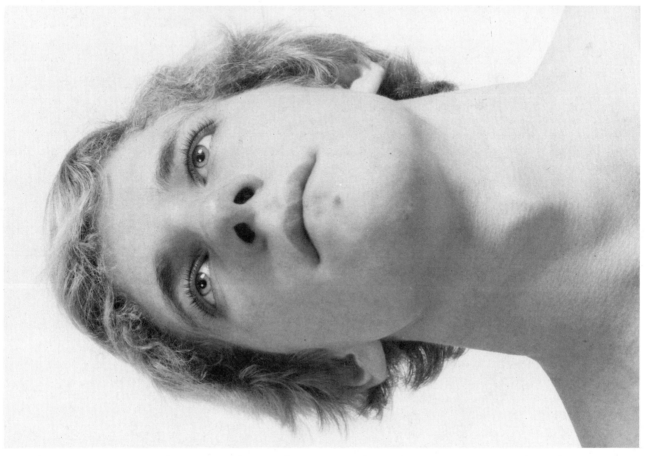

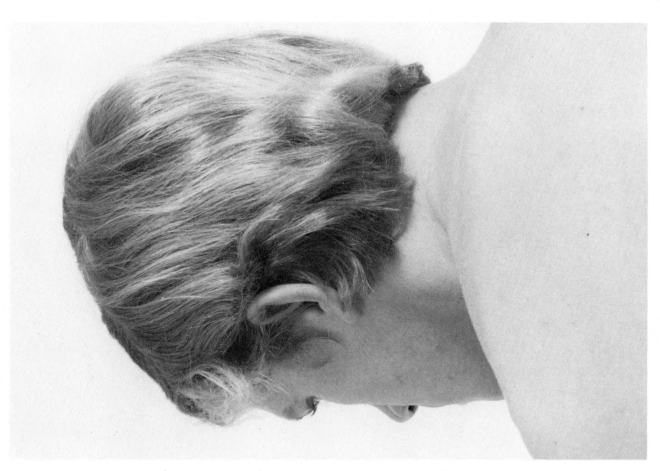

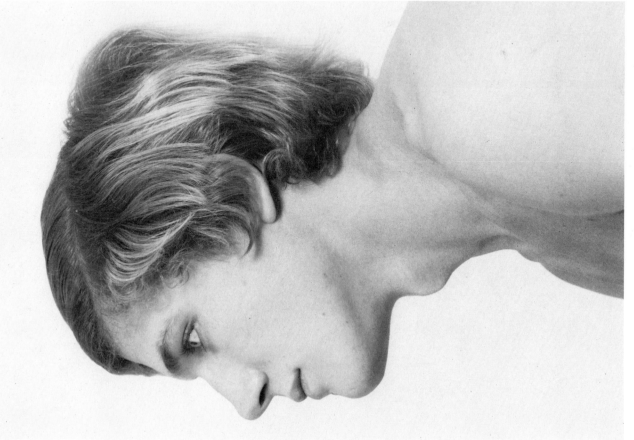

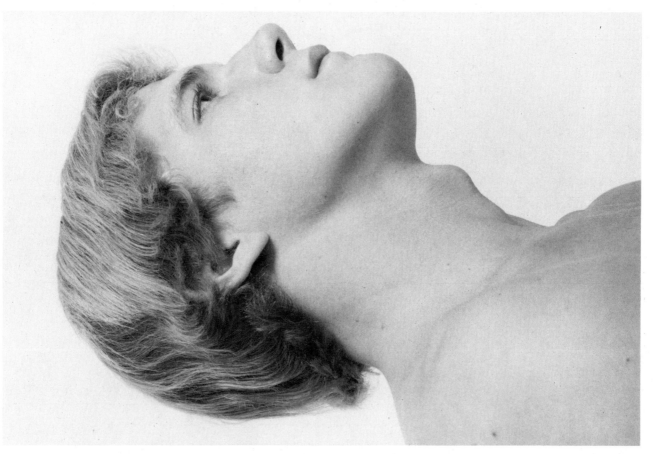

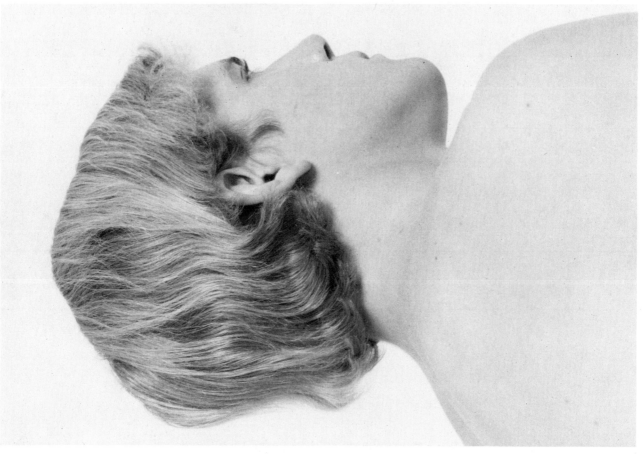

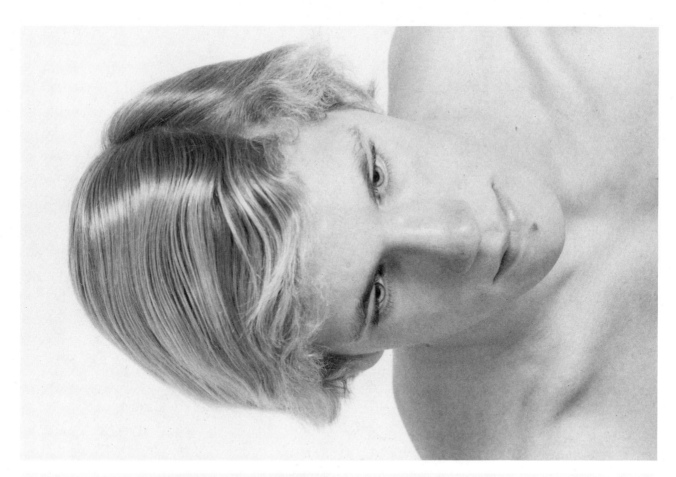

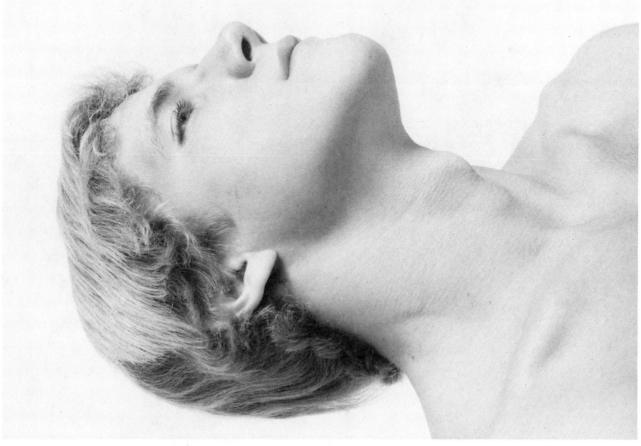

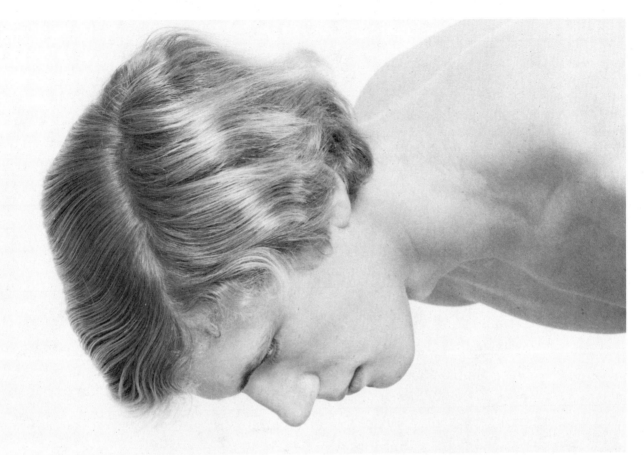

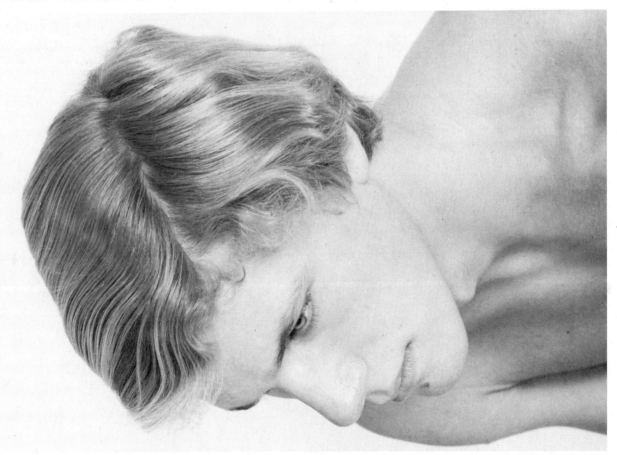

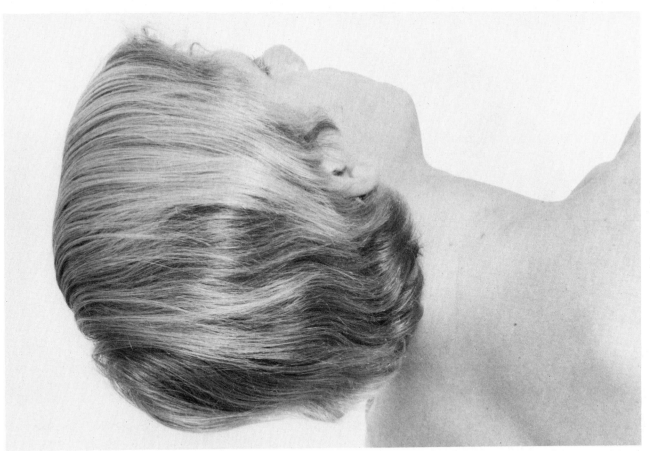

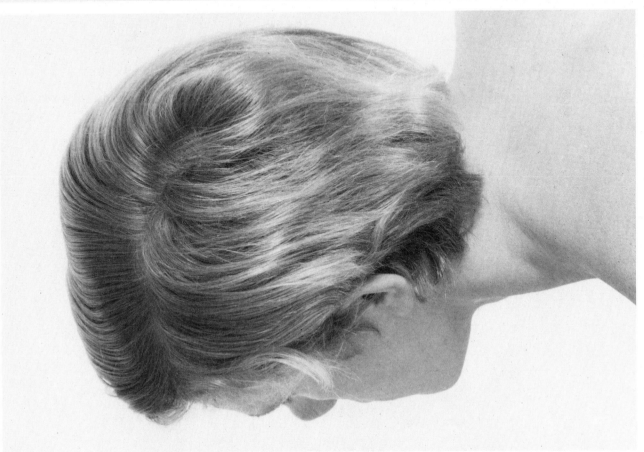

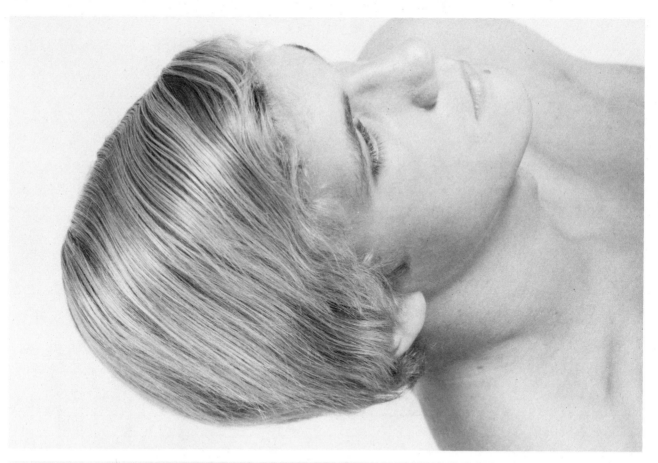

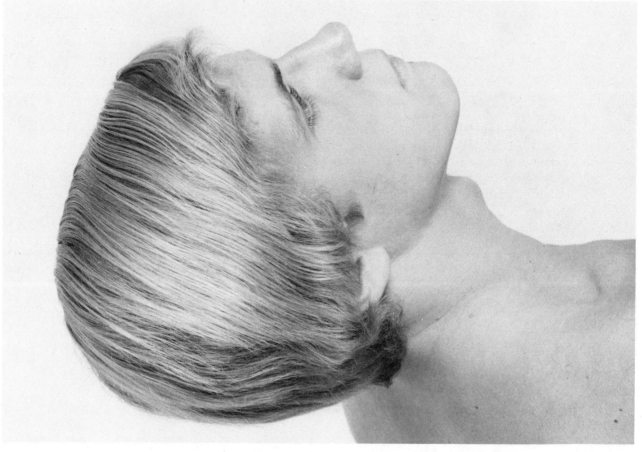

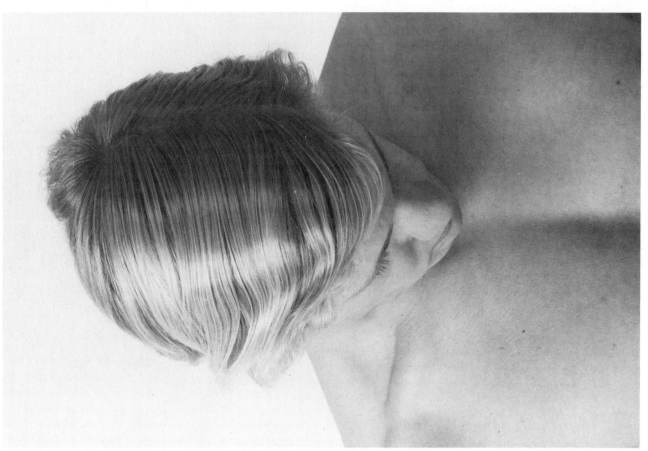

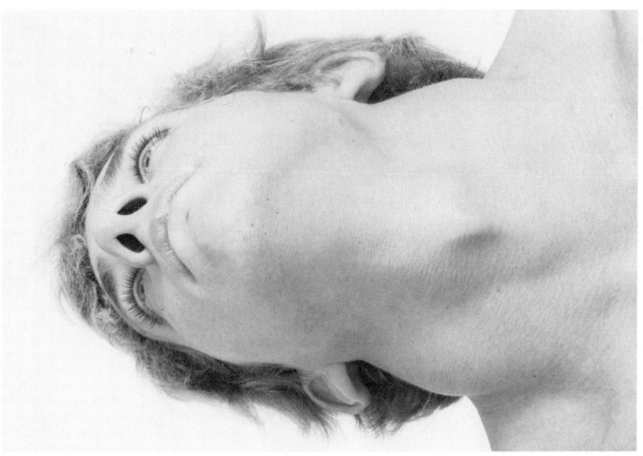

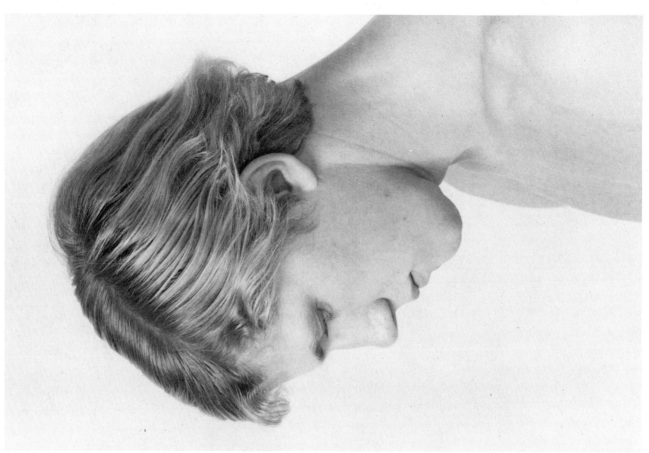

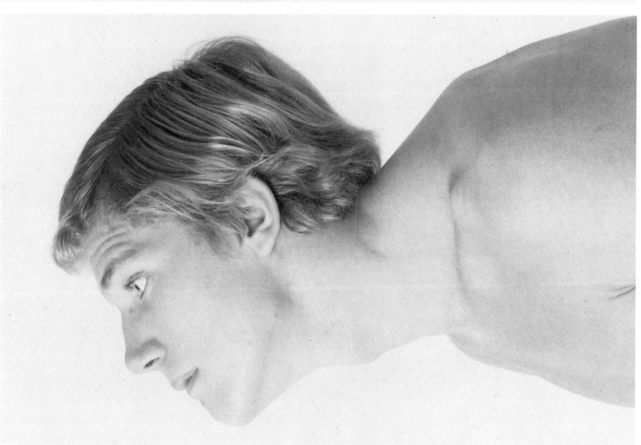

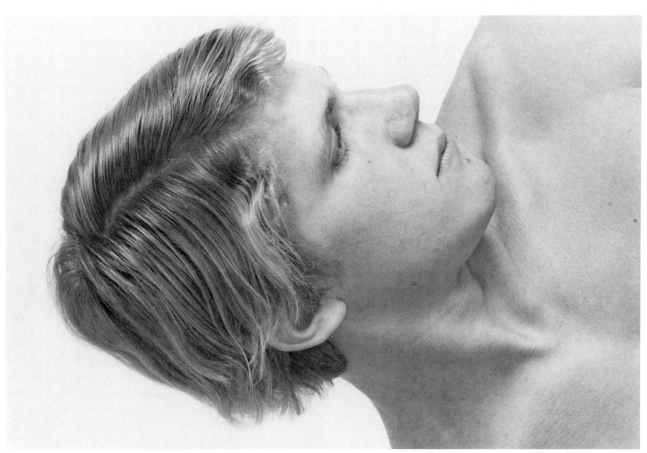

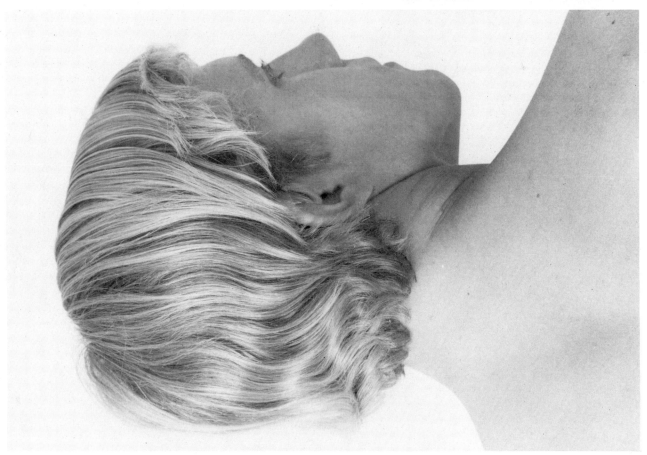

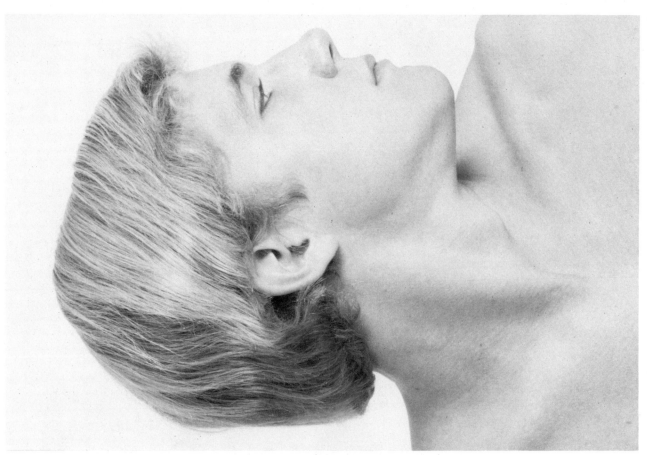

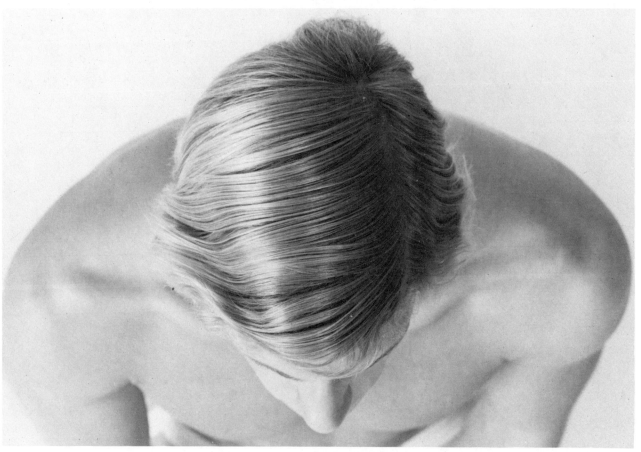

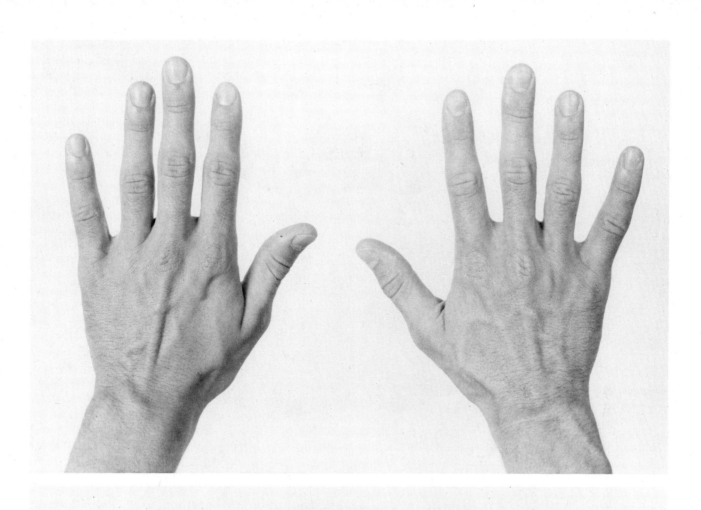

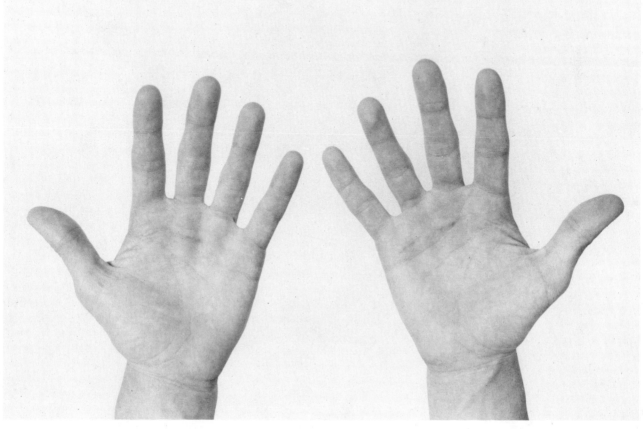

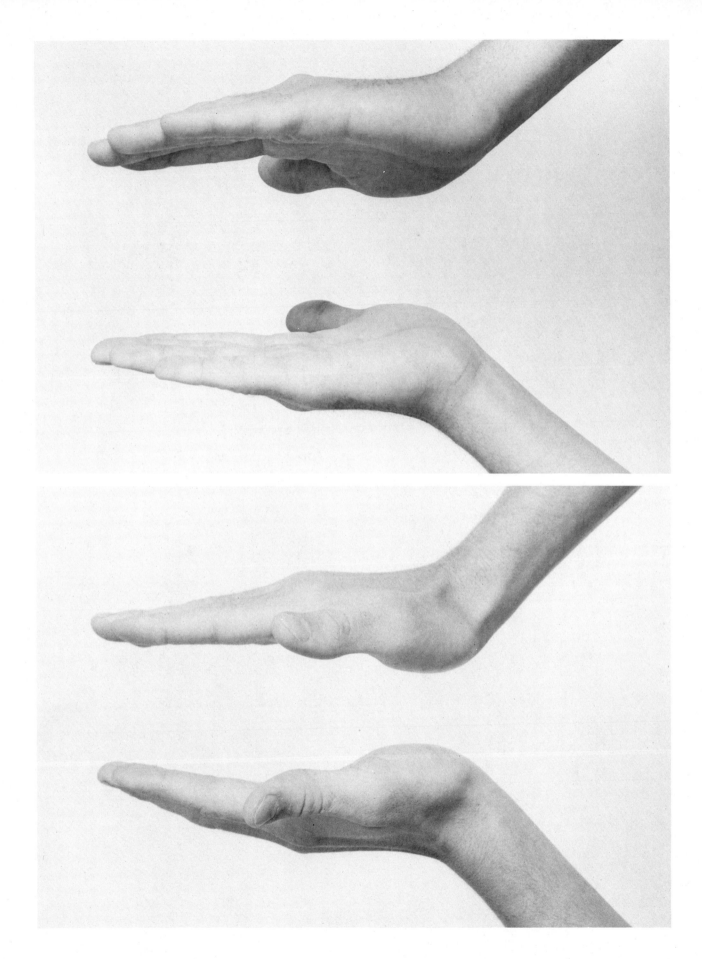

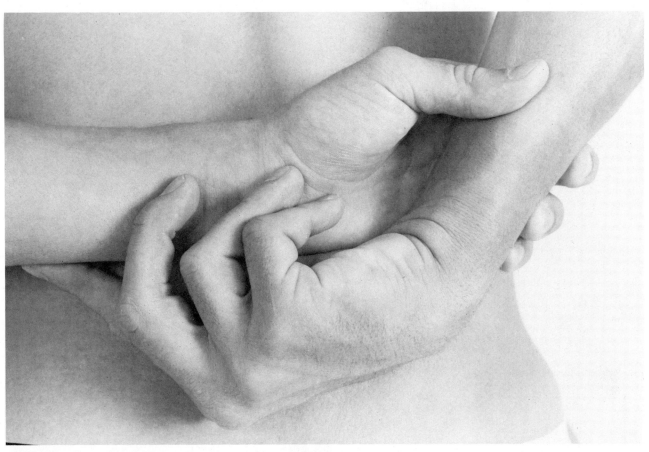

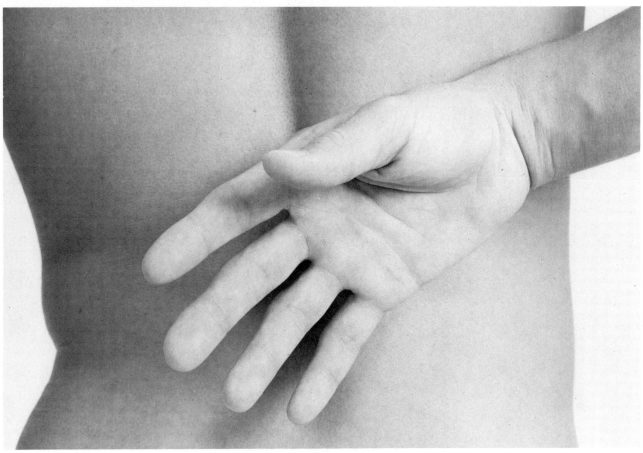

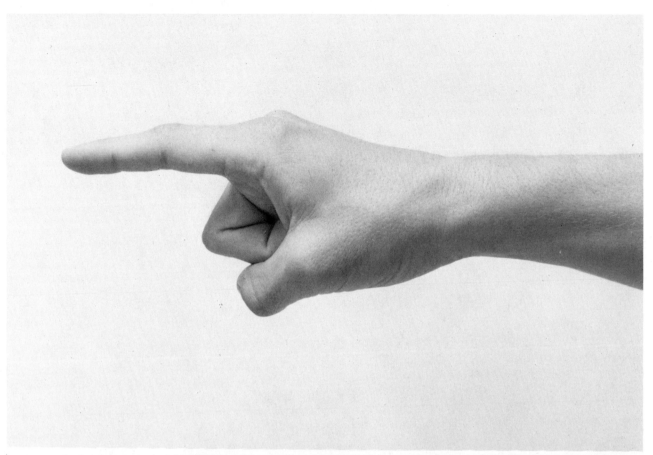

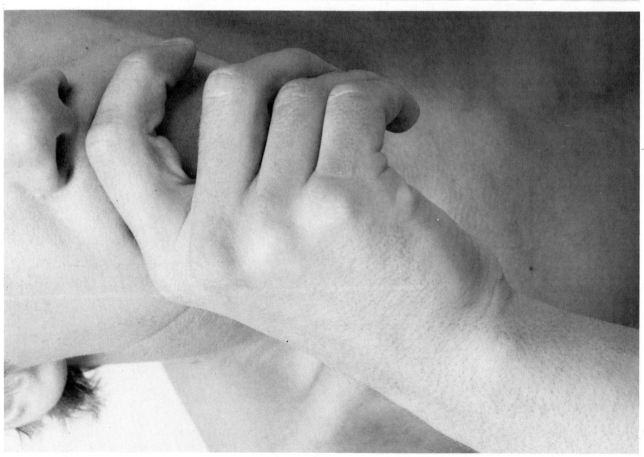

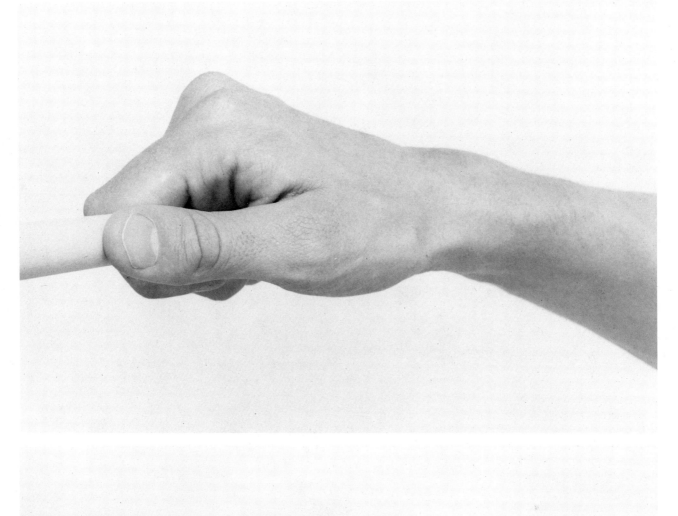

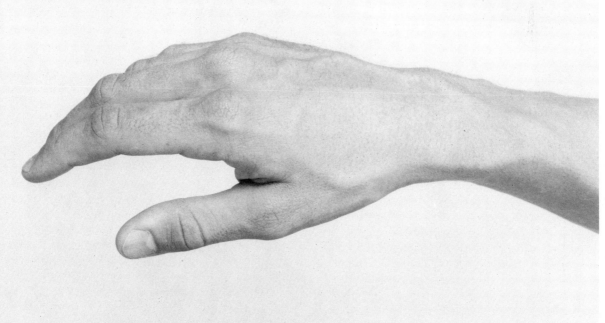

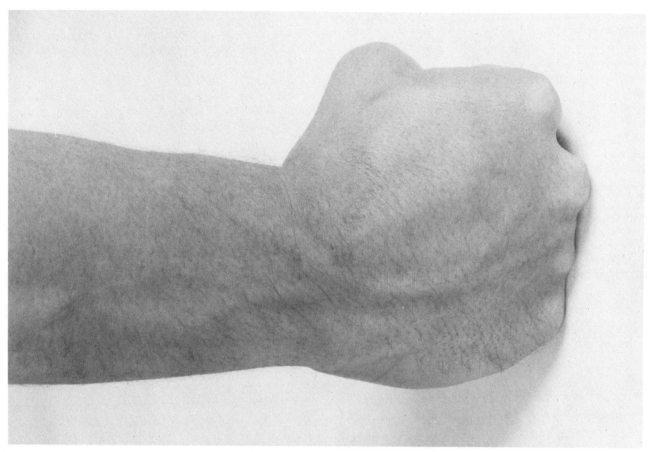

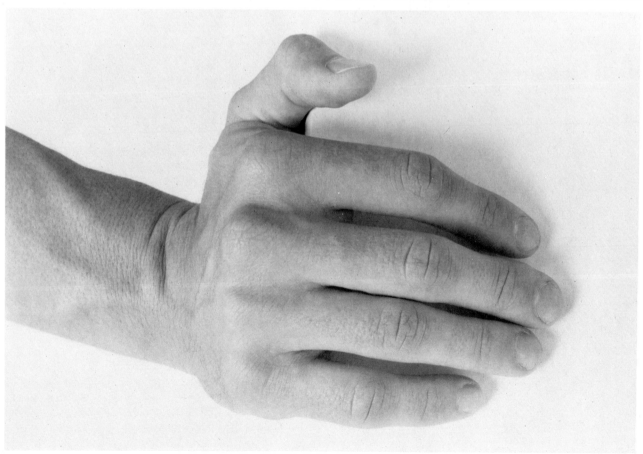

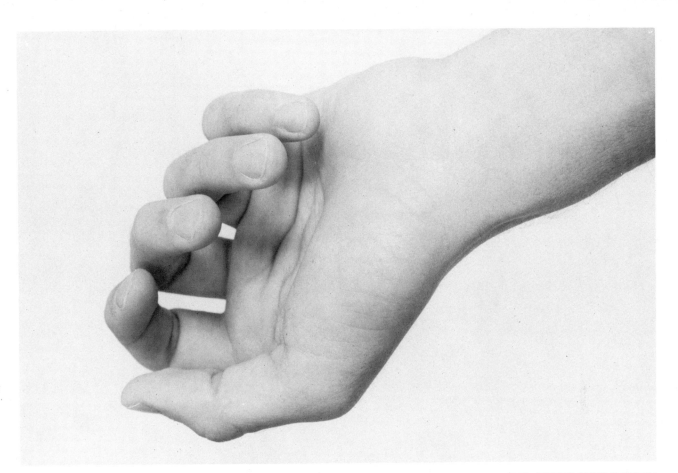

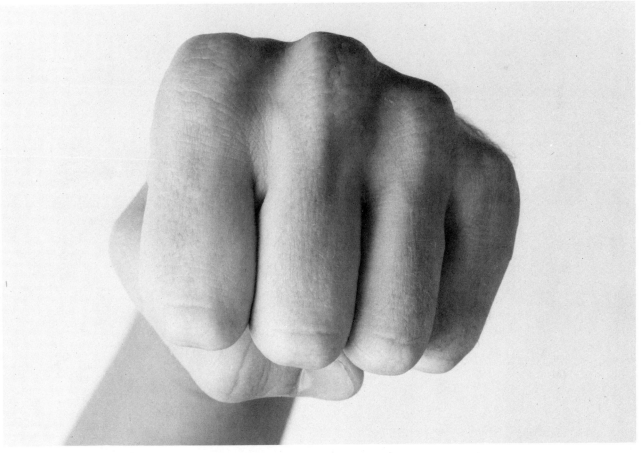

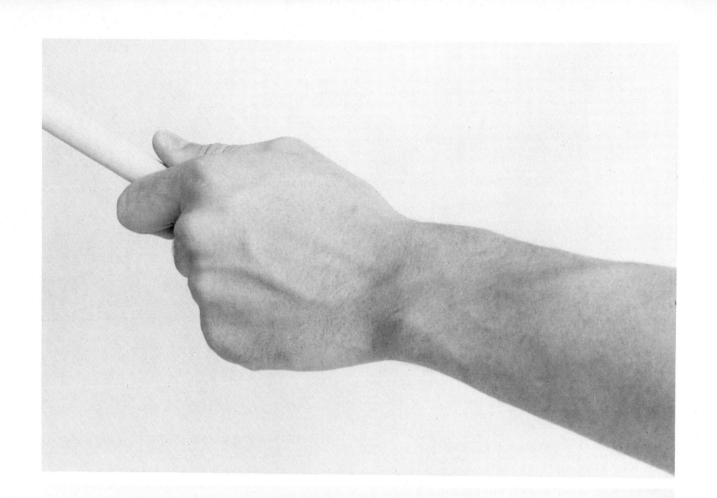

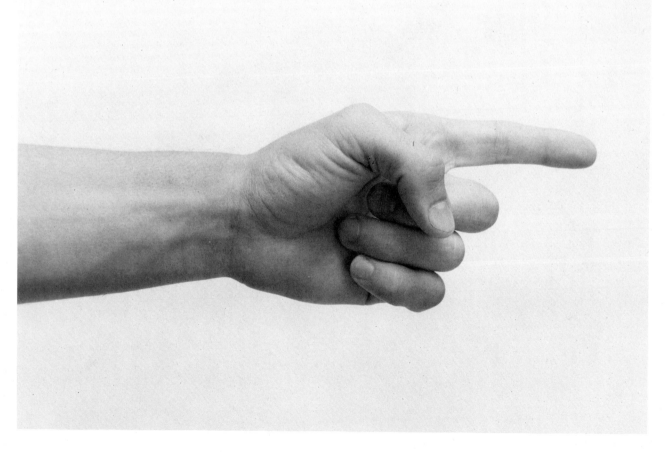

124

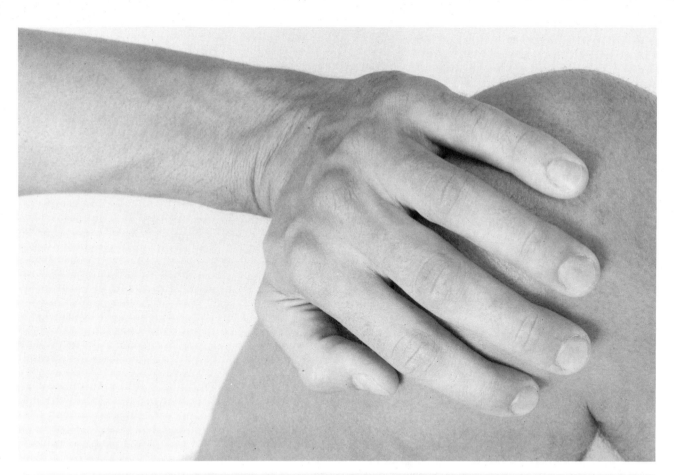

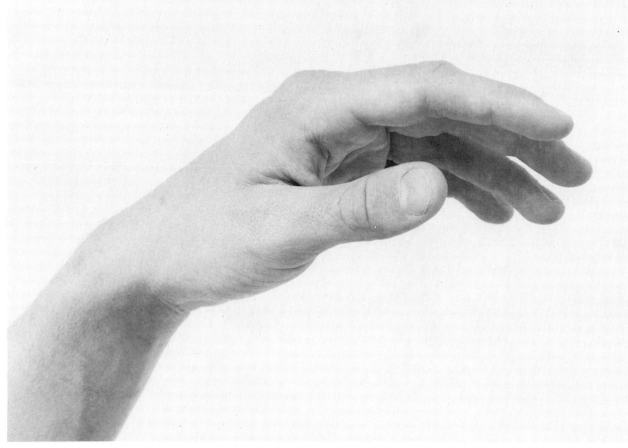

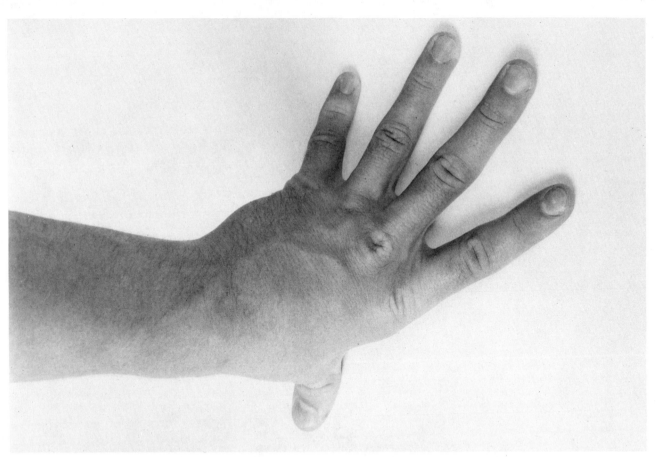

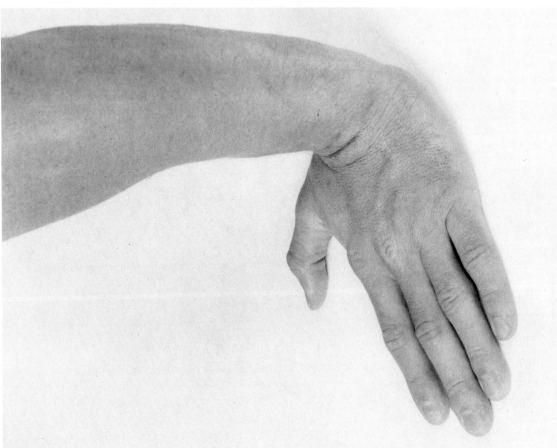

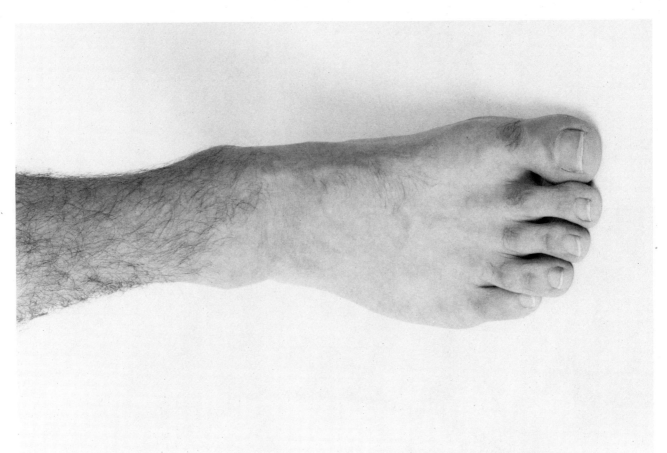

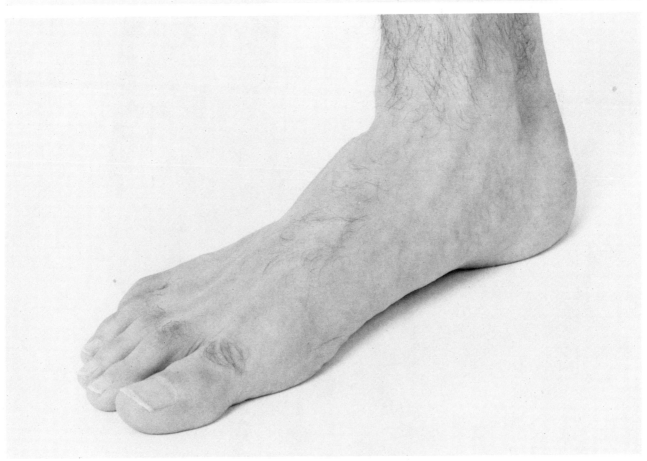

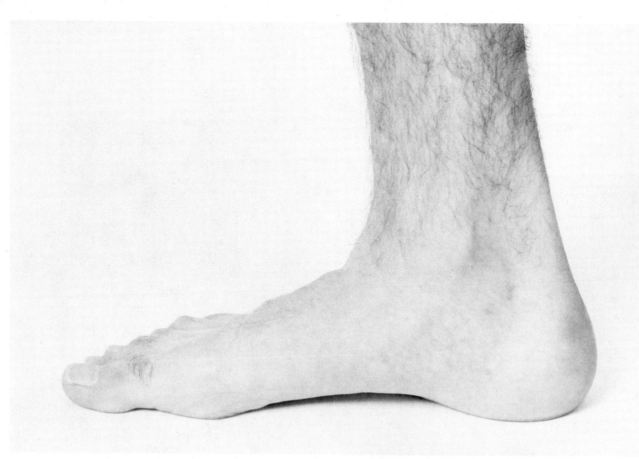

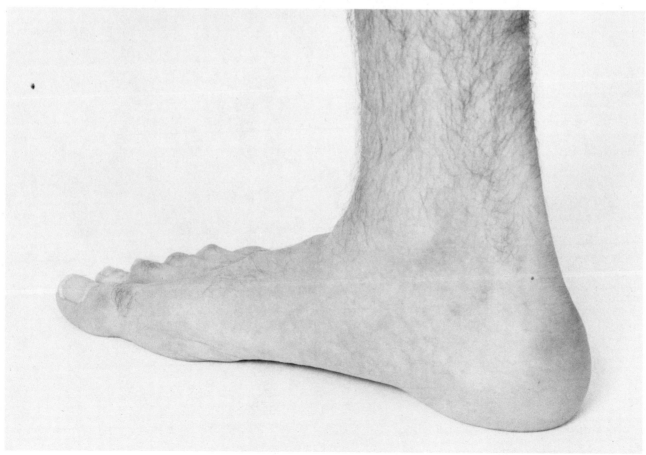

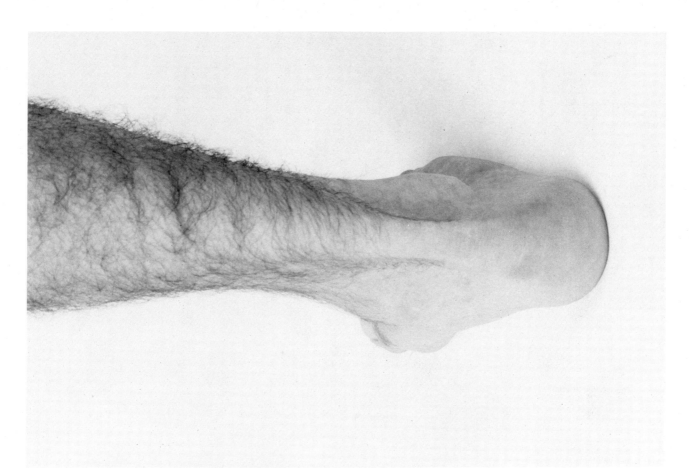

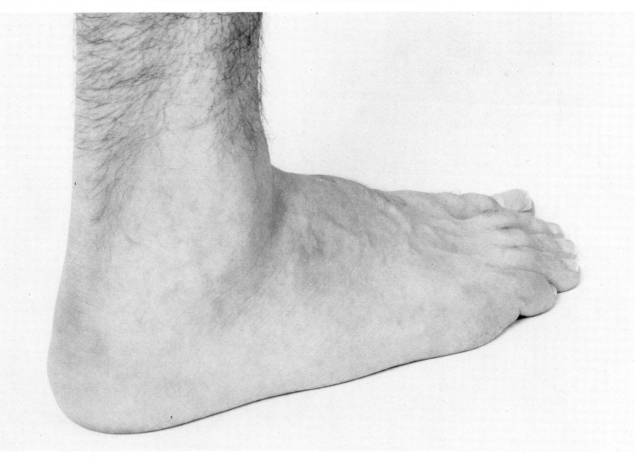

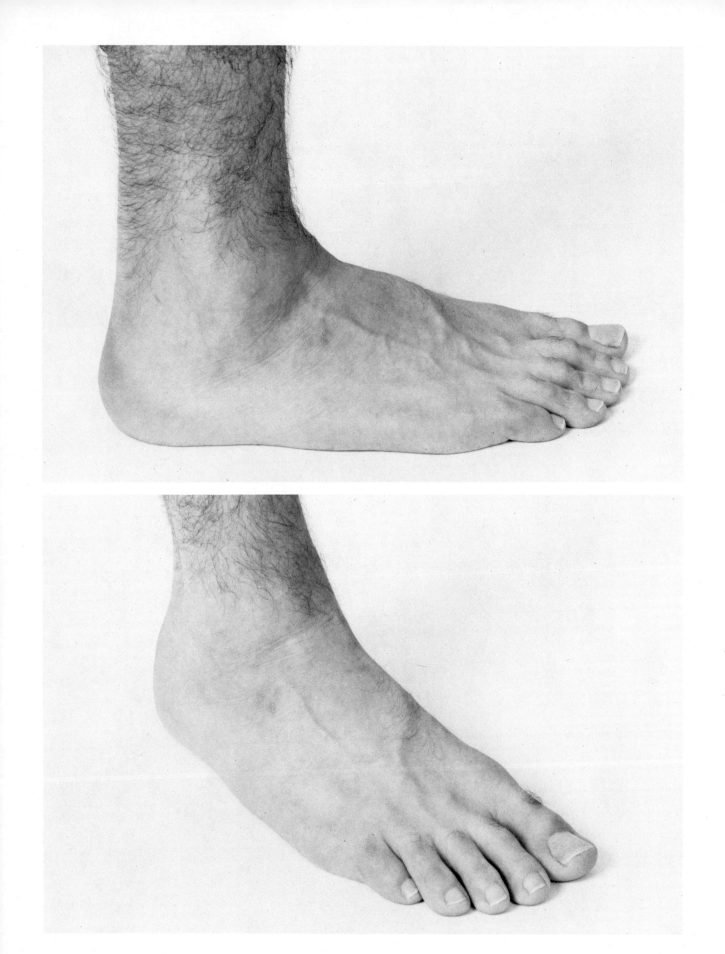

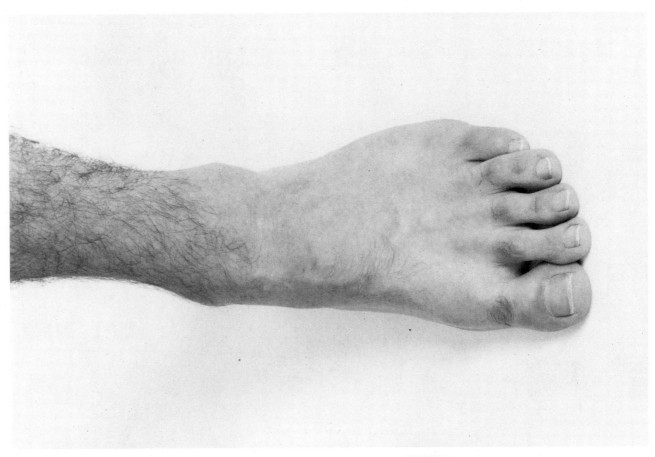

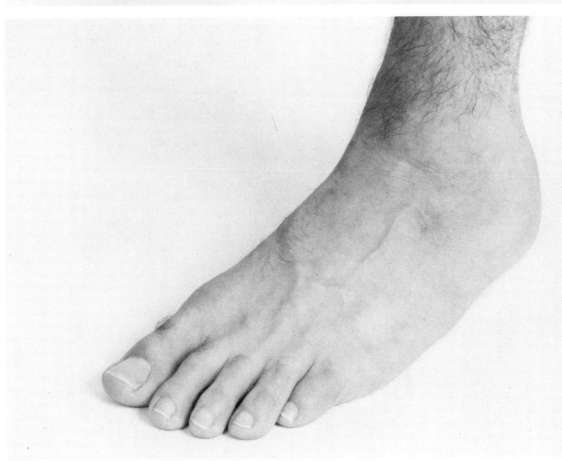

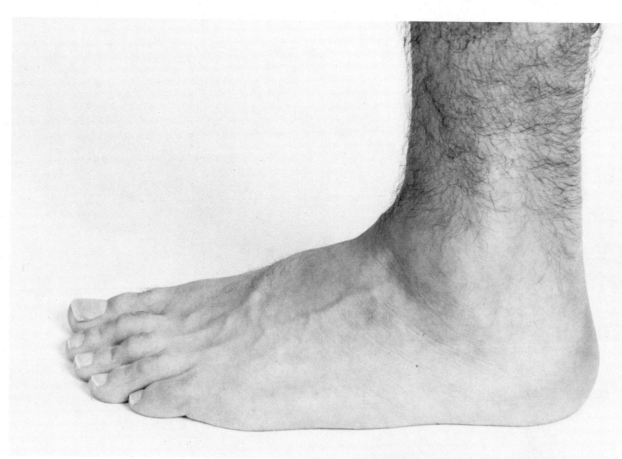

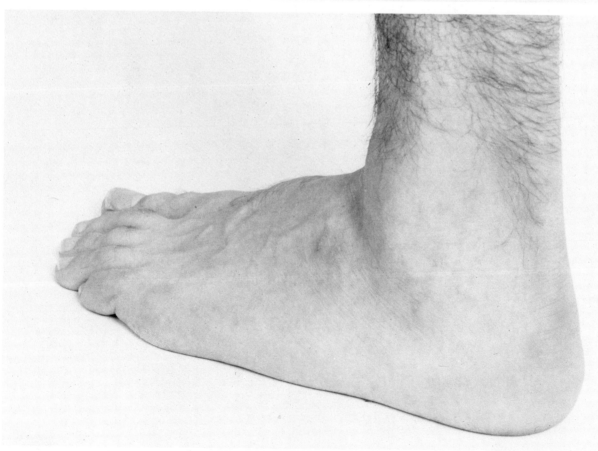

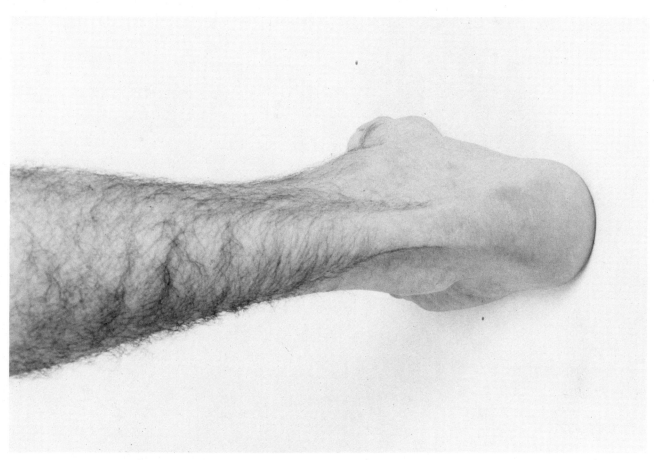

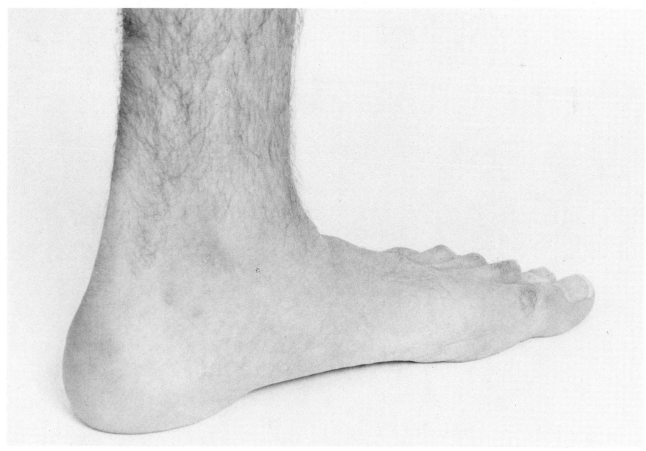

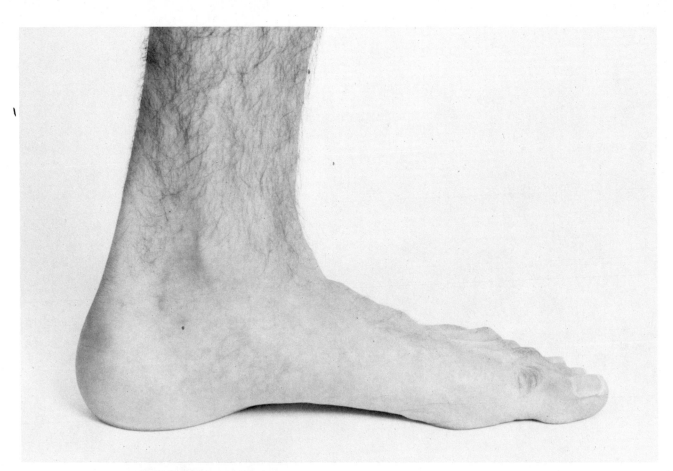

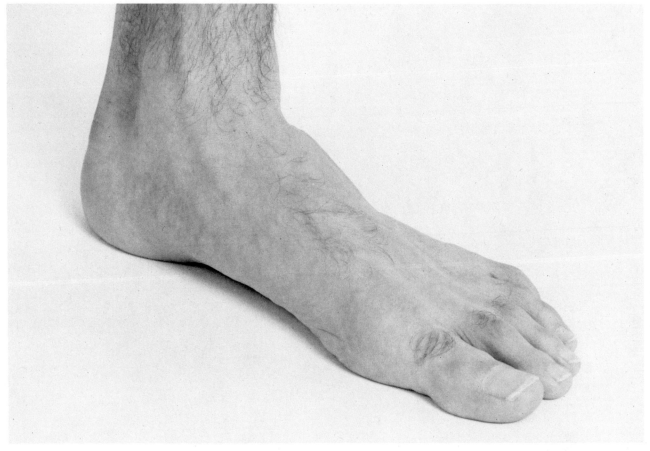

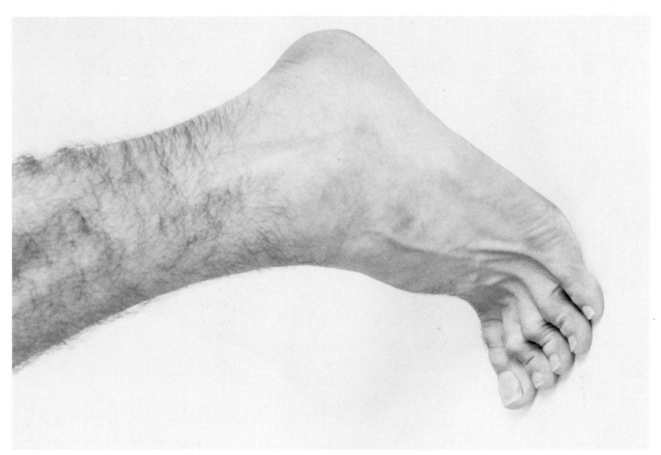

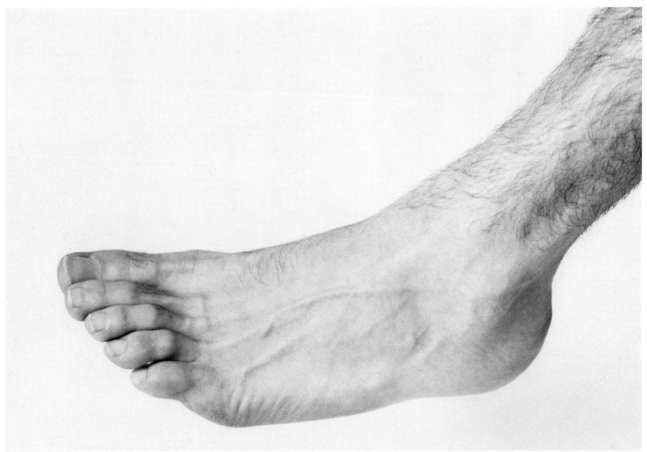

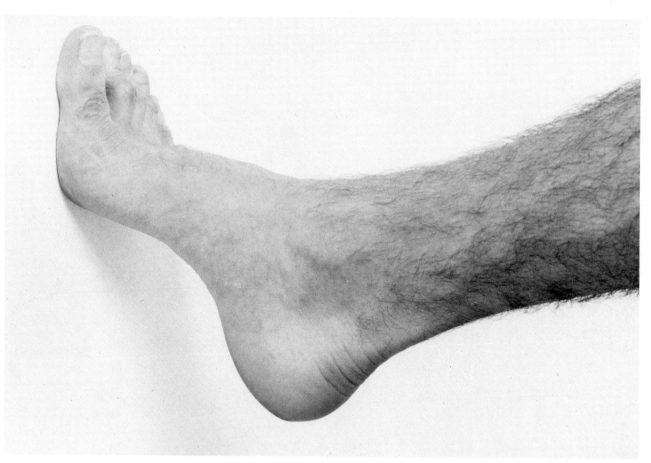

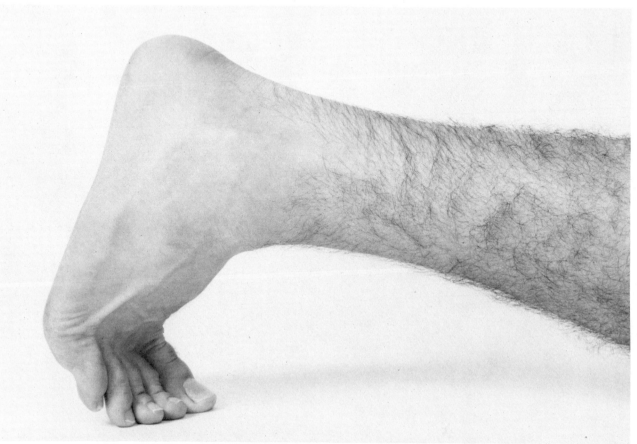

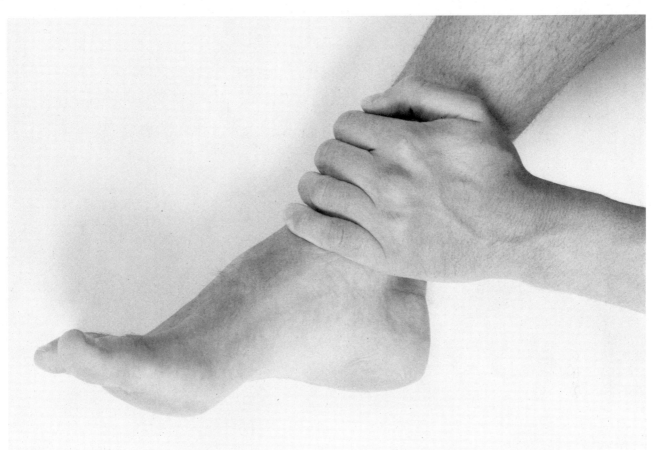

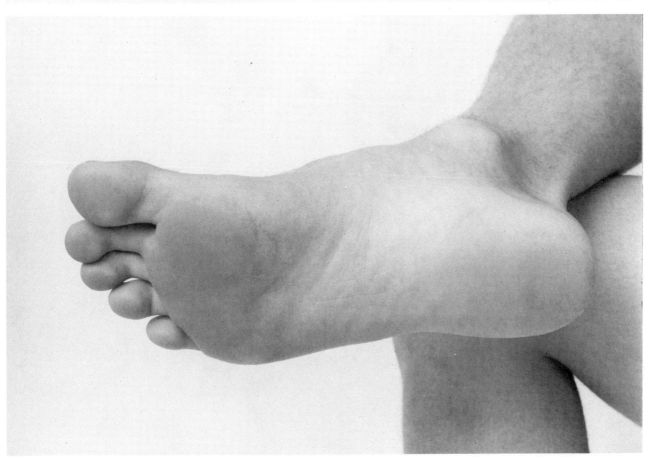

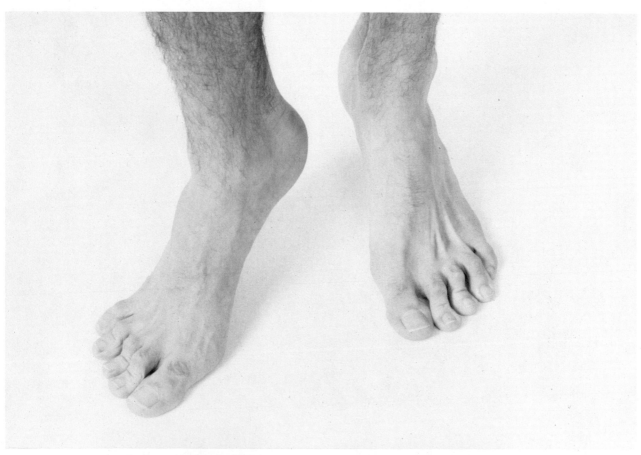

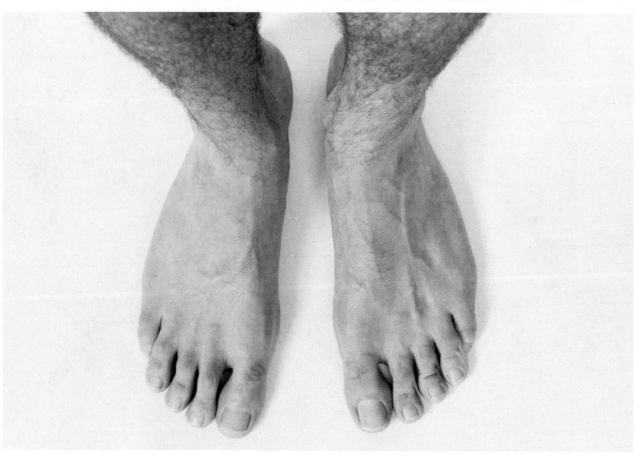

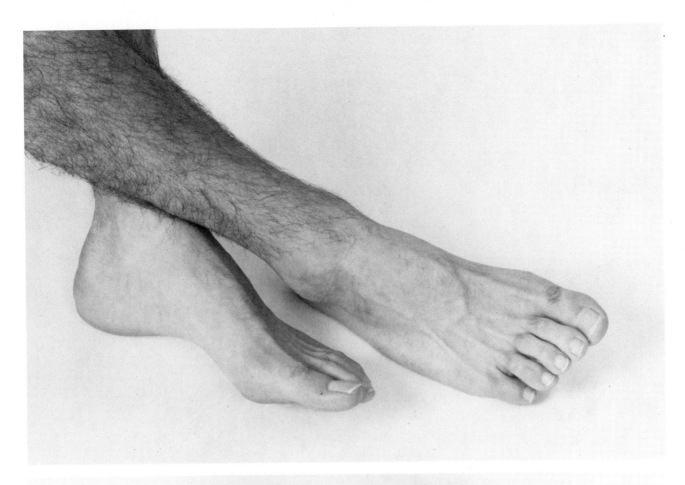

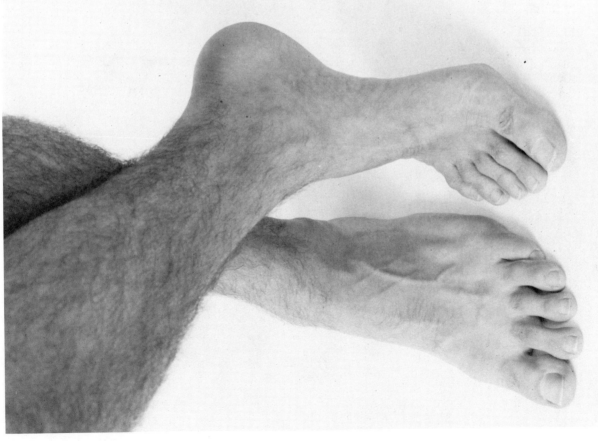

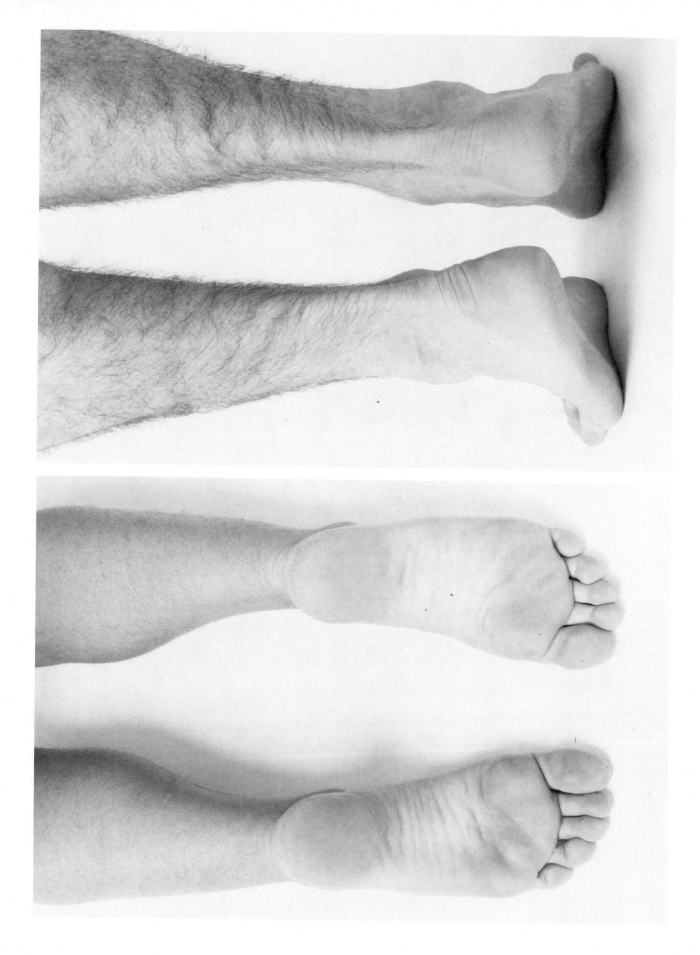

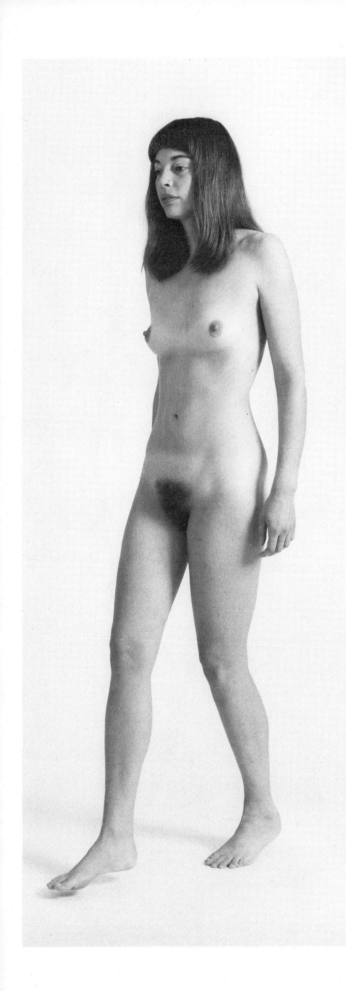
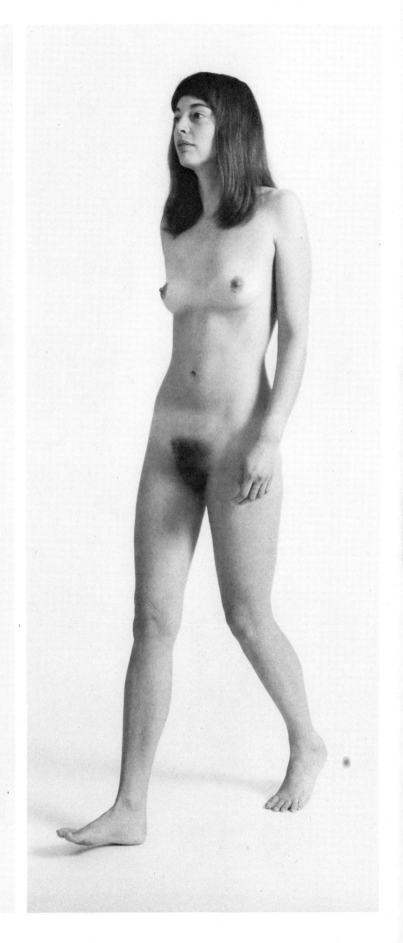

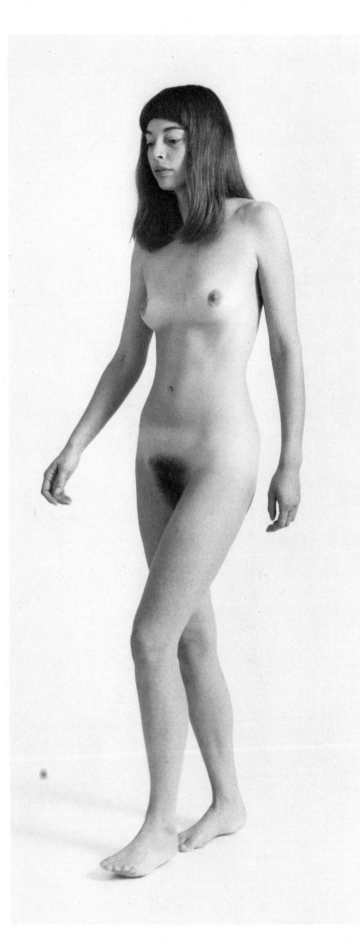
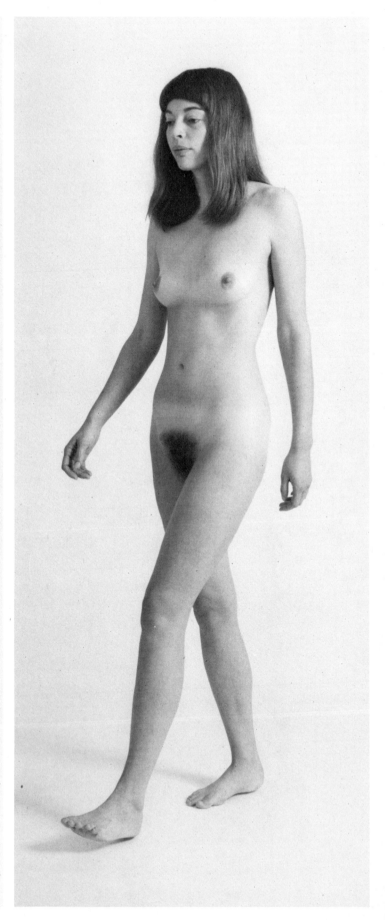

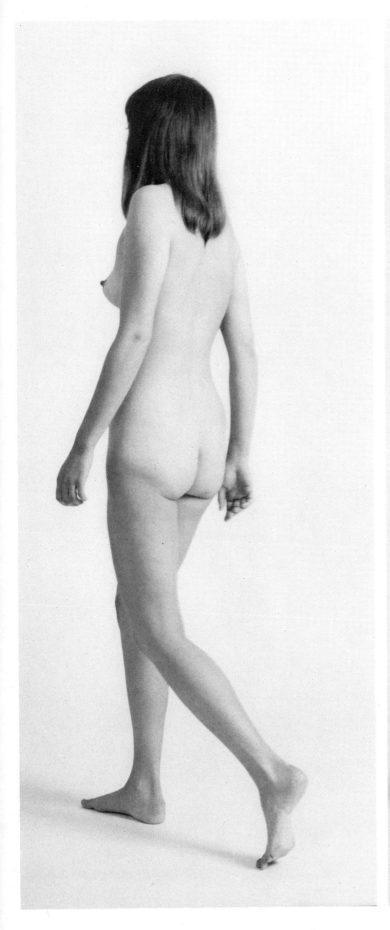
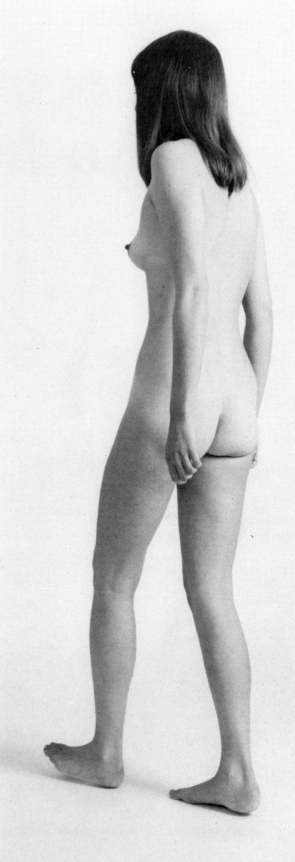

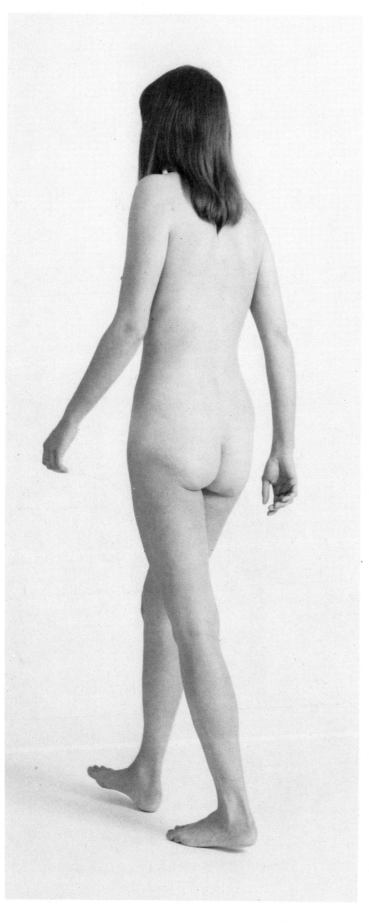
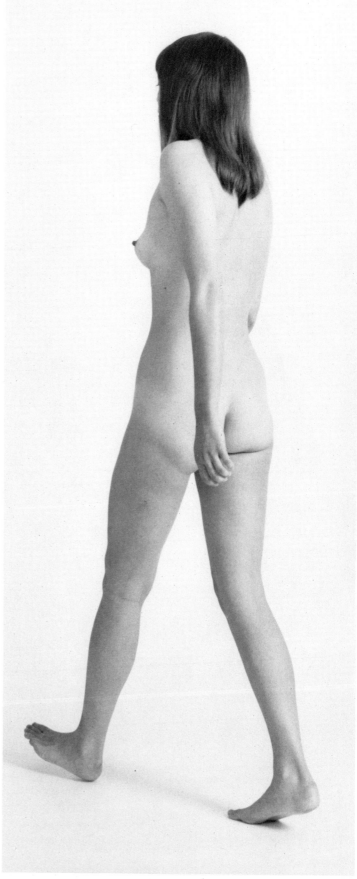

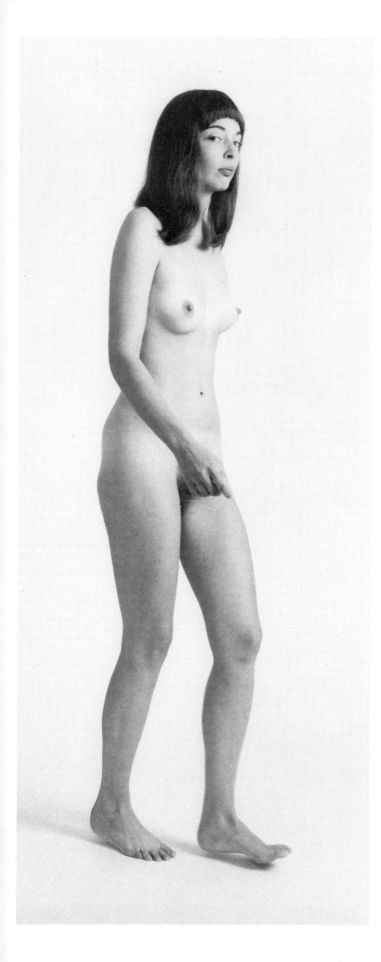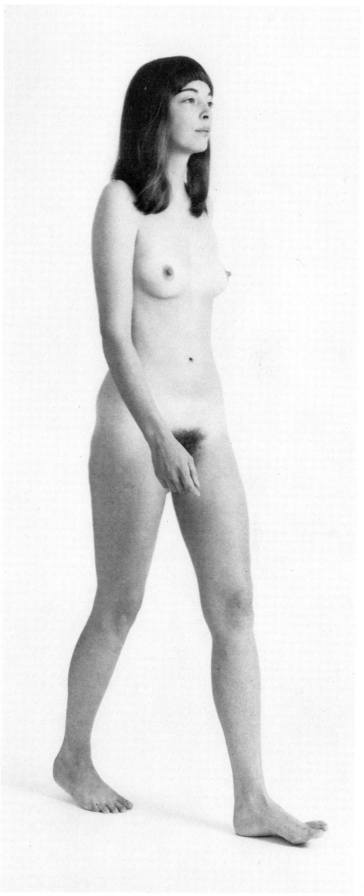

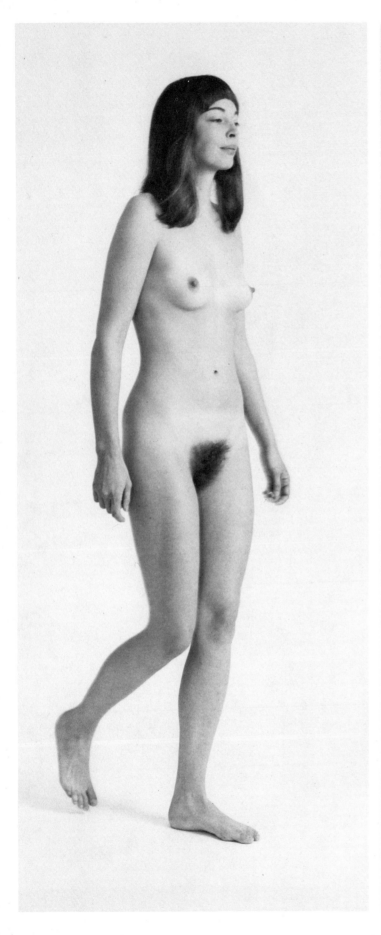
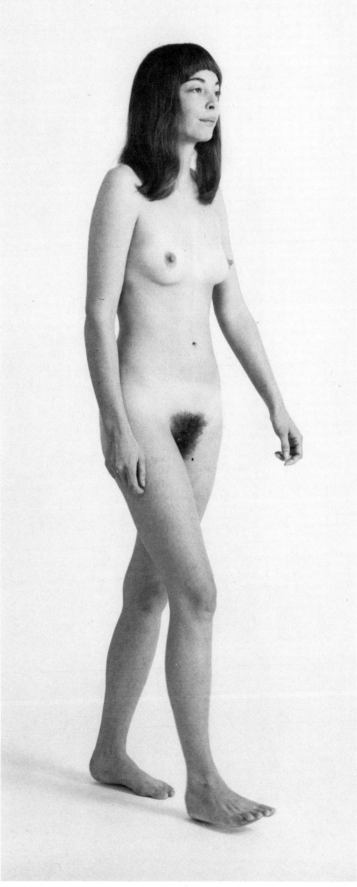

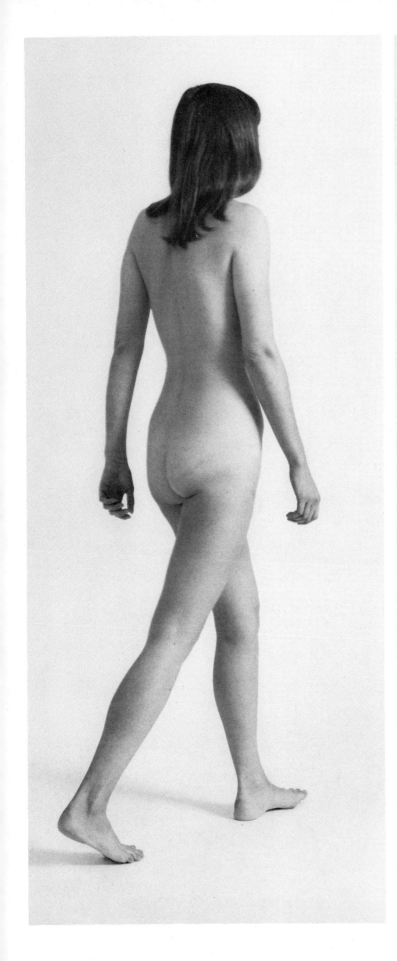
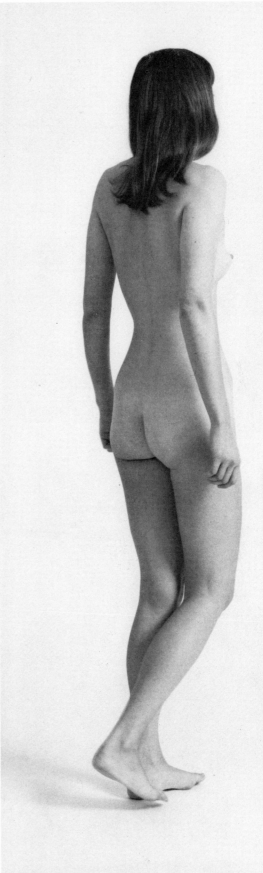

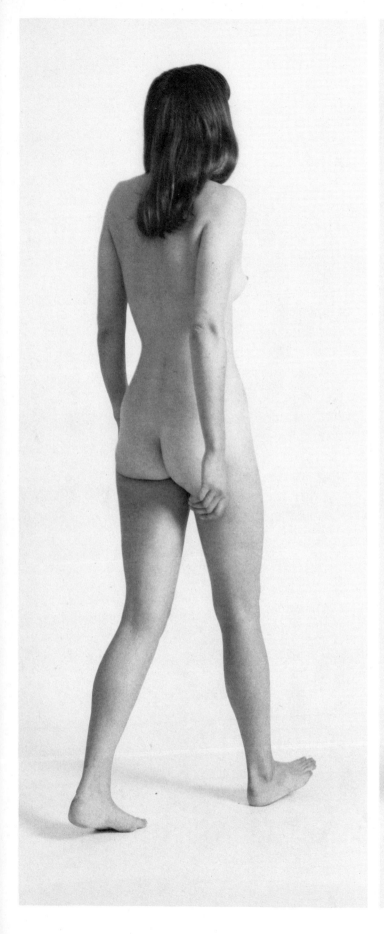
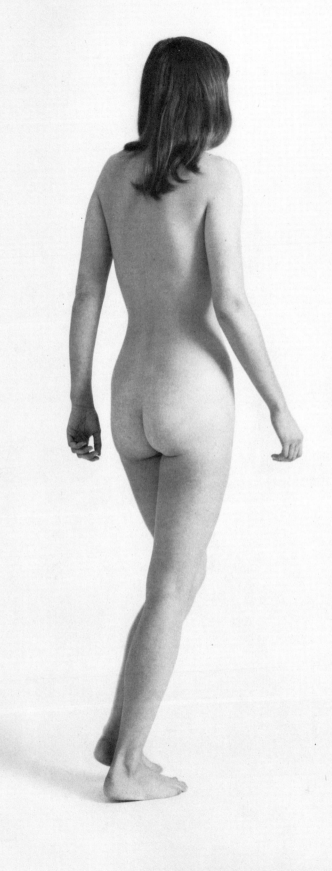

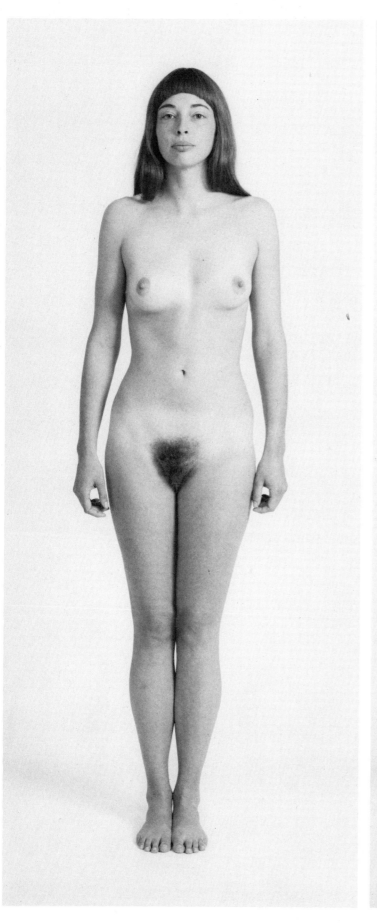
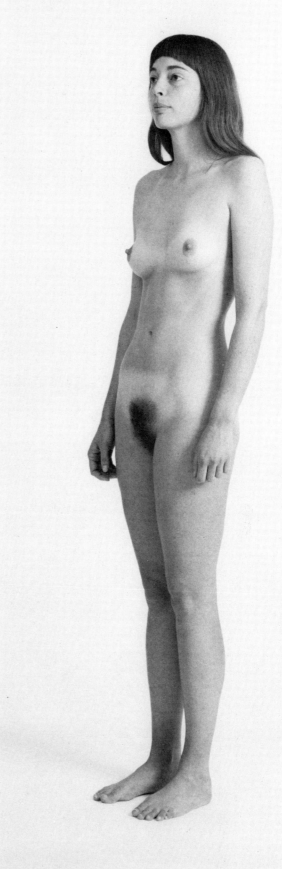

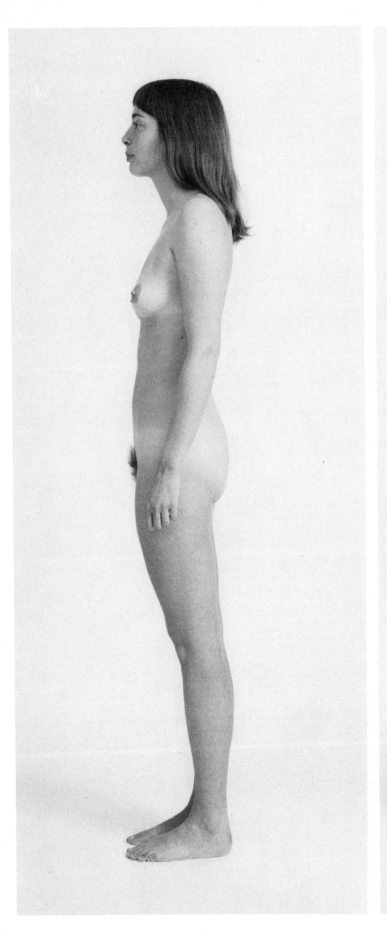
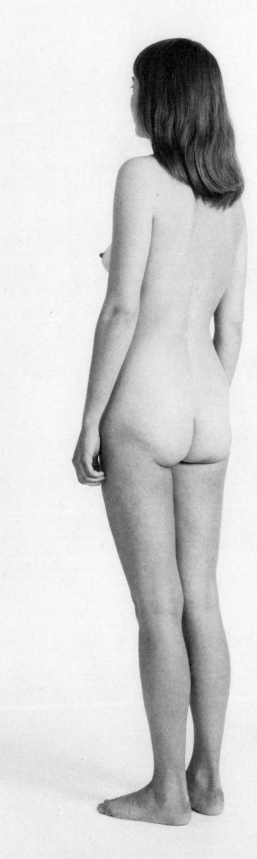

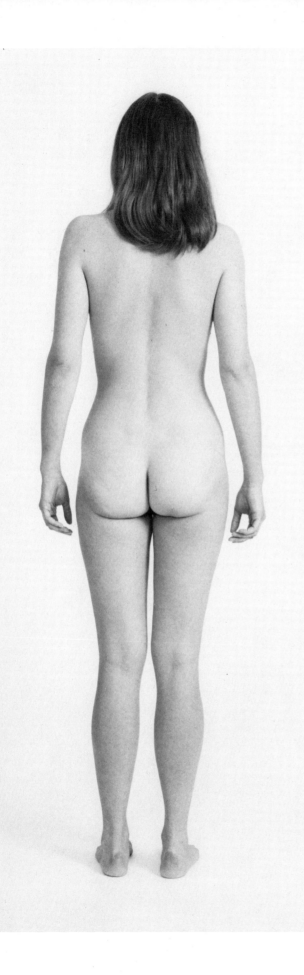
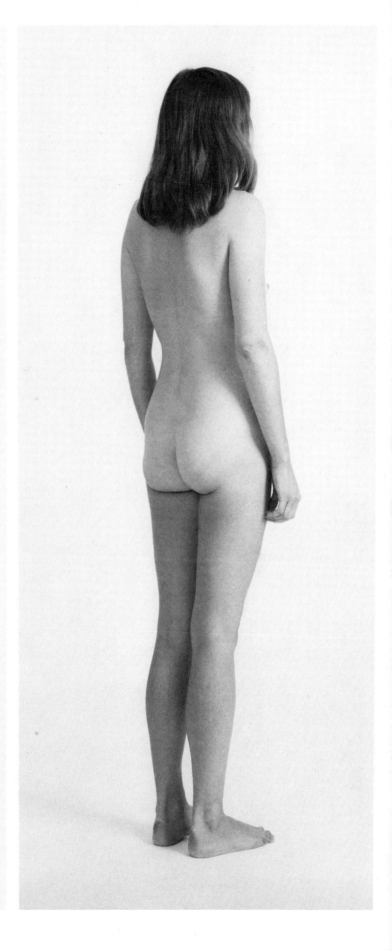

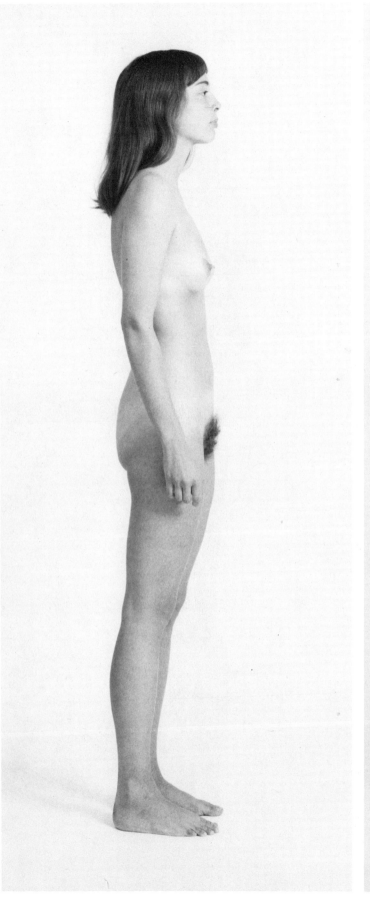
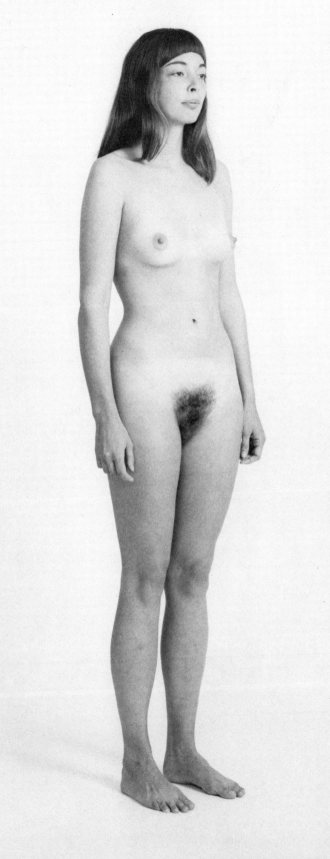

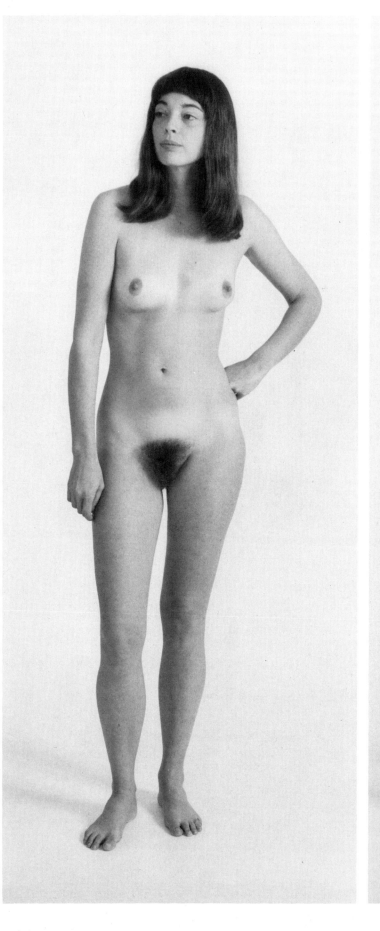
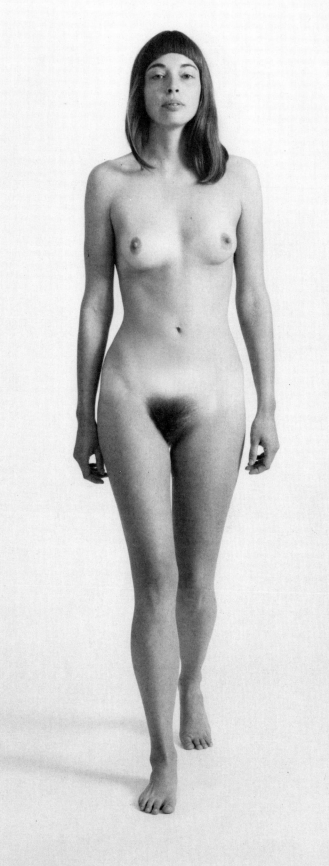

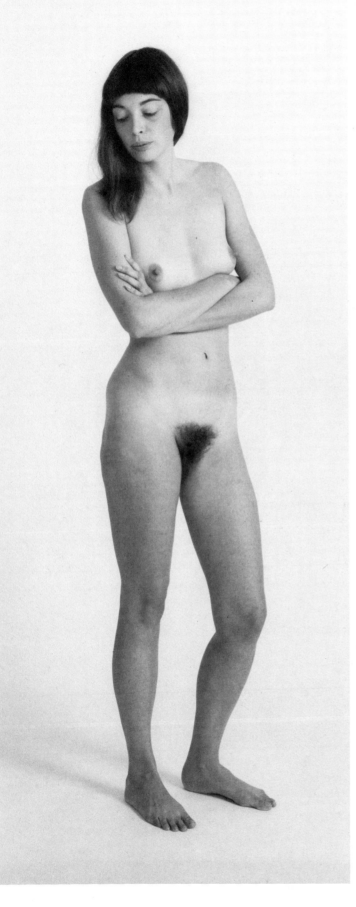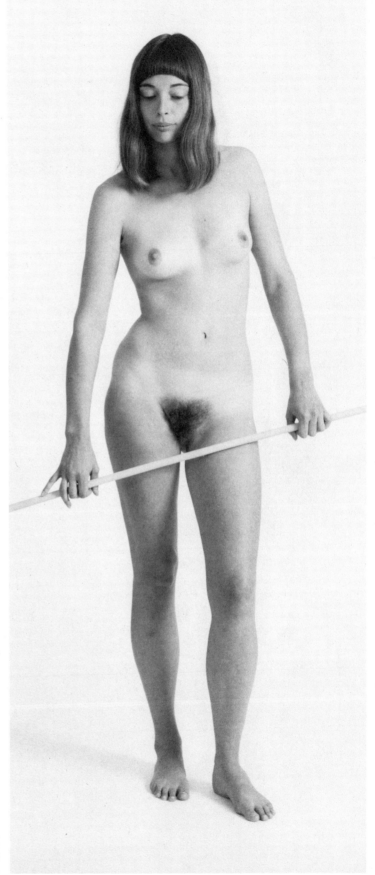

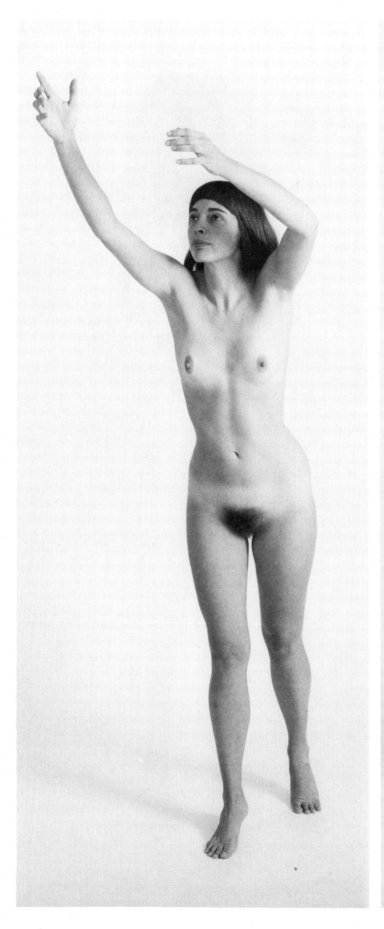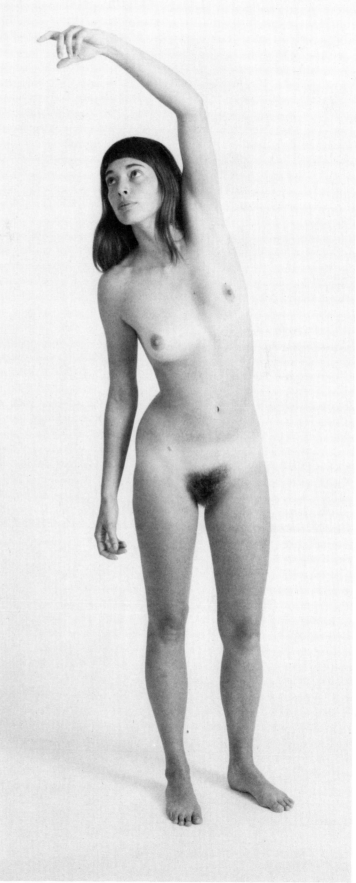

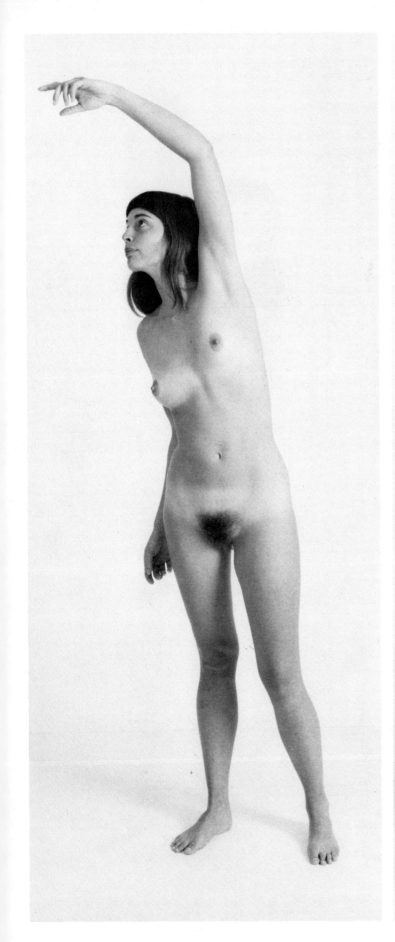
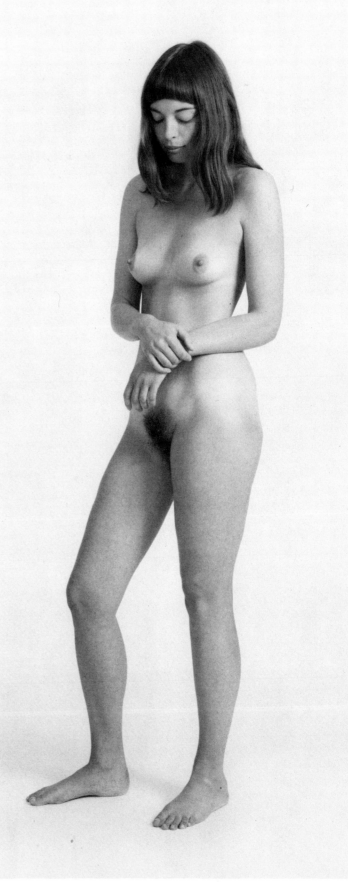

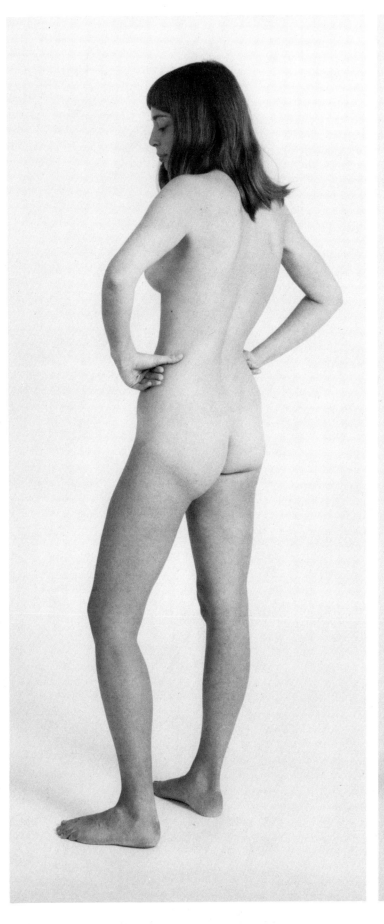
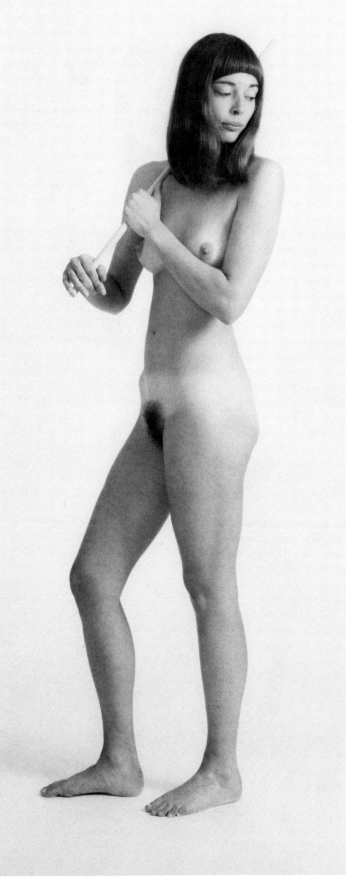

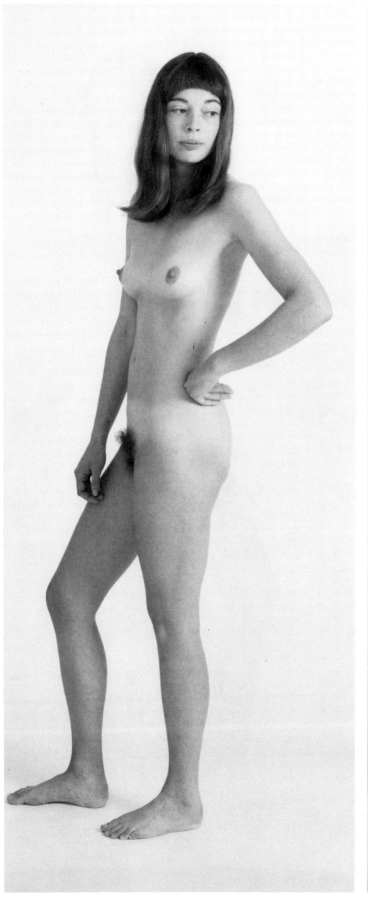 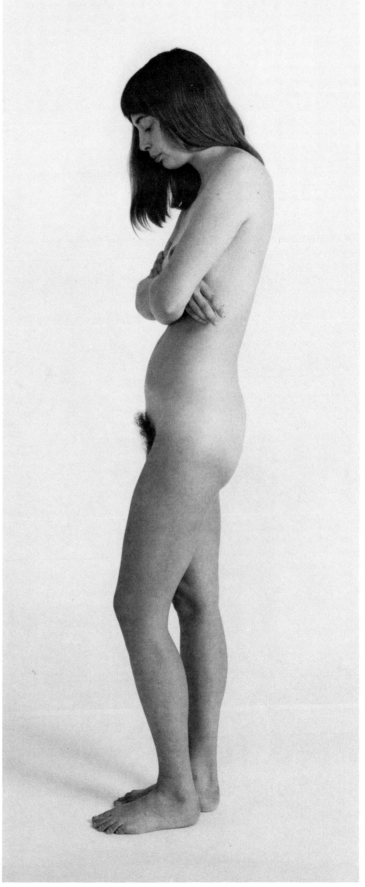

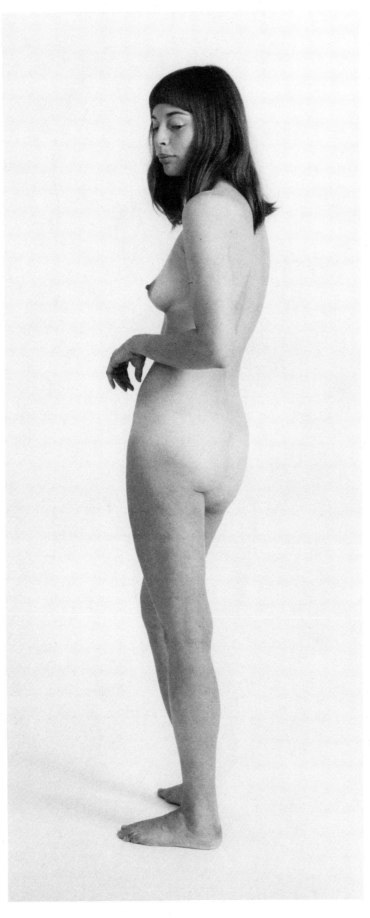

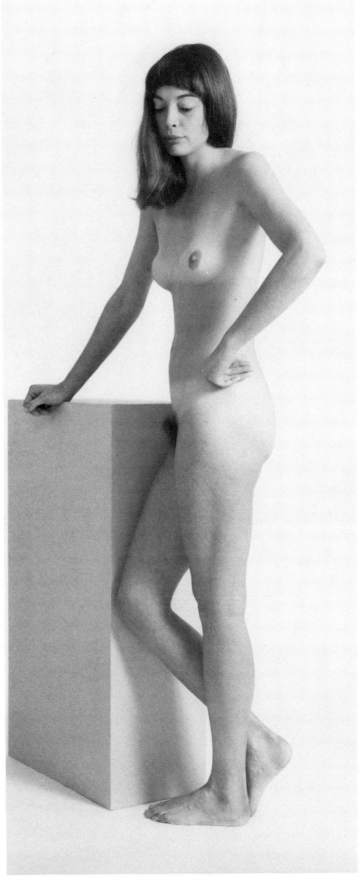

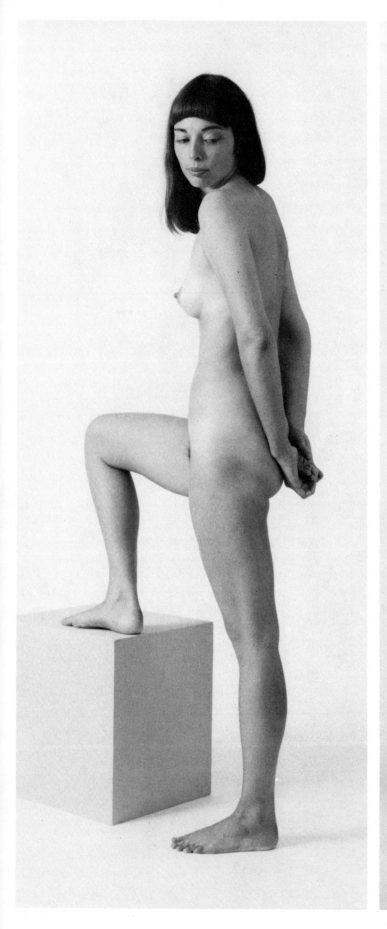
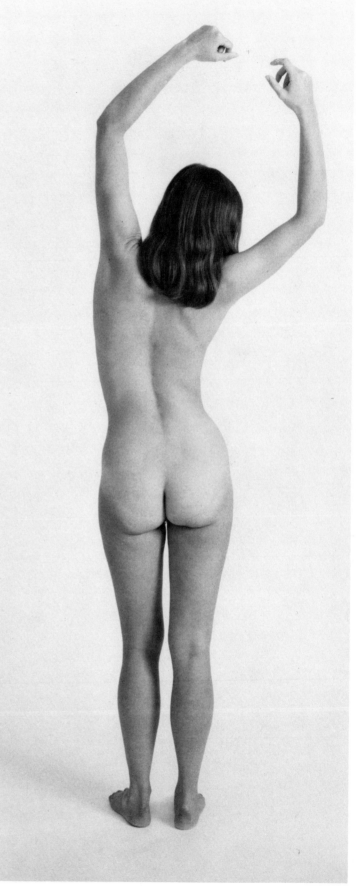

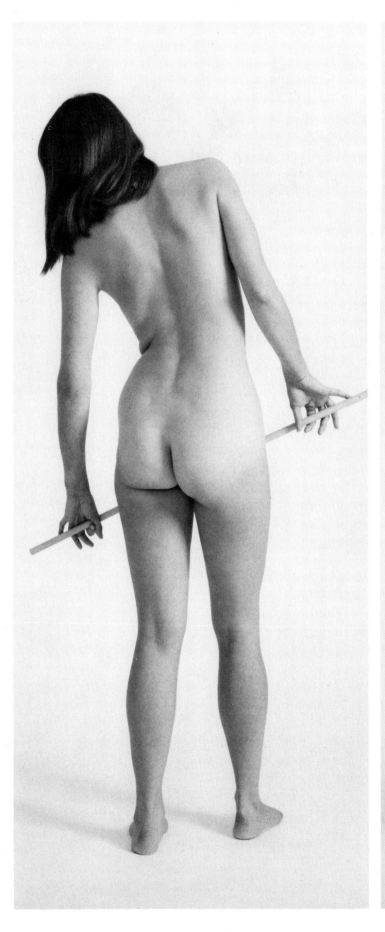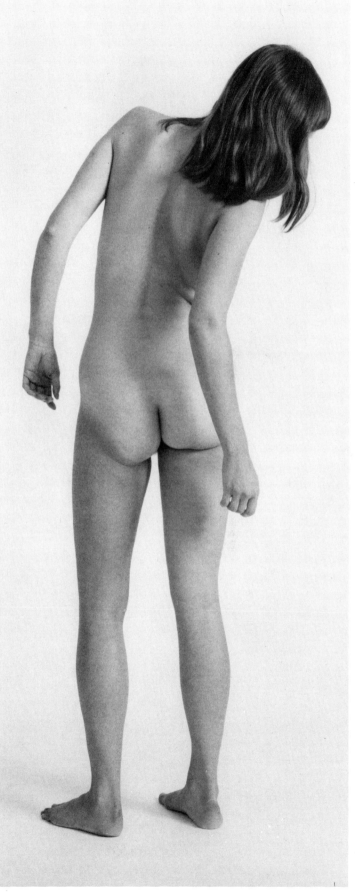

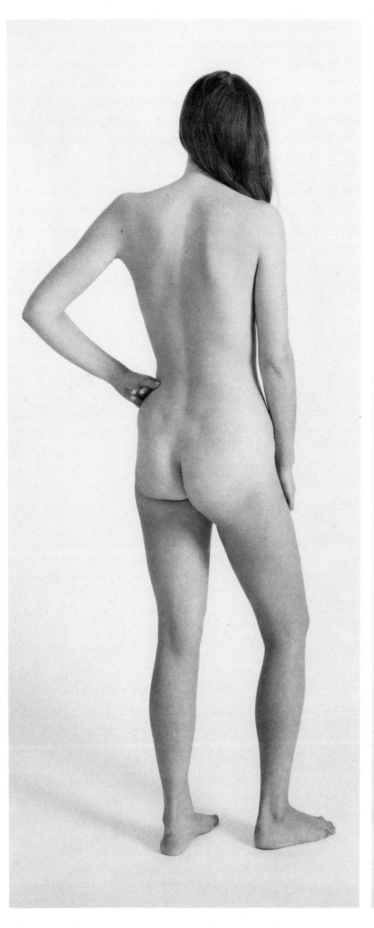
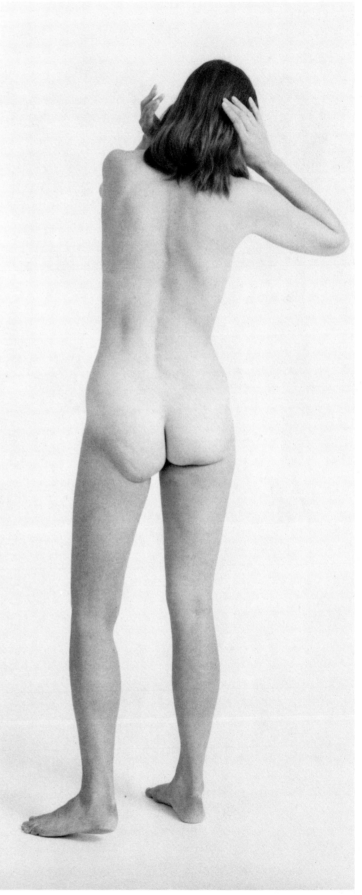

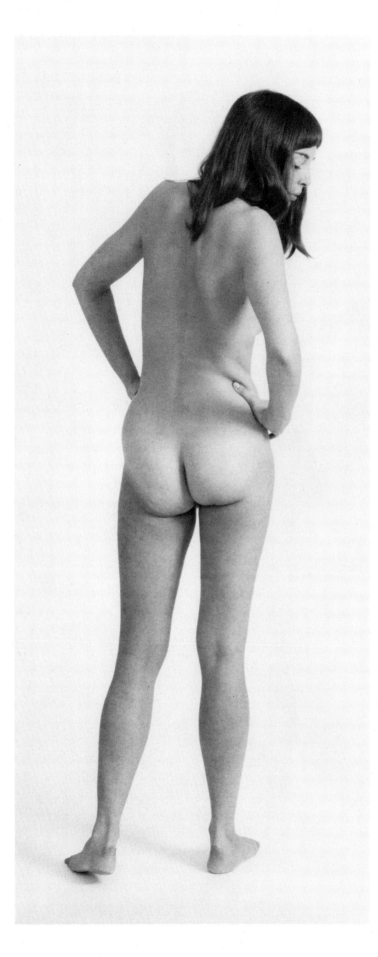
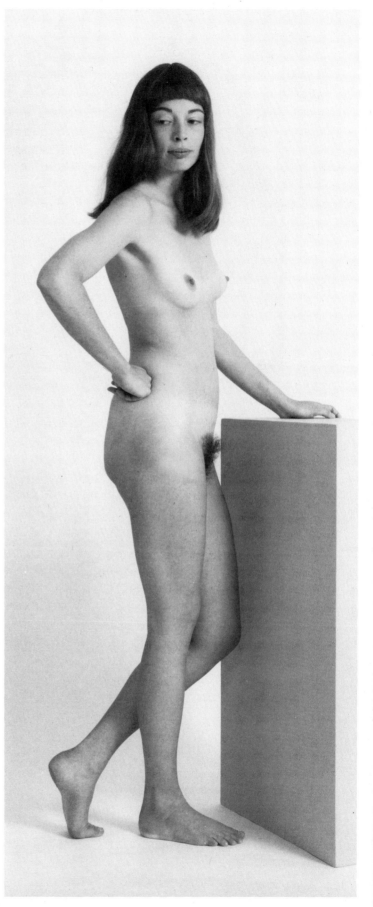

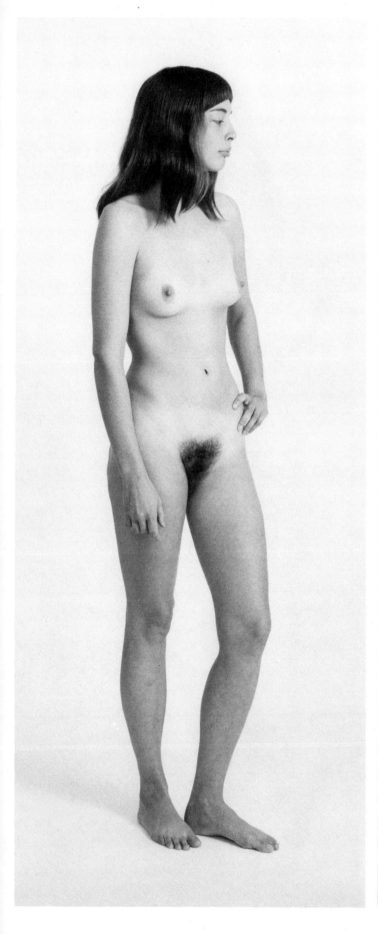
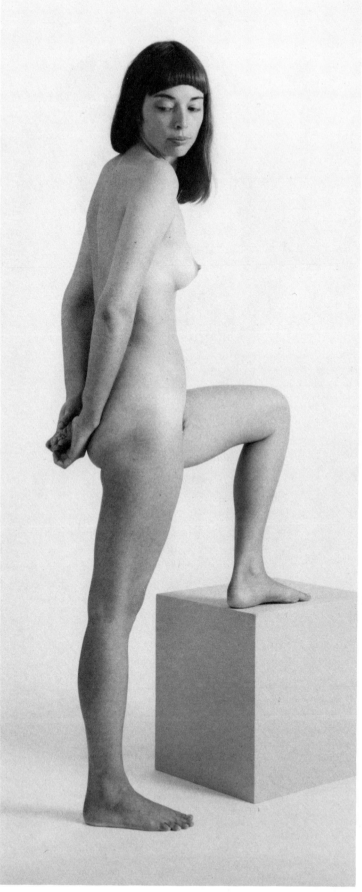

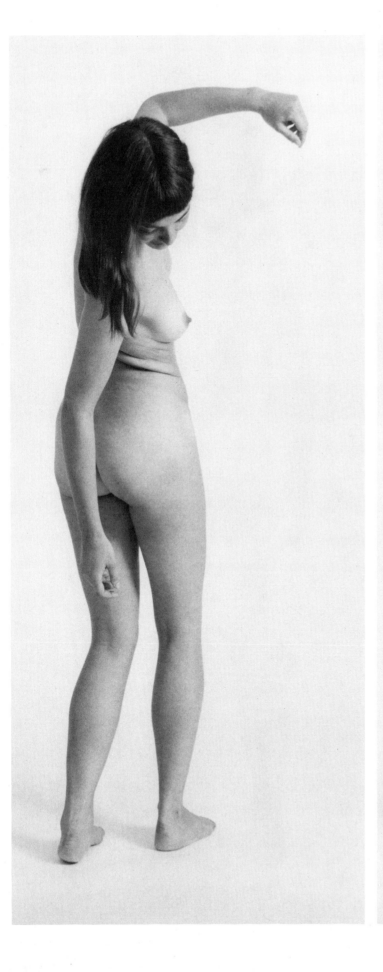
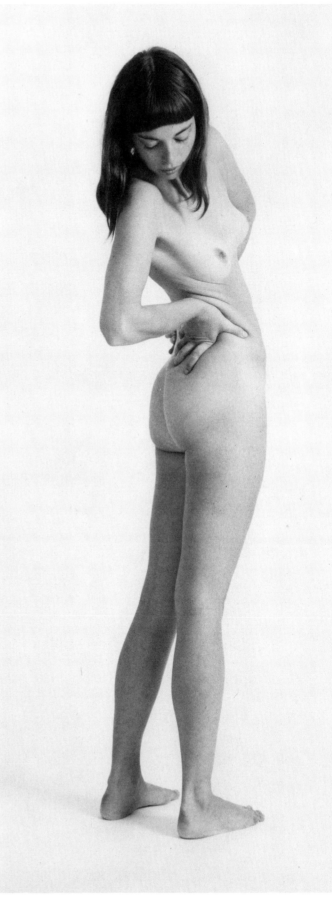

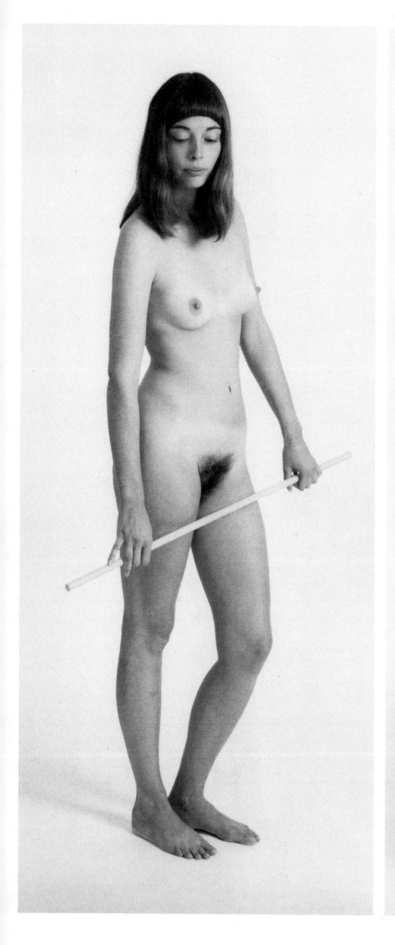
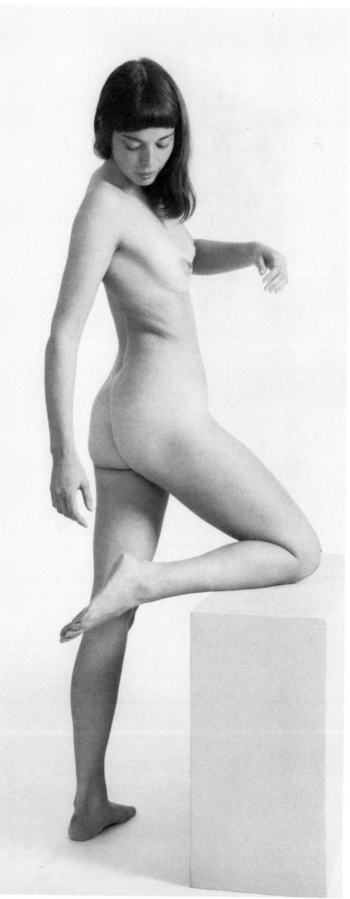

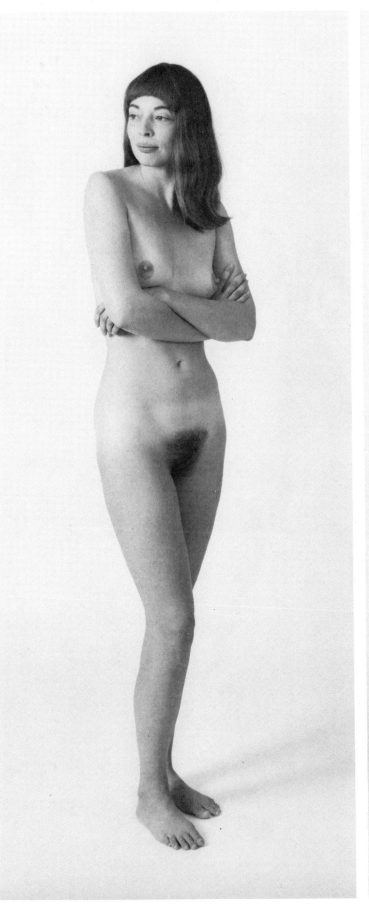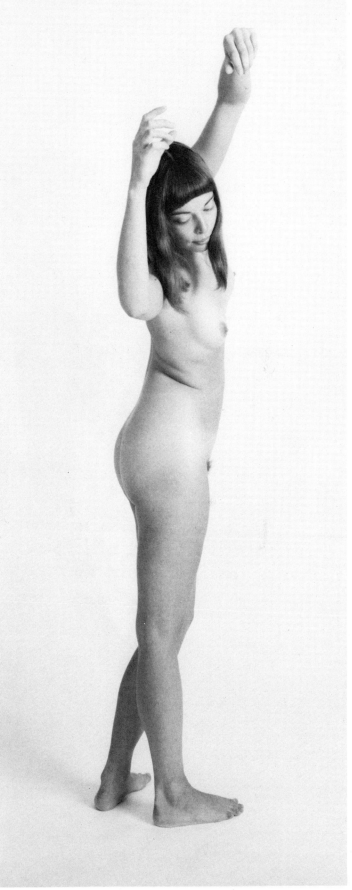

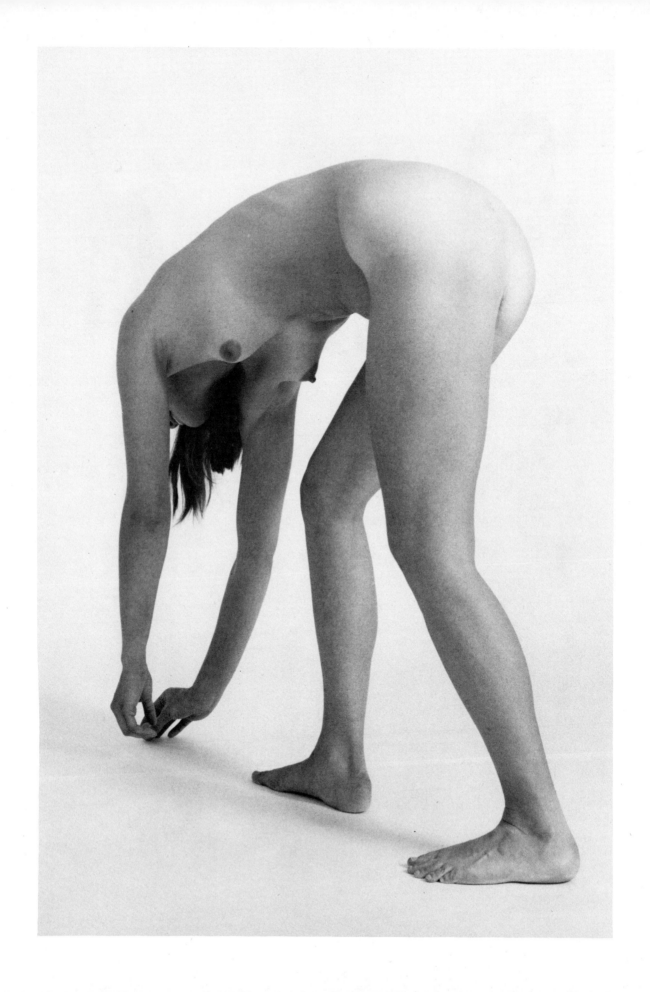

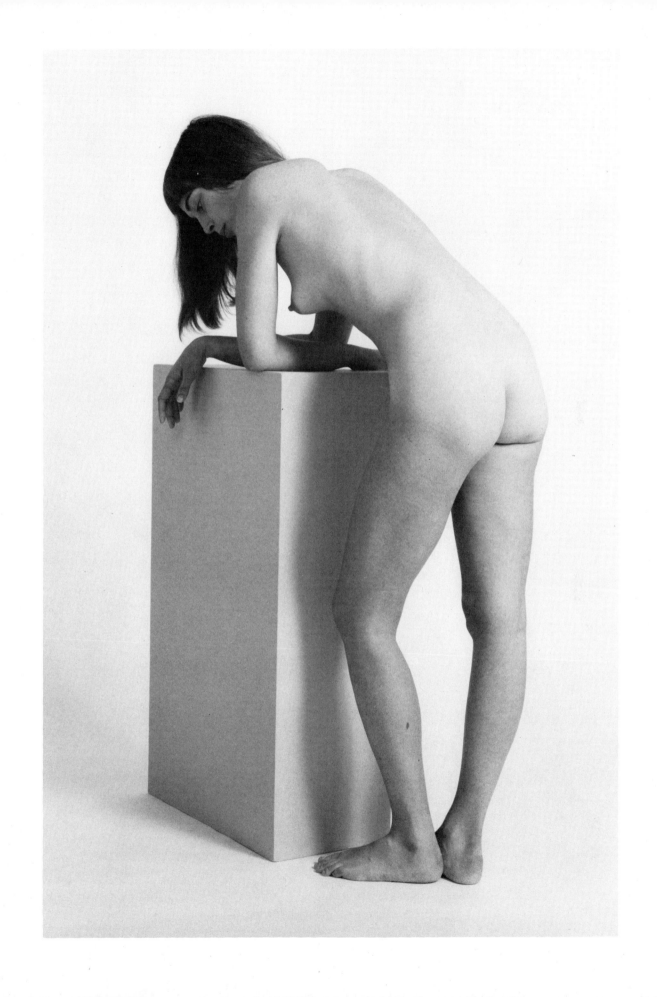

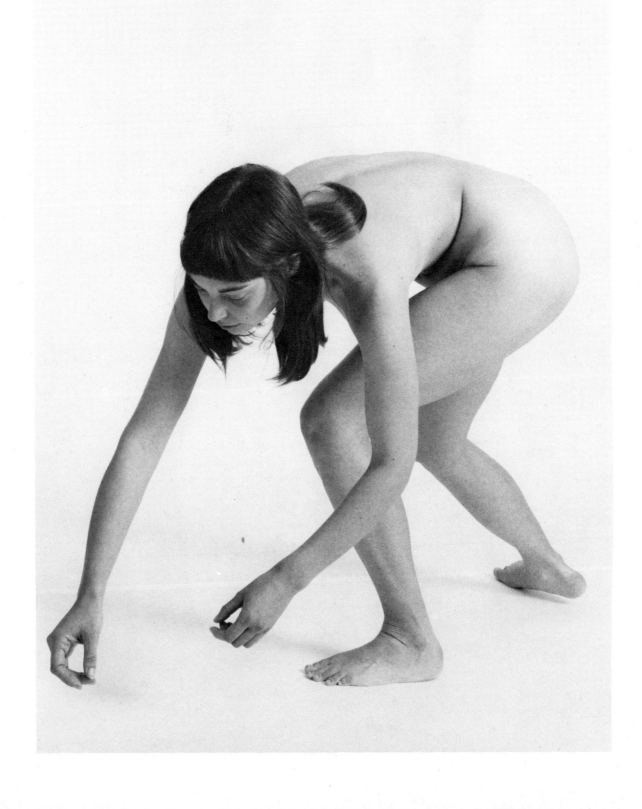

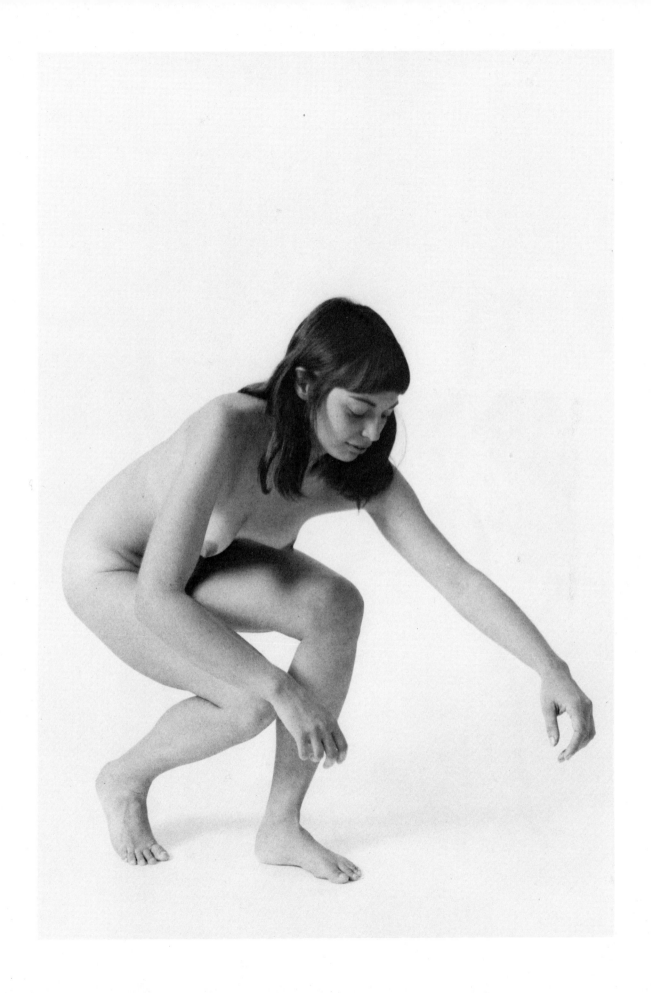

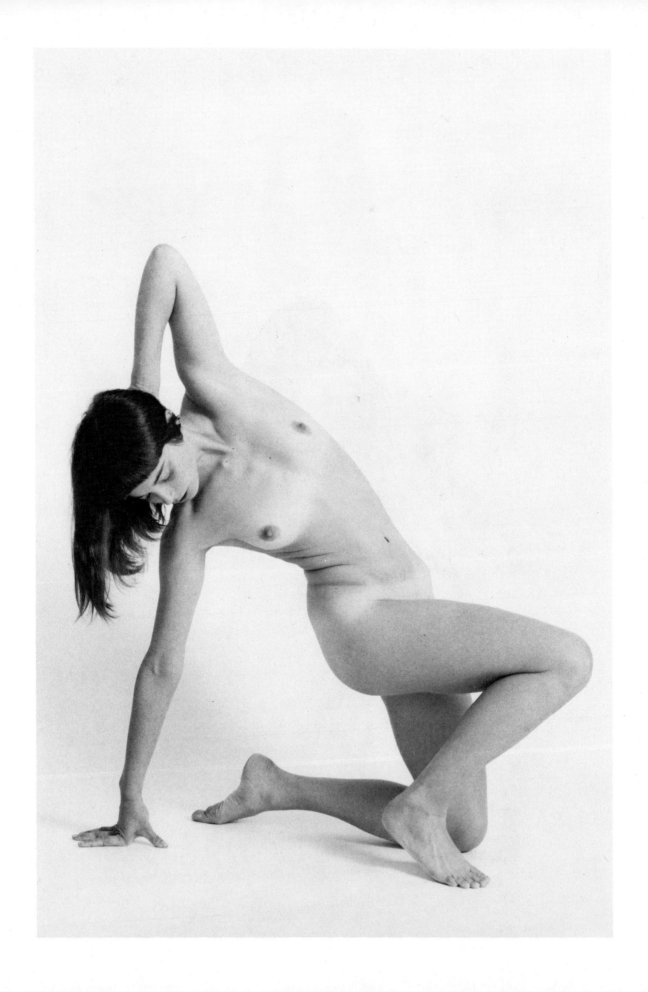

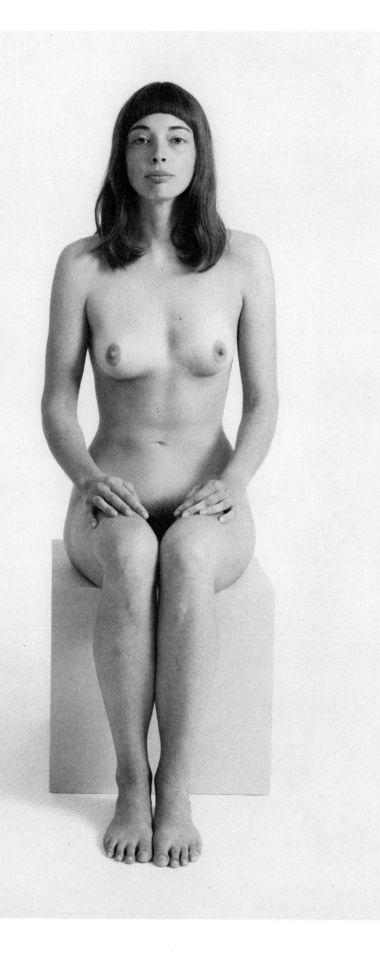

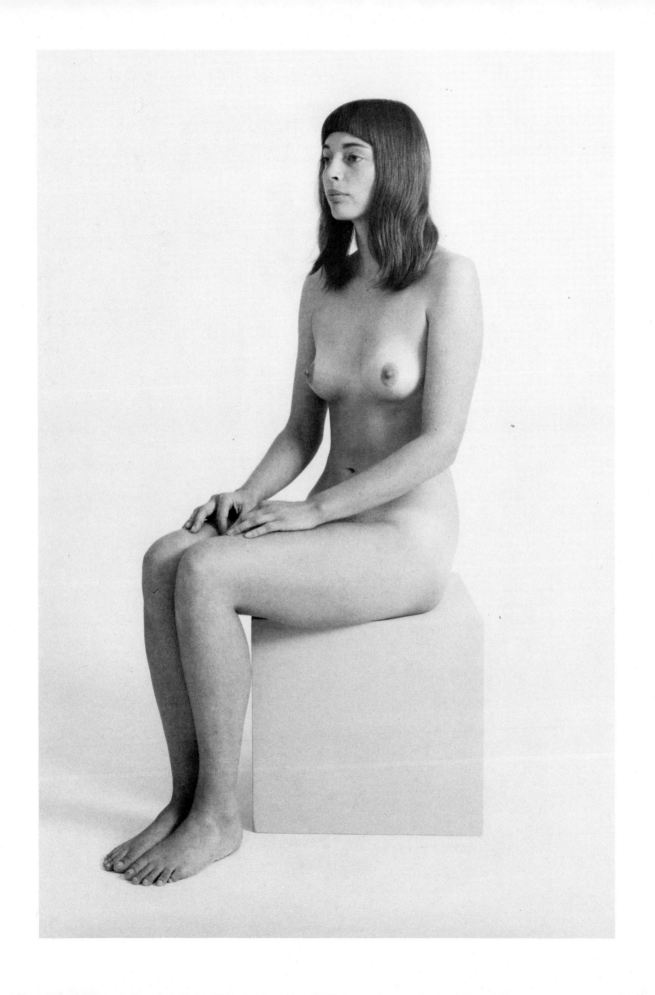

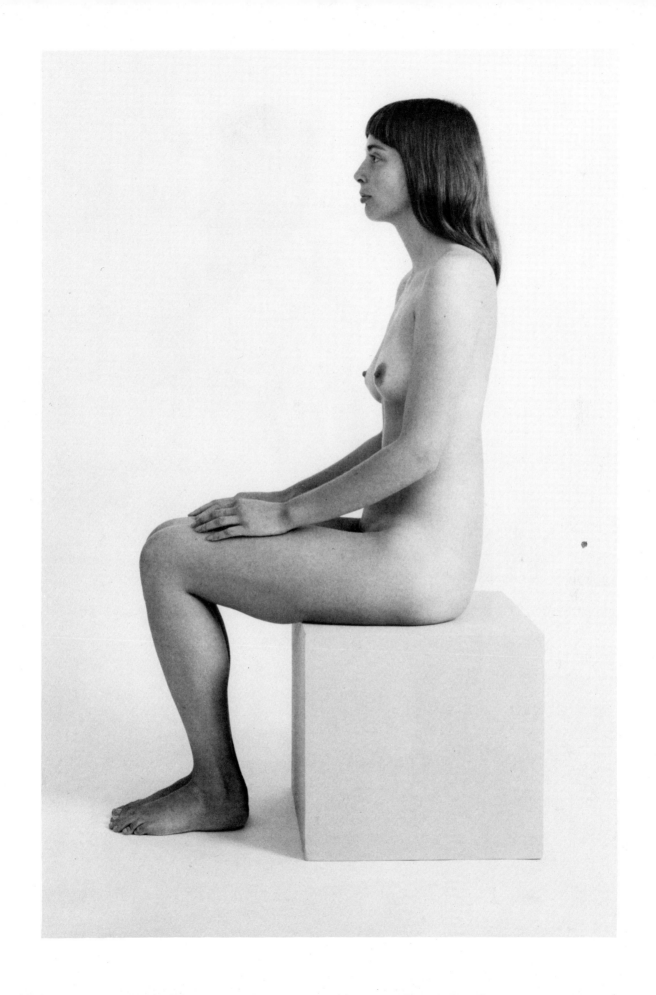

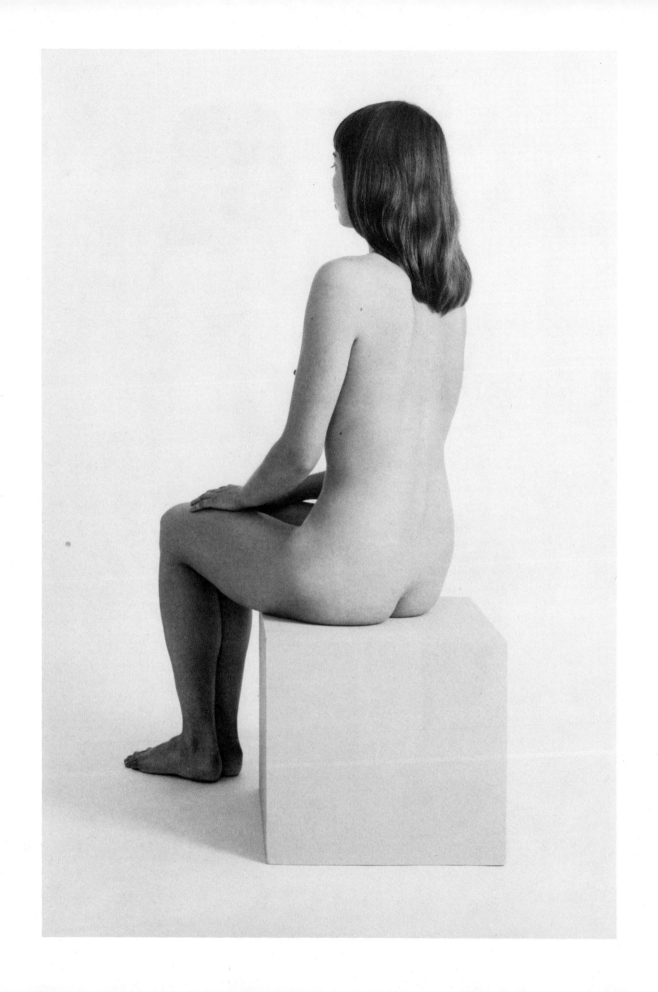

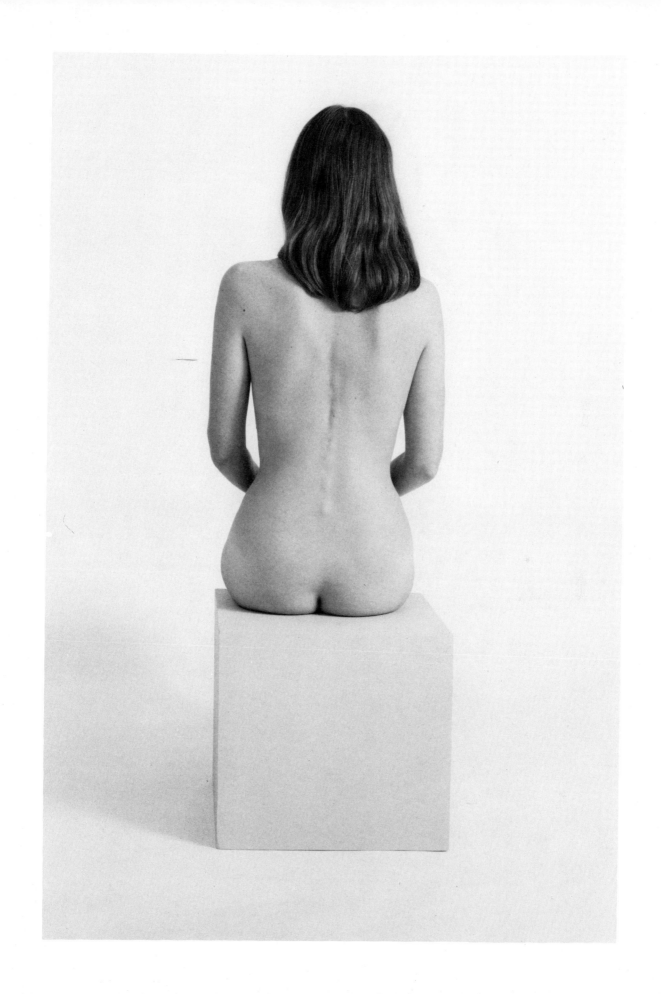

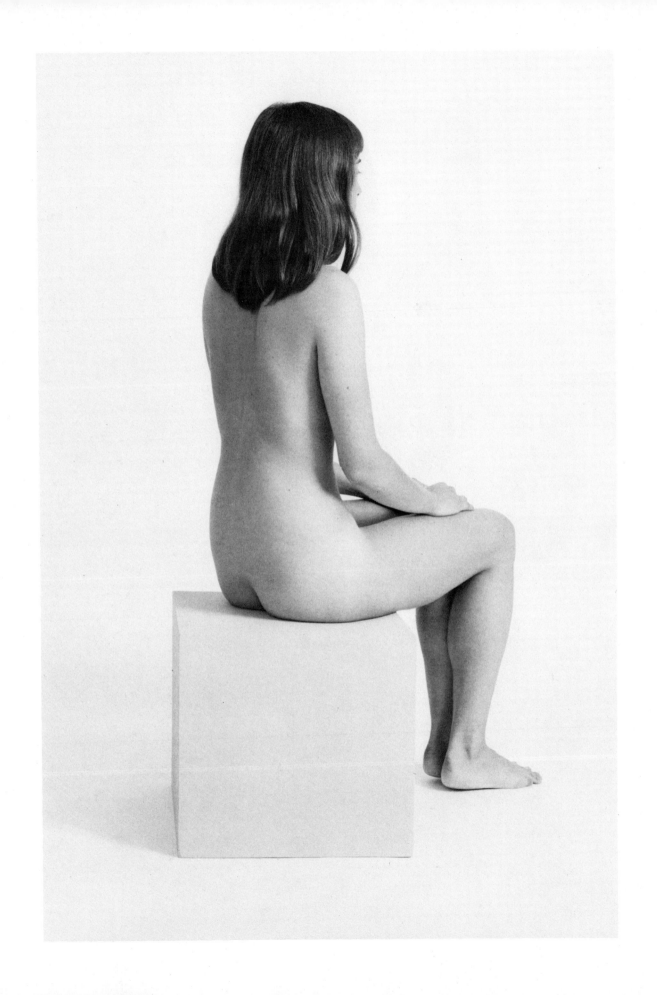

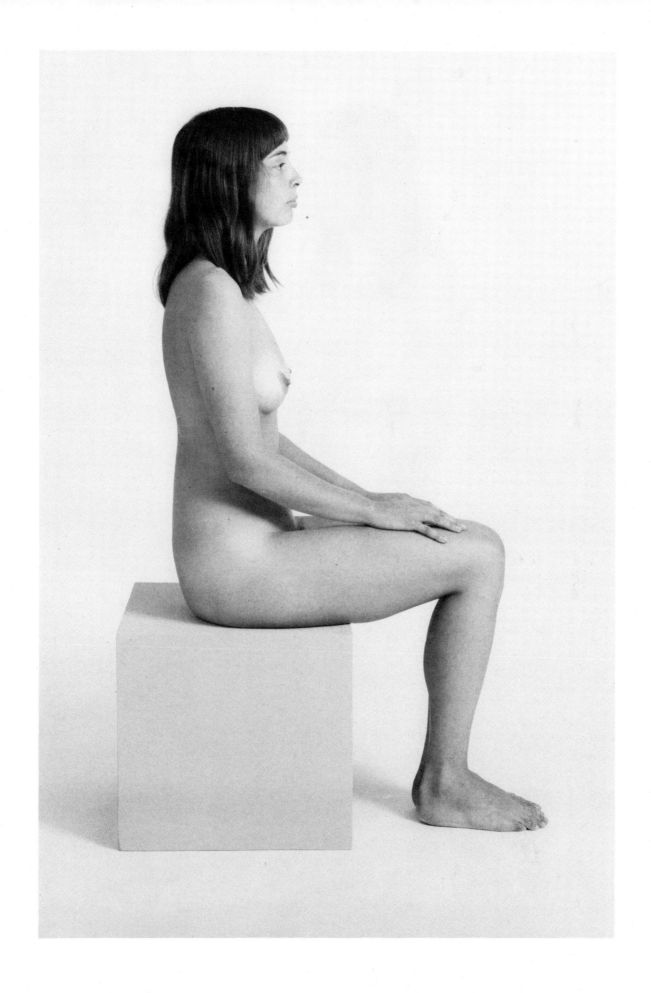

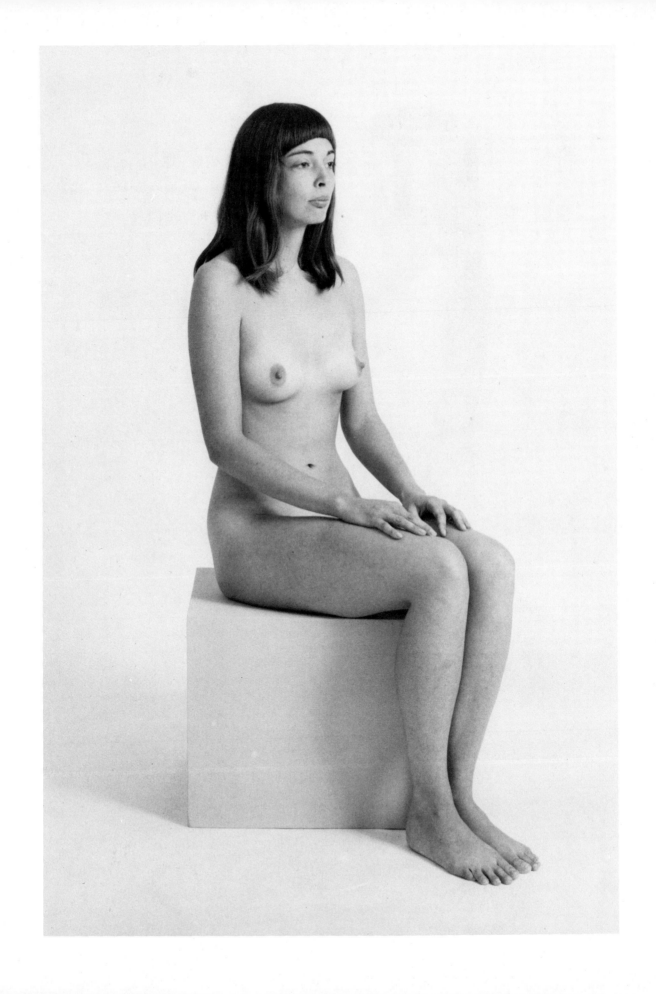

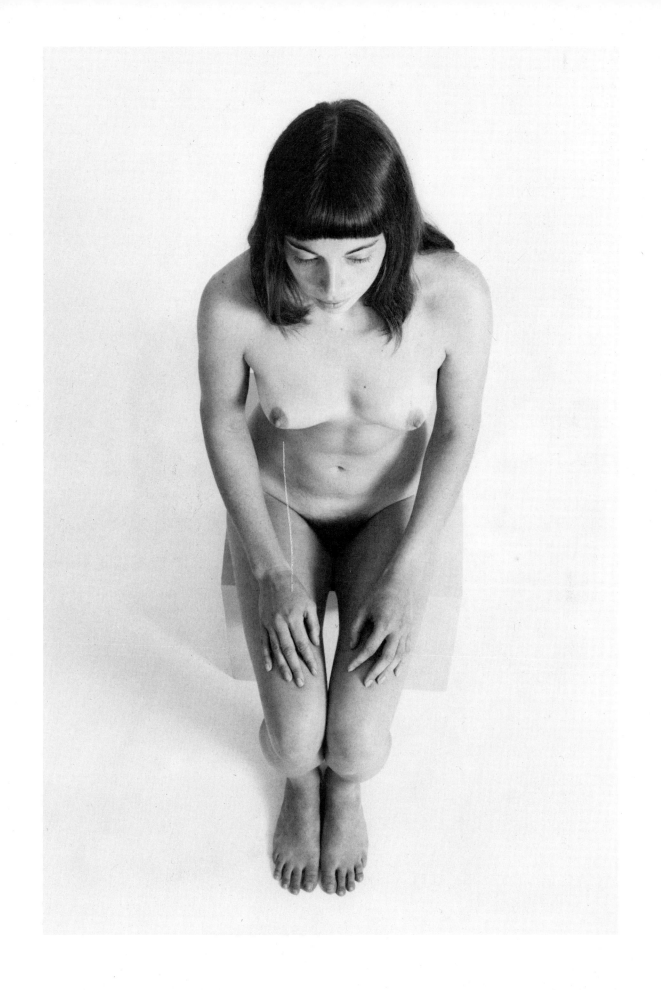

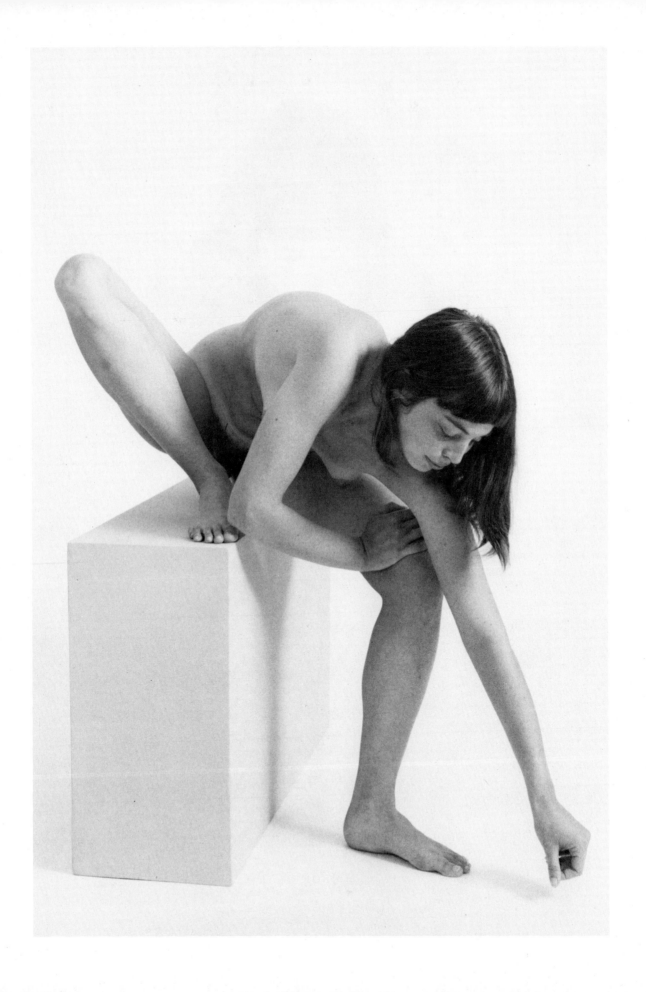

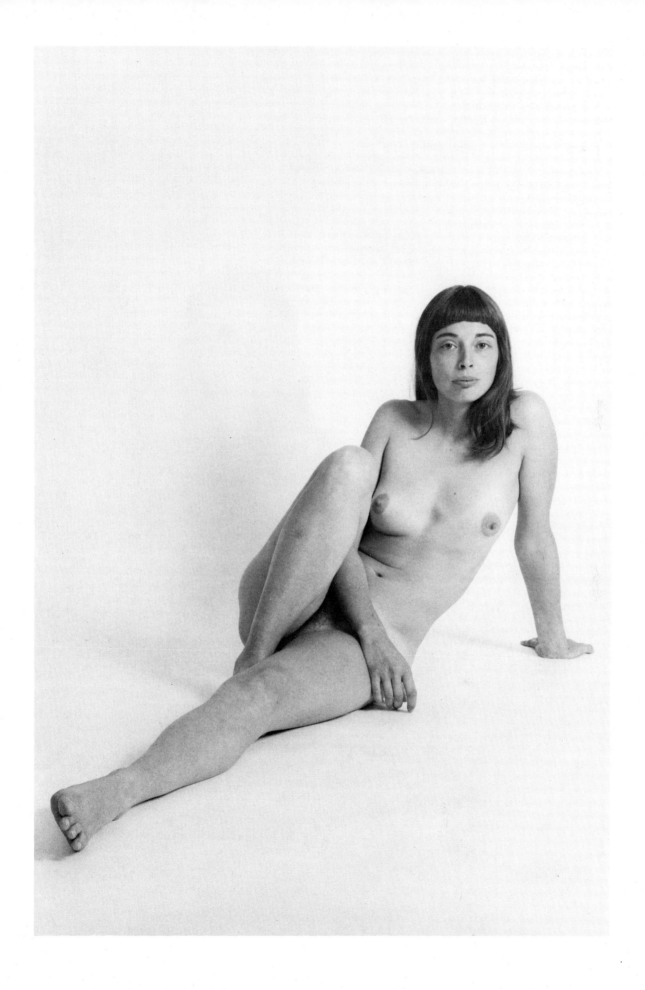

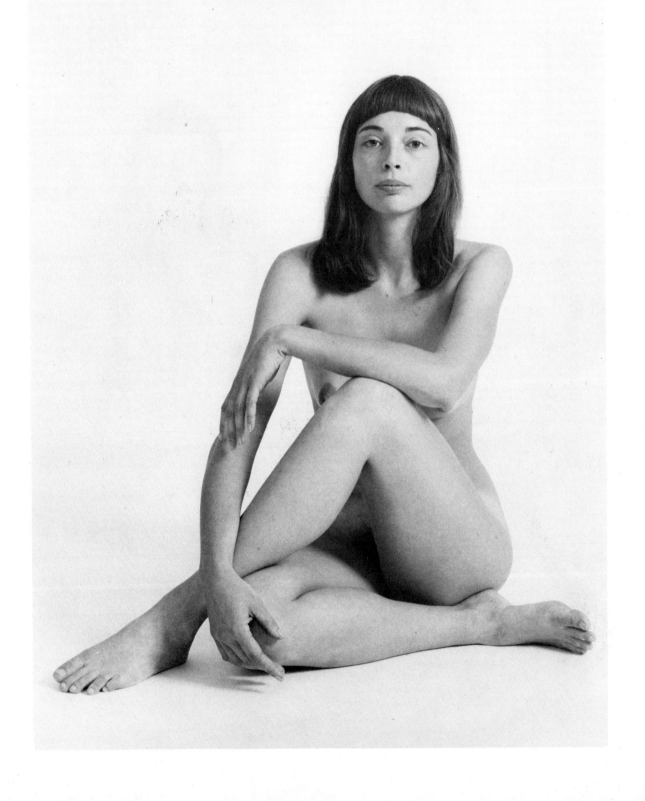

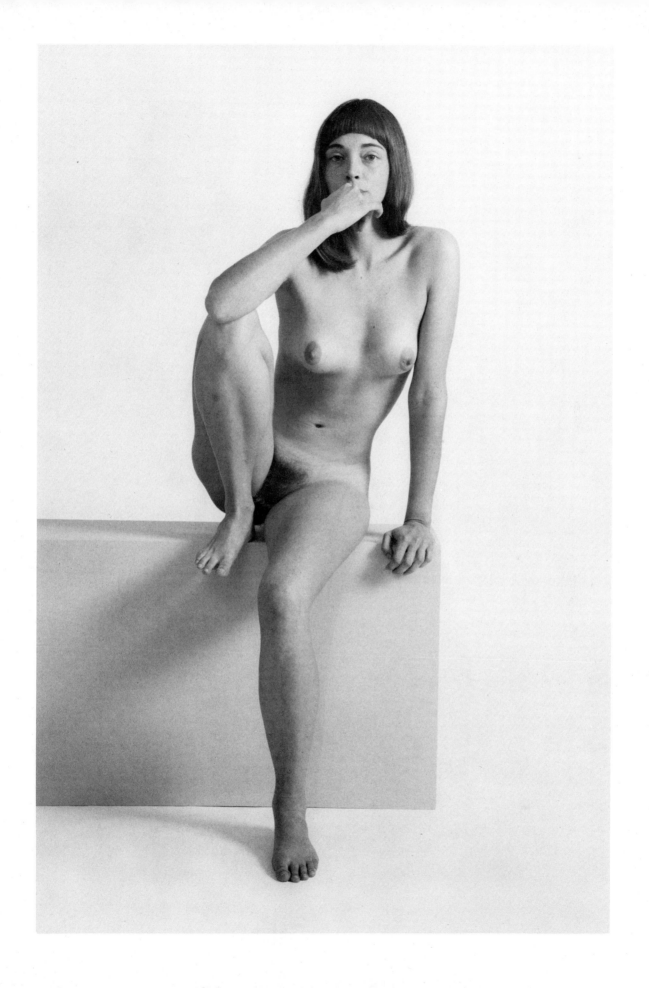

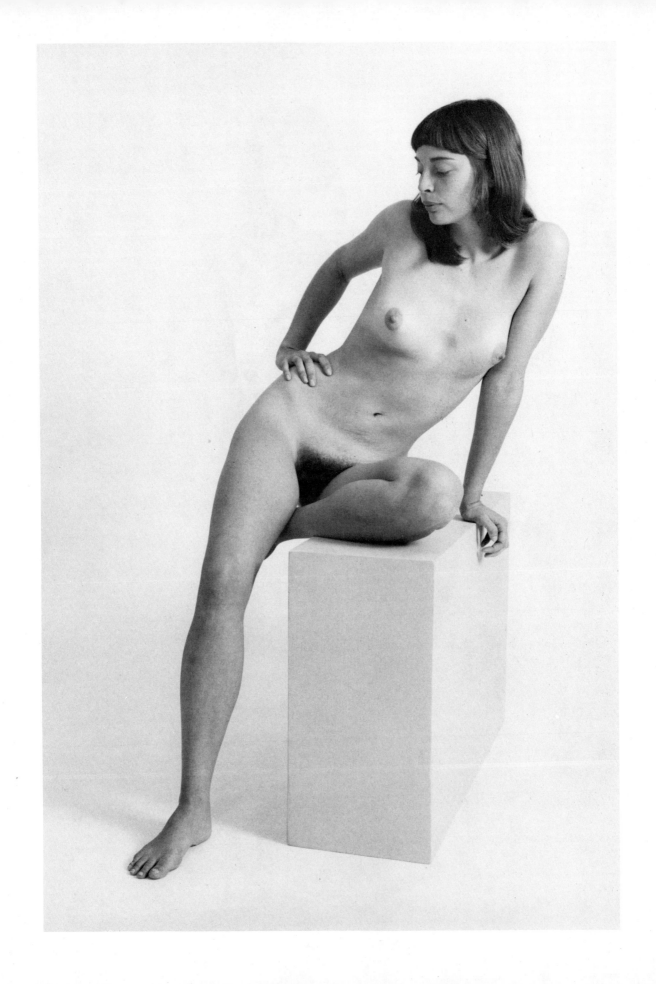

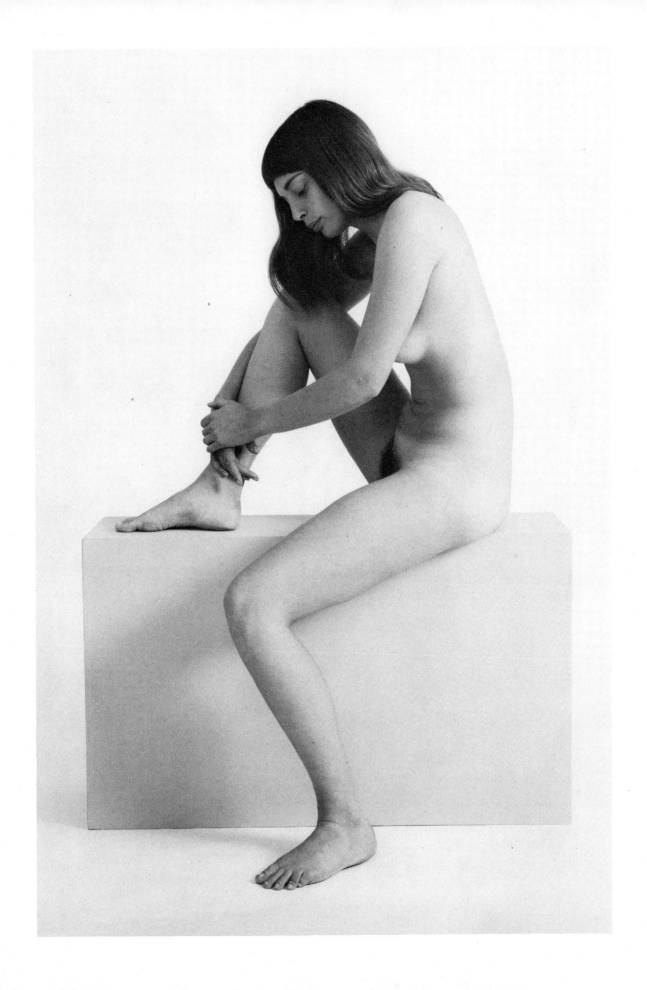

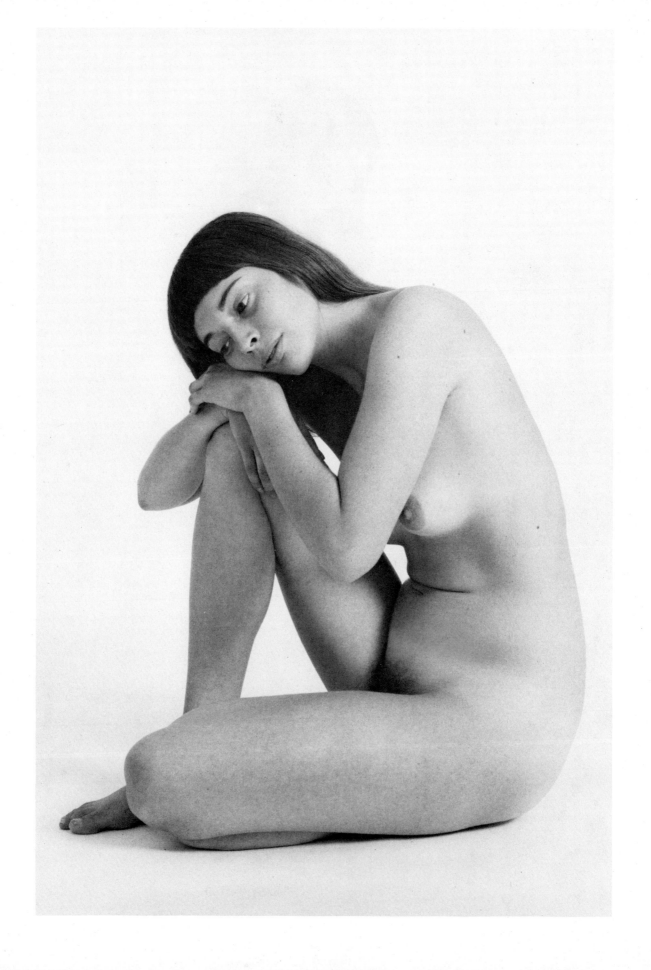

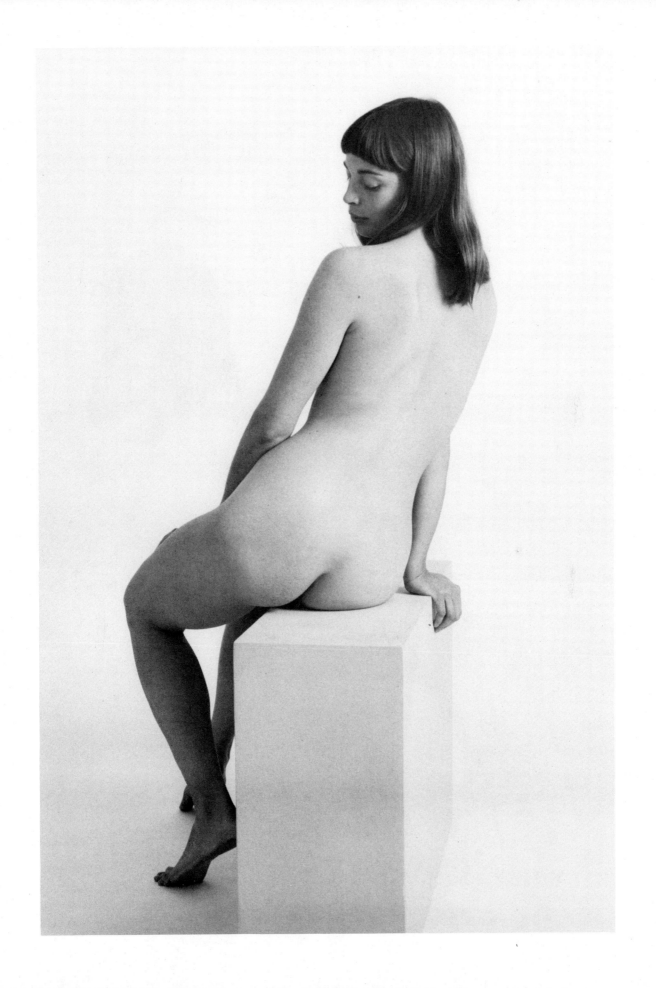

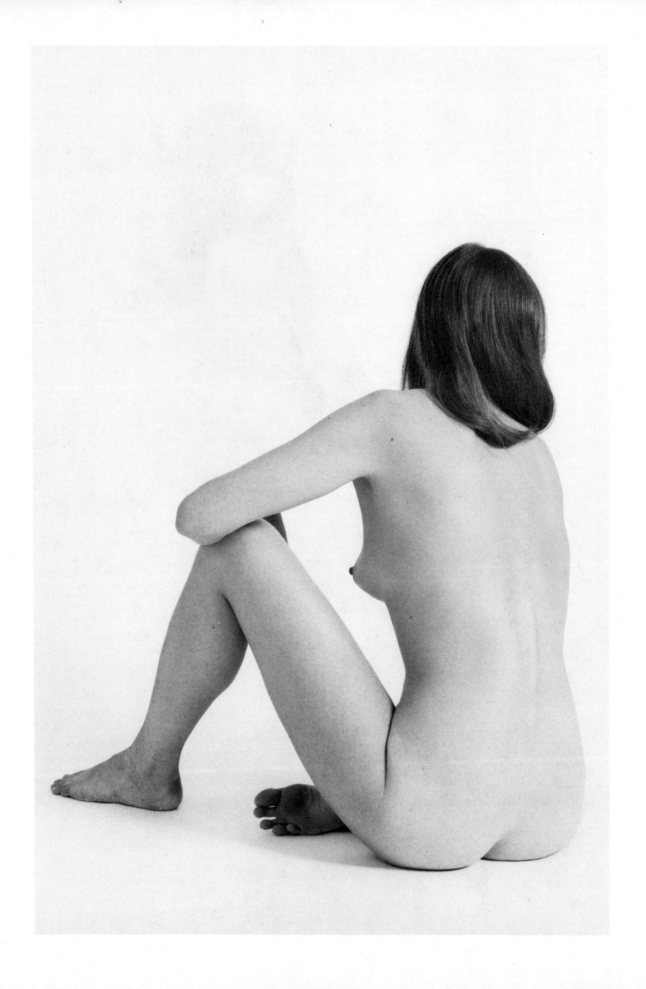

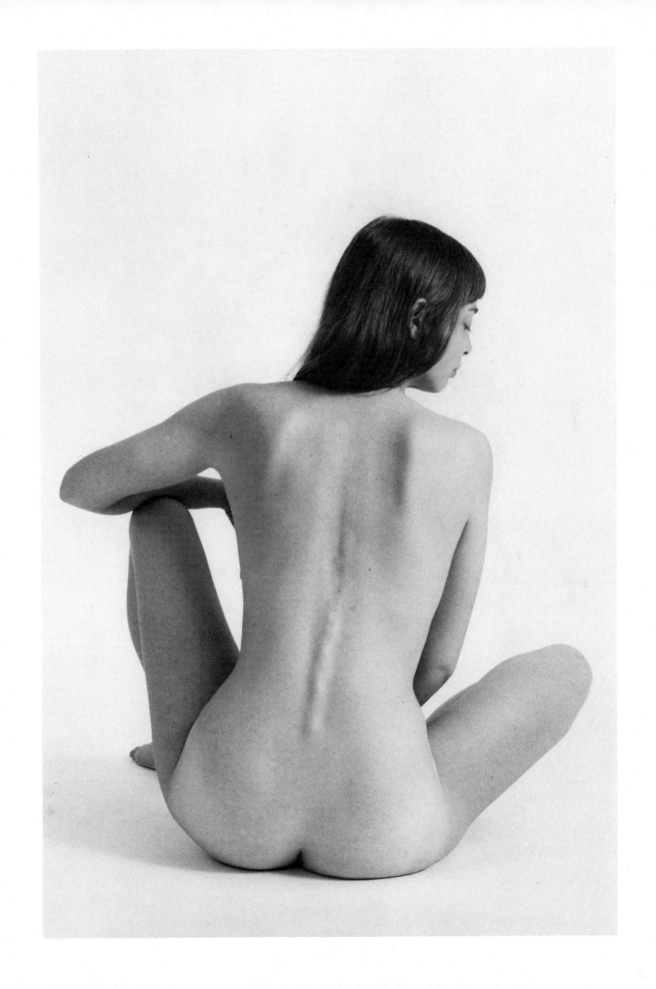

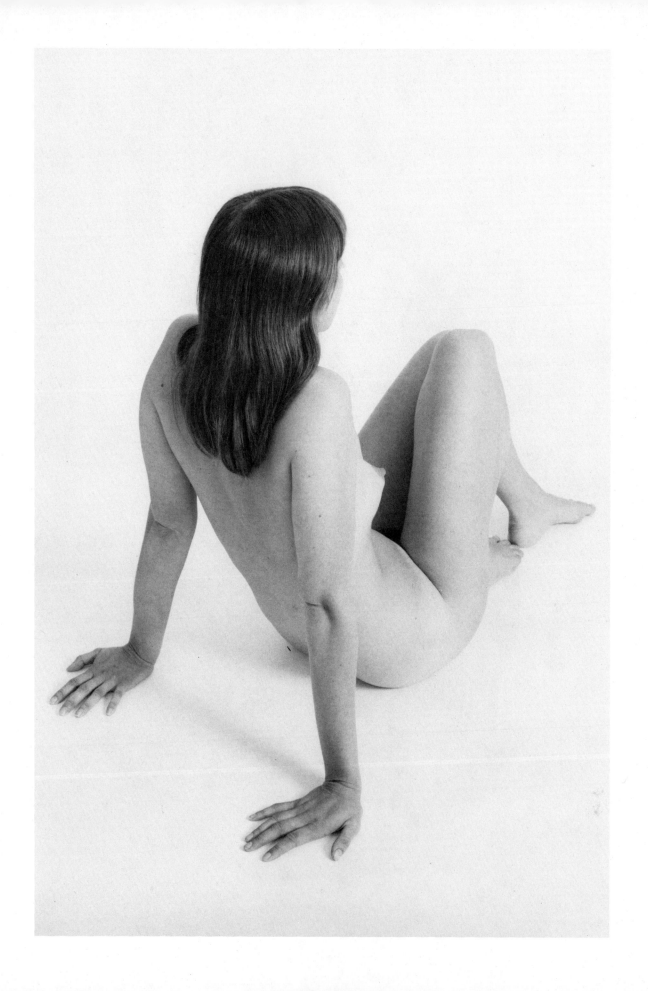

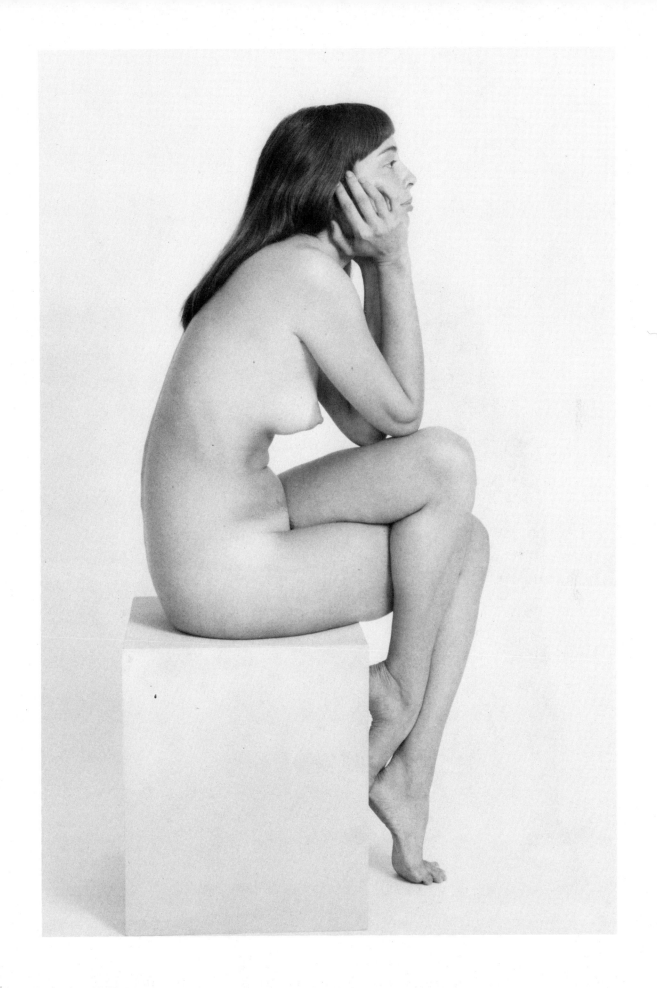

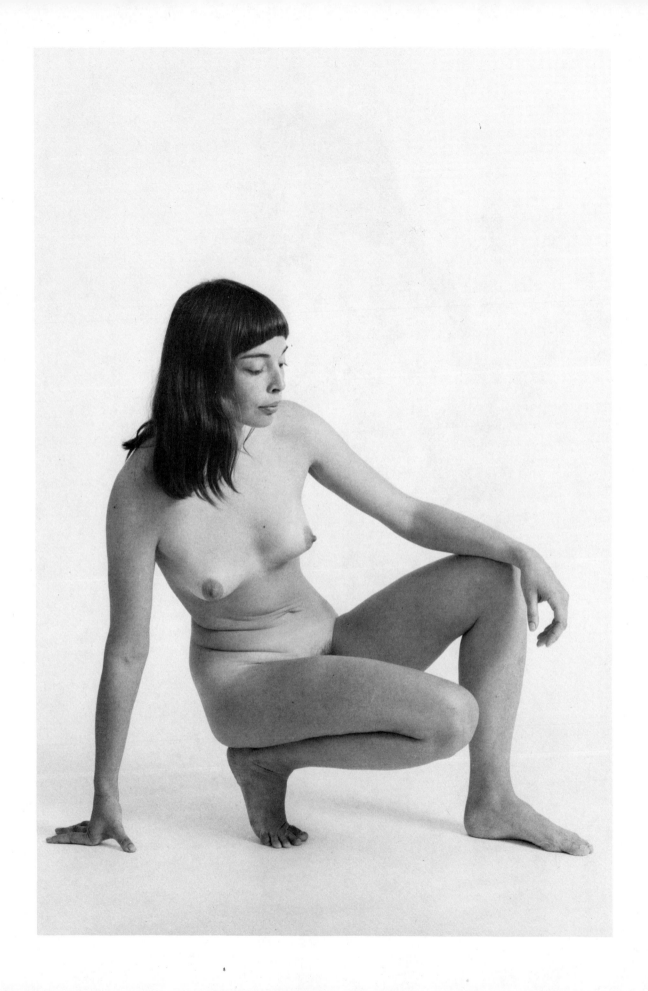

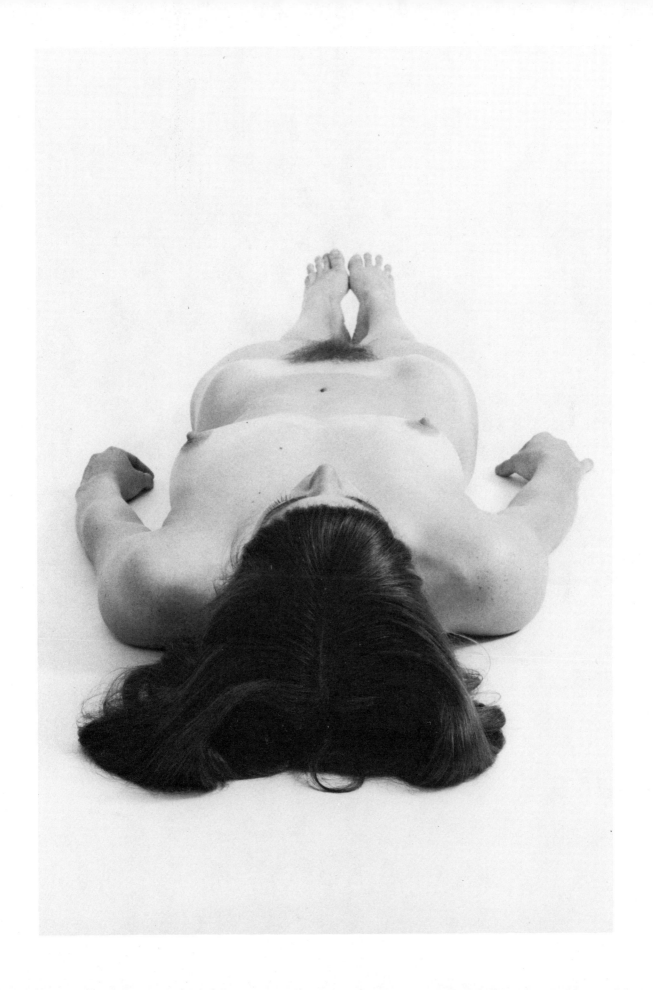

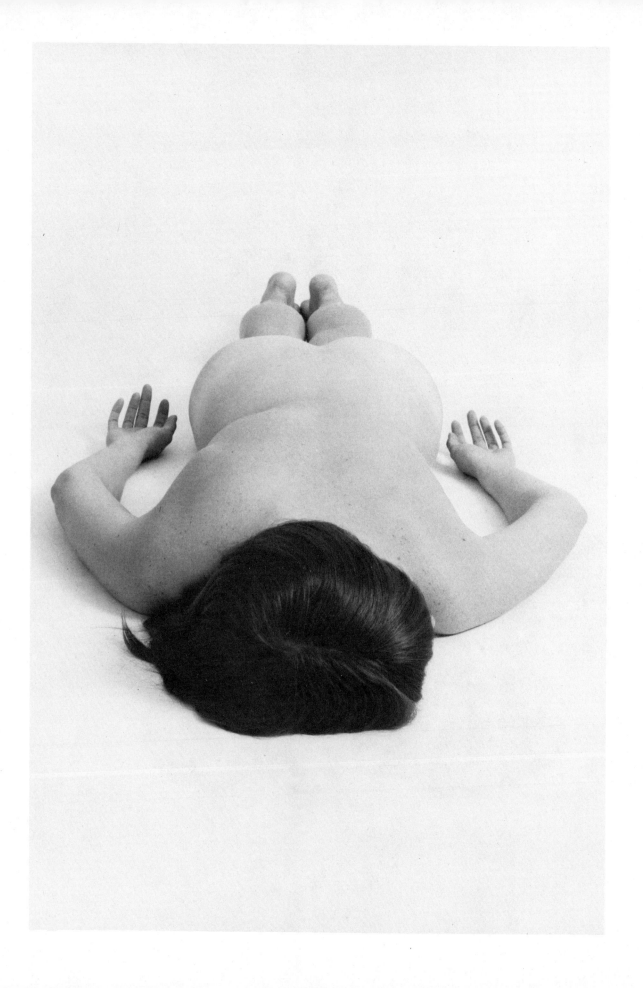

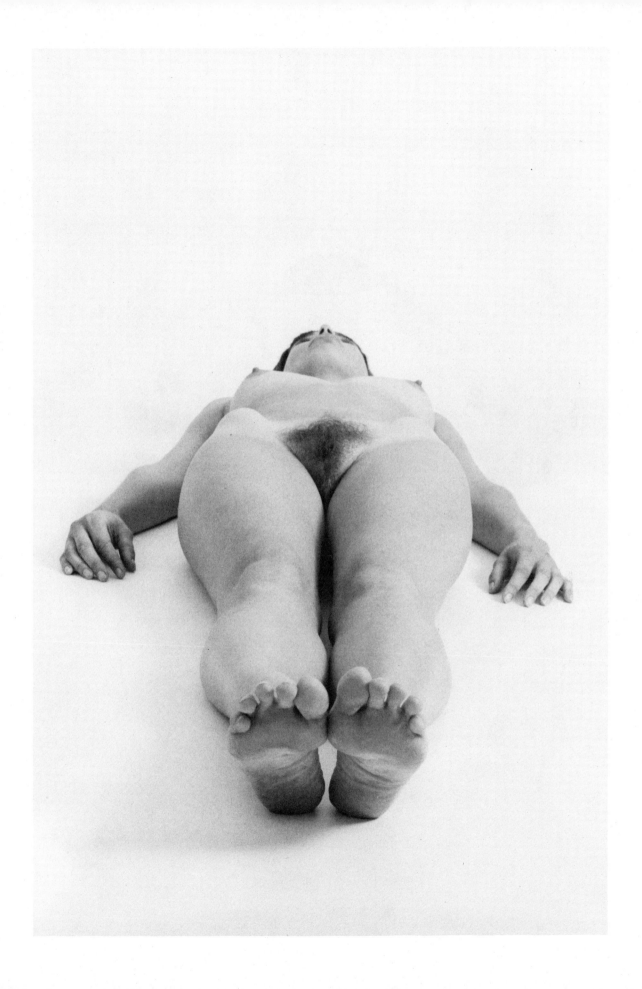

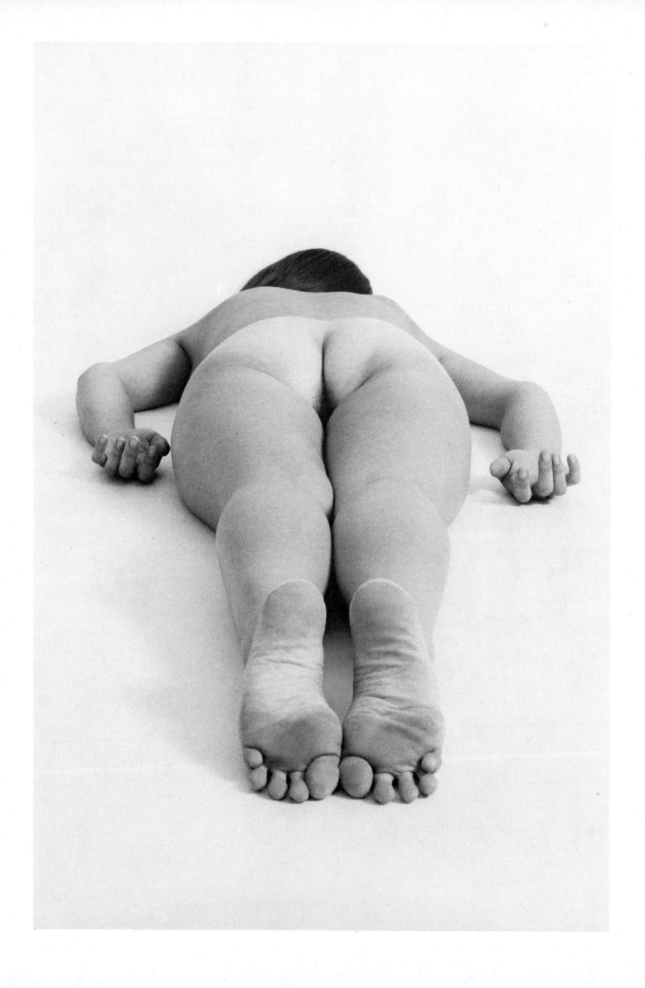

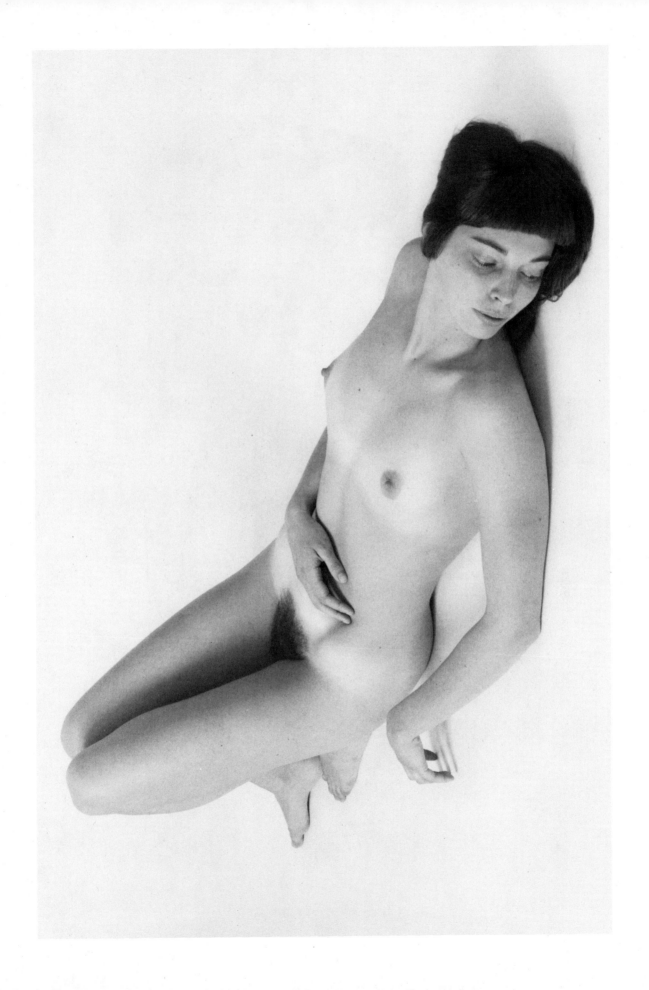

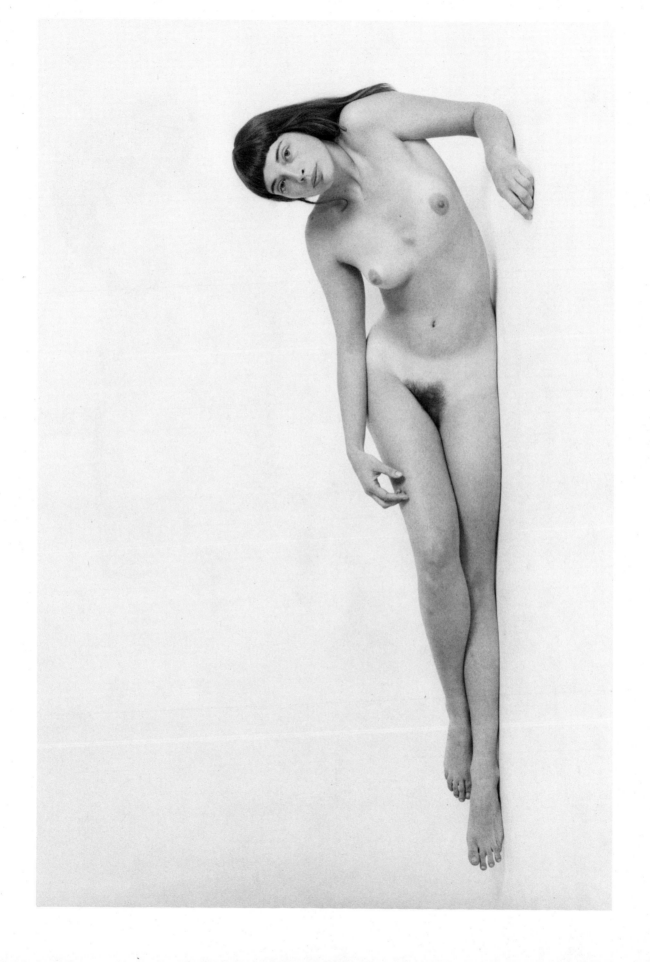

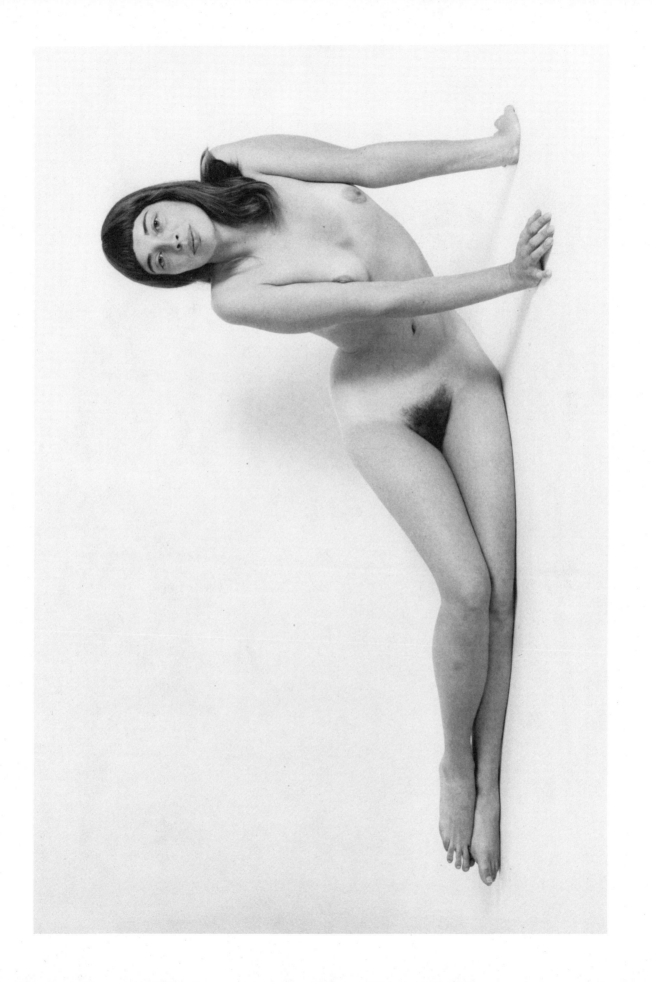

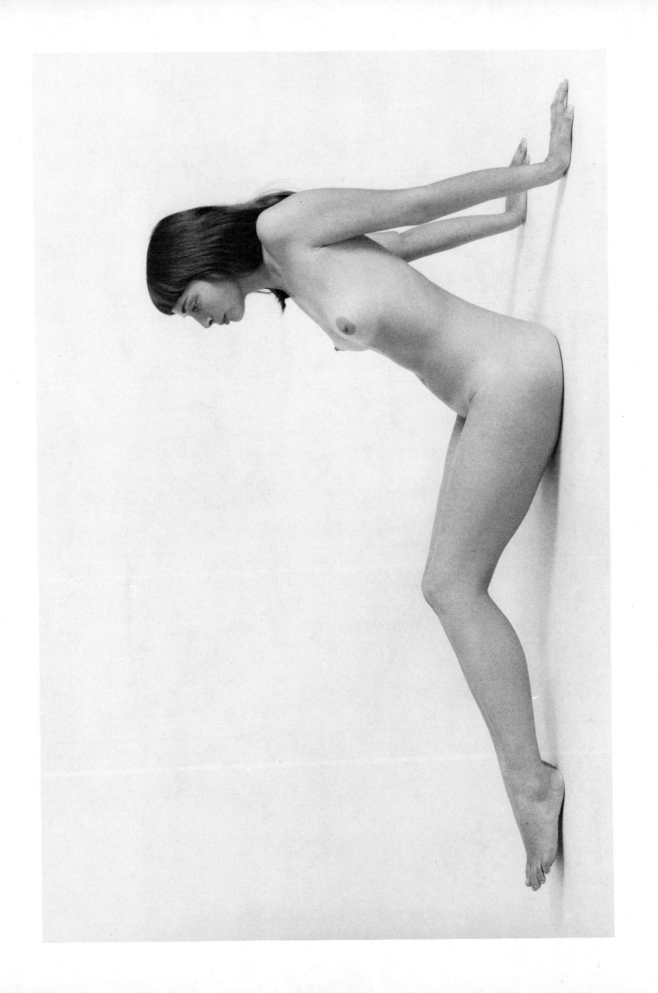

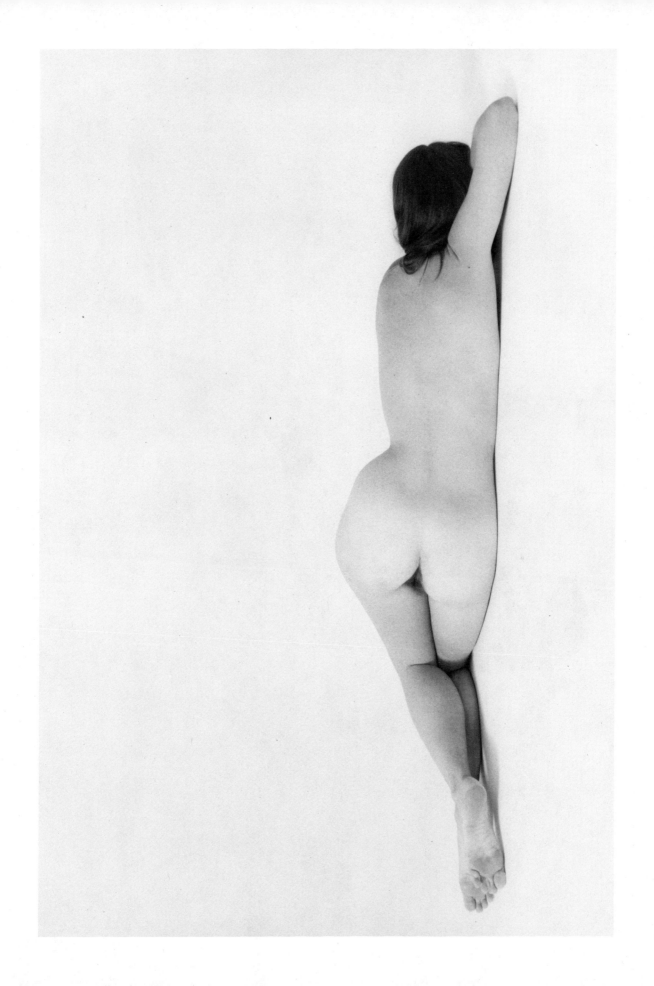

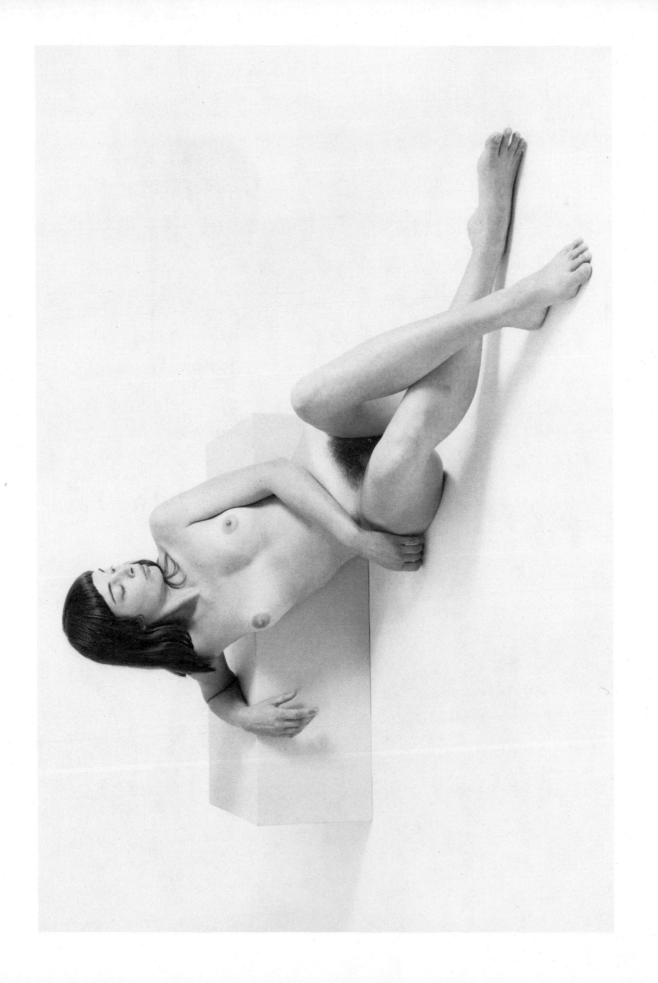

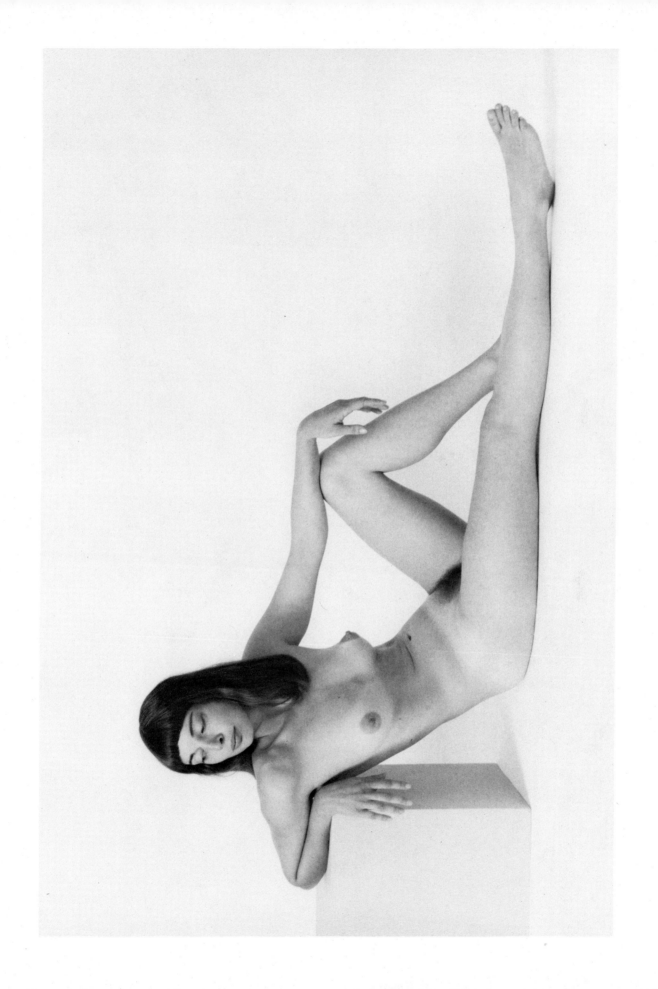

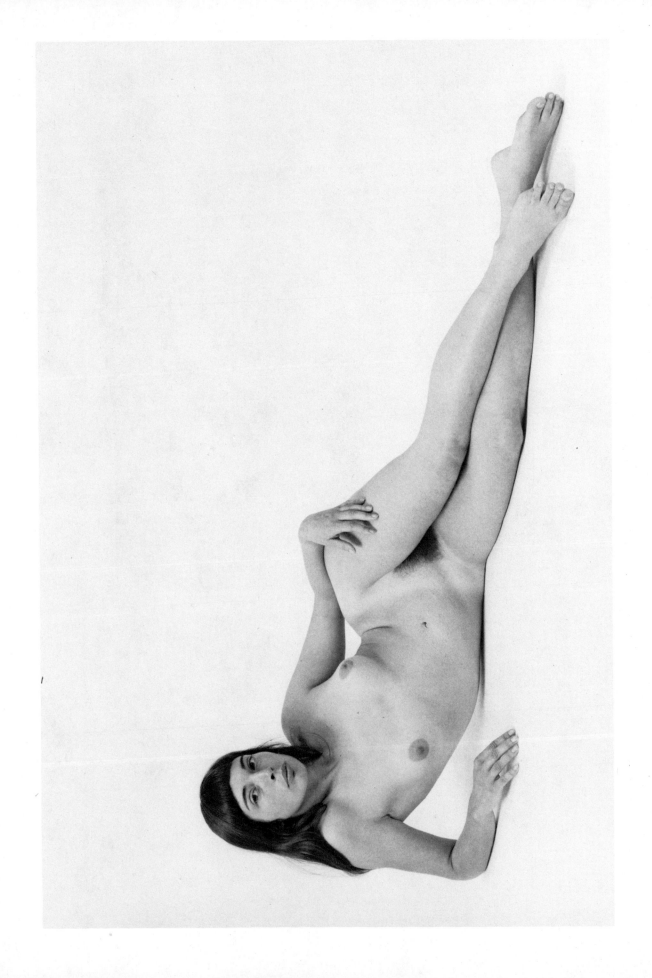

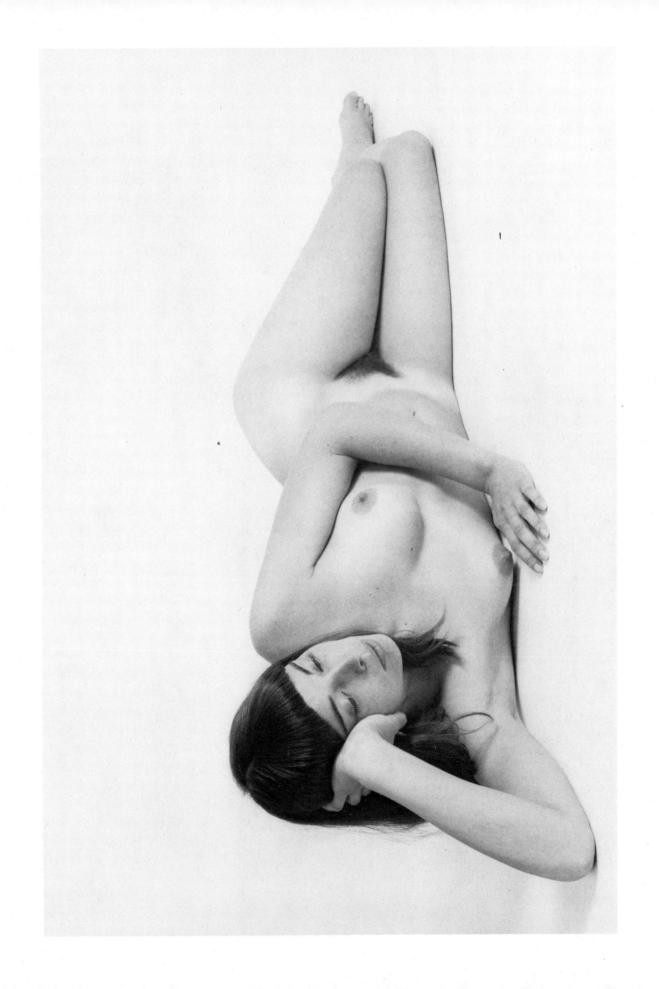

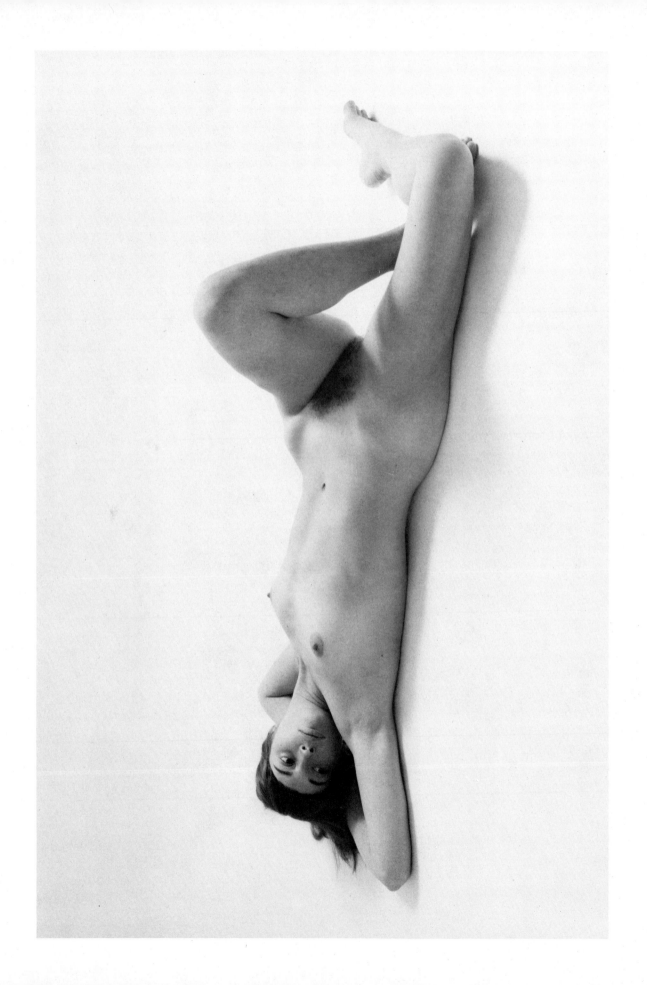

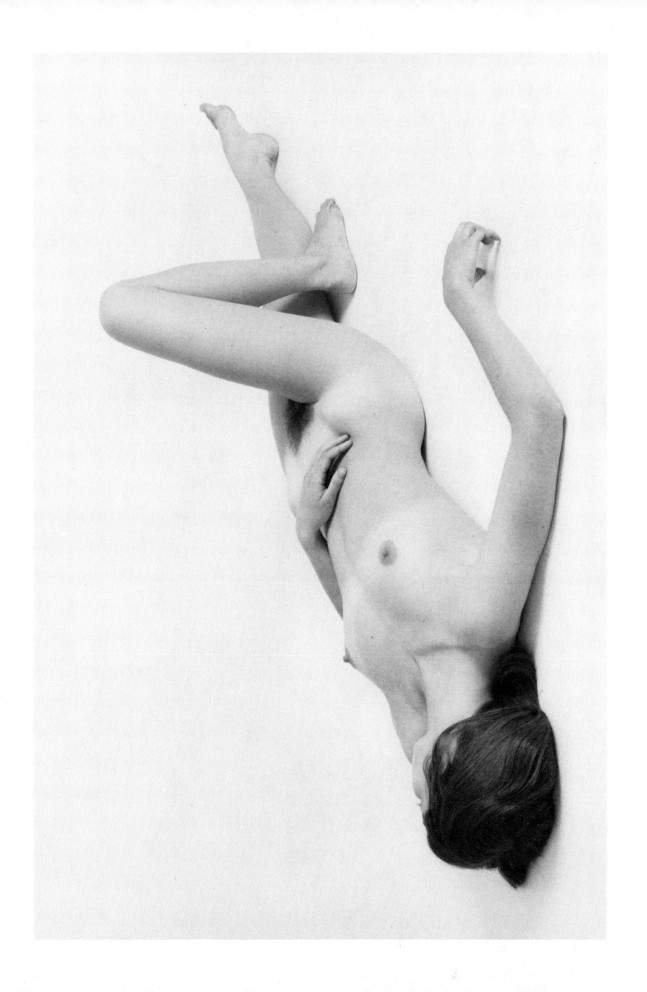

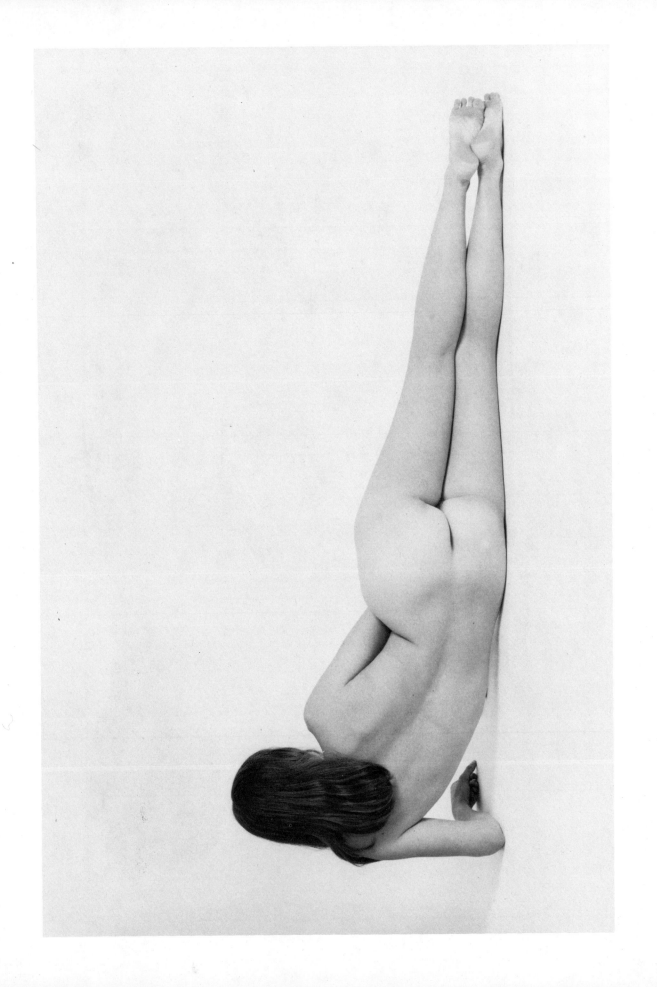

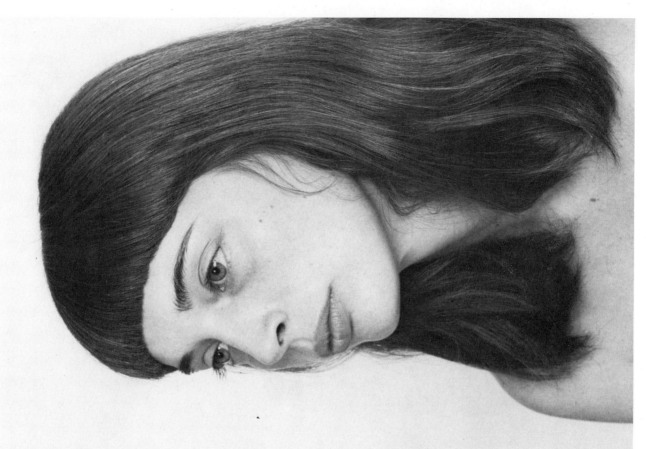

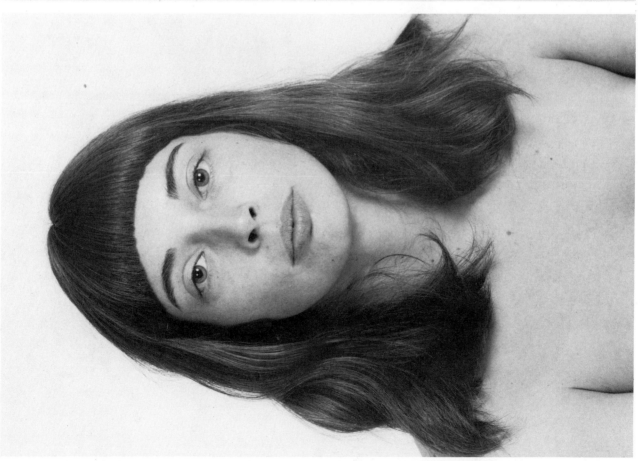

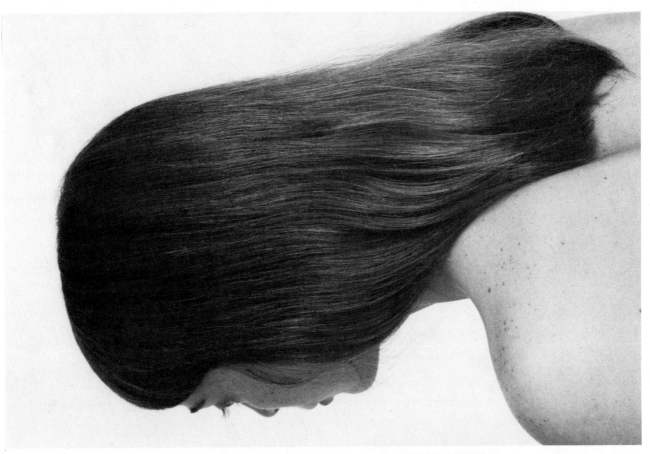

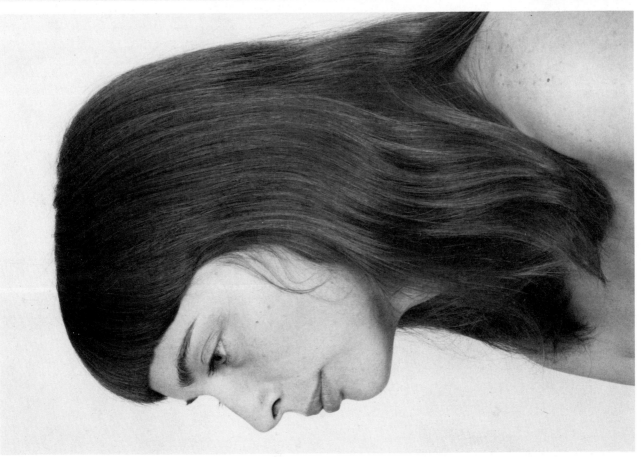

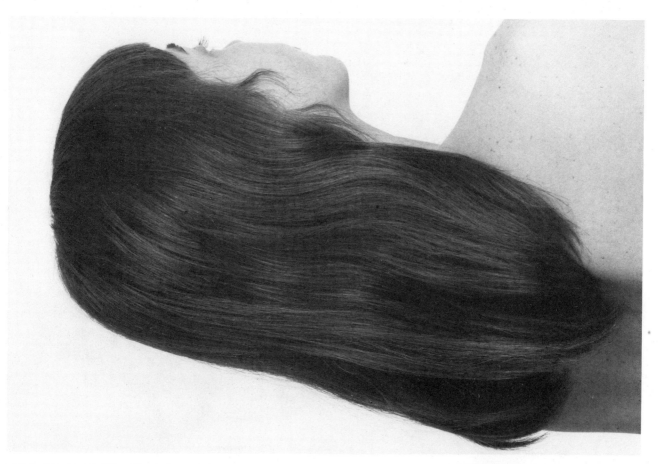

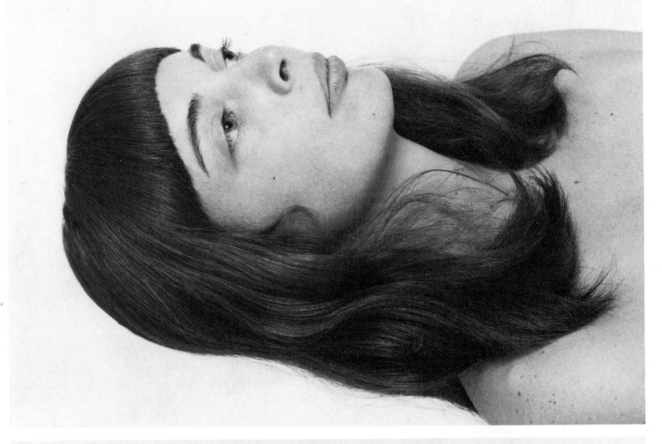

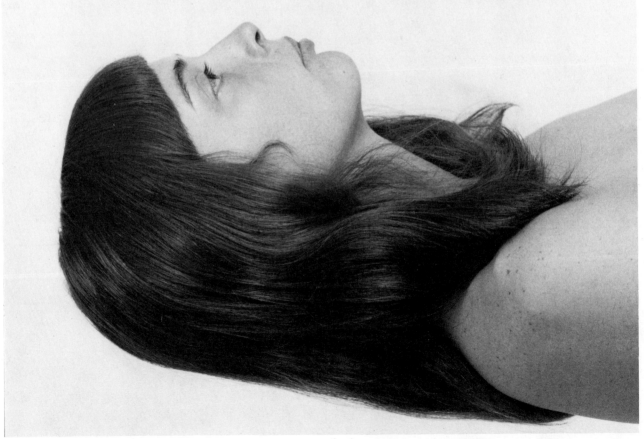

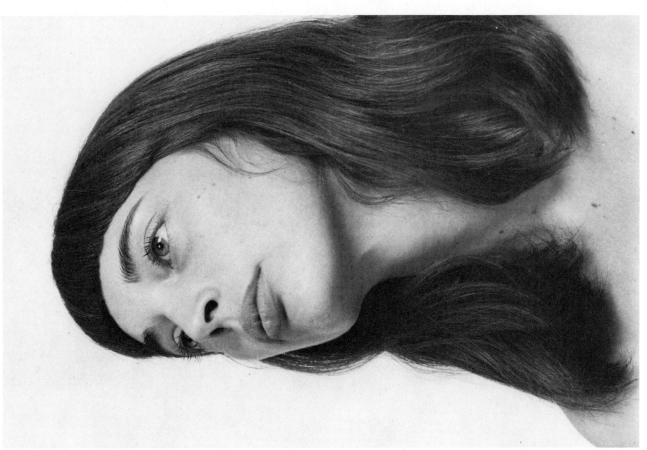

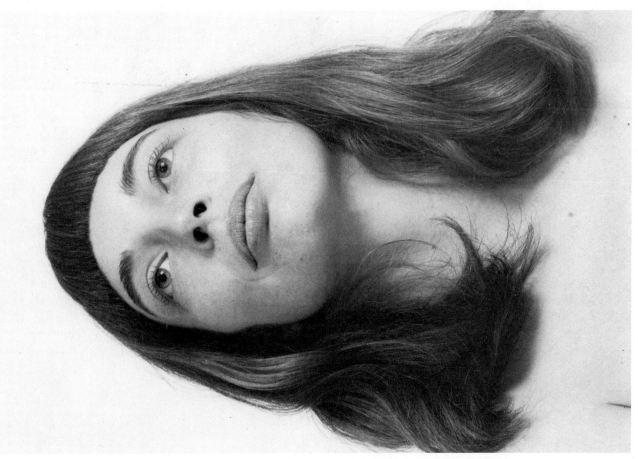

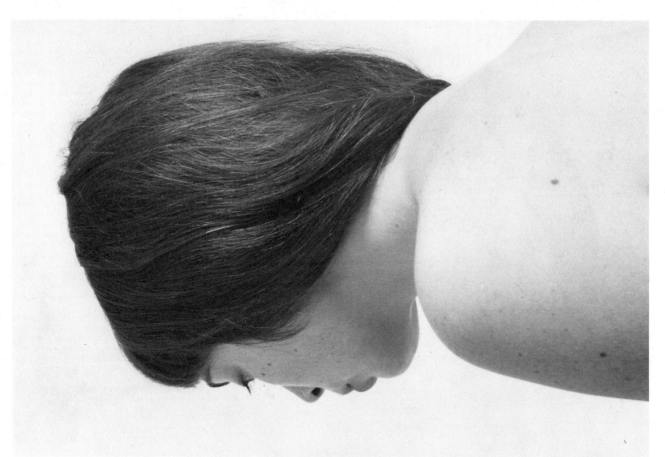

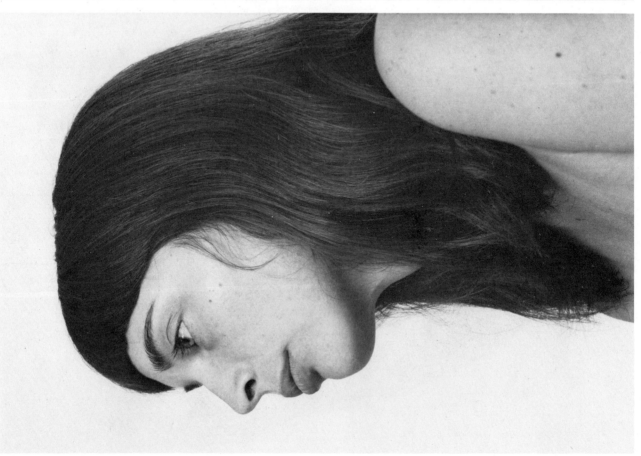

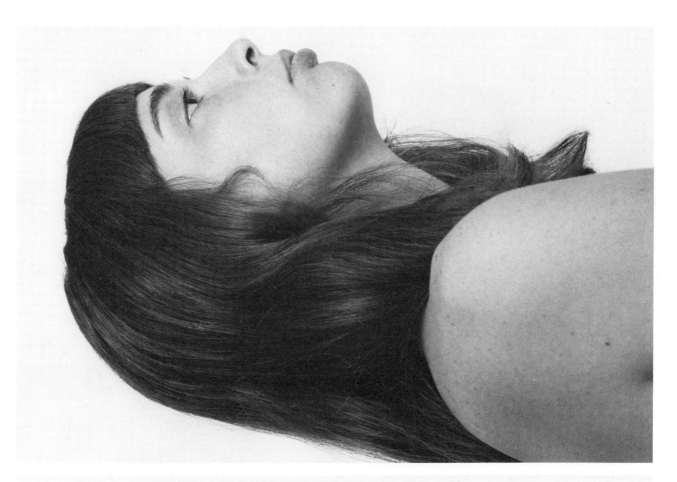

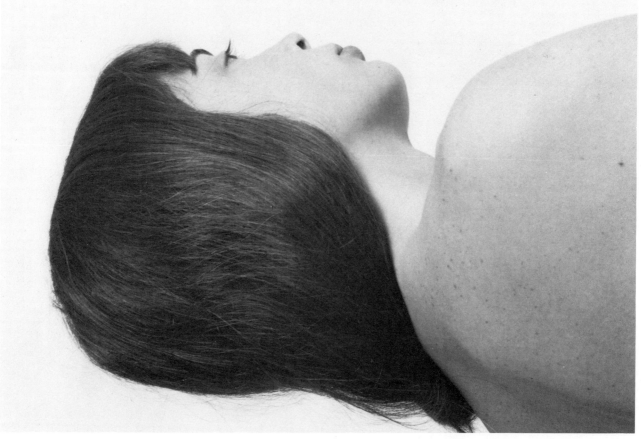

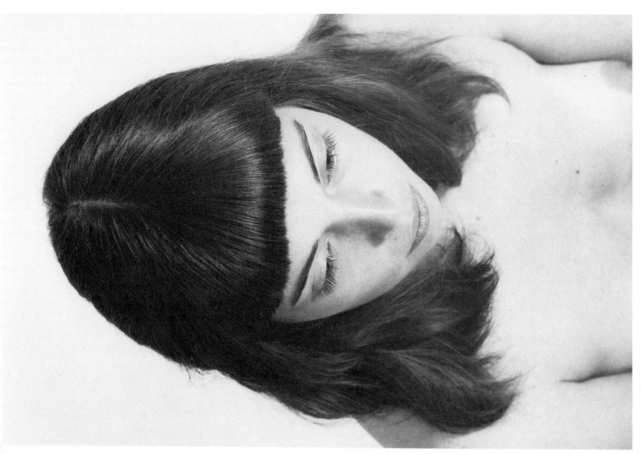

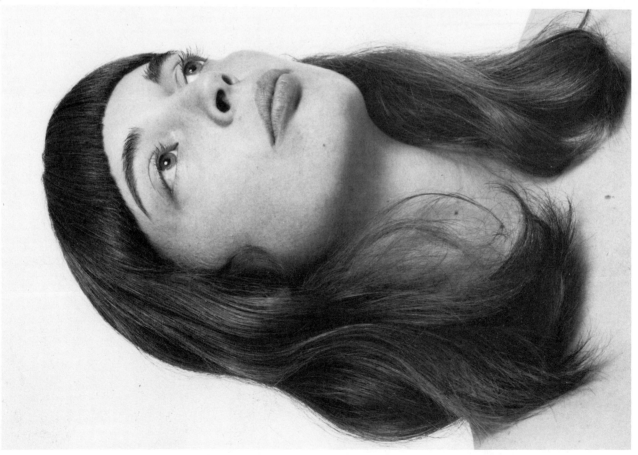

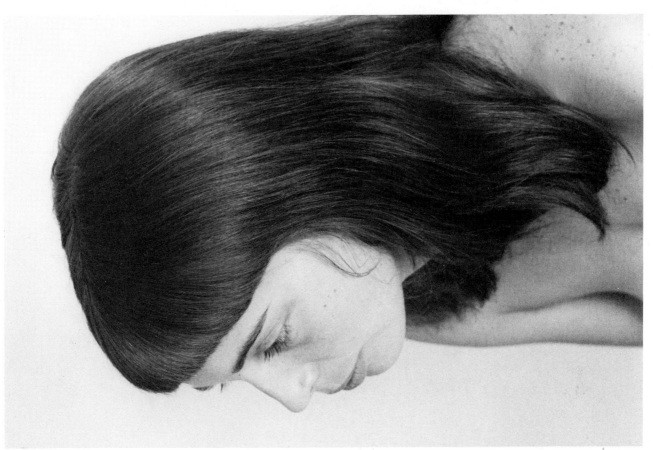

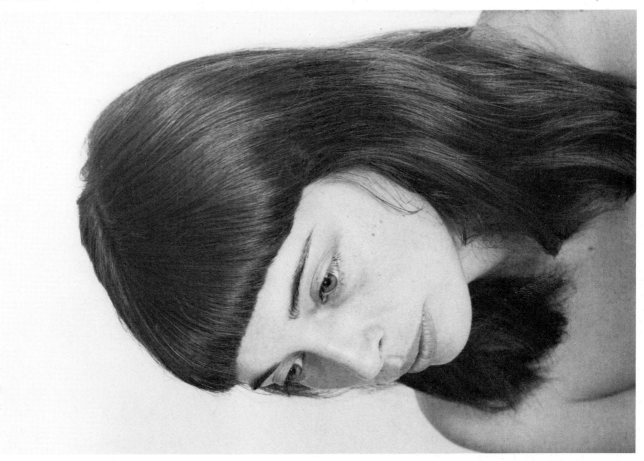

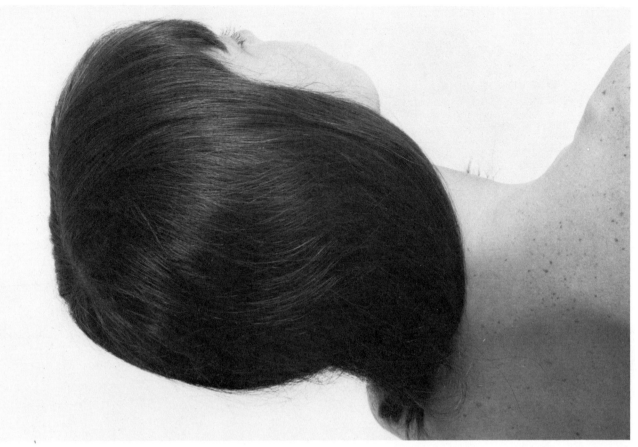

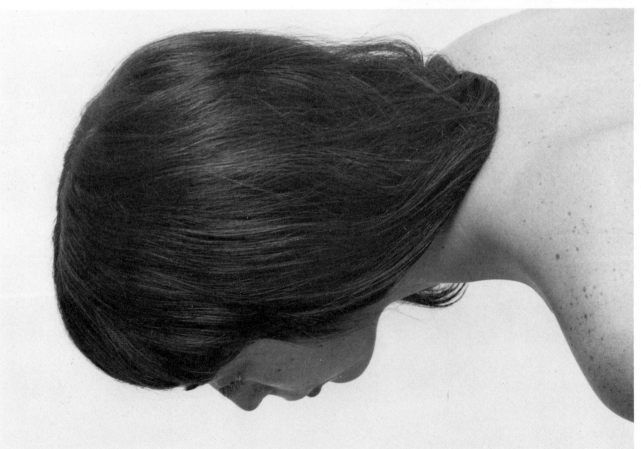

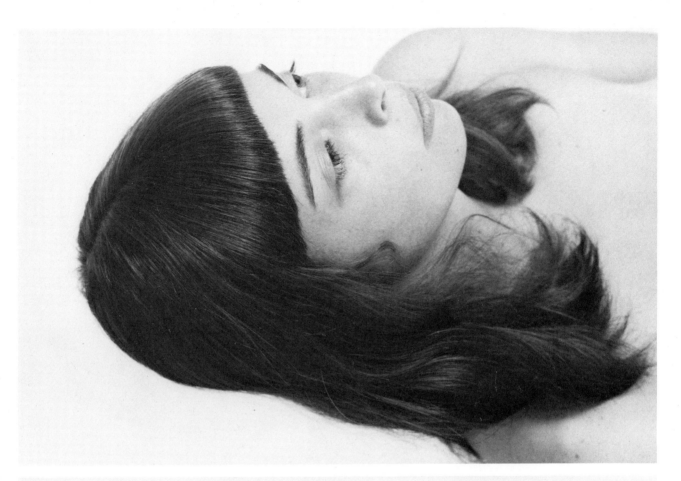

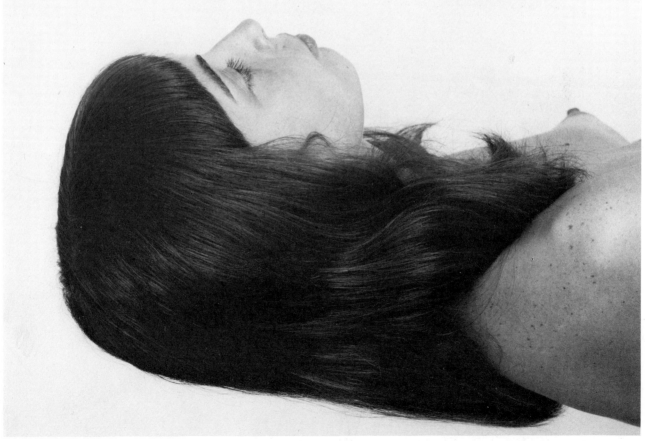

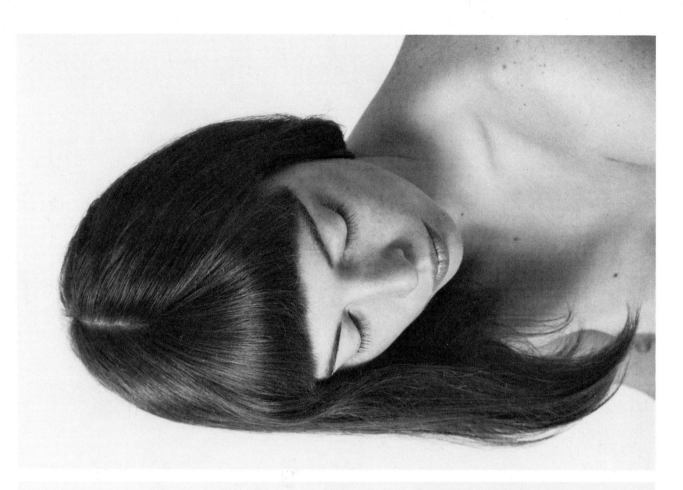

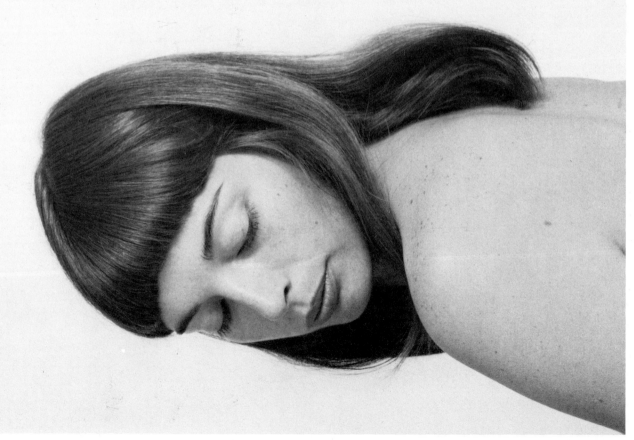

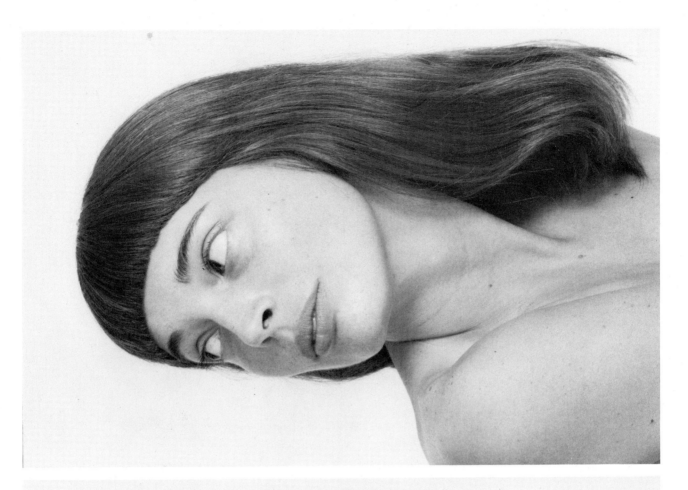

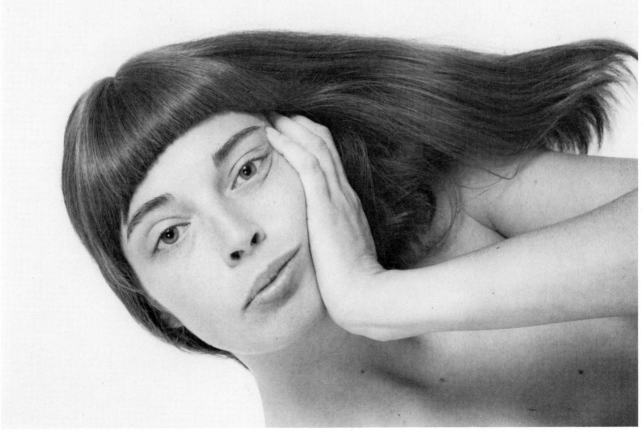

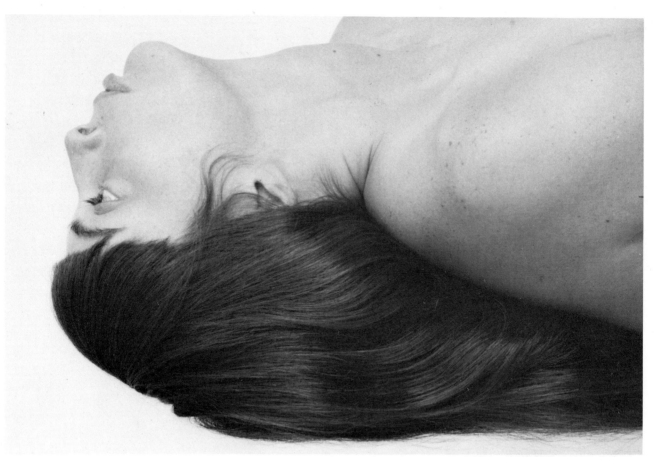

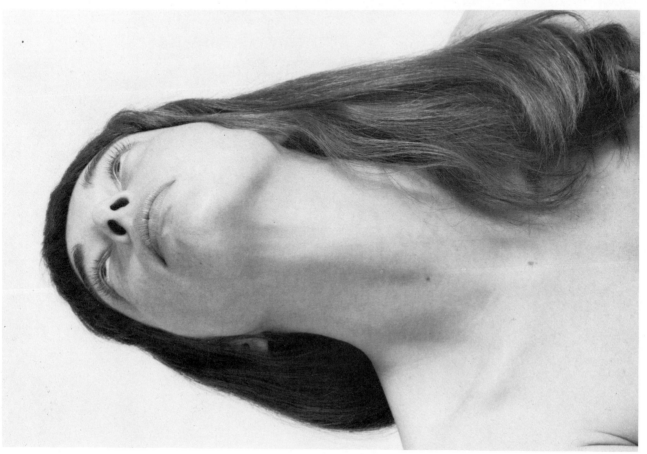

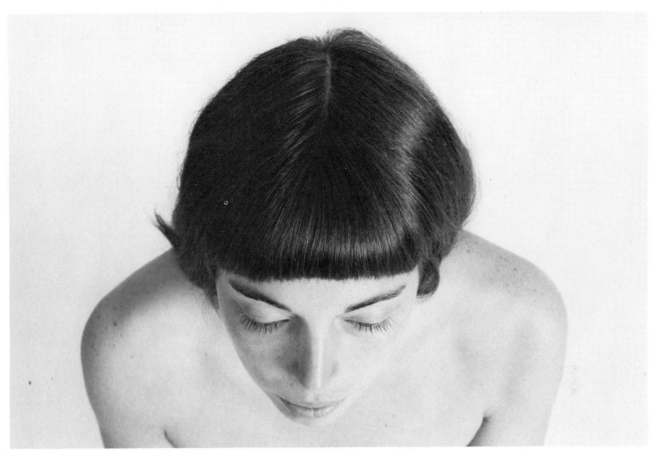

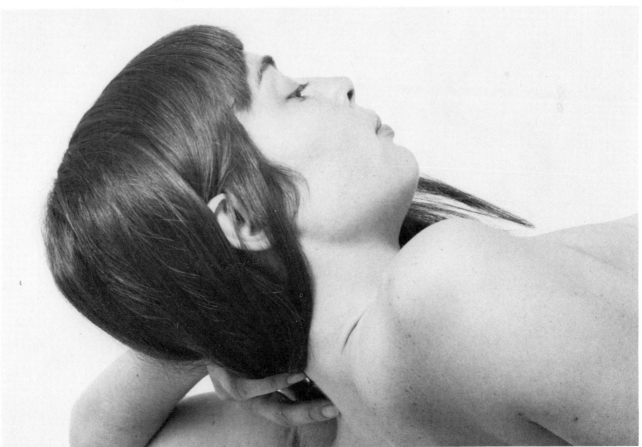

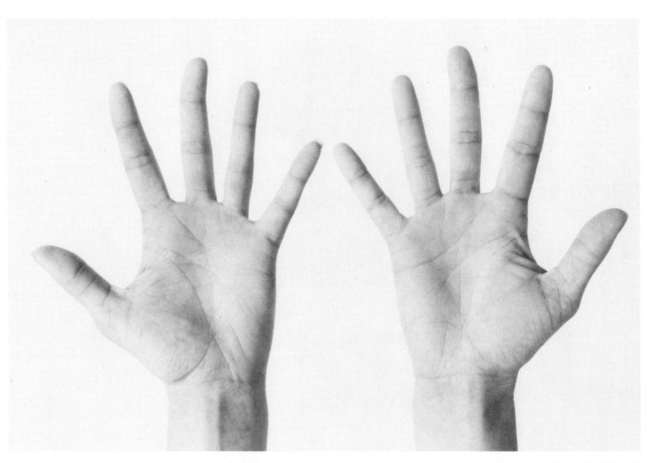

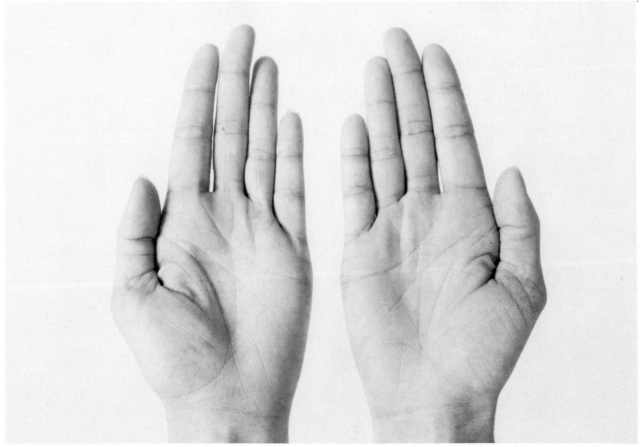

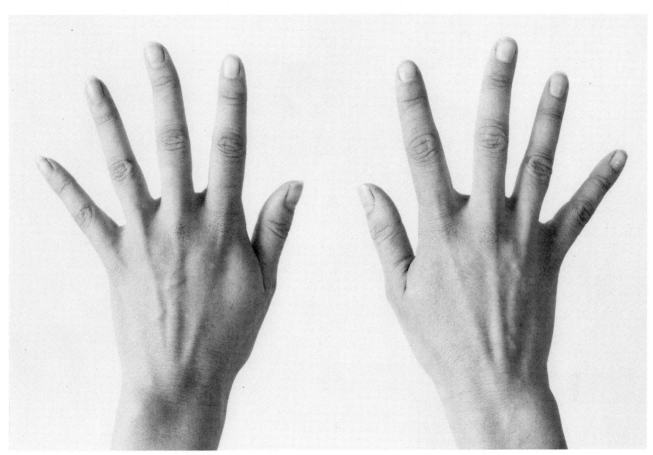

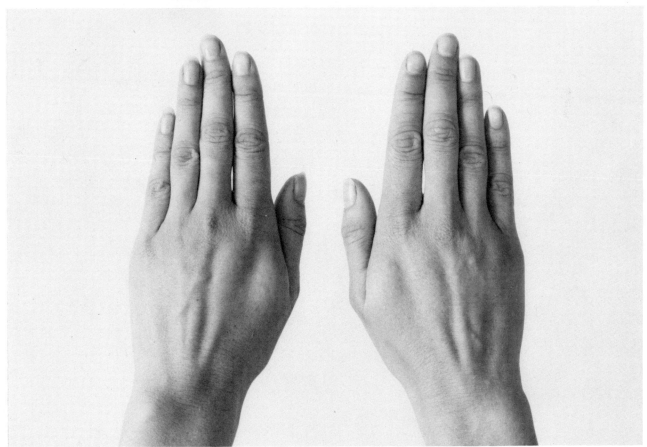

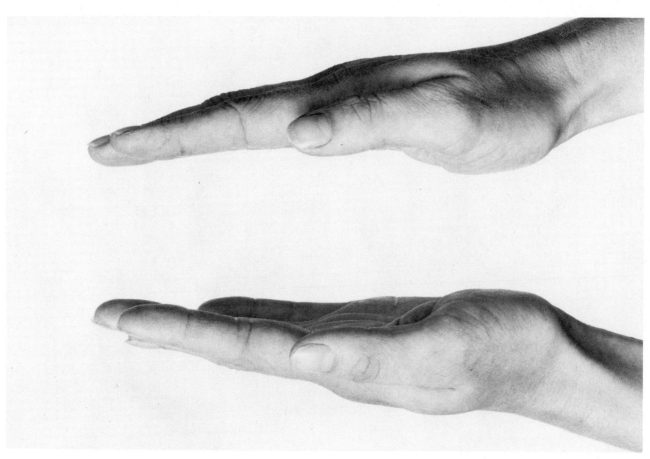

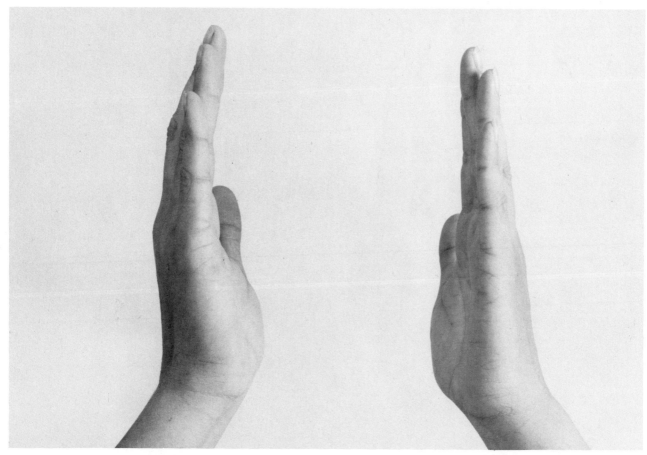

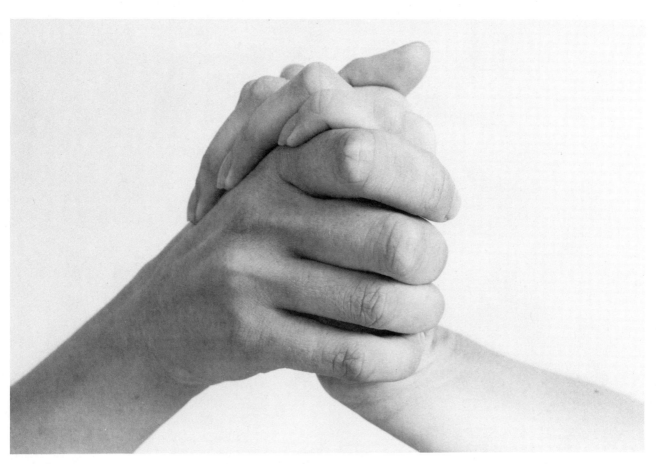

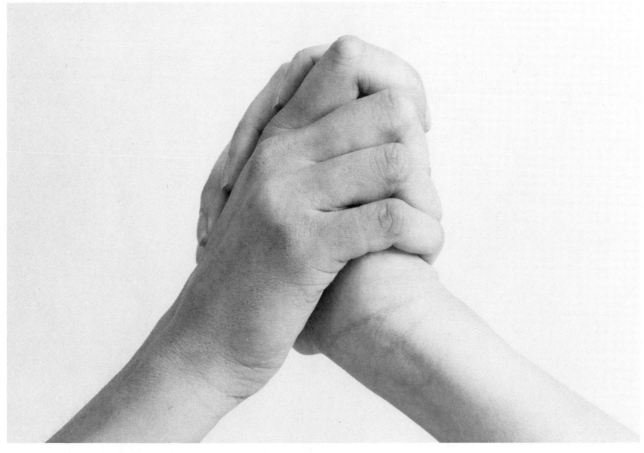

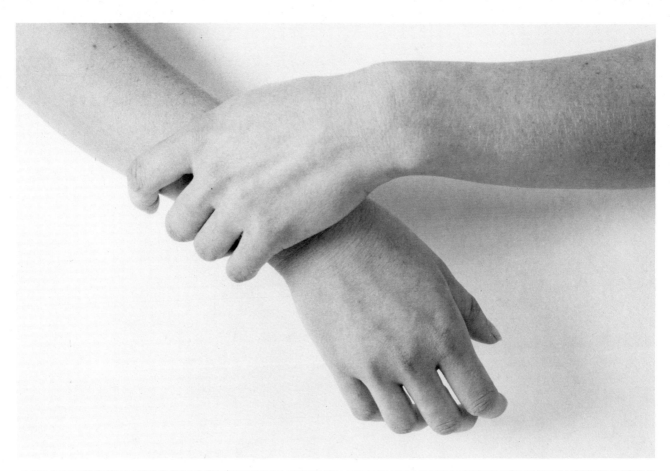

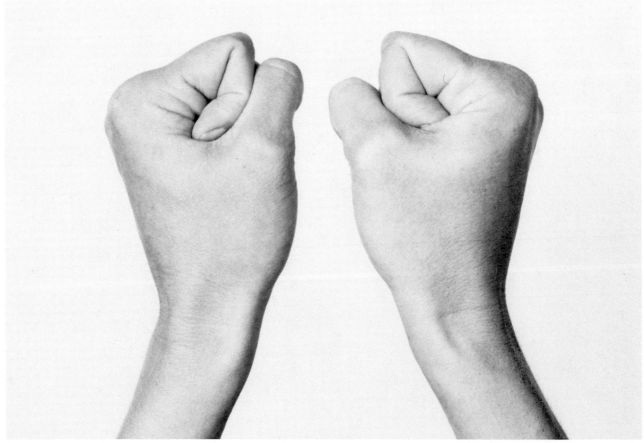

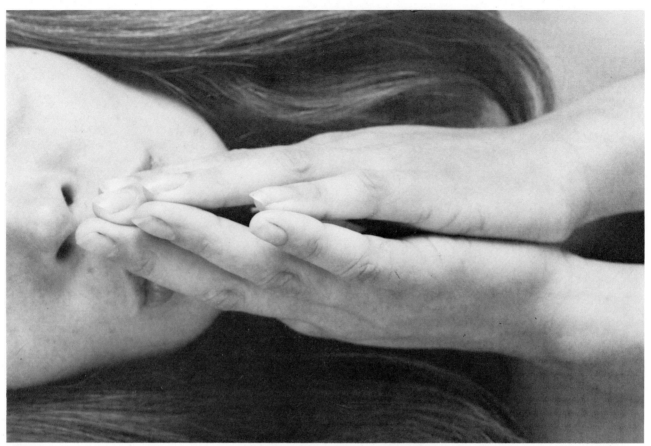

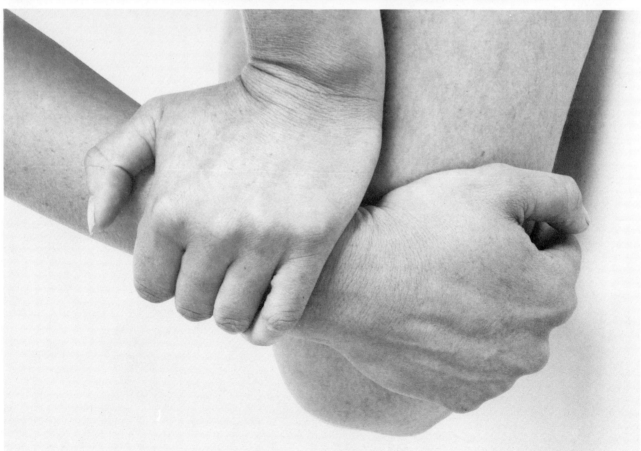

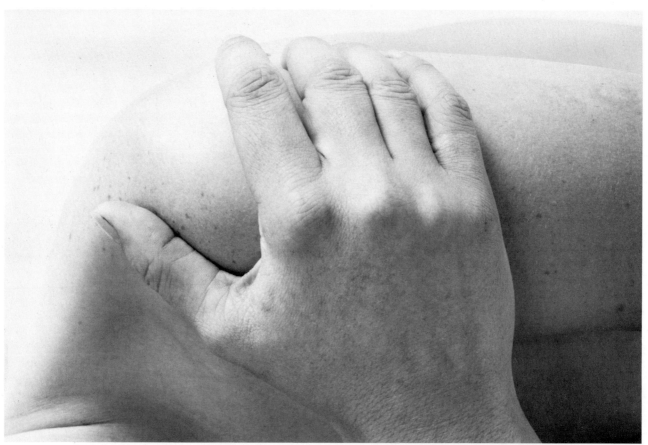

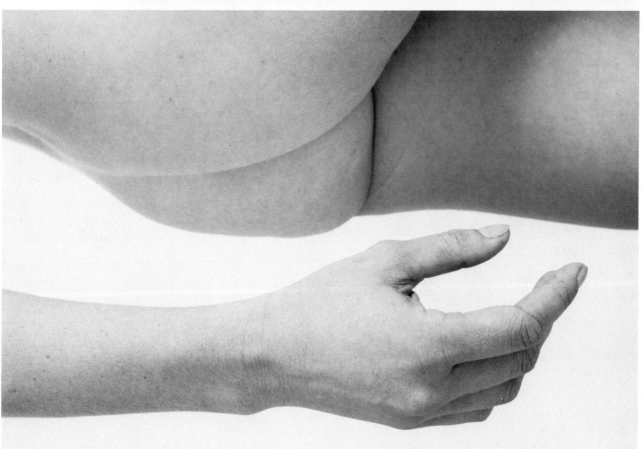

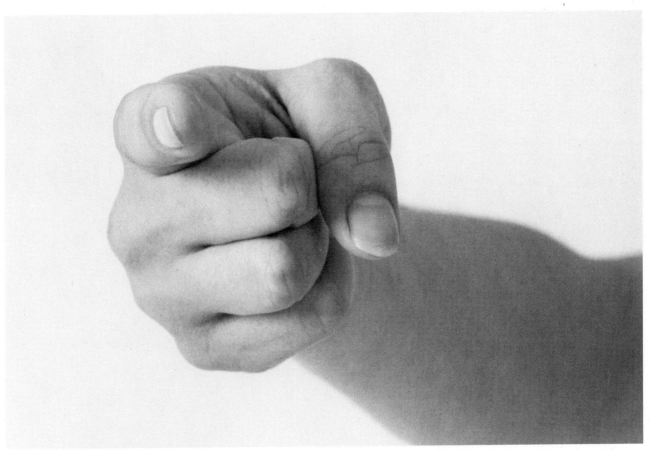

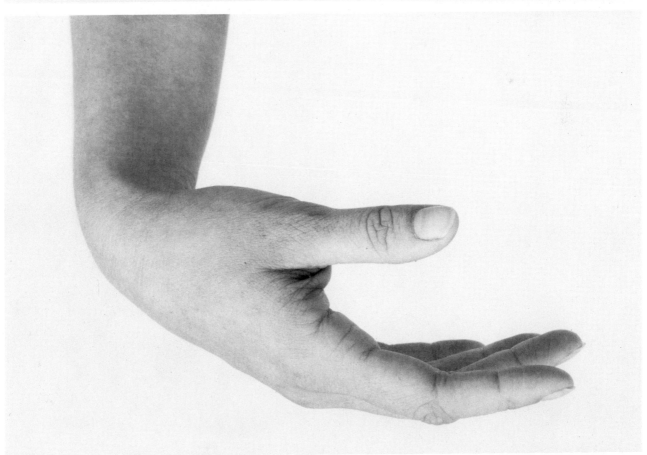

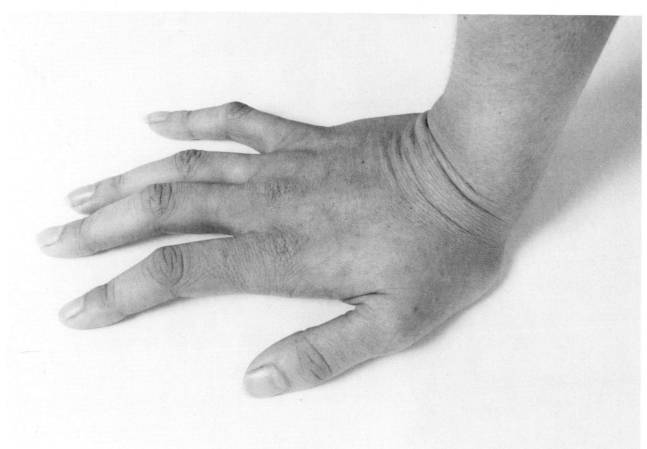

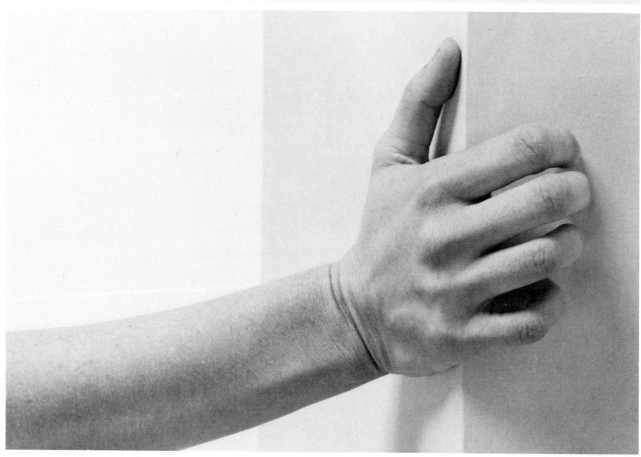

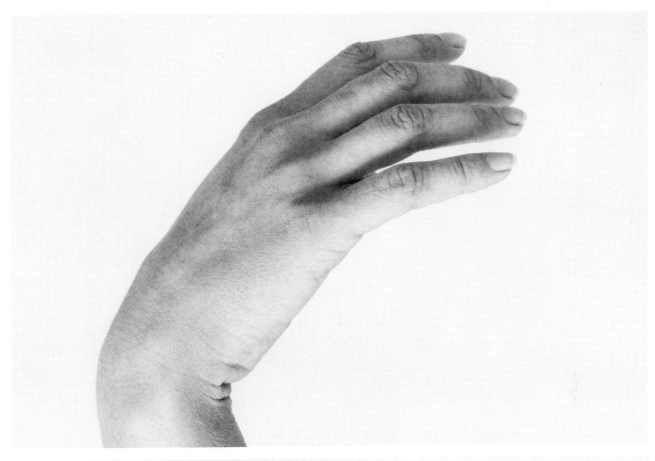

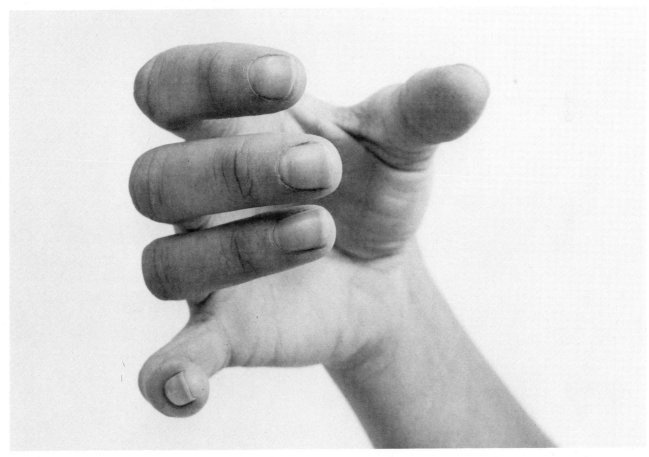

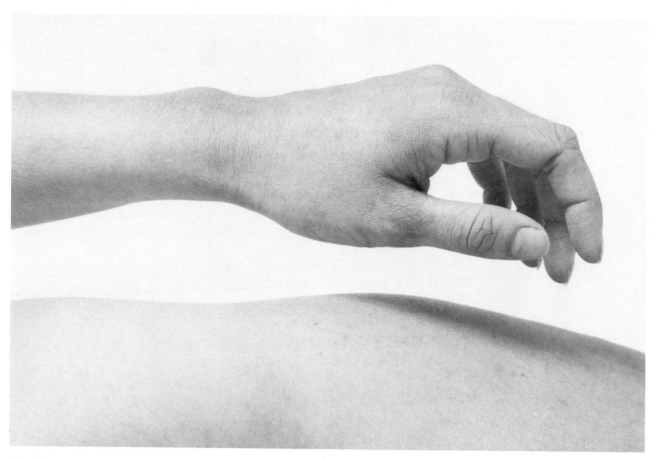

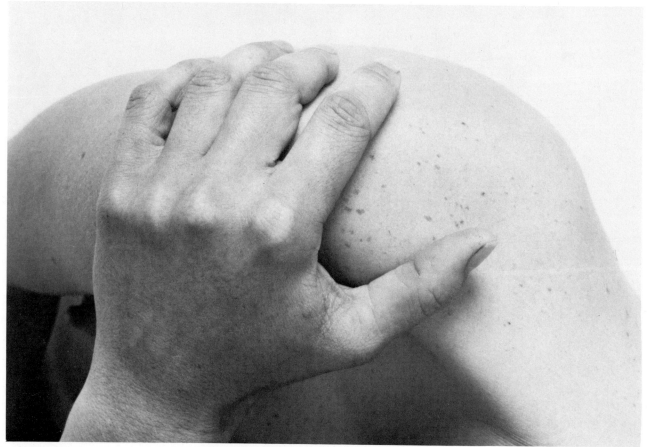

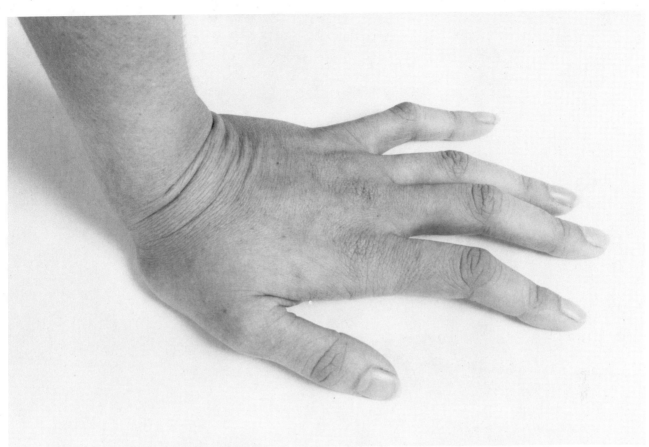

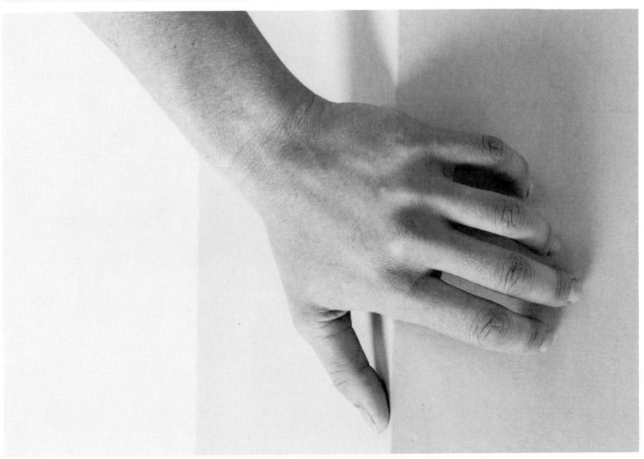

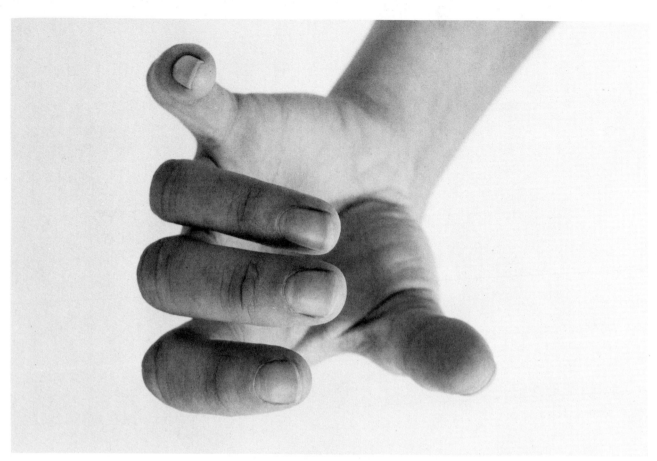

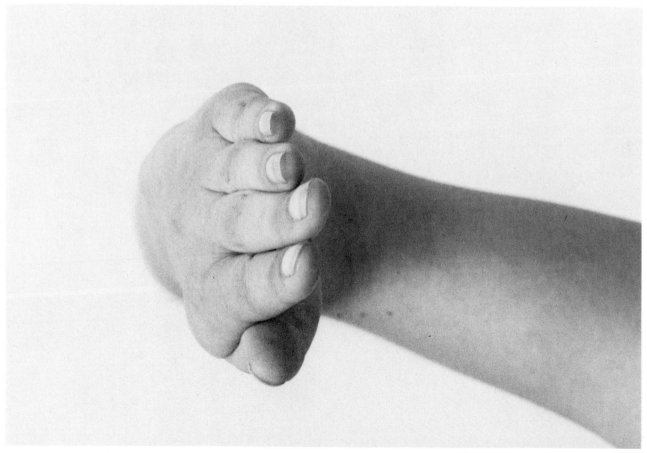

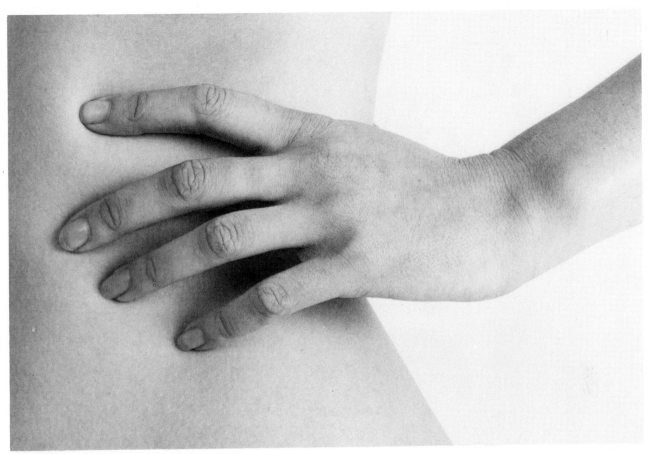

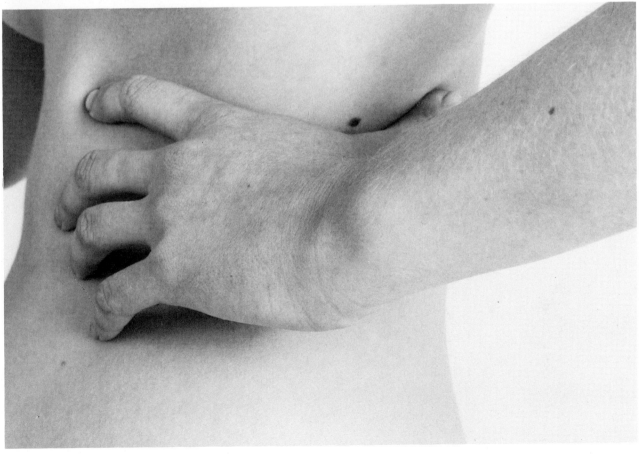

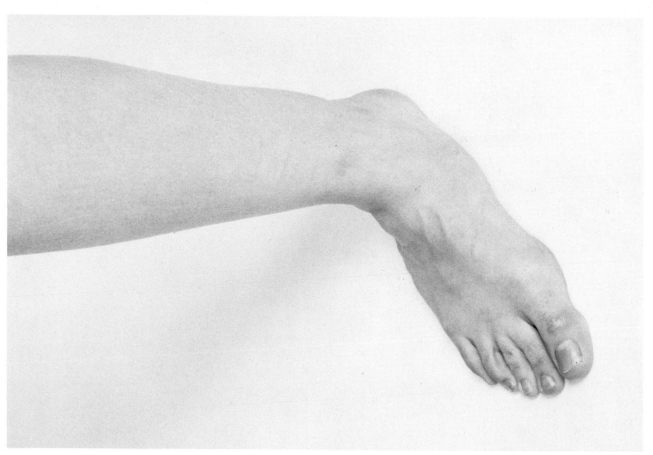

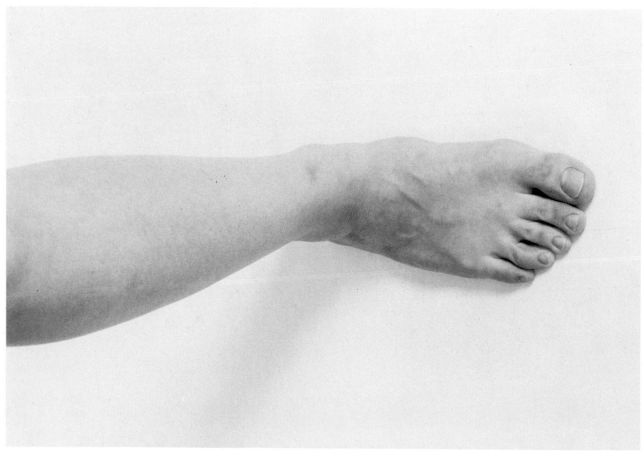

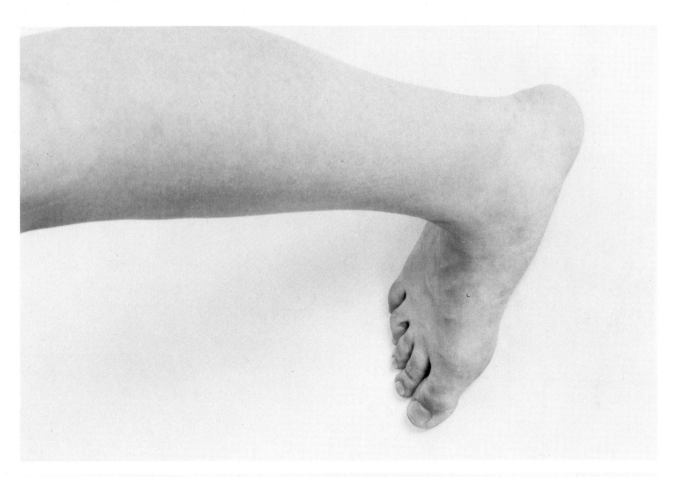

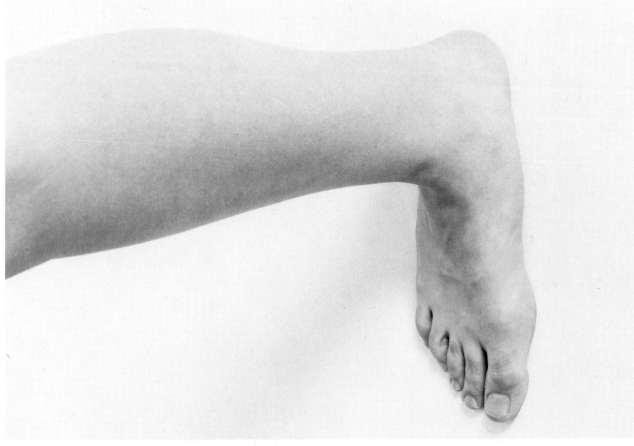

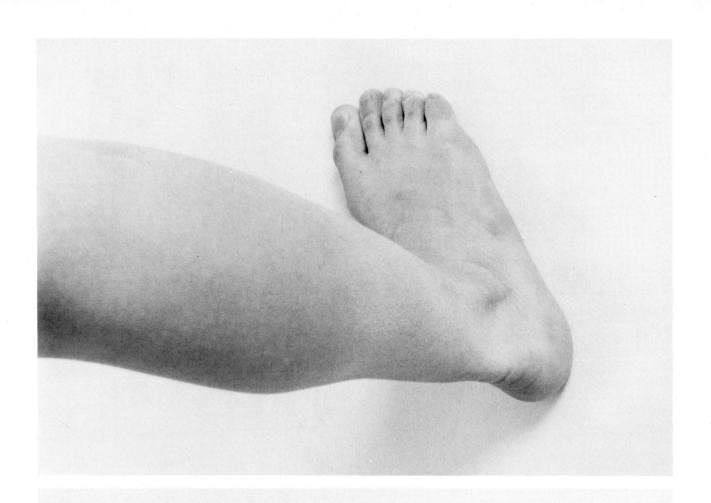

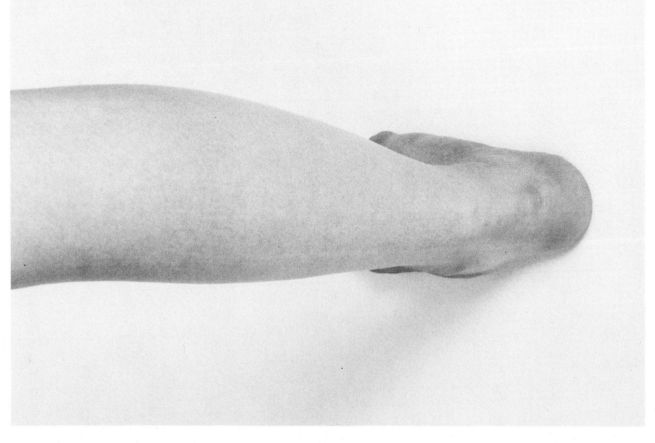

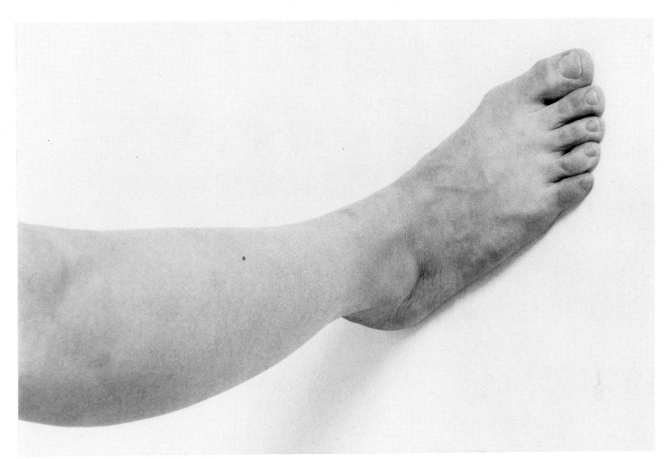

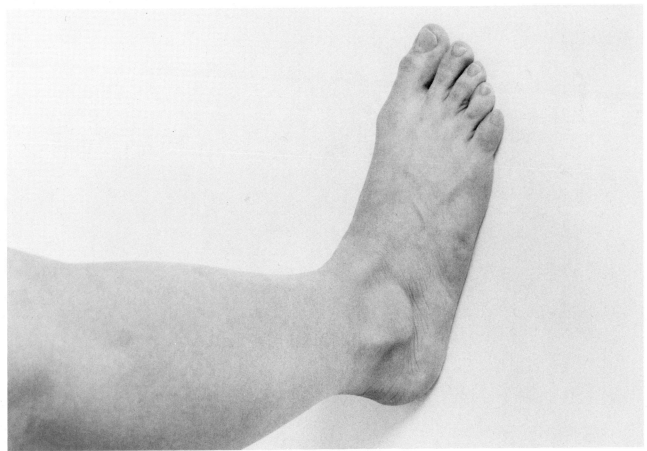

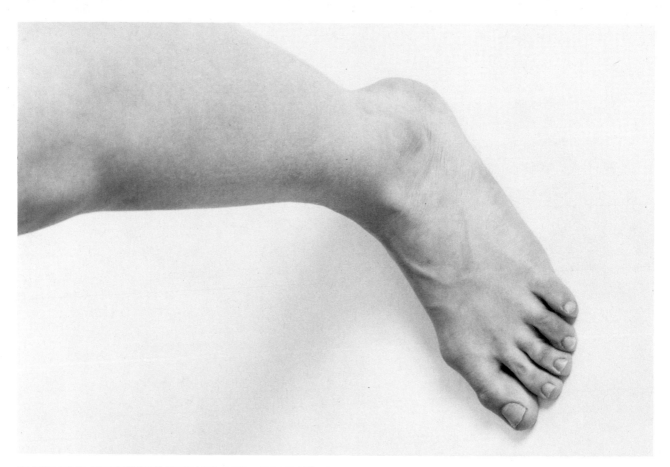

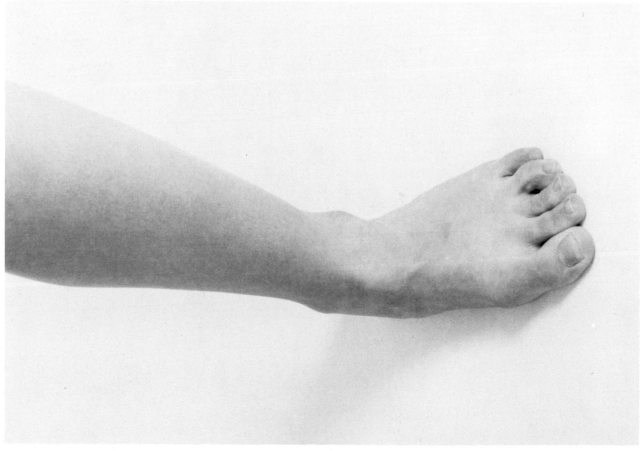

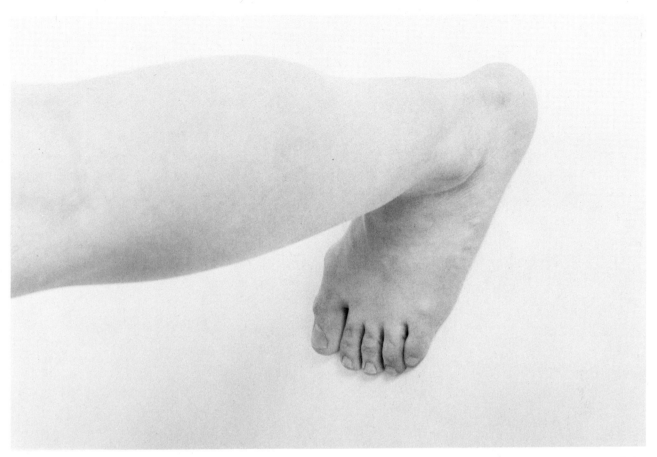

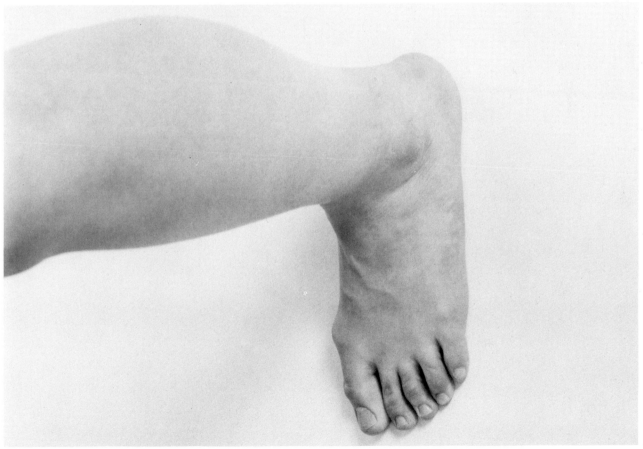

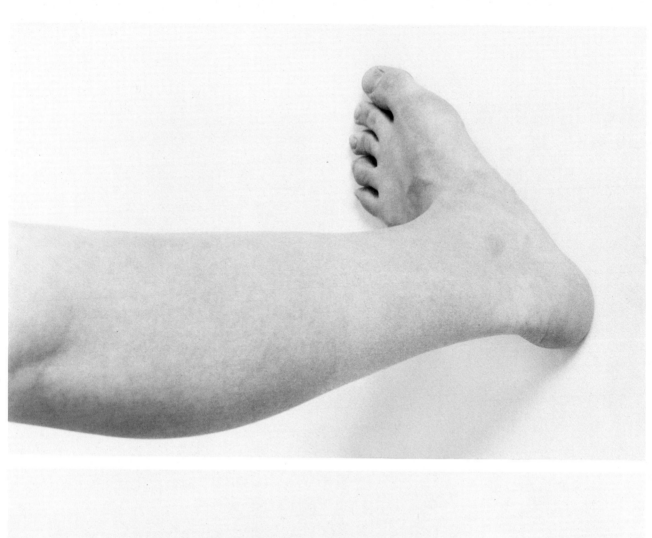

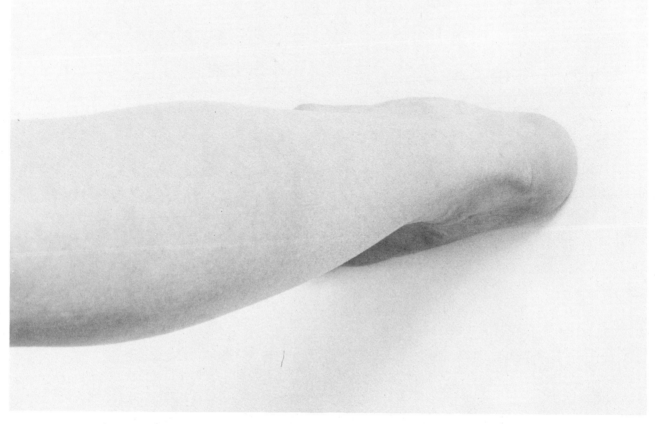

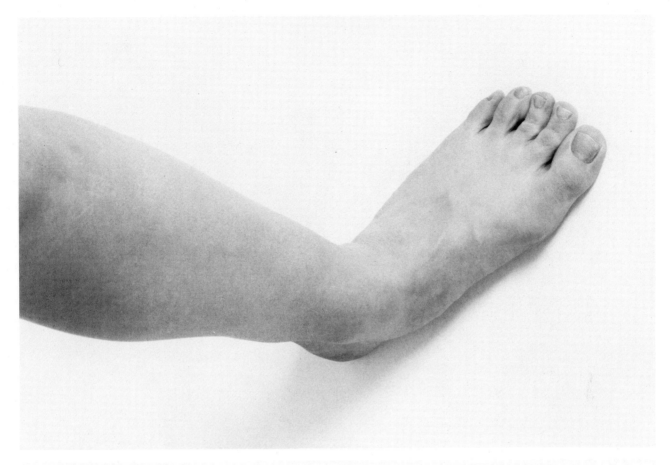

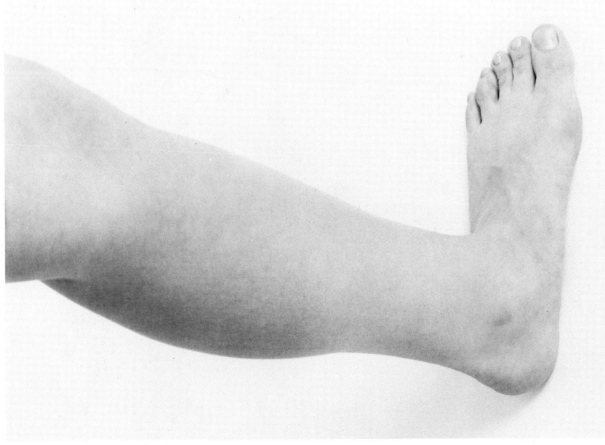

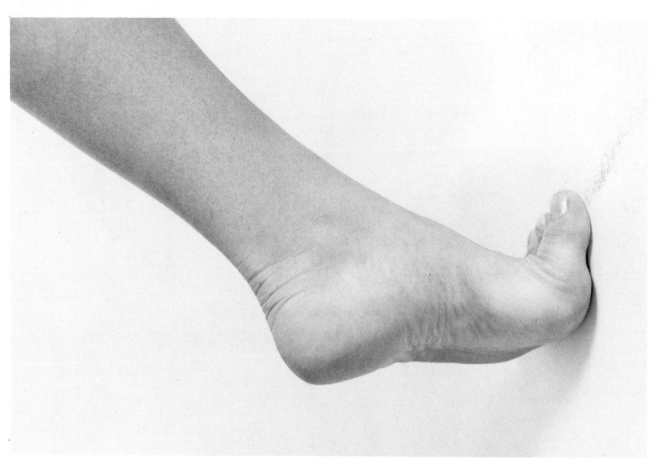

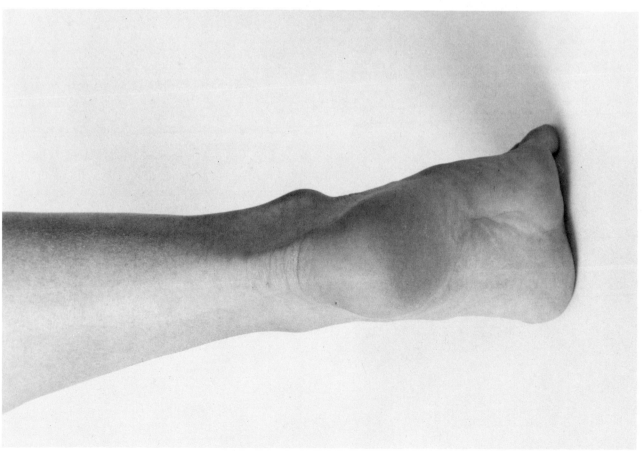

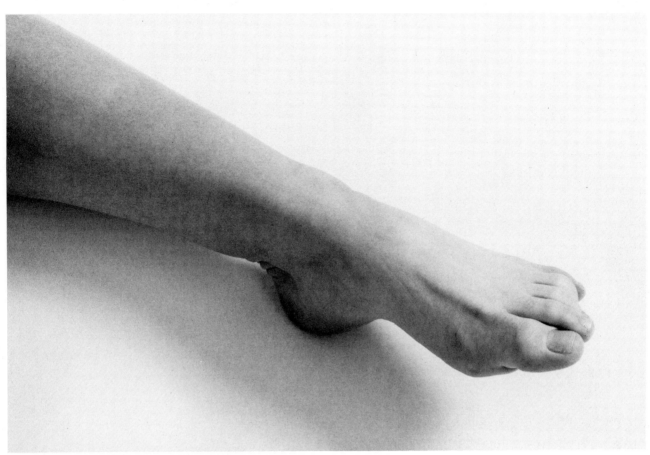

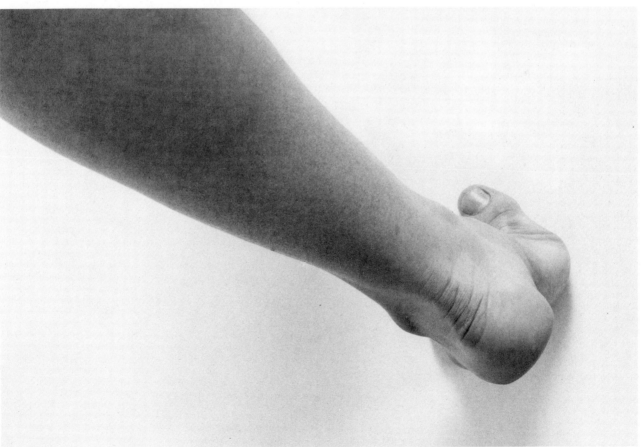

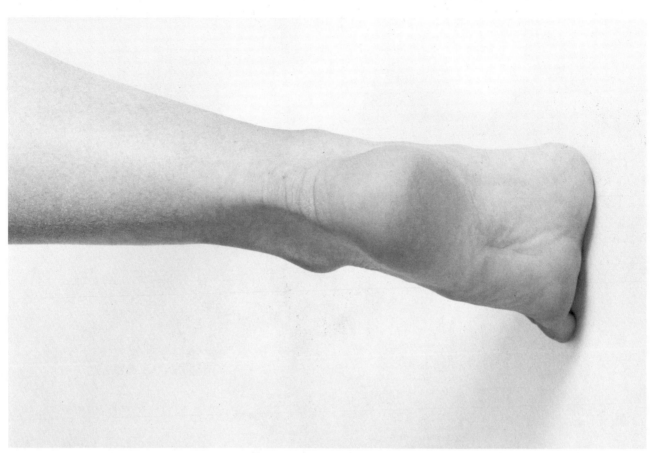

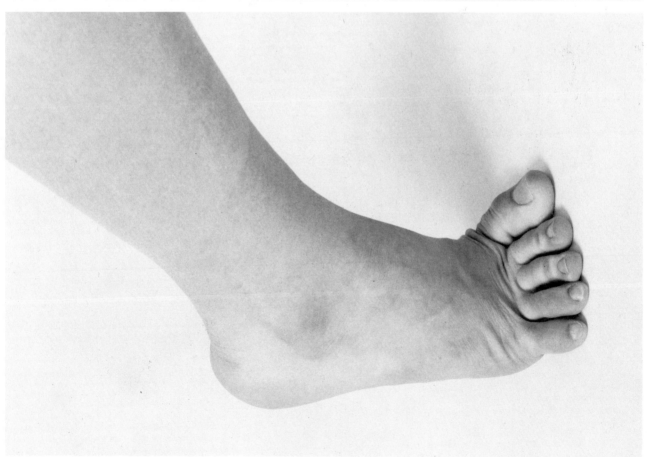

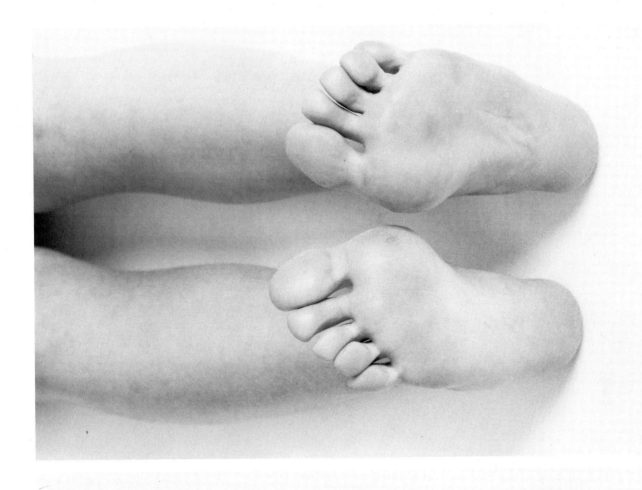

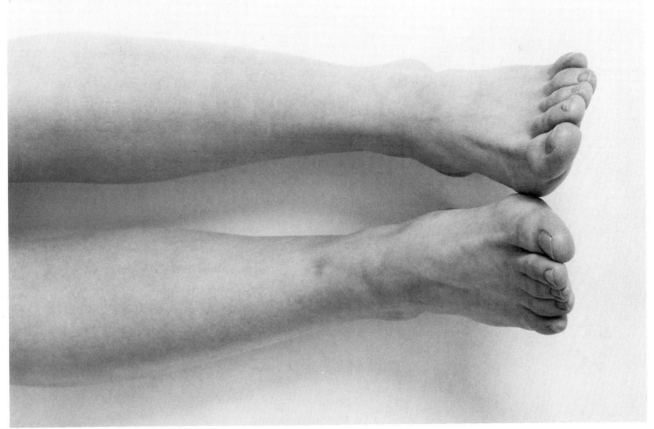

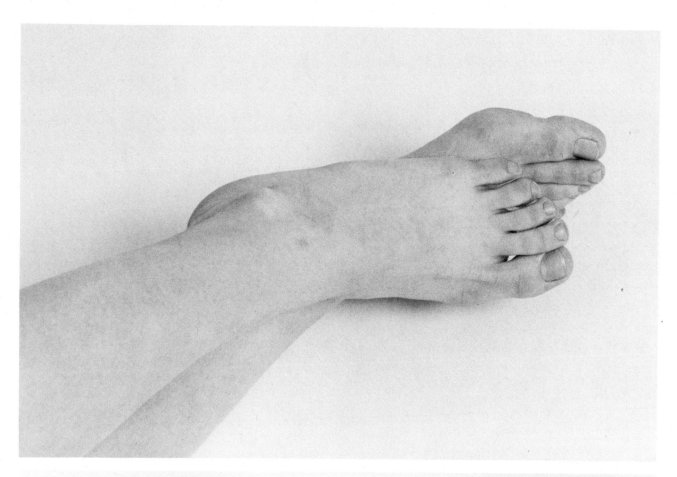

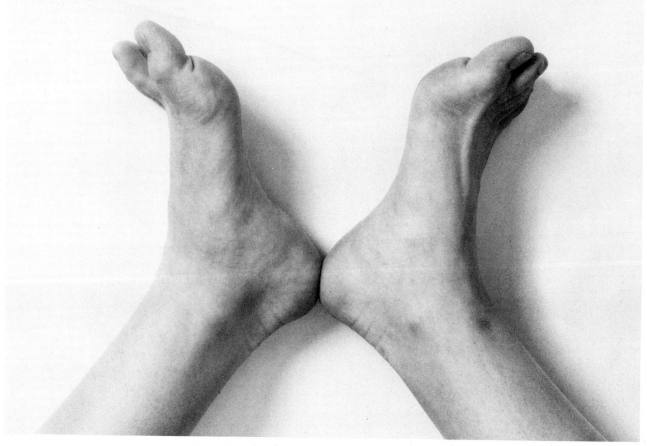

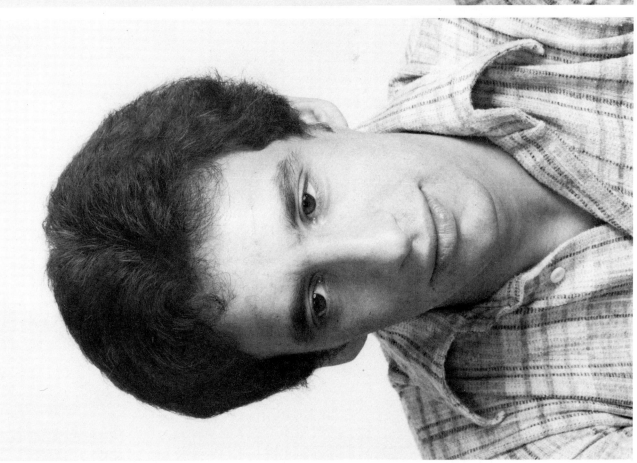

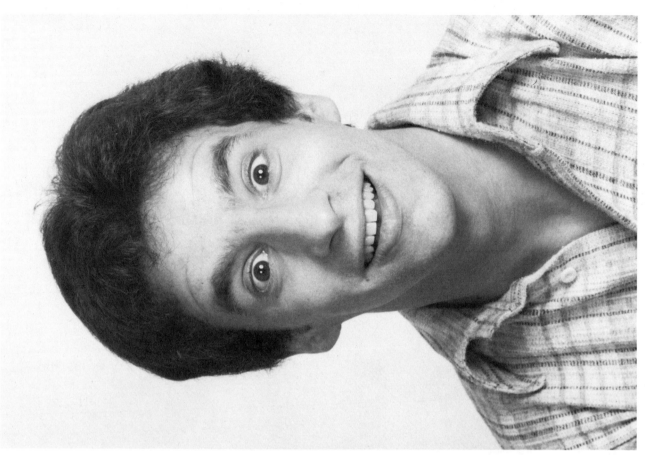

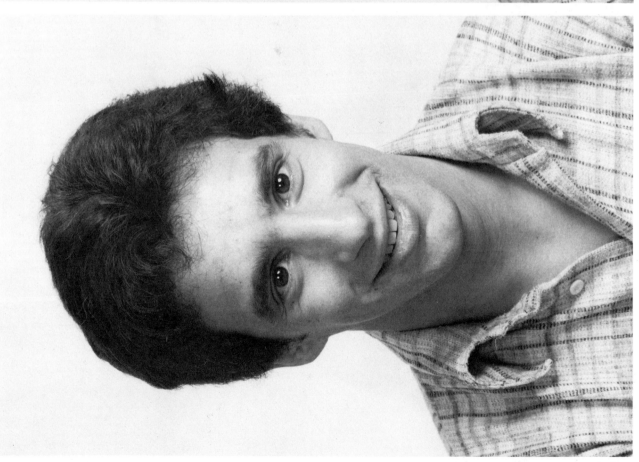

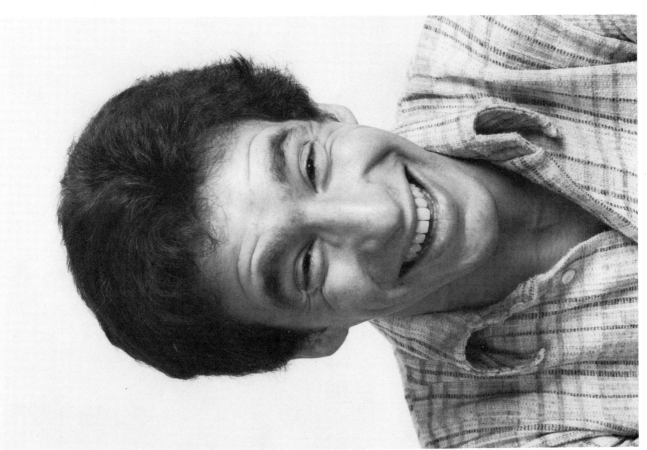

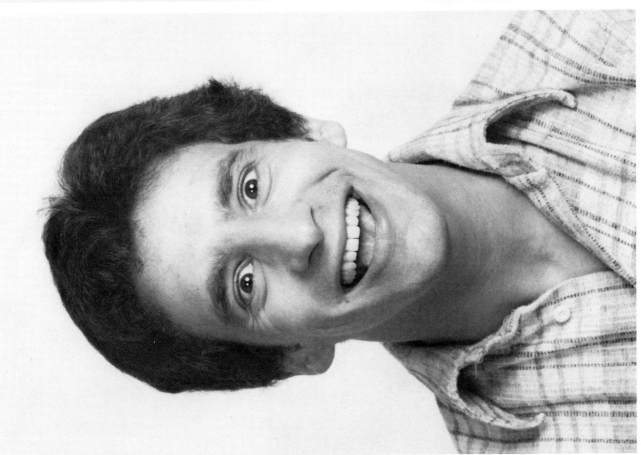

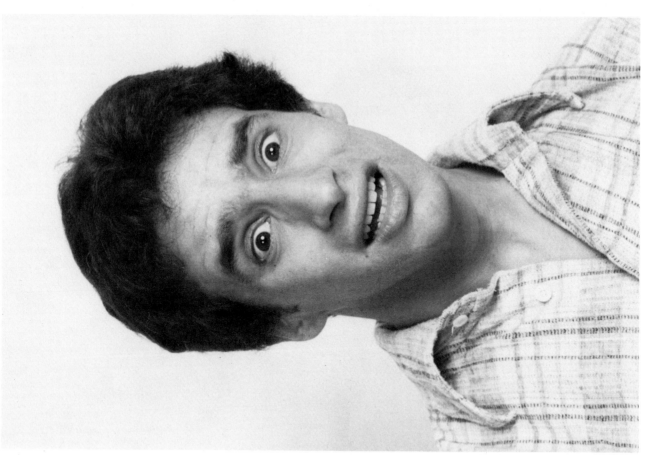

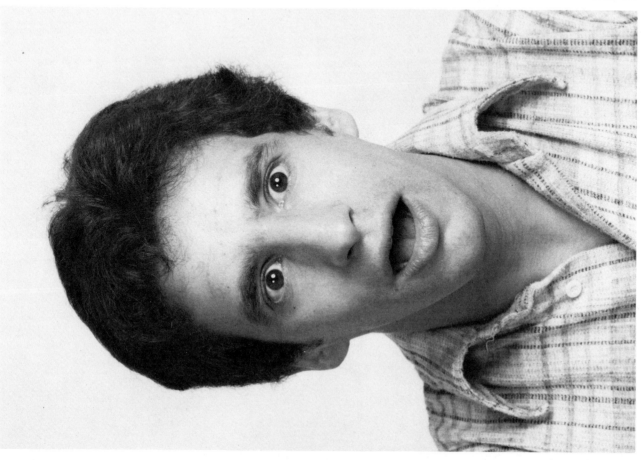

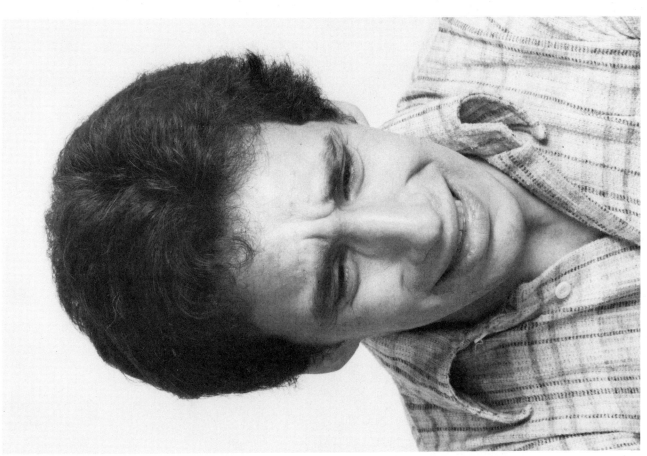

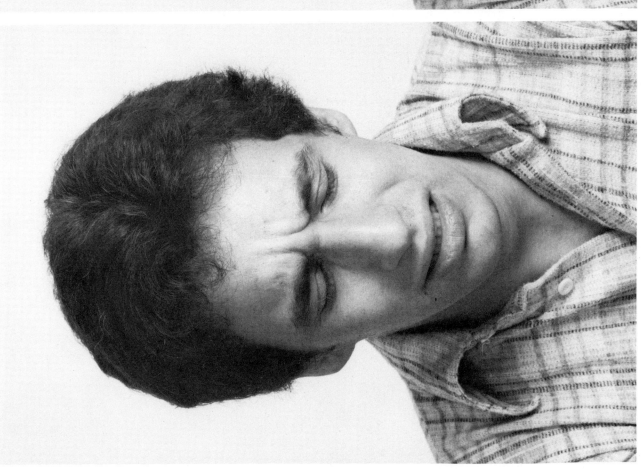

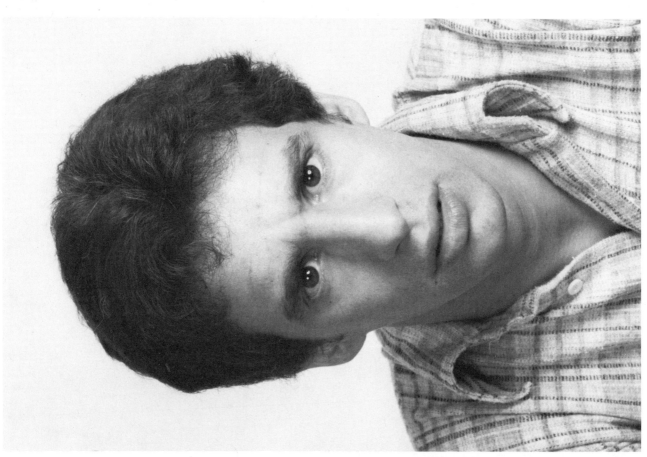

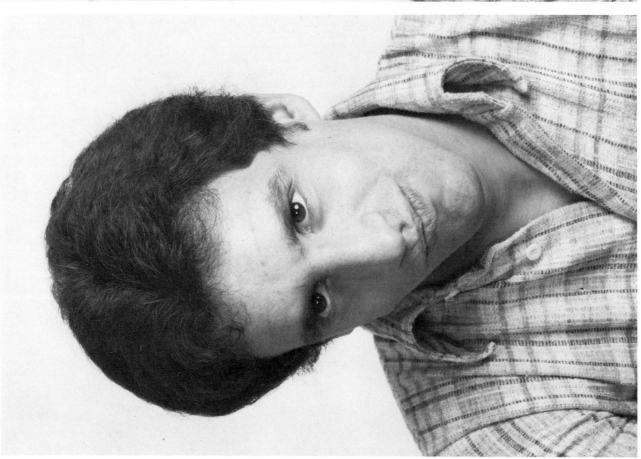

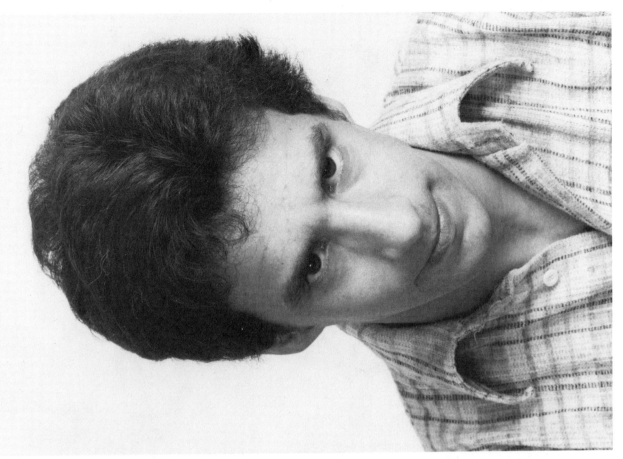

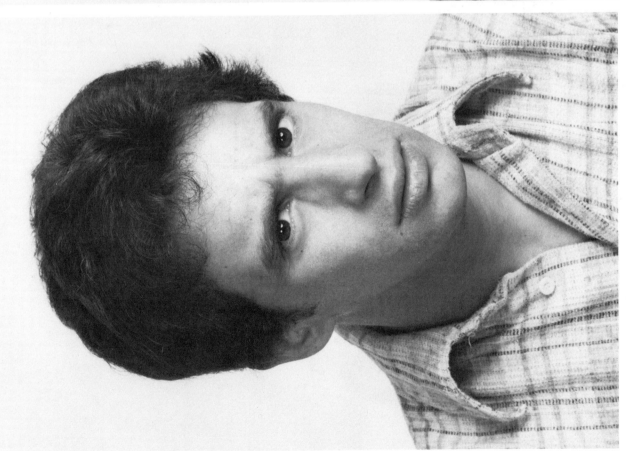

259

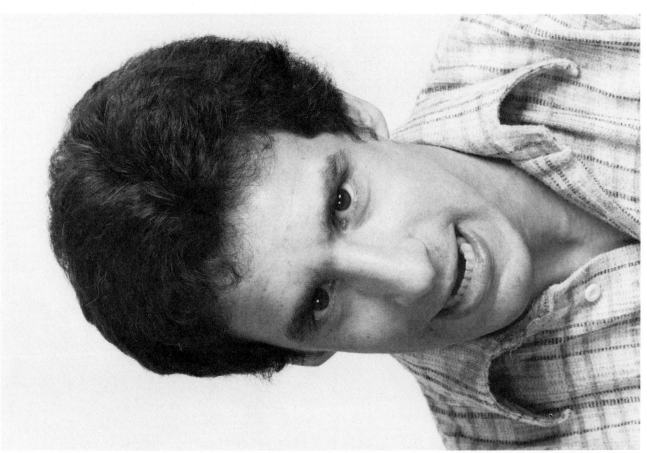

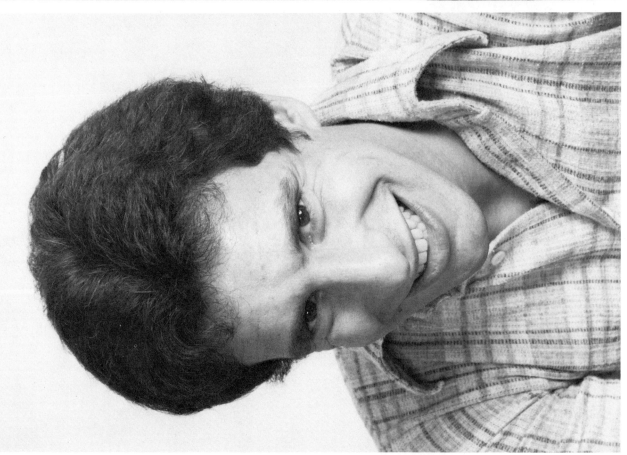

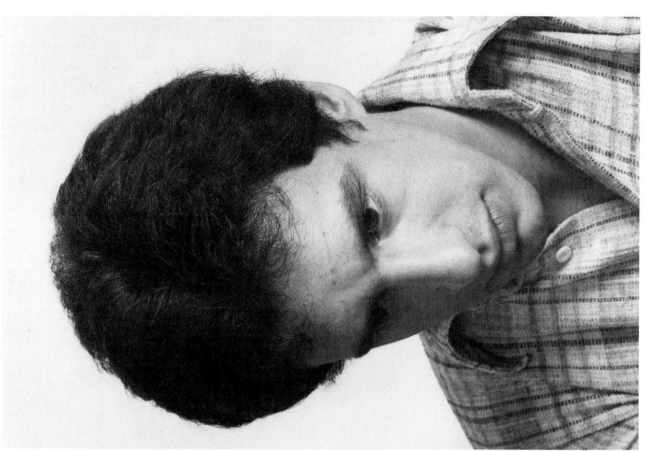

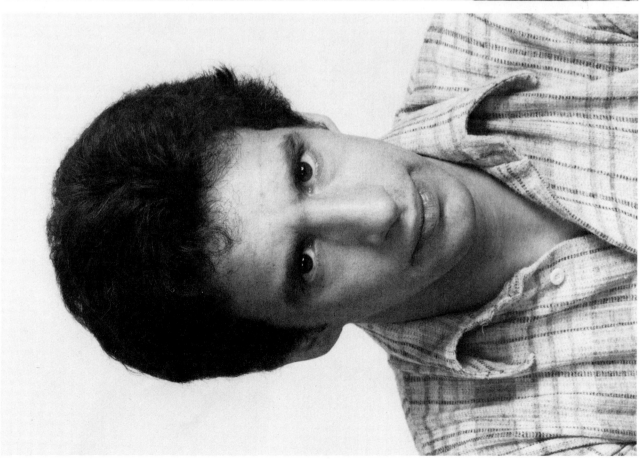

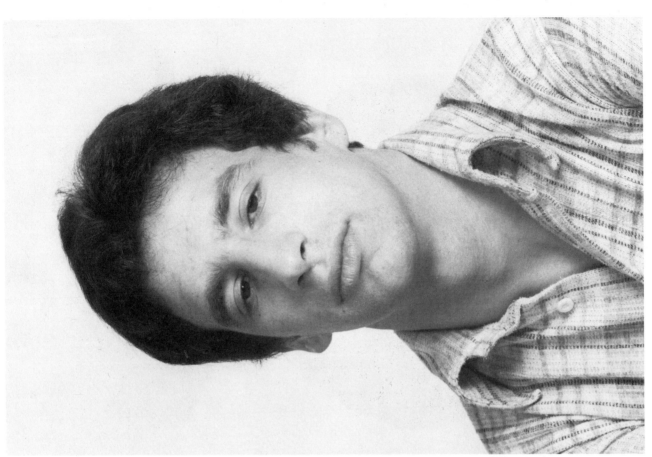

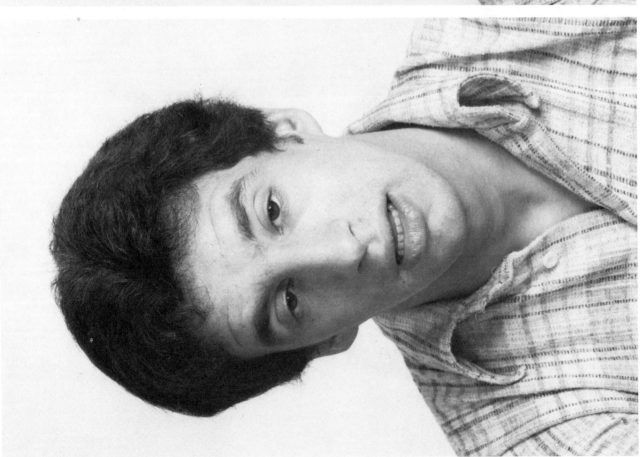

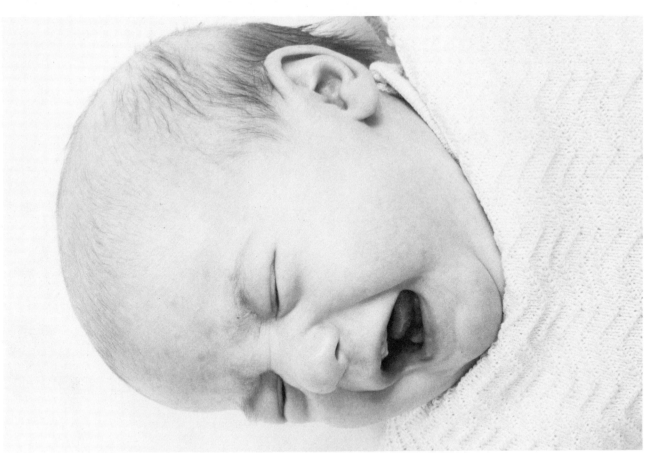

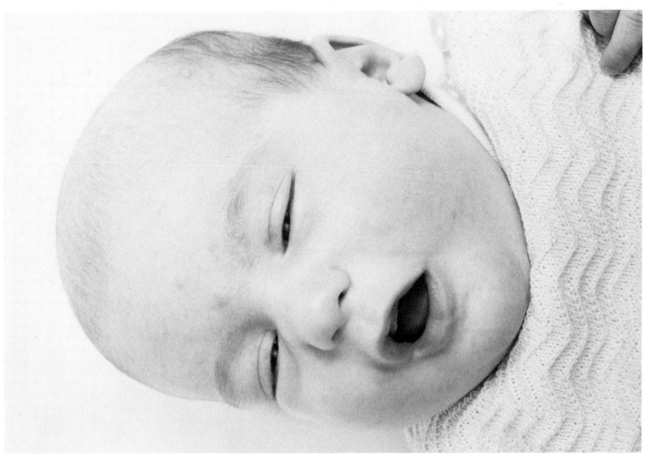

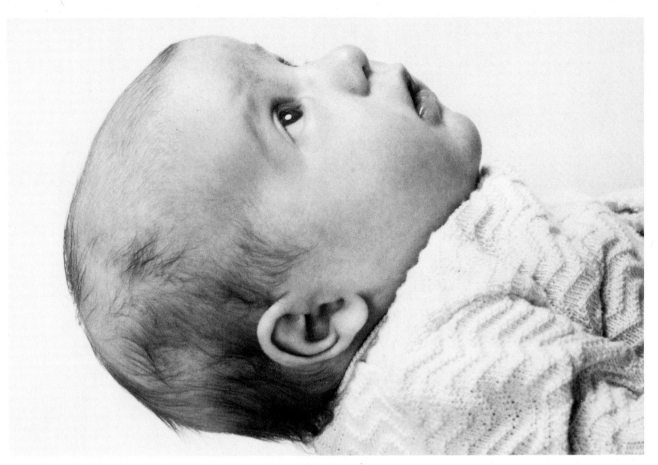

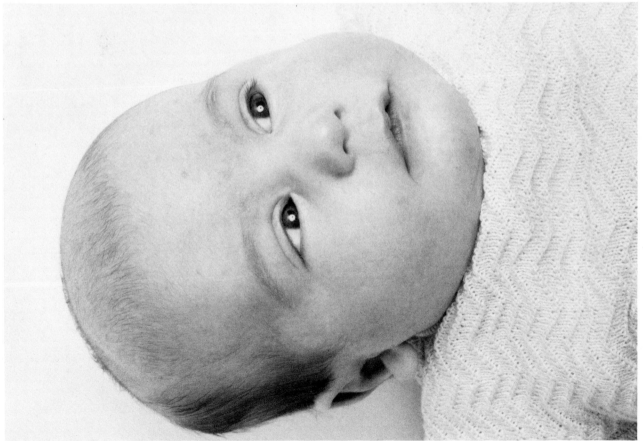

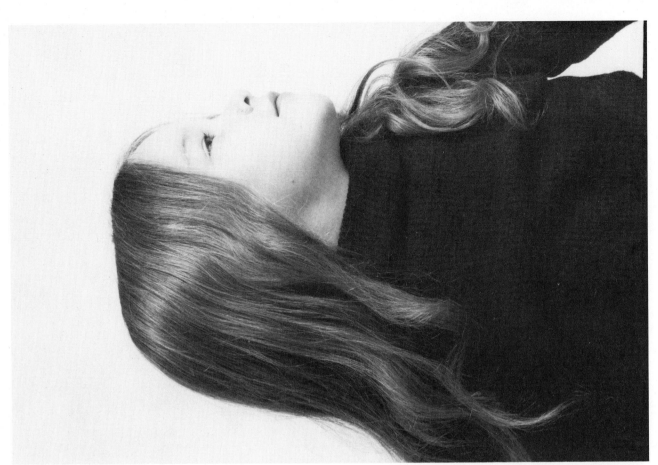

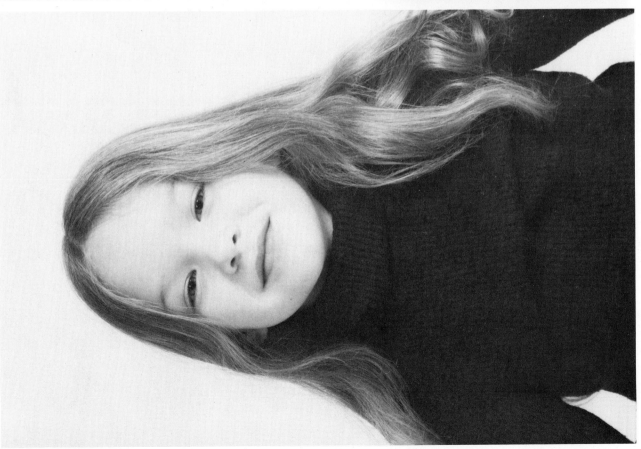

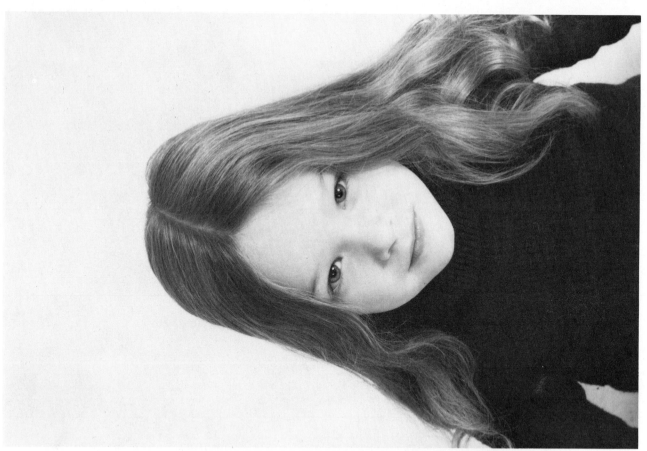

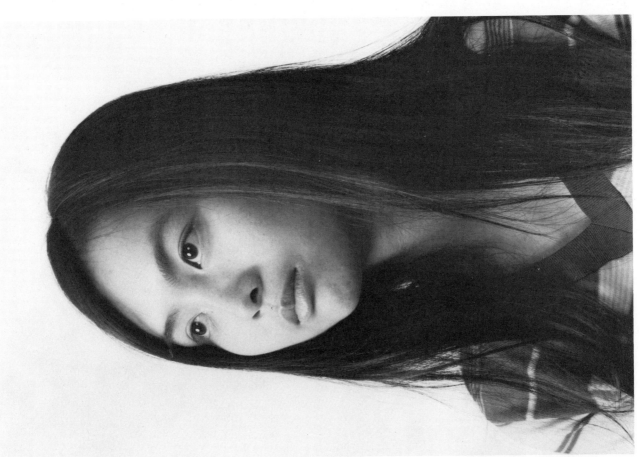

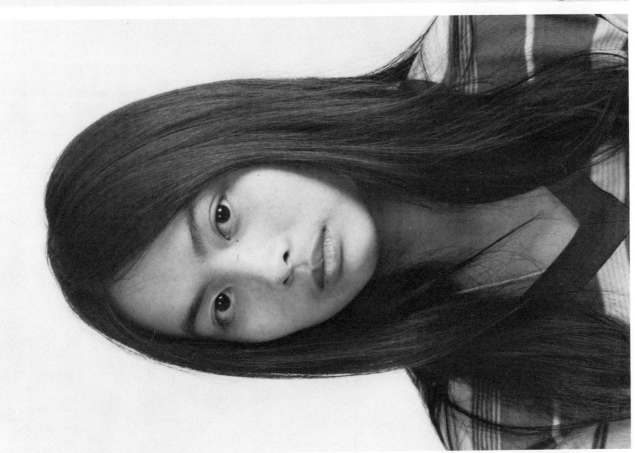

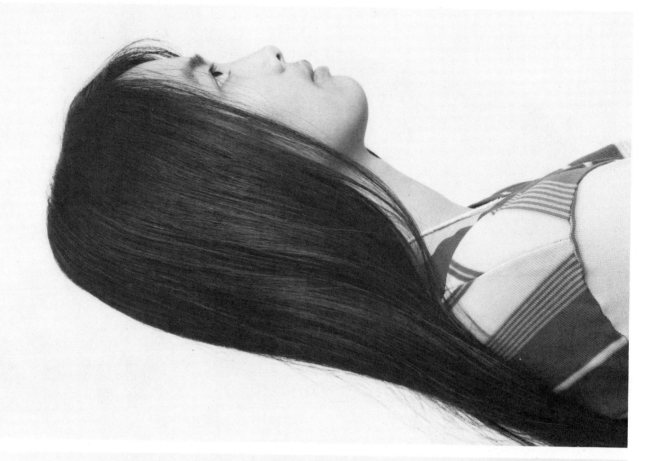

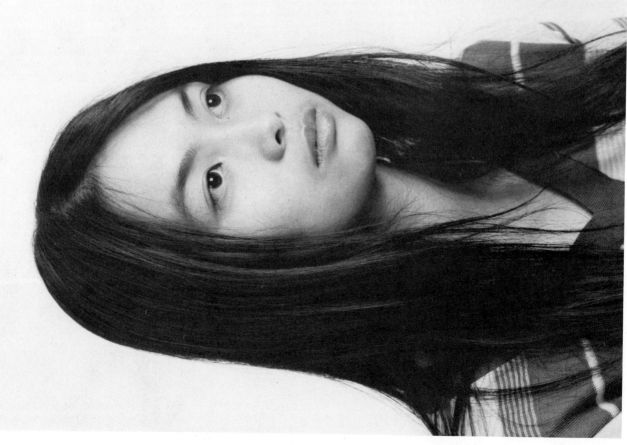

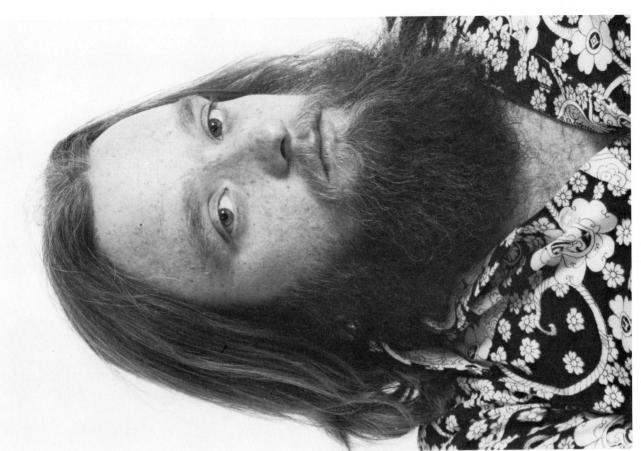

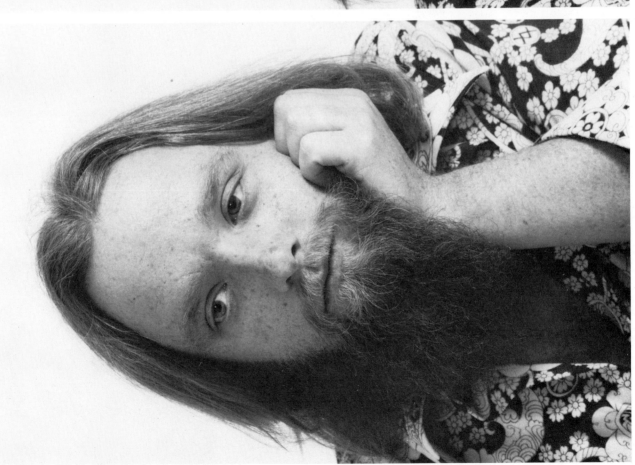

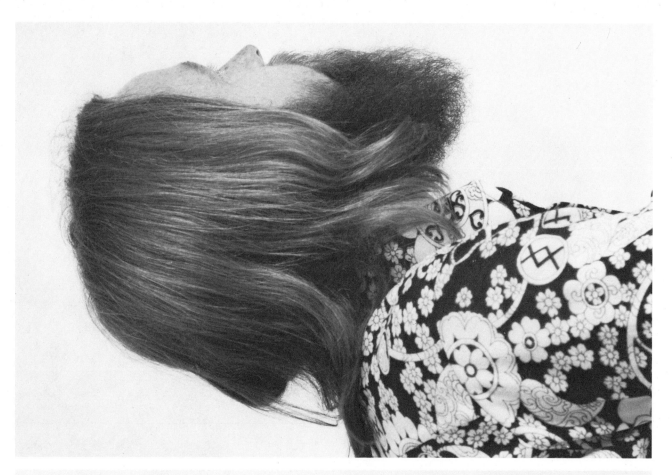

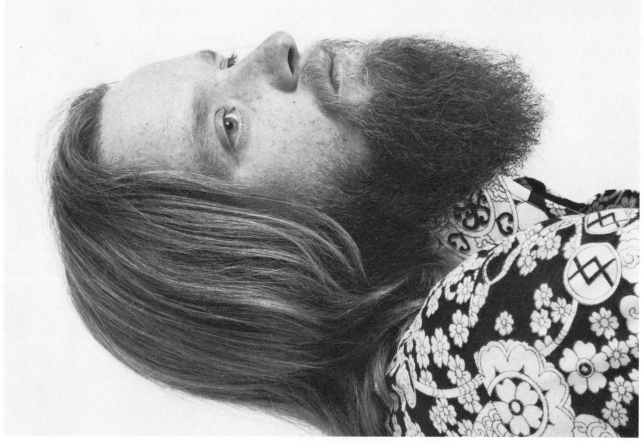

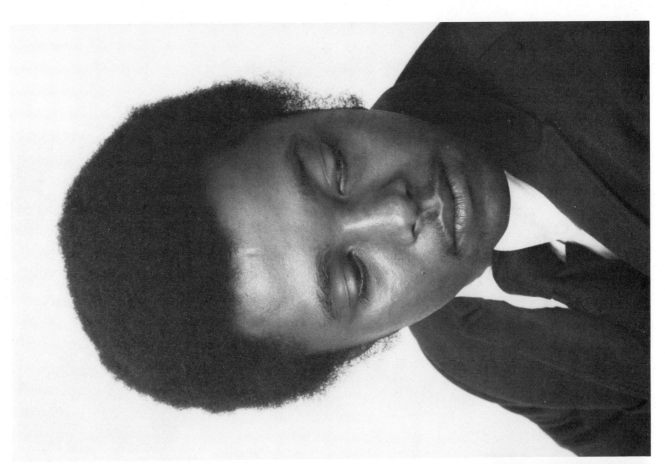

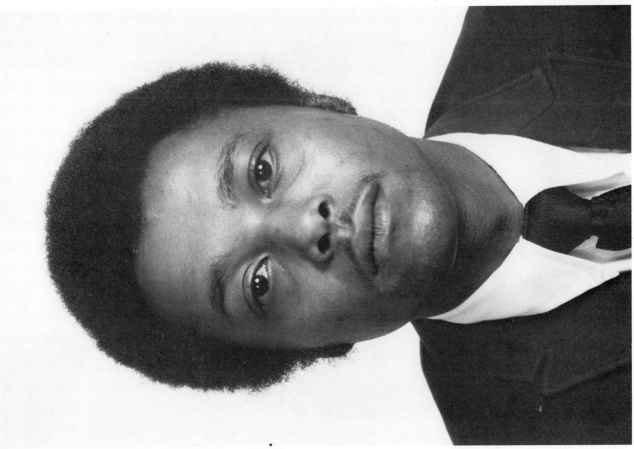

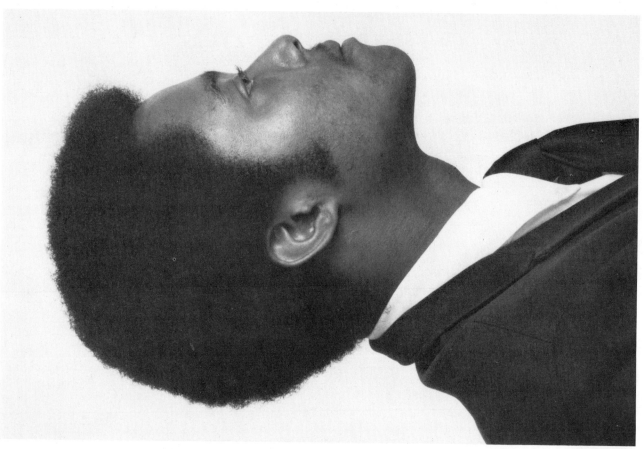

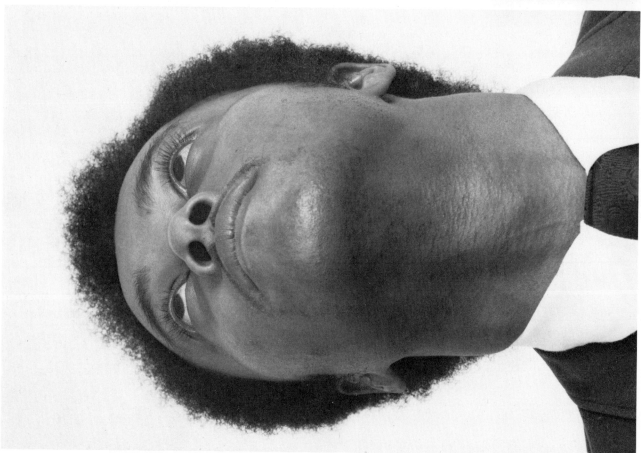

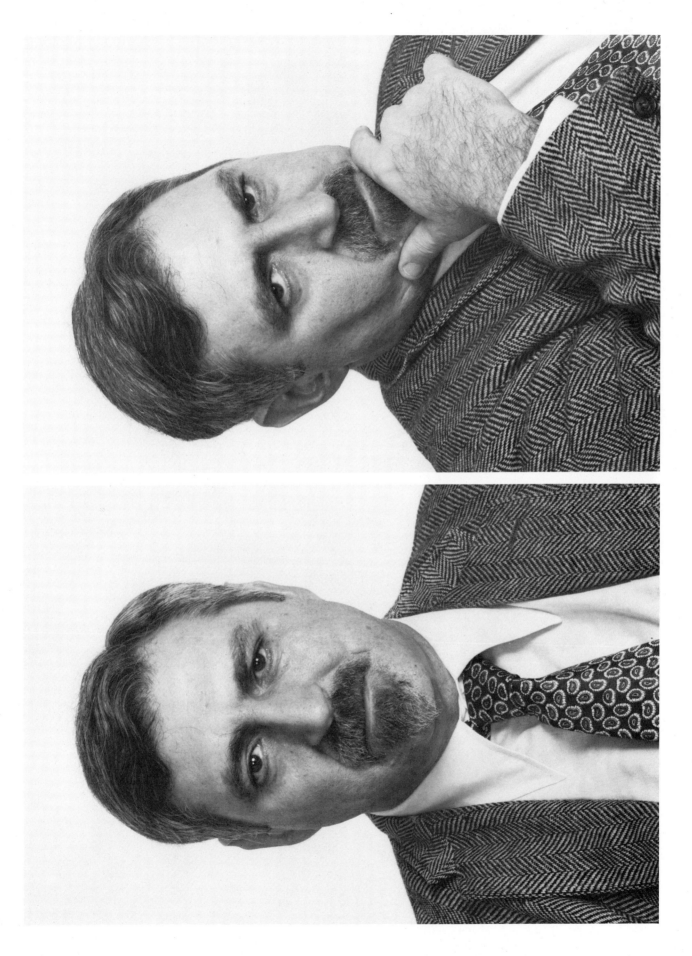

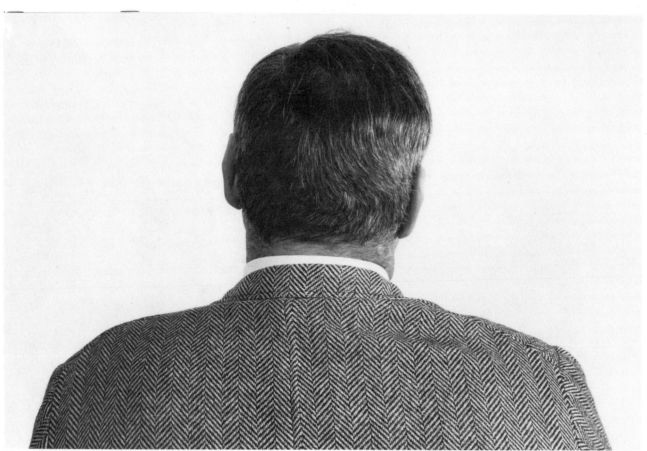

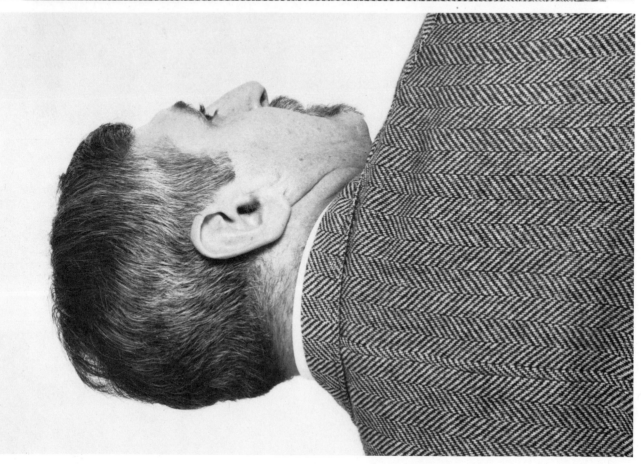

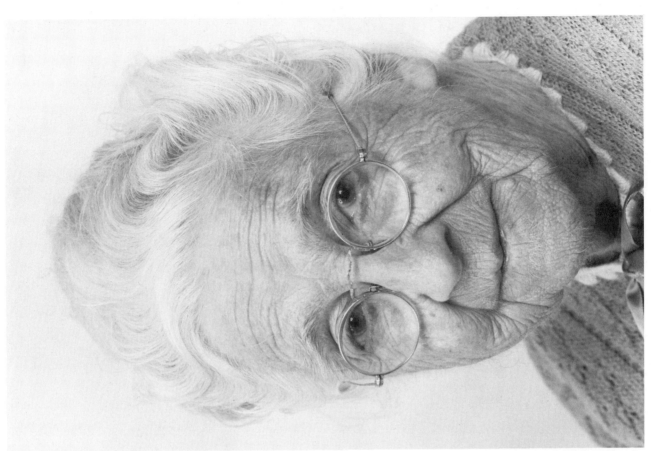

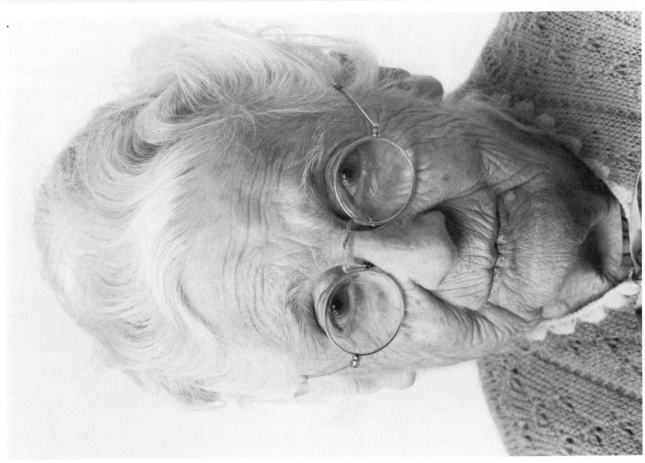

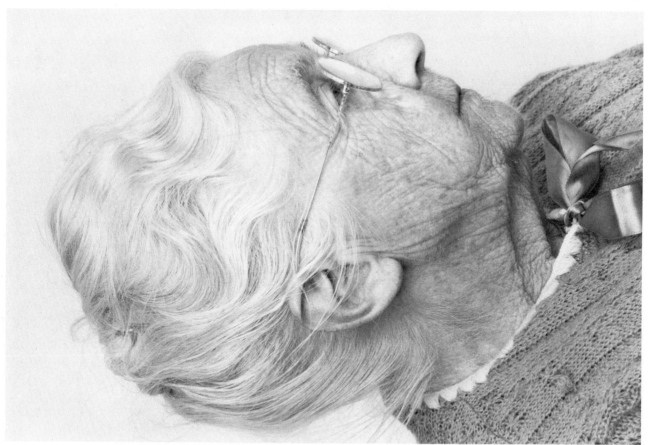

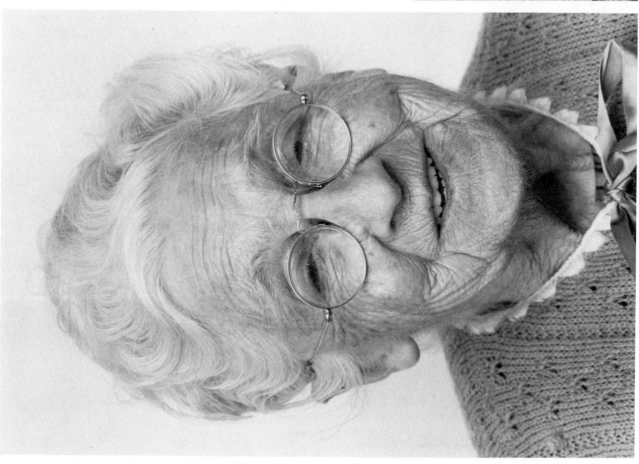

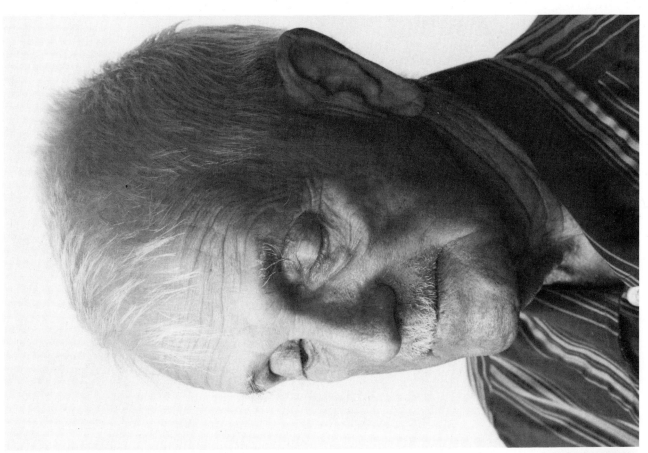

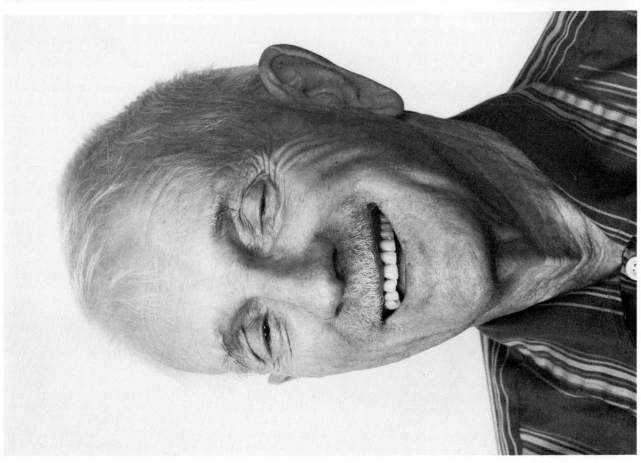

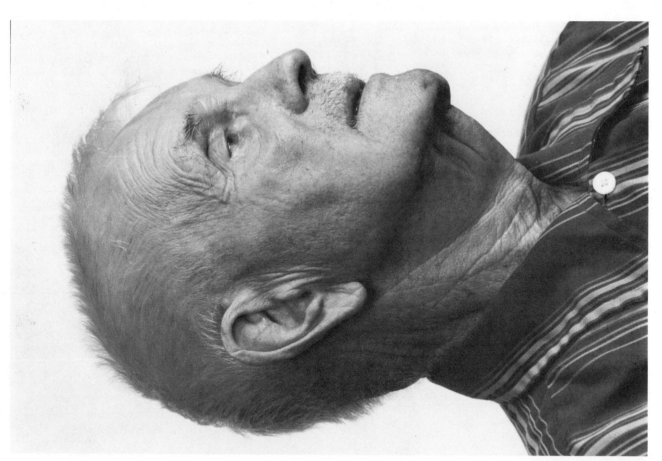

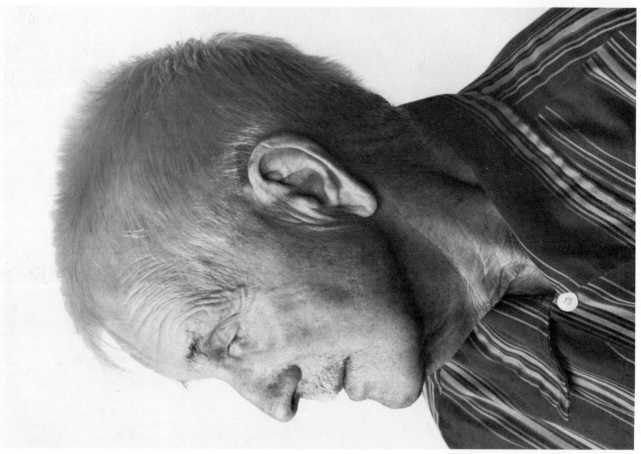

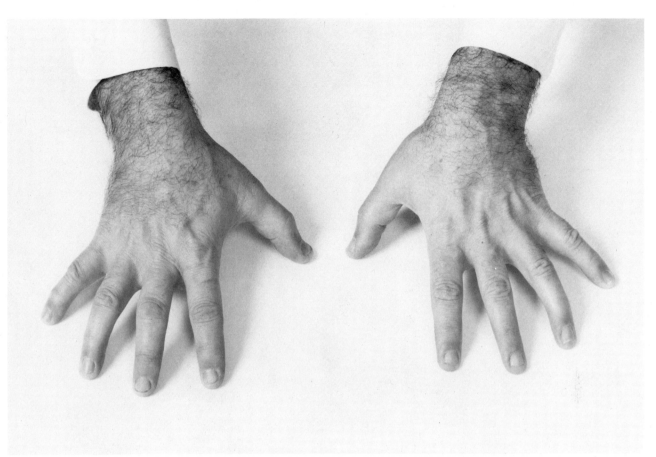

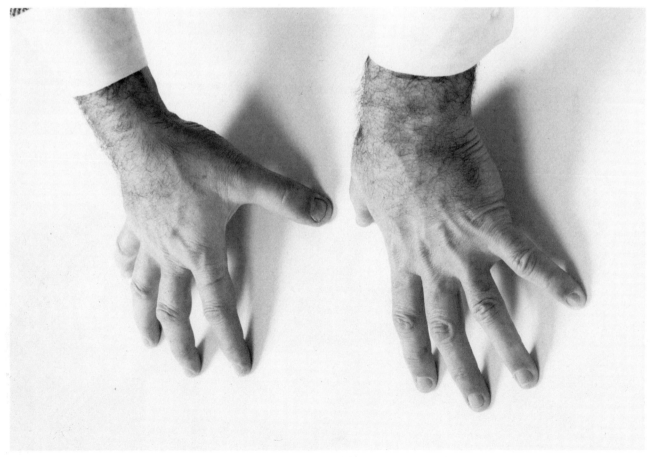

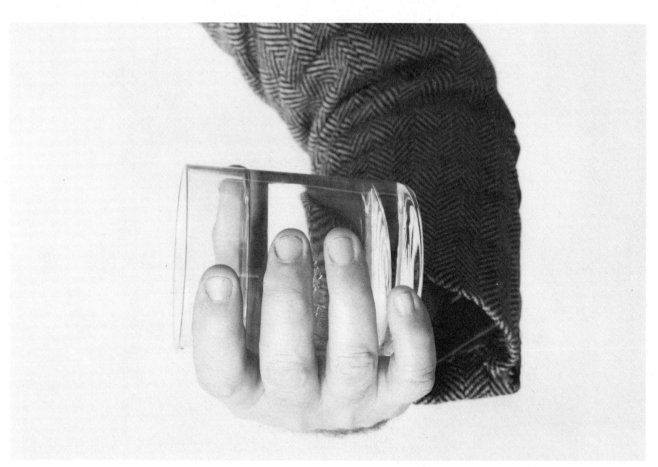

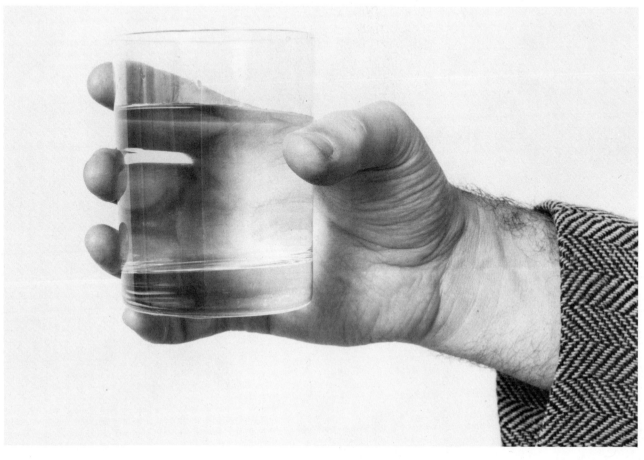

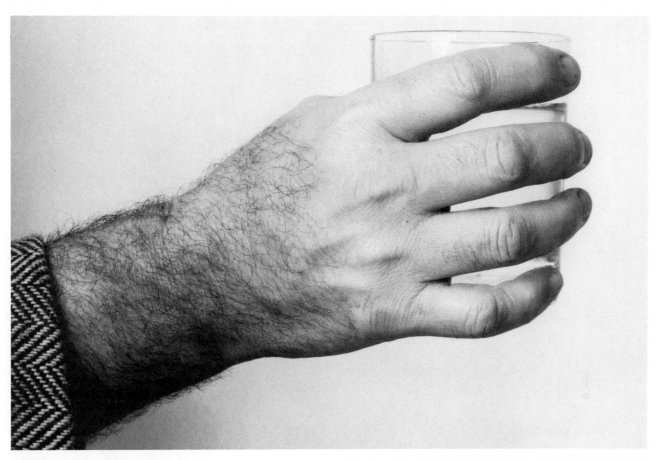

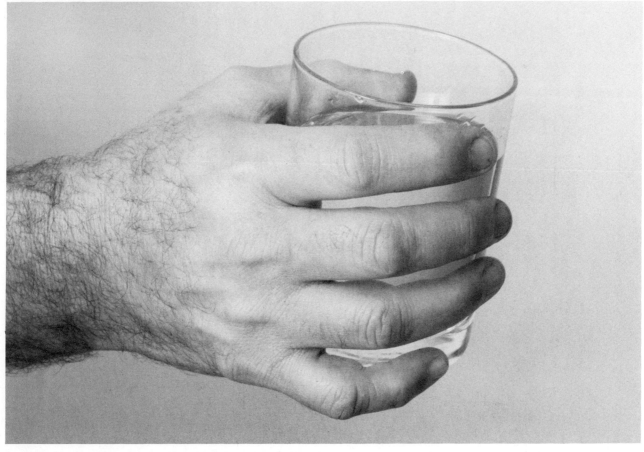

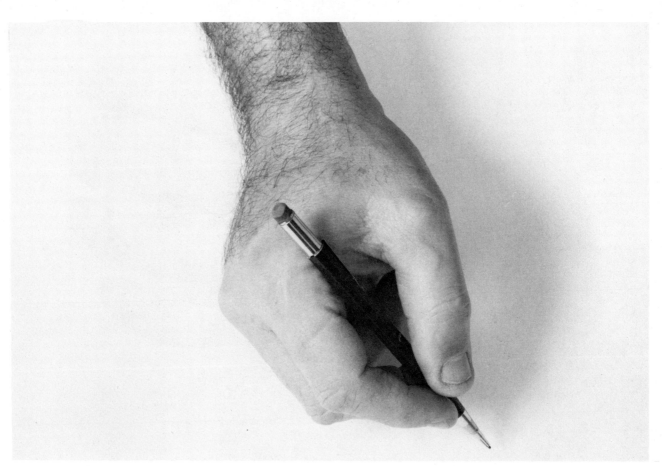

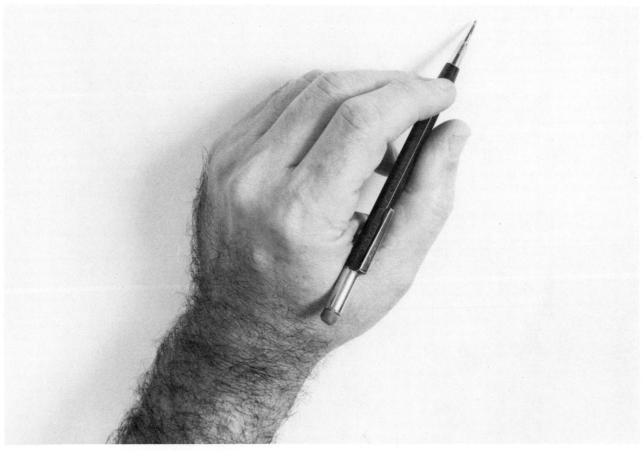

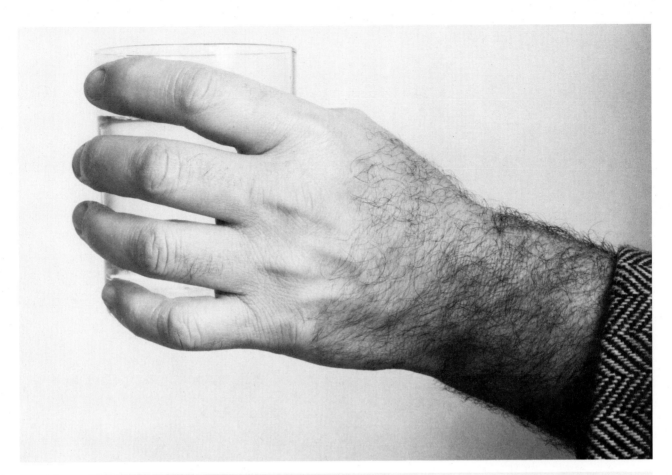

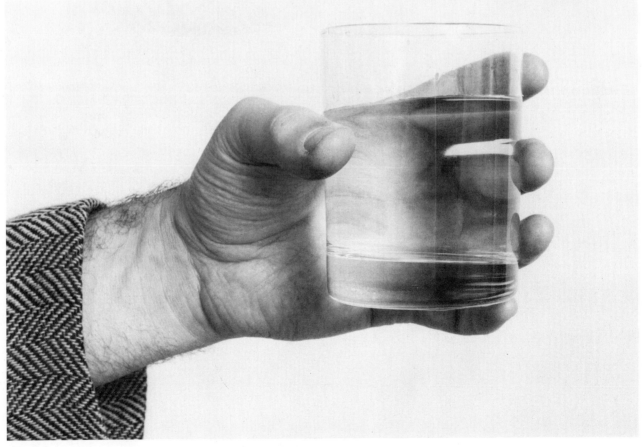

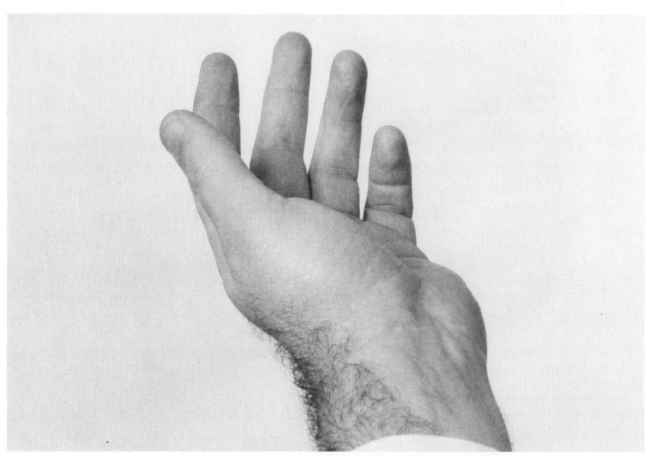
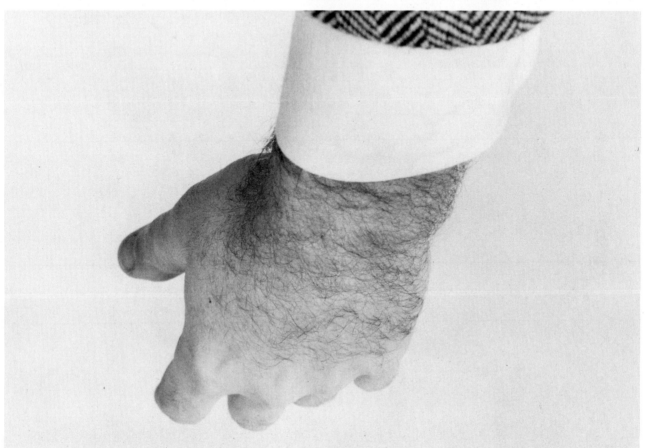

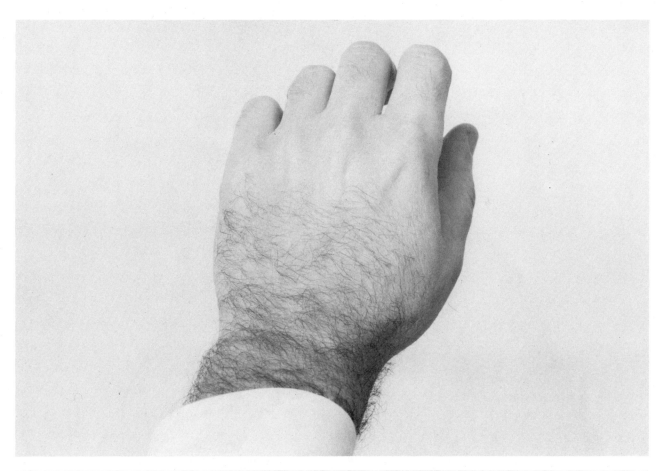

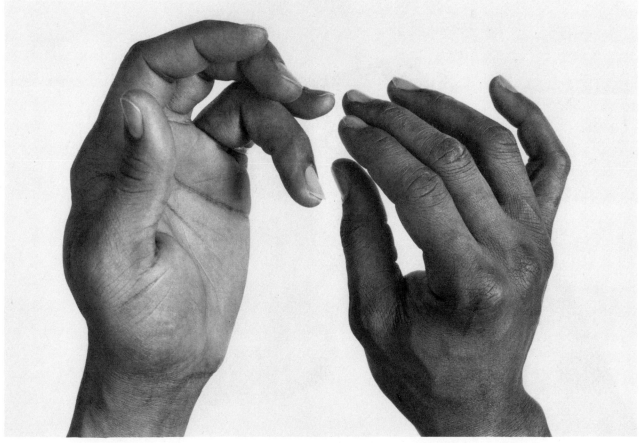

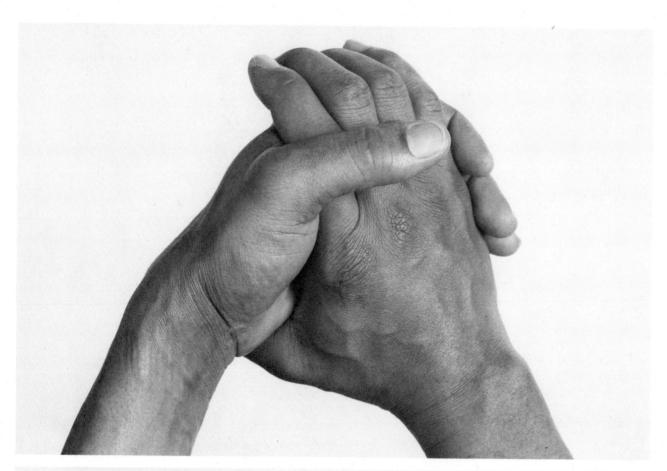

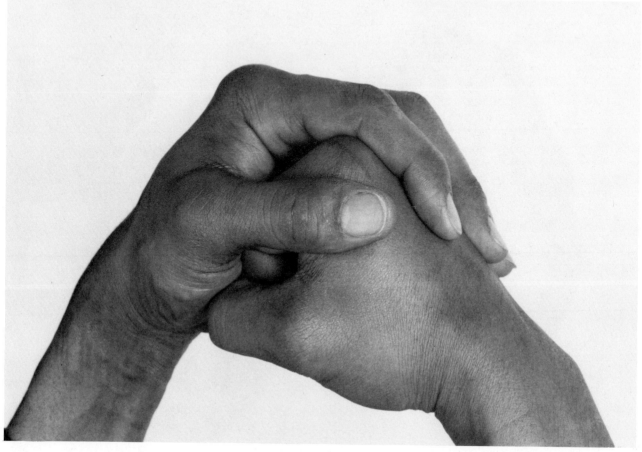

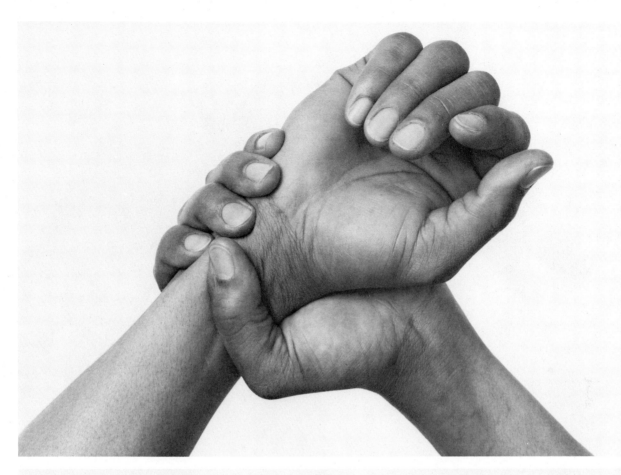

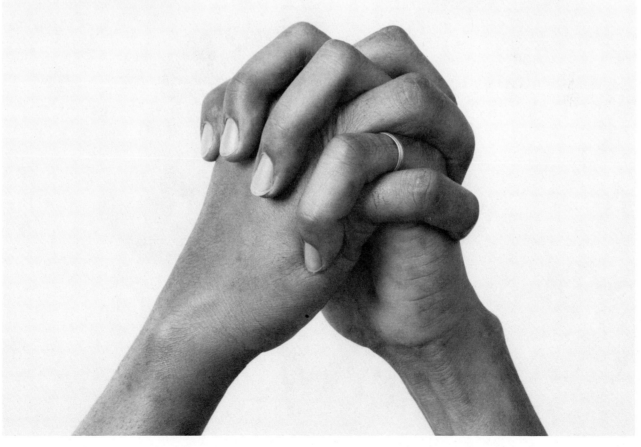

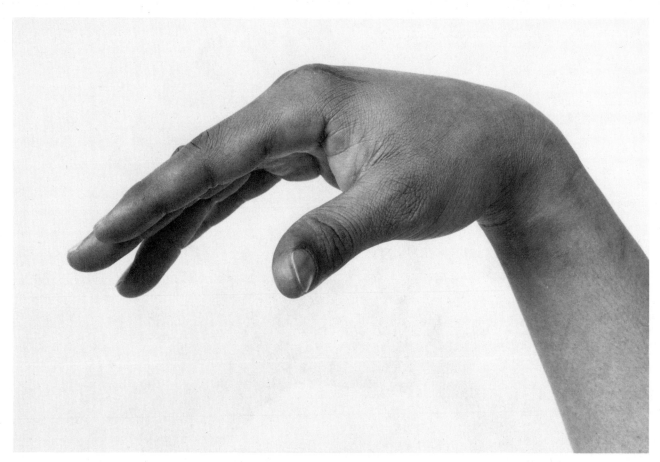

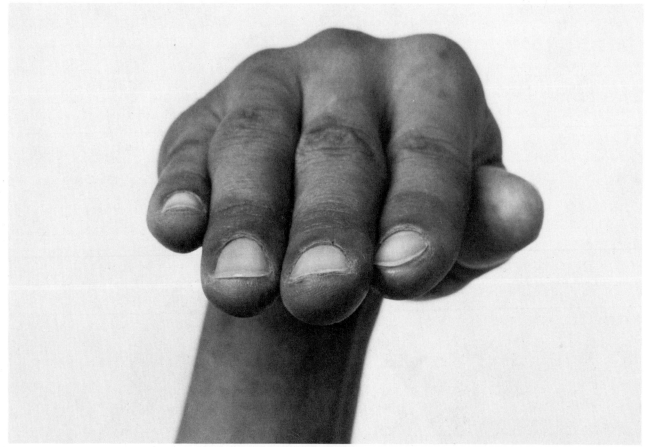

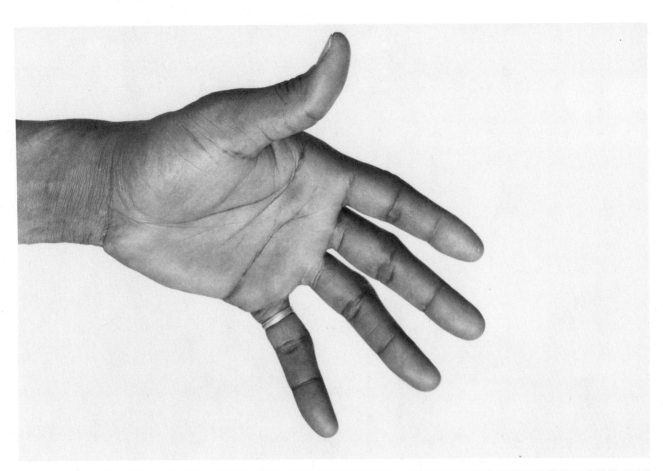

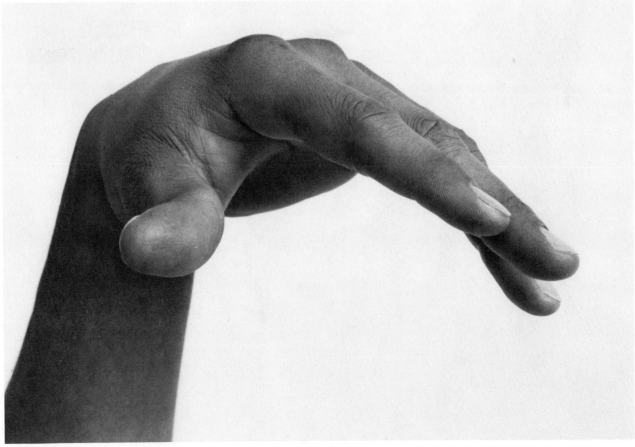

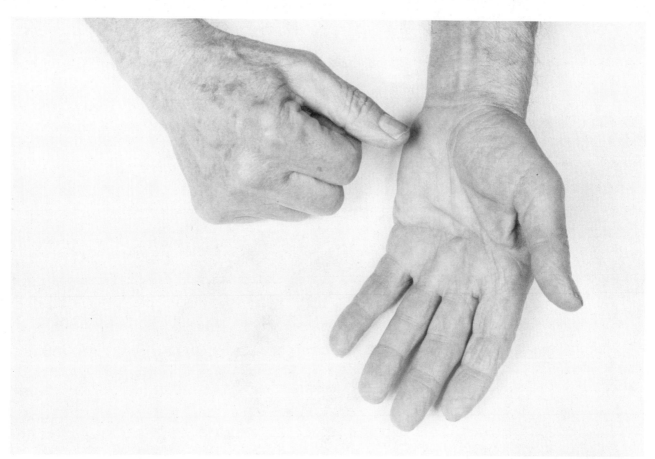

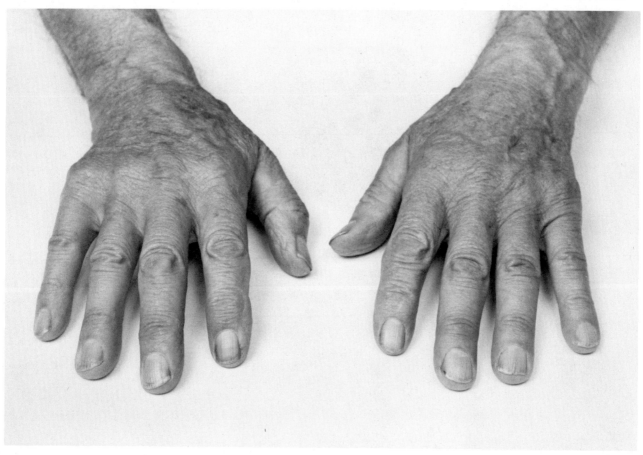

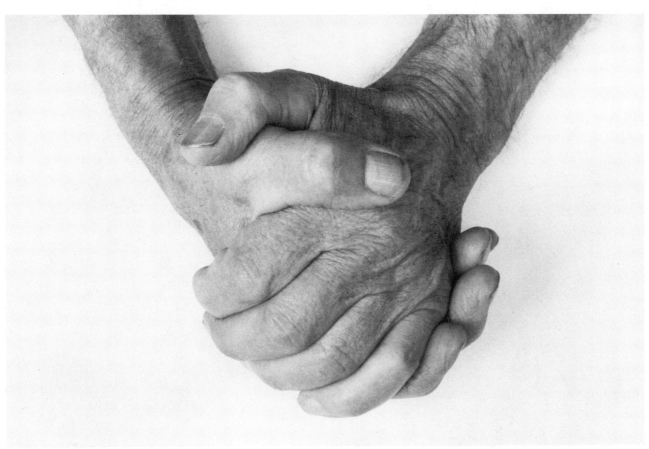

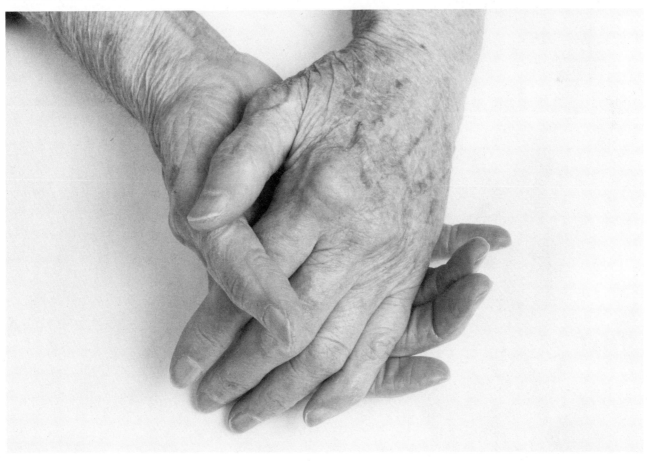

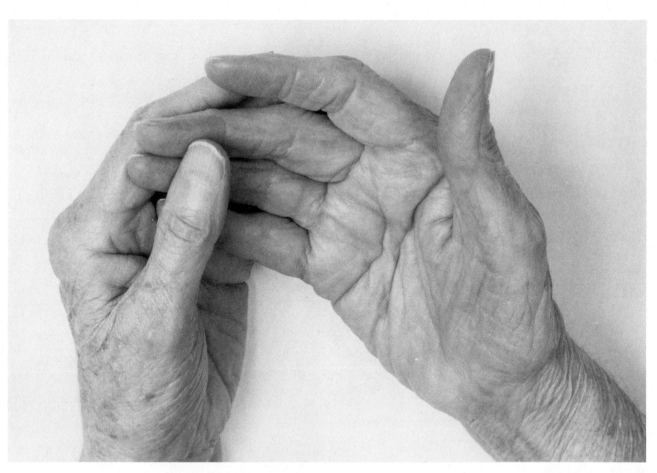

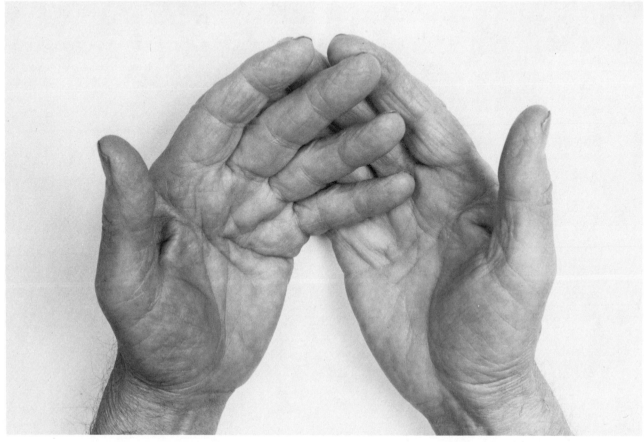

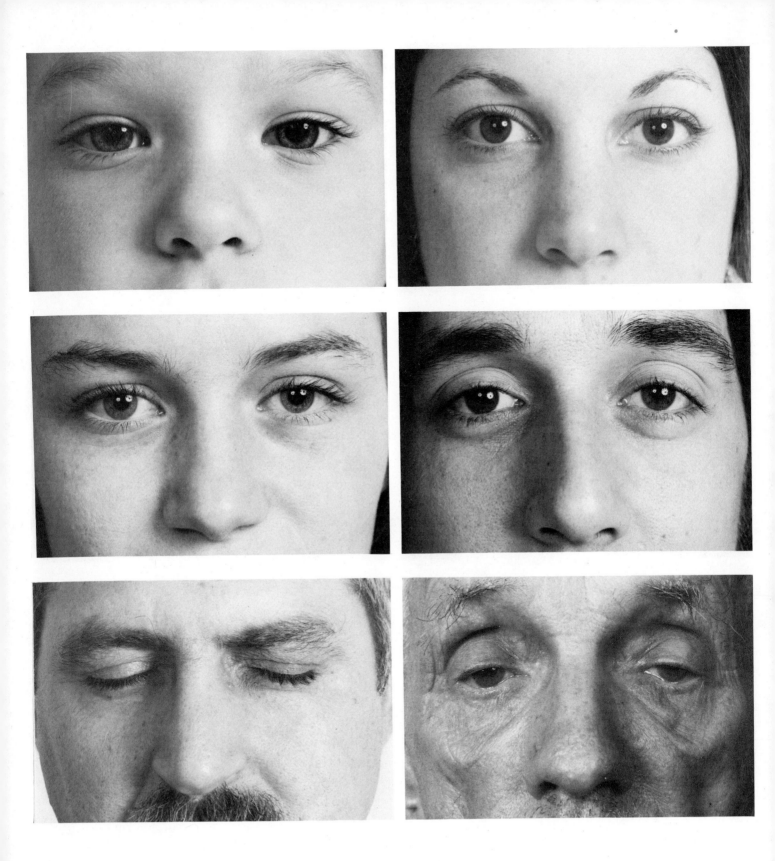

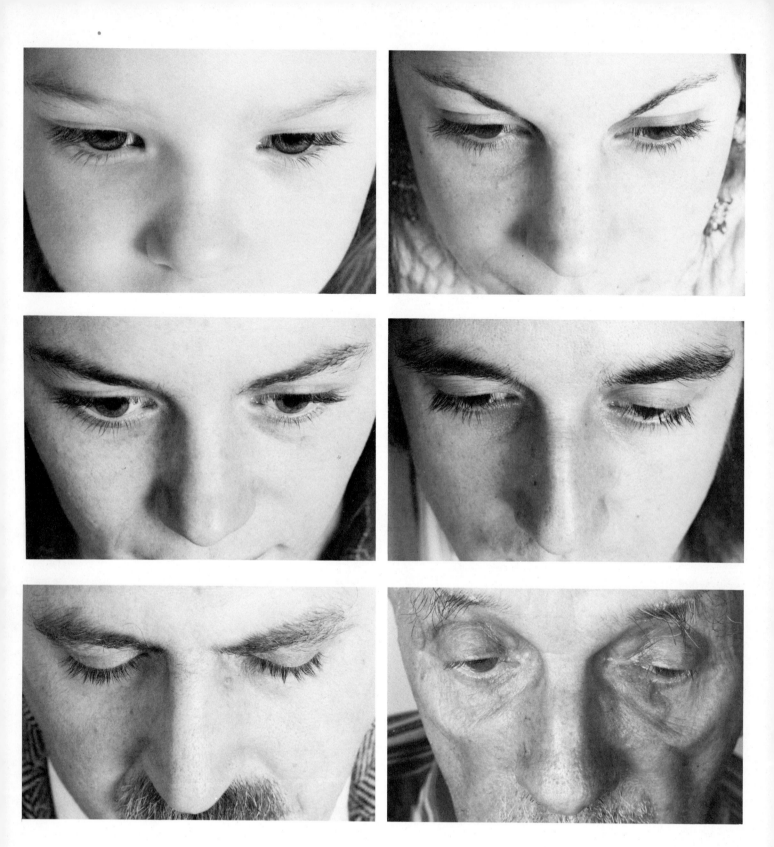

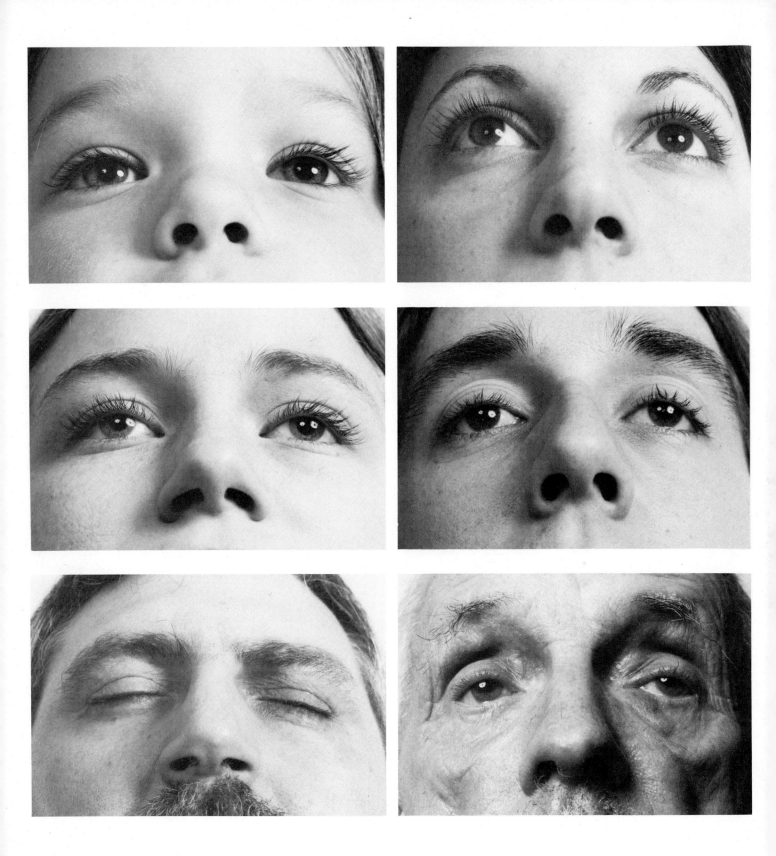

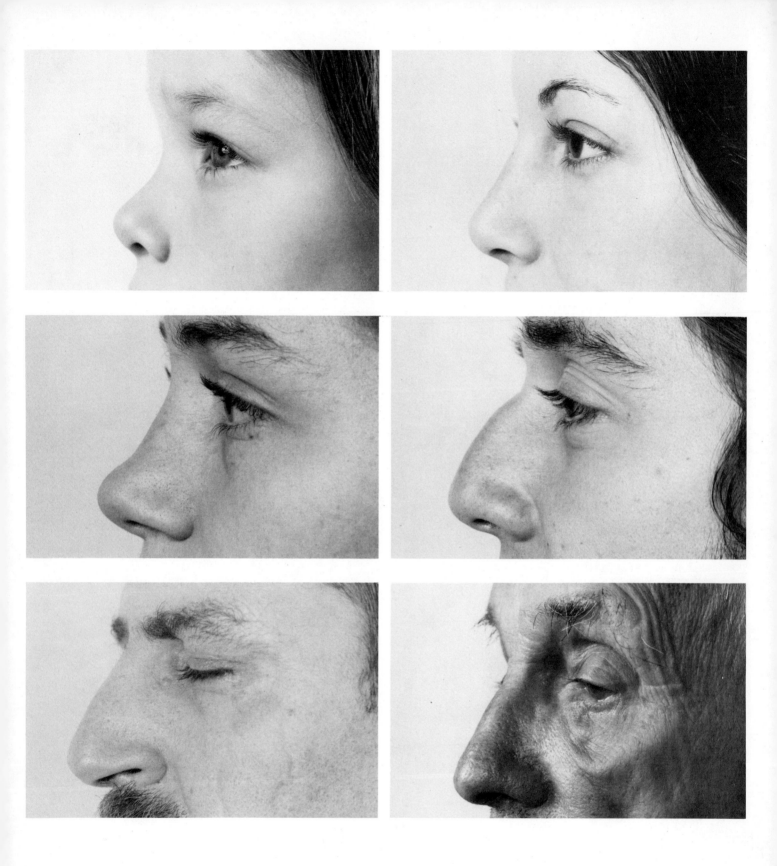

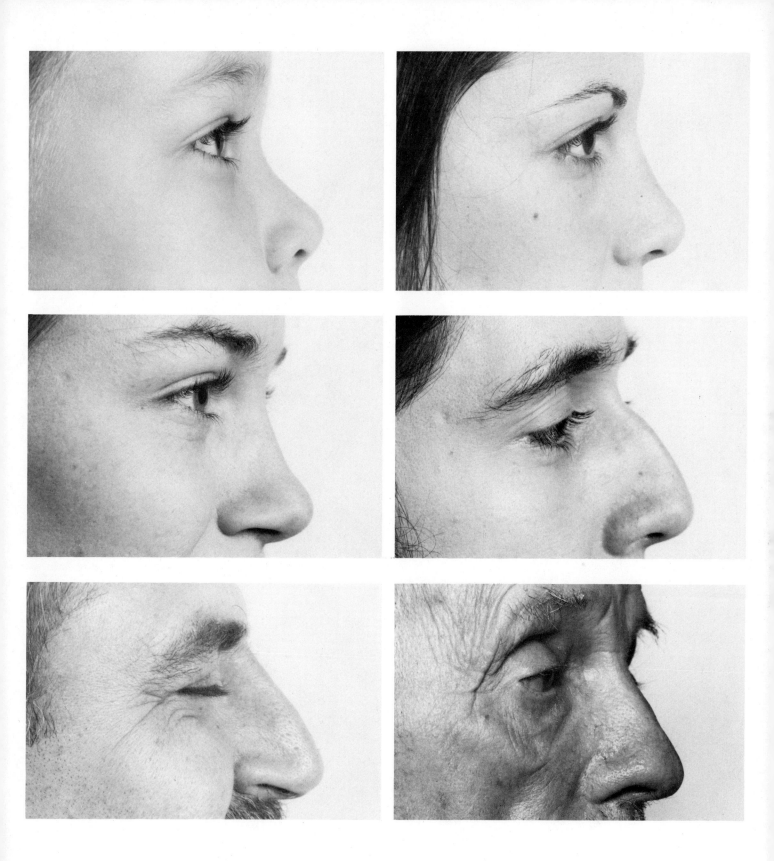

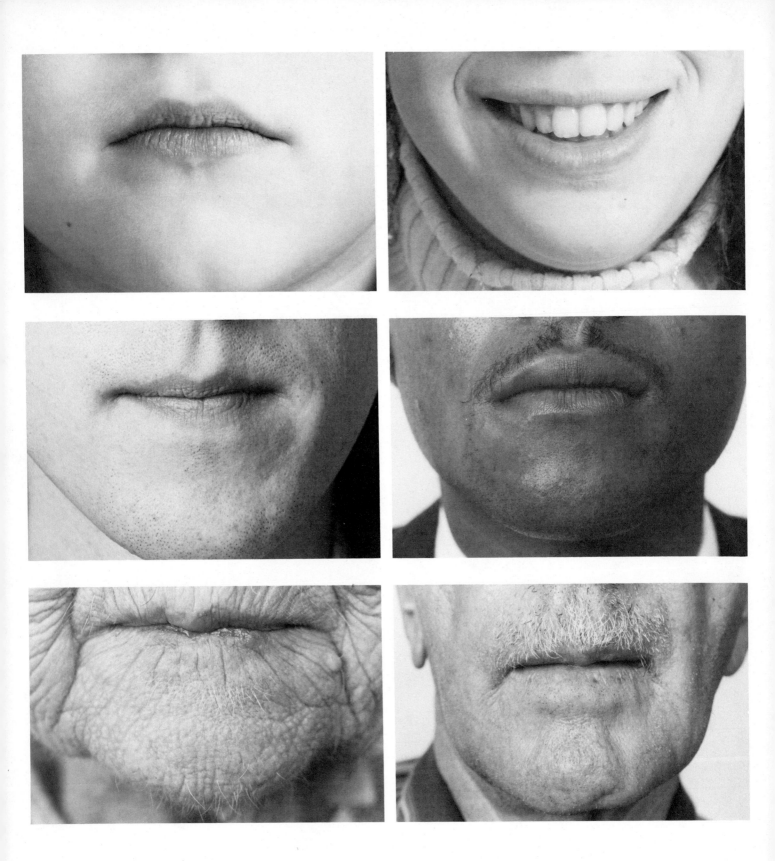

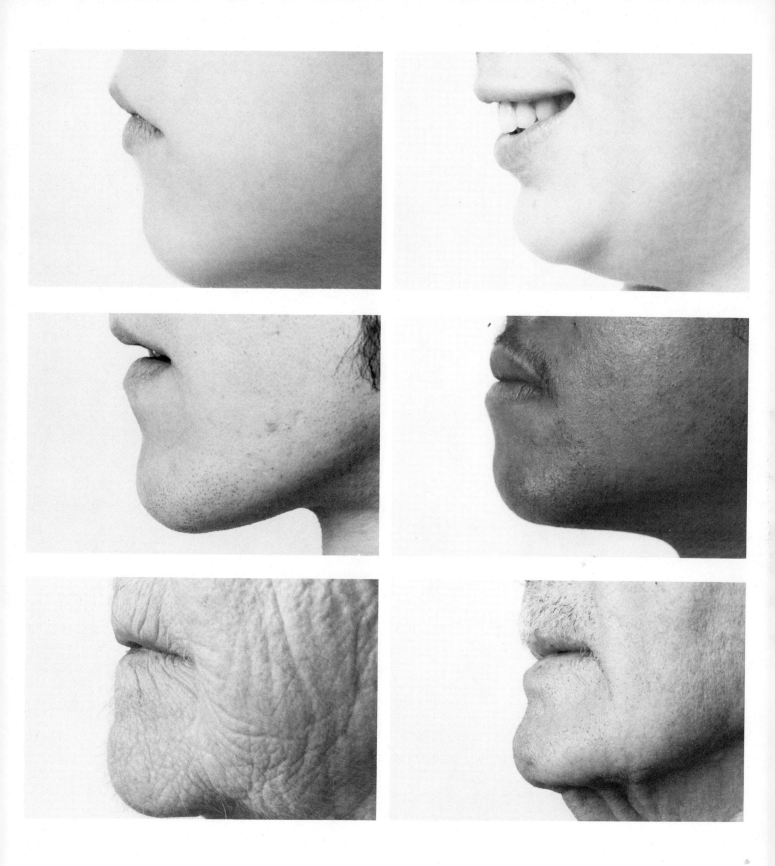

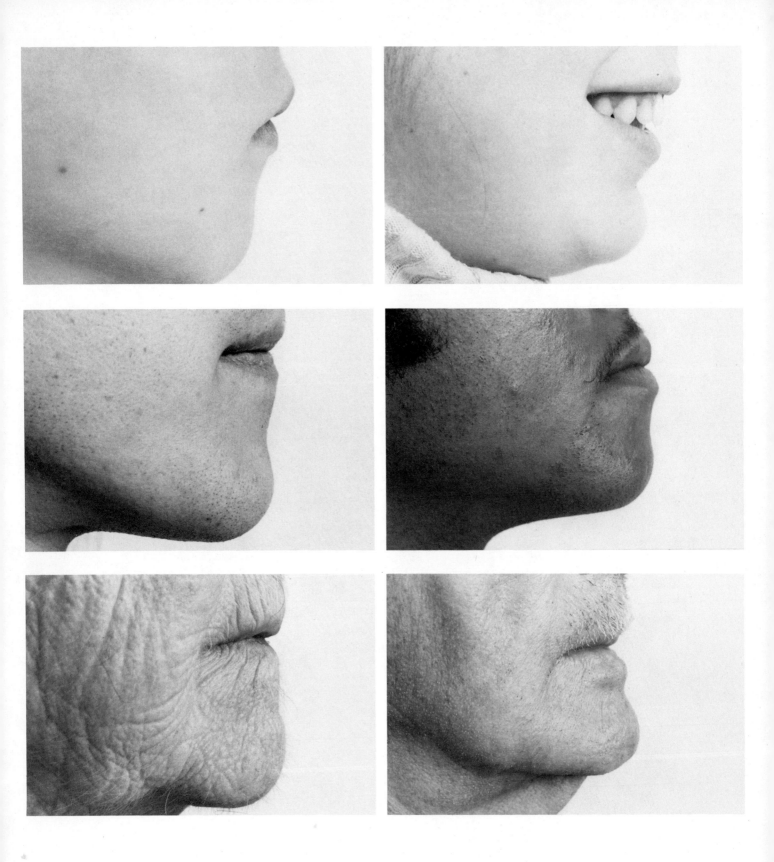

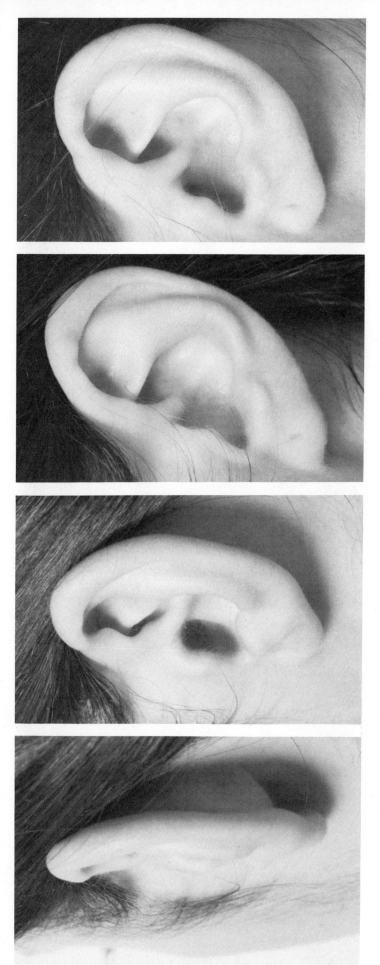

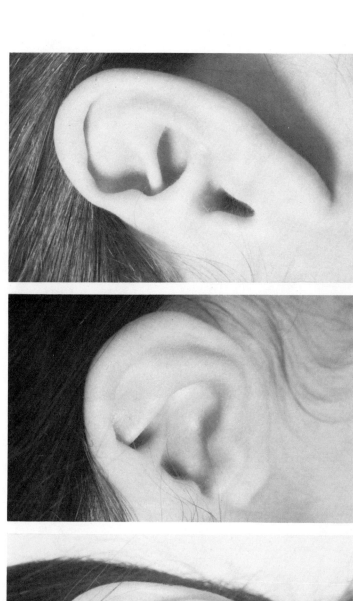

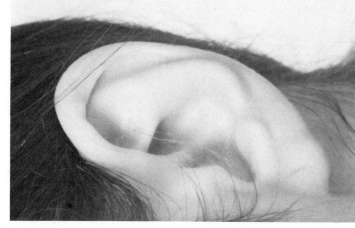

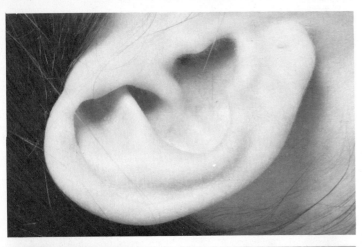

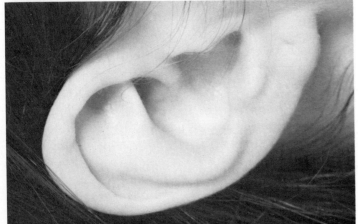

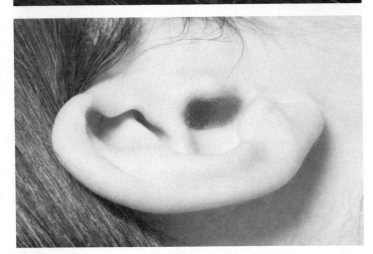

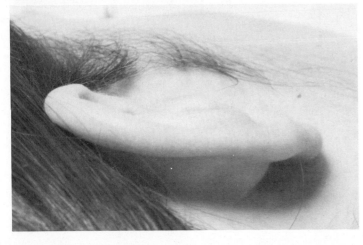

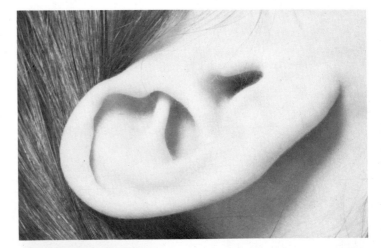

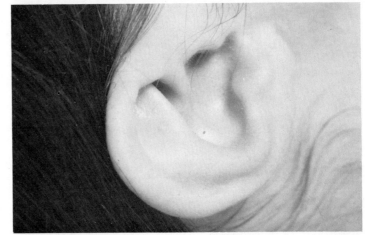

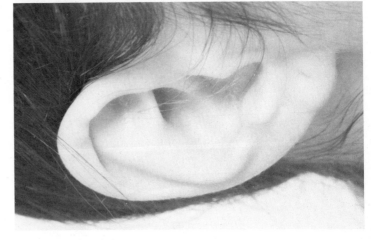

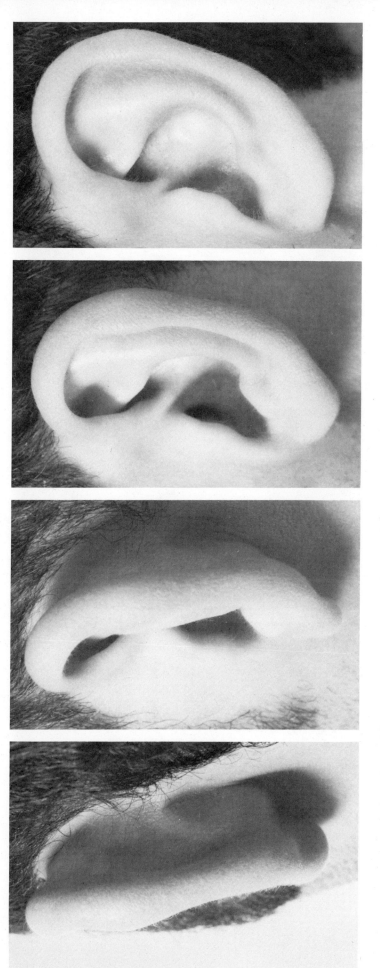

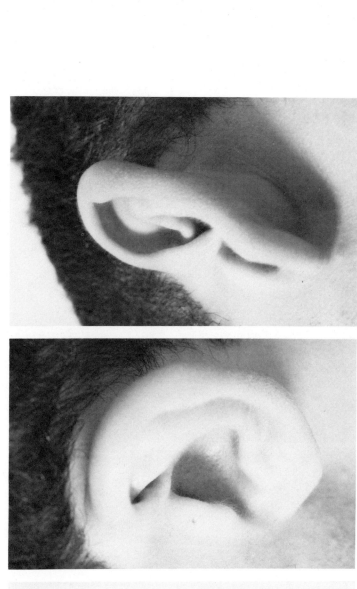

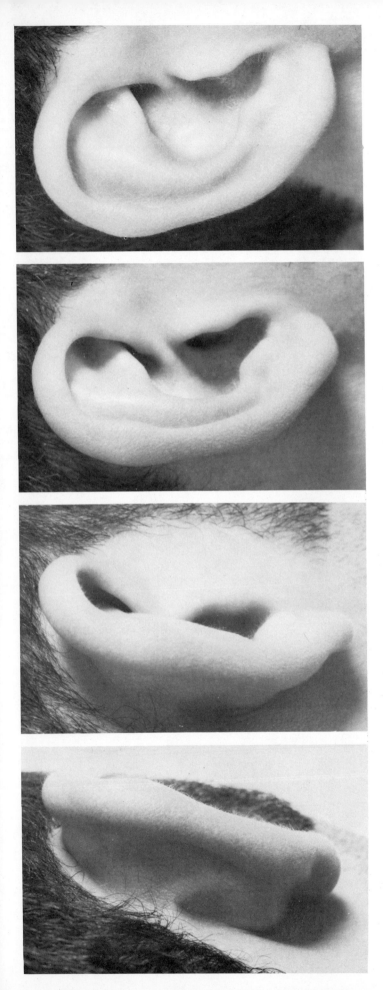

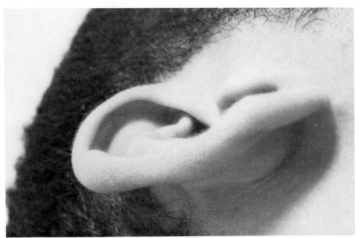

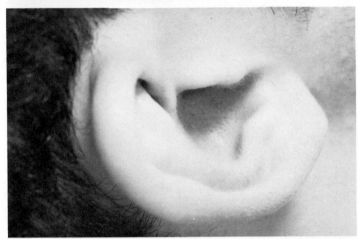

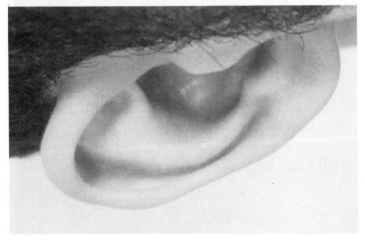

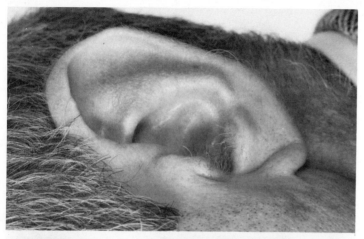

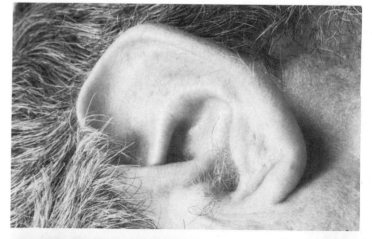

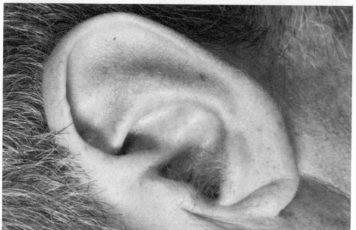

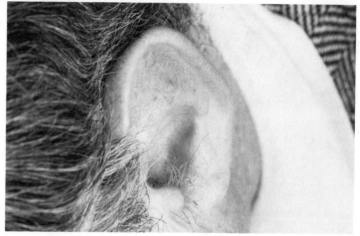

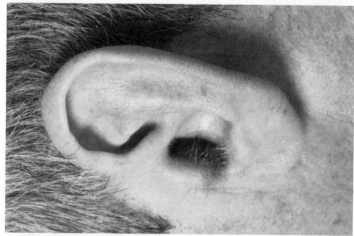

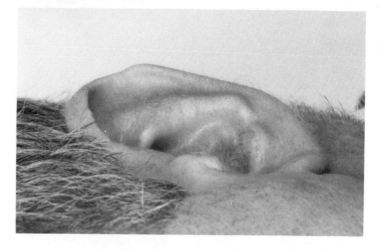

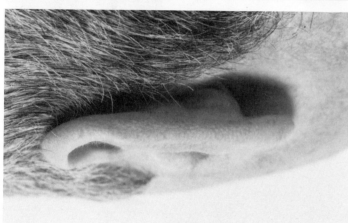

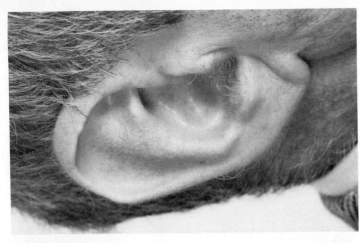

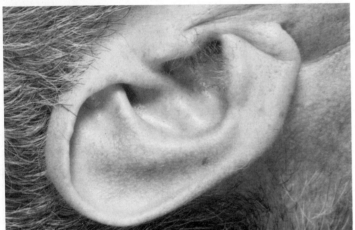

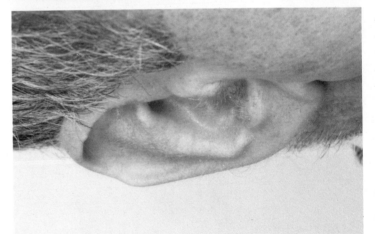

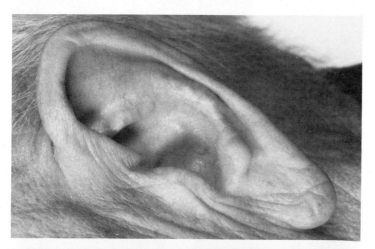

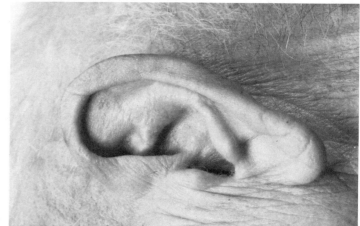

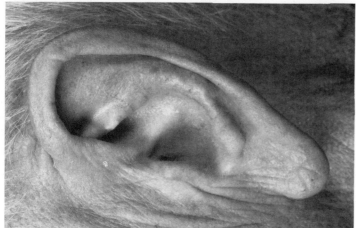

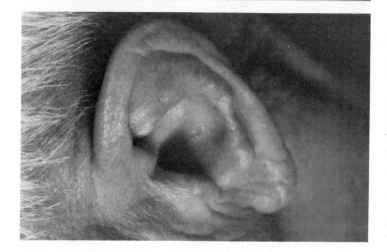

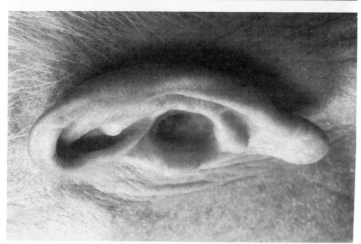

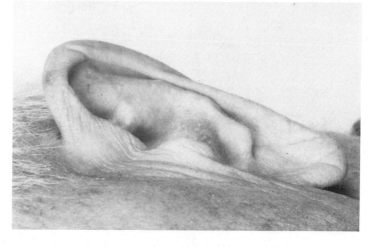

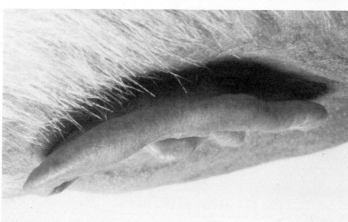

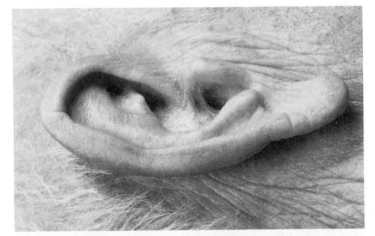

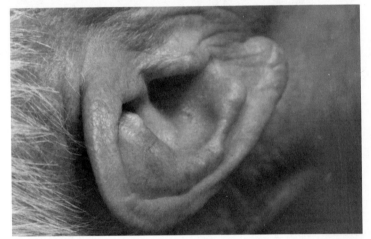

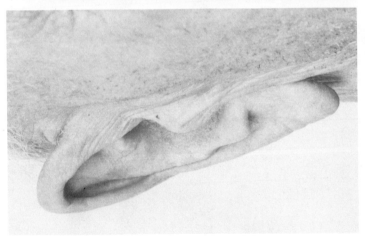

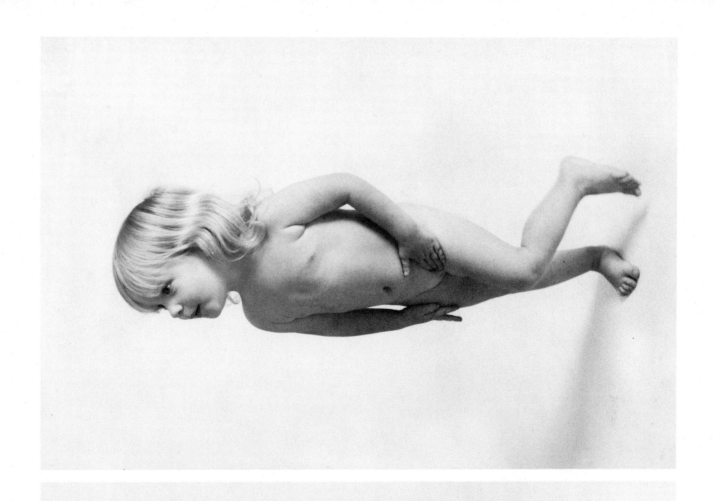

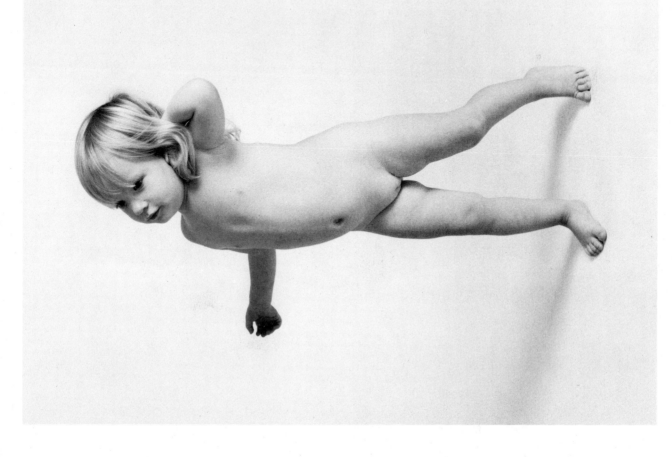

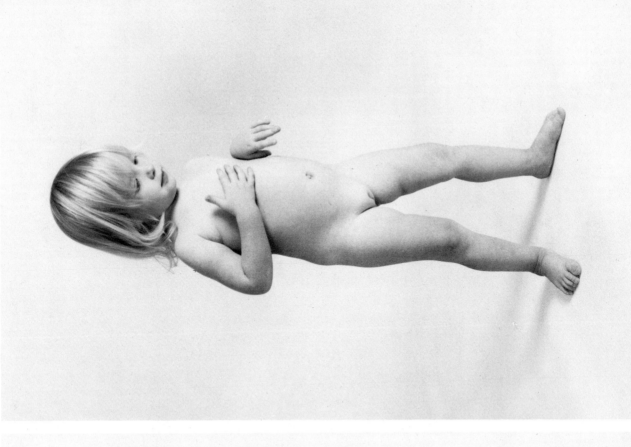

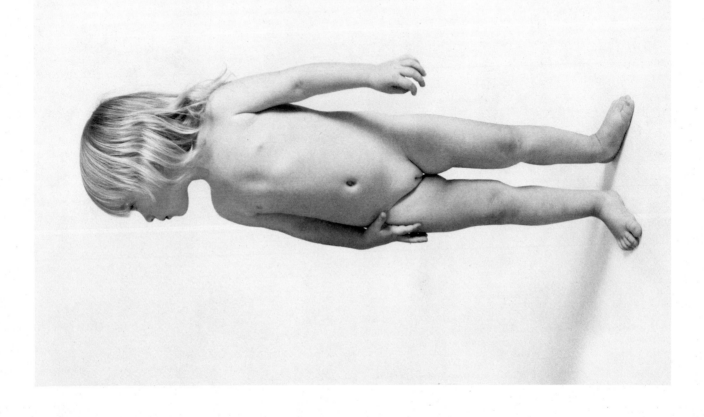

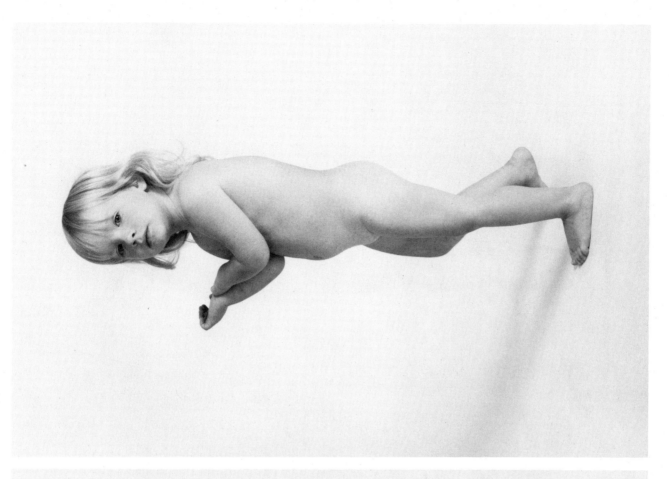

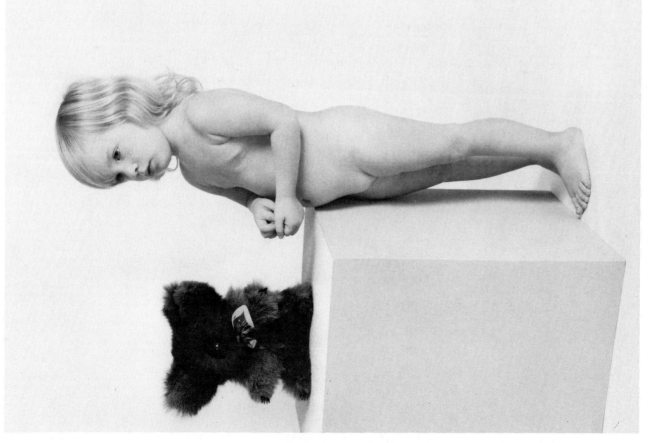

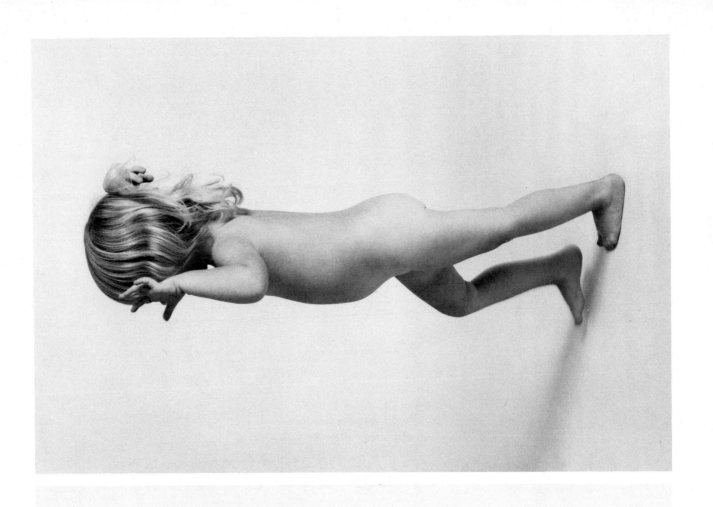

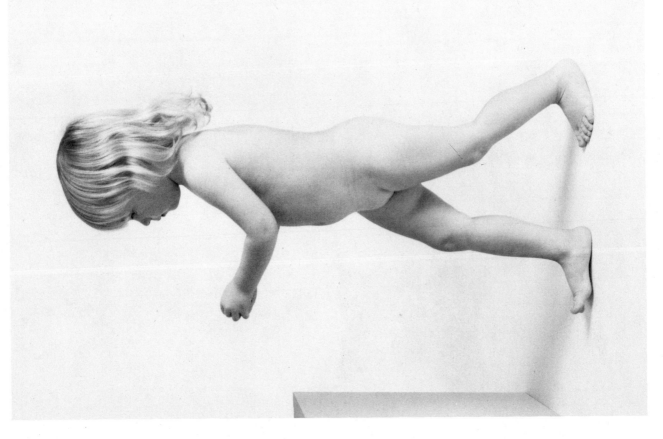

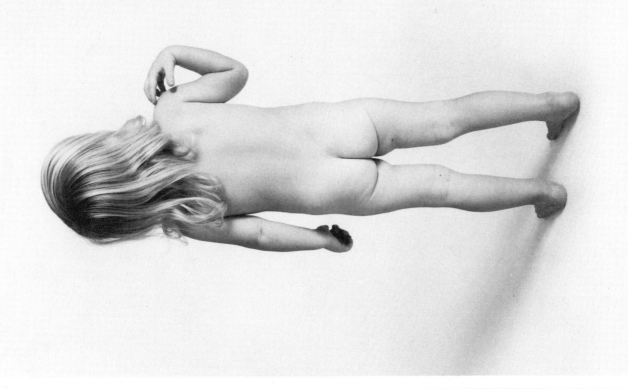

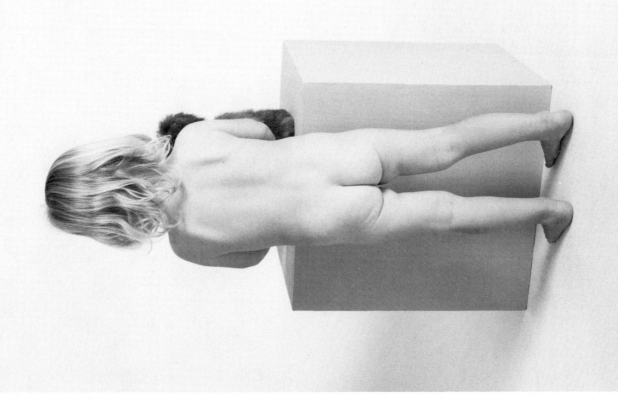

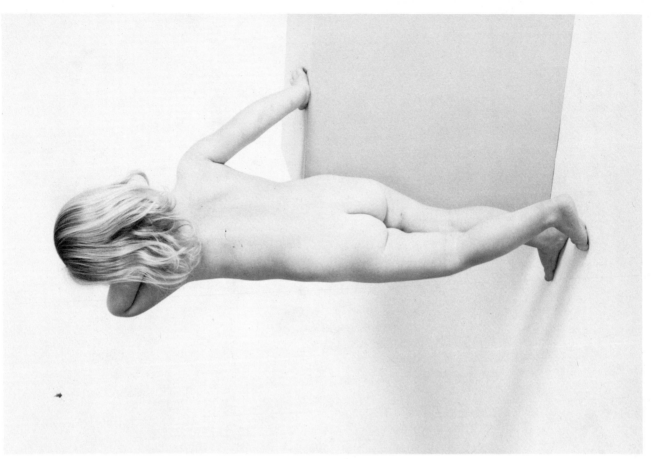

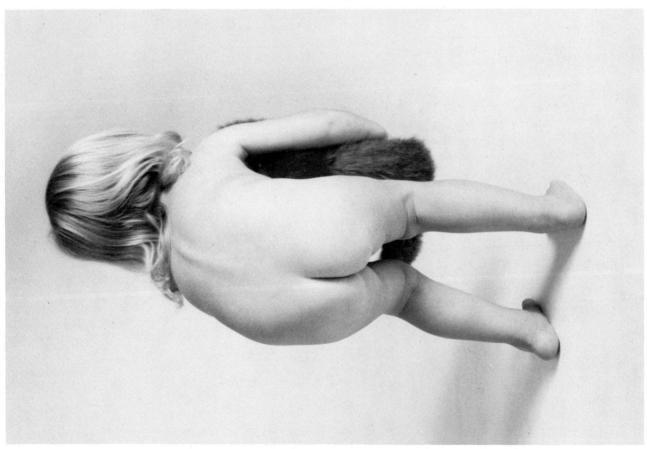

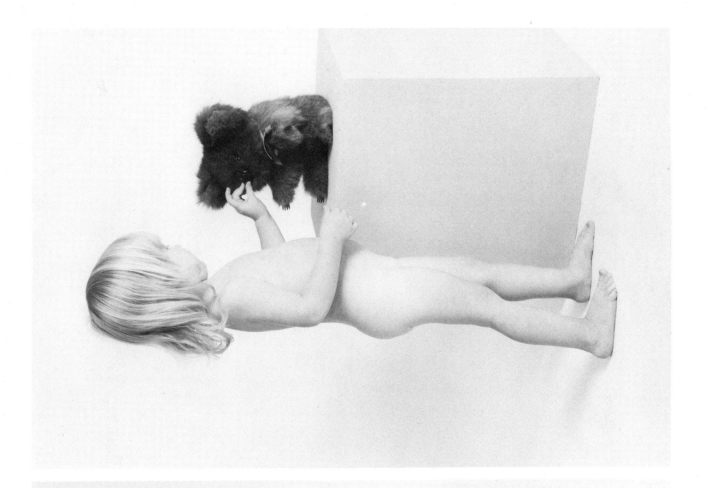

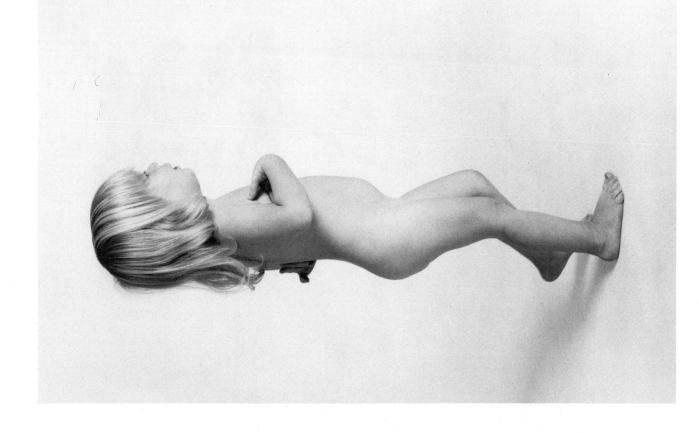

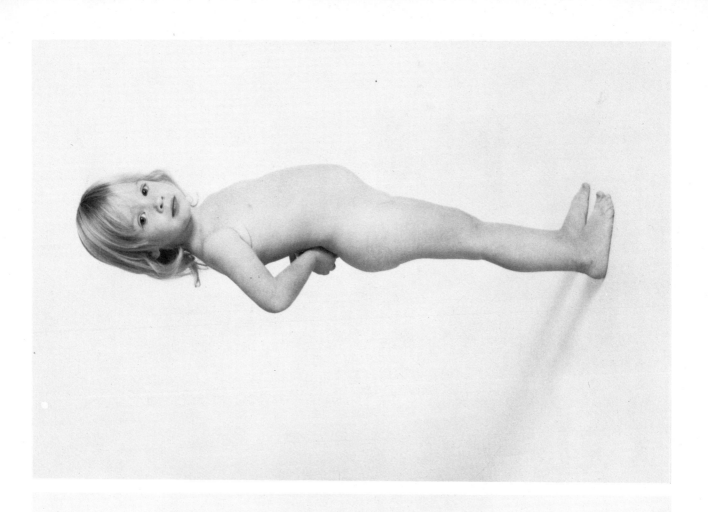

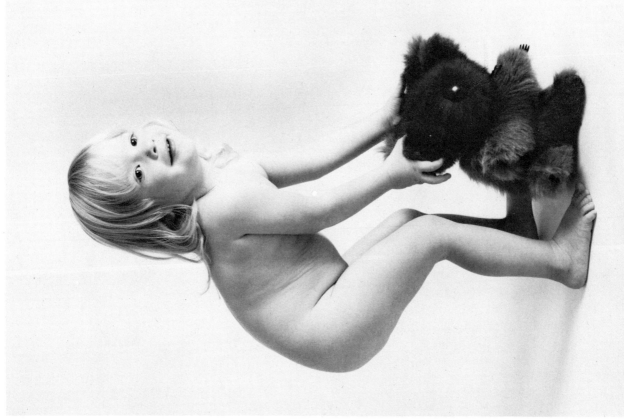

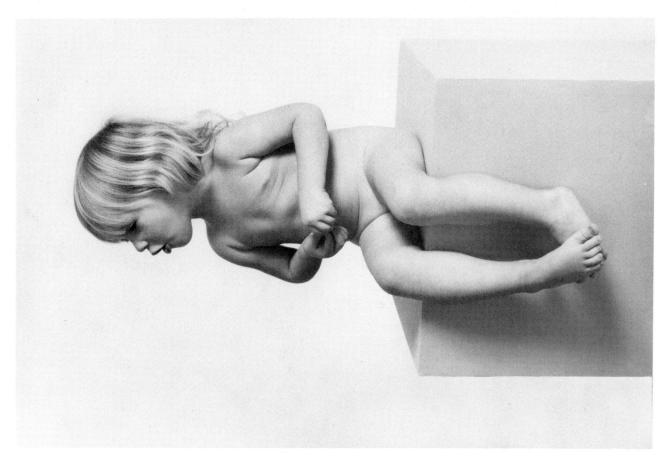

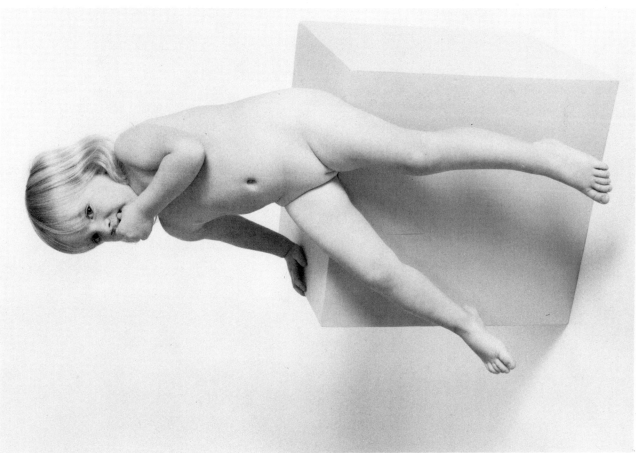

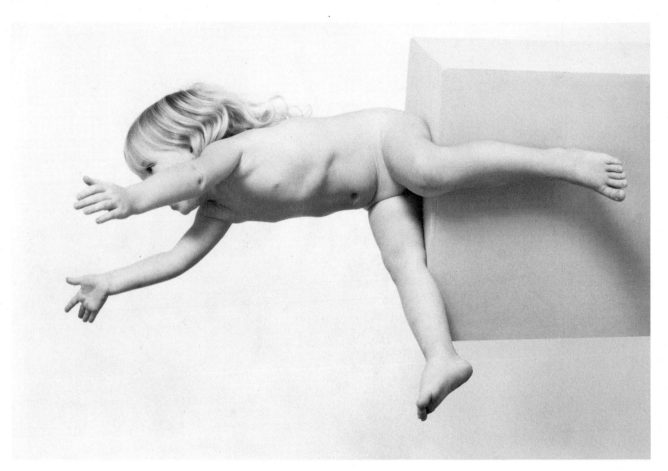

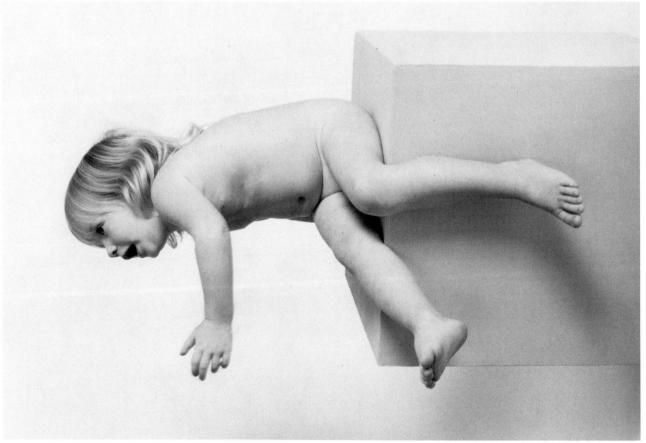

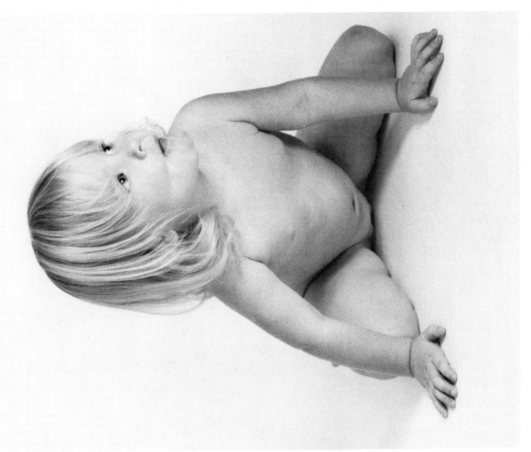

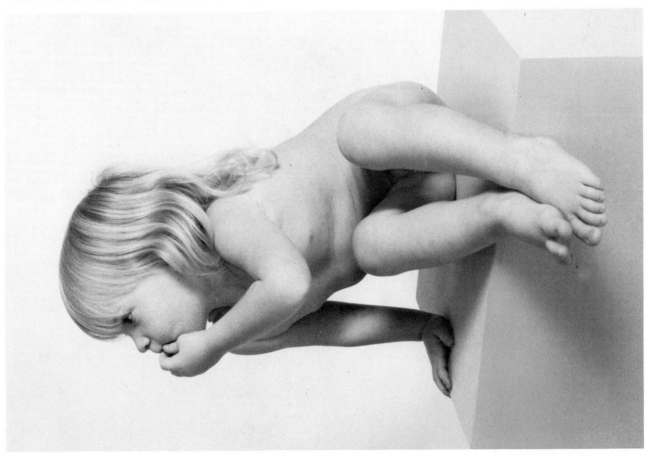

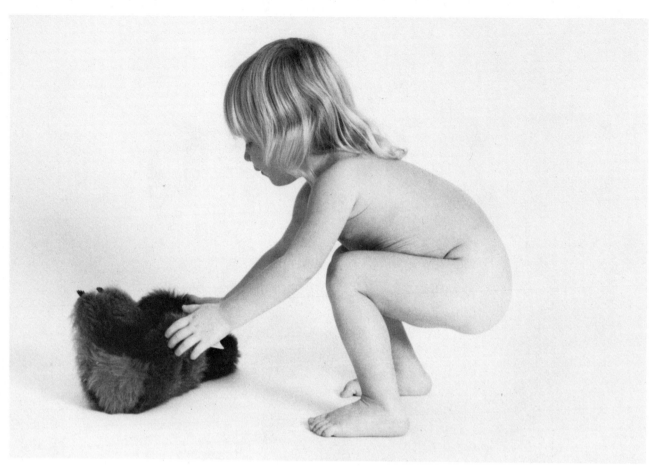

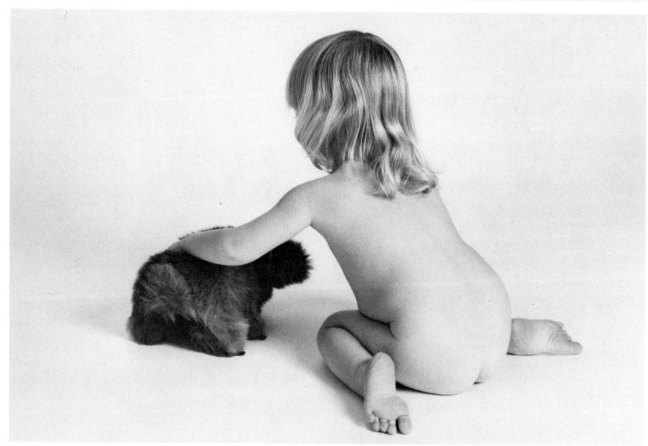

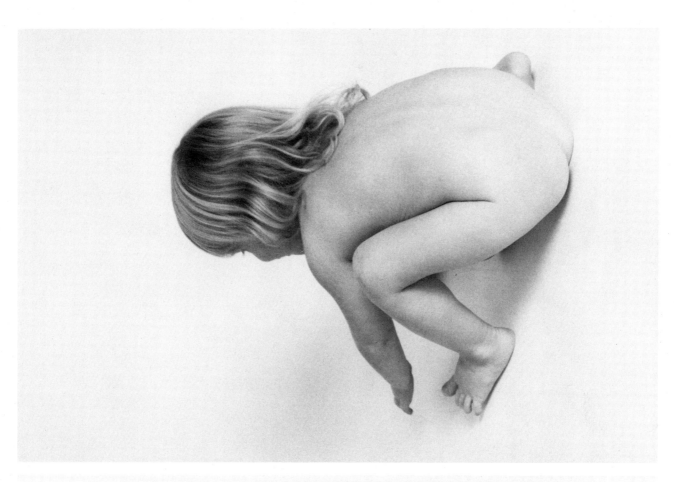

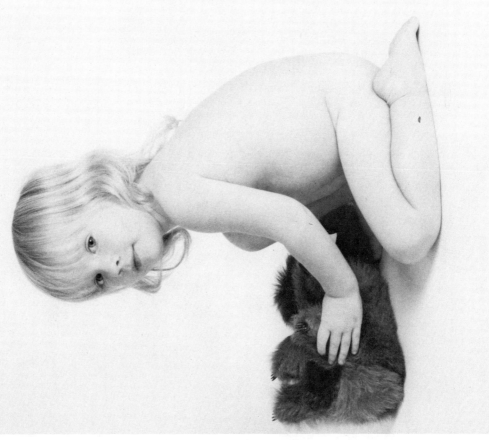

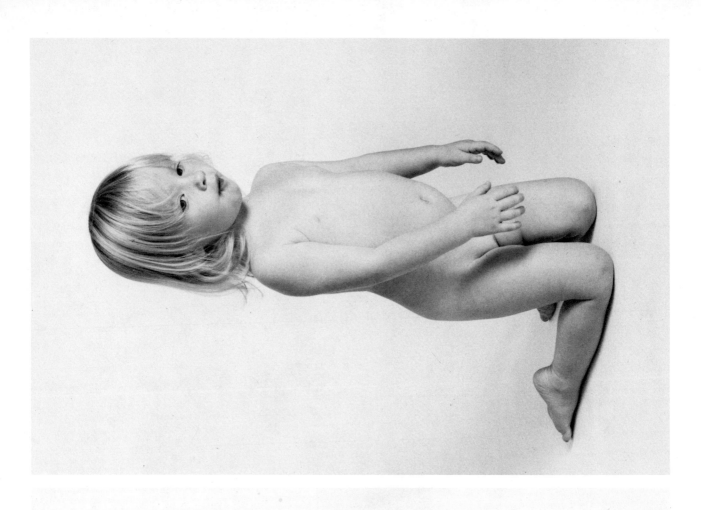

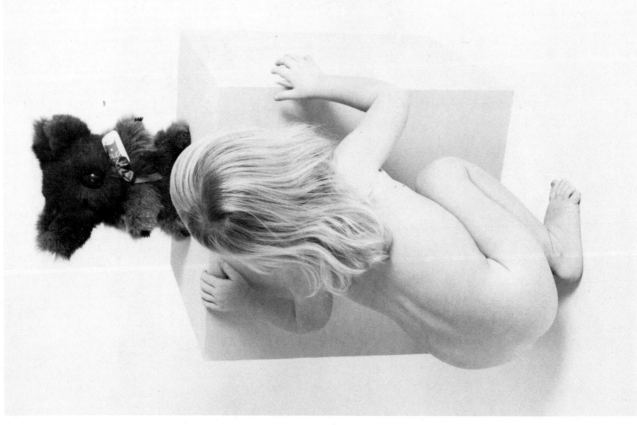

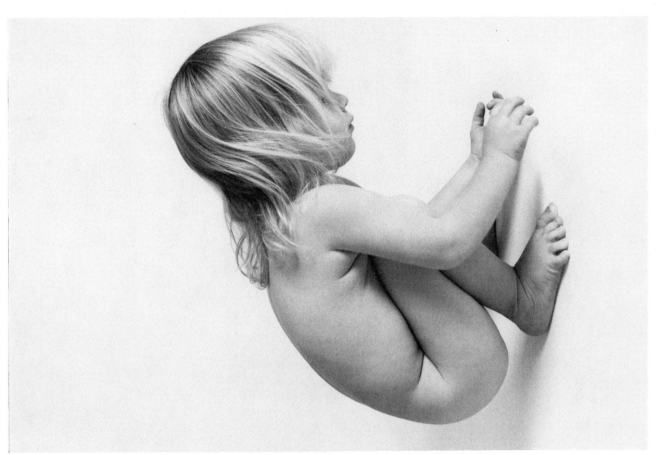

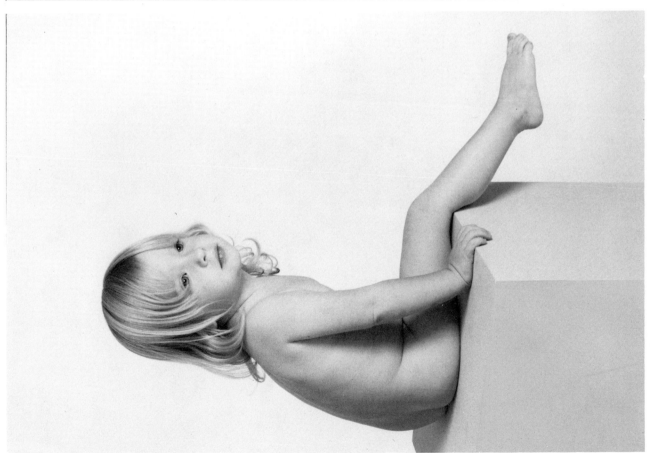

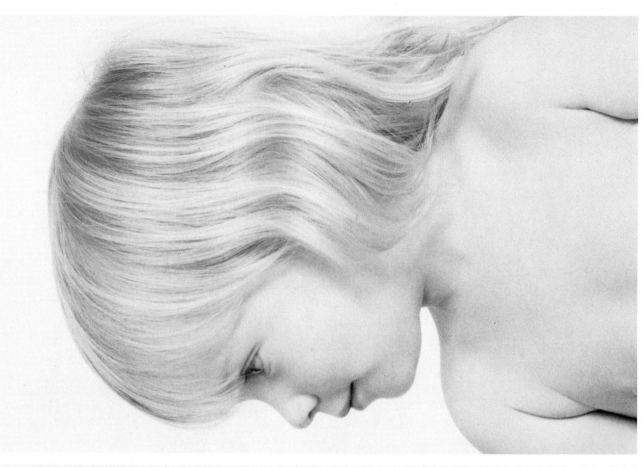

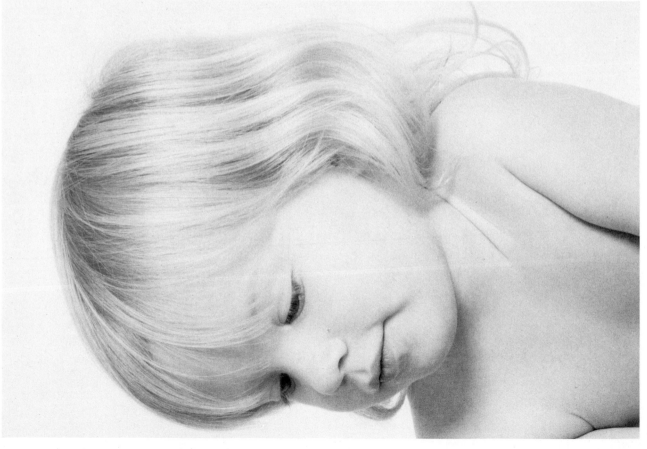

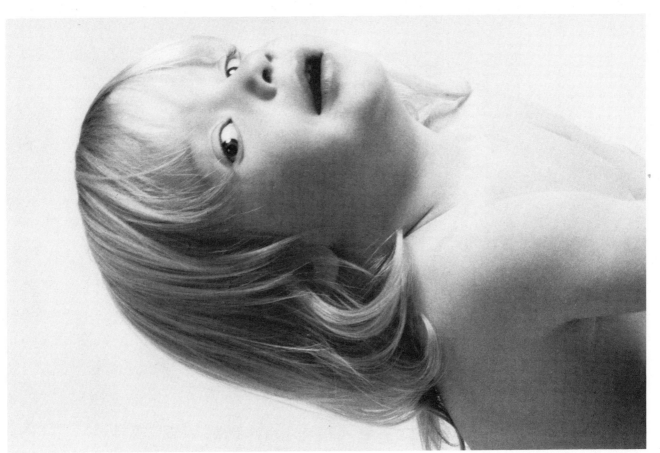

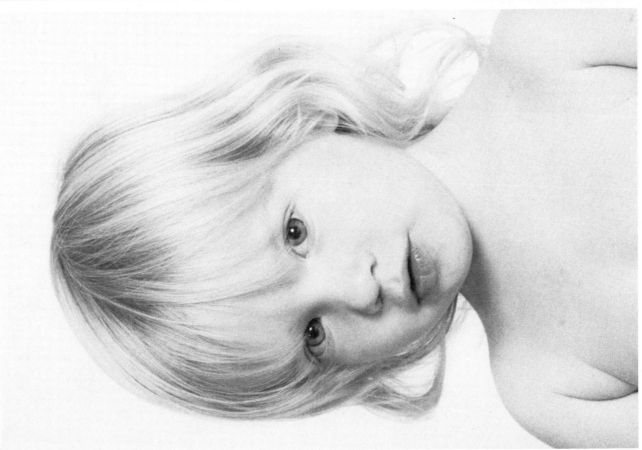

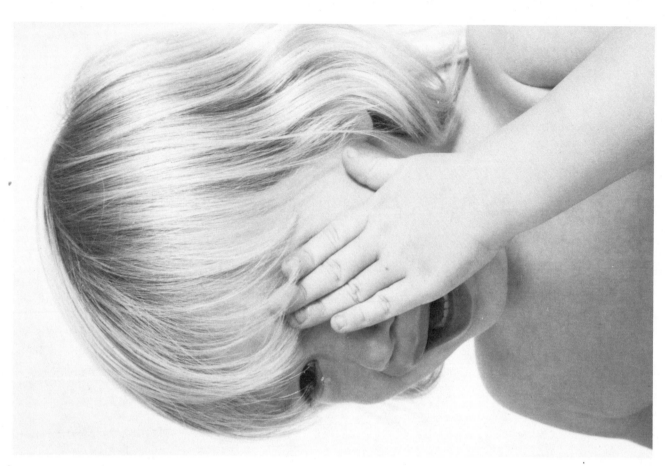

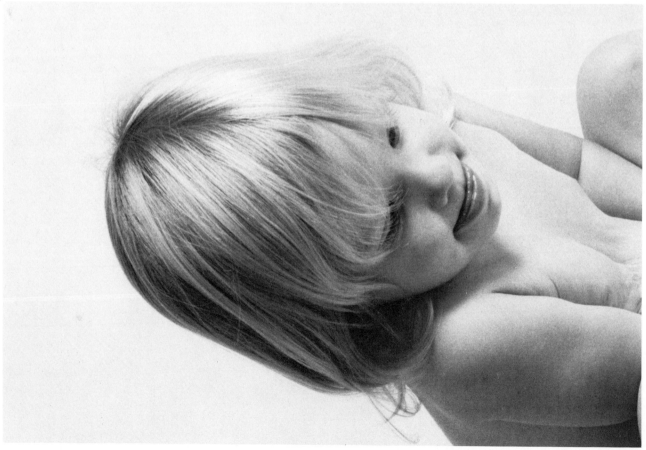

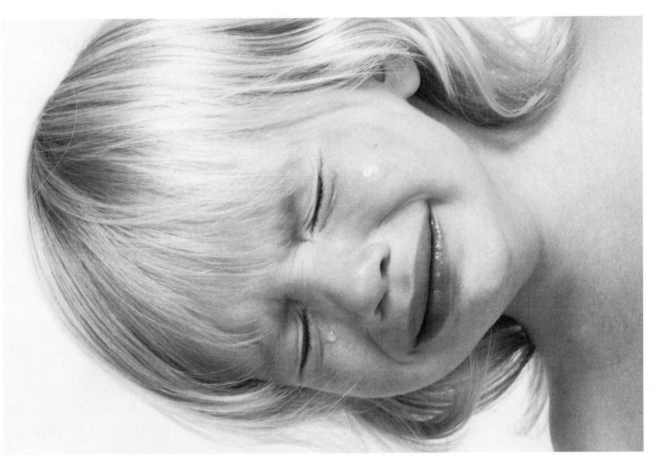

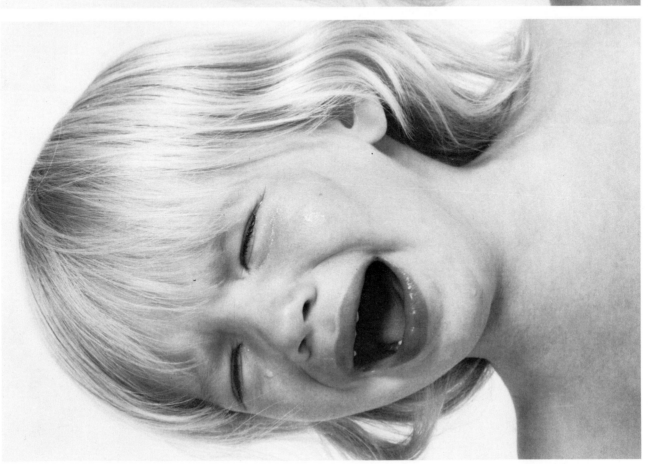

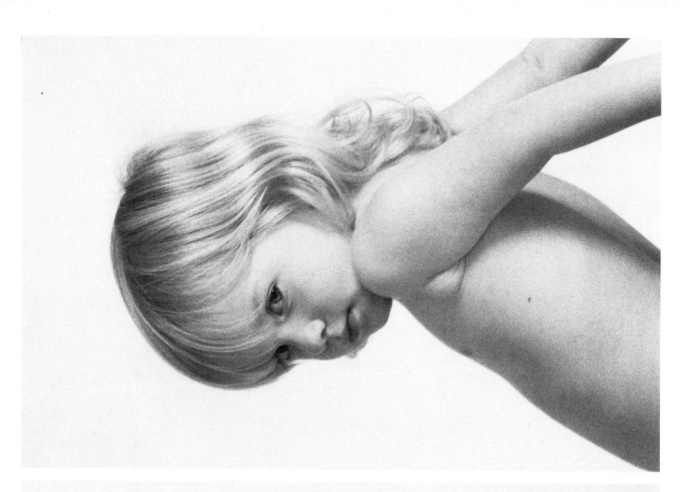

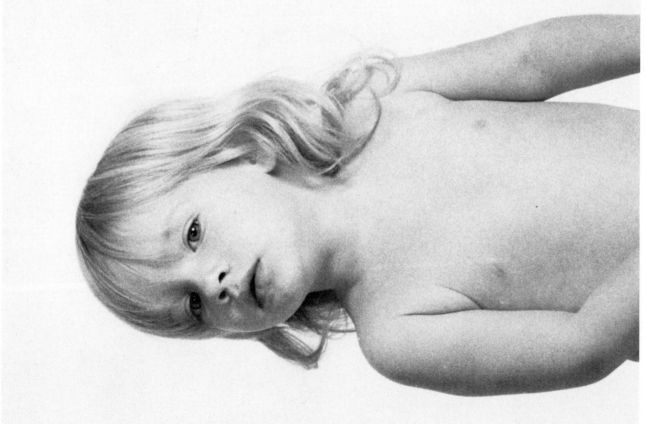

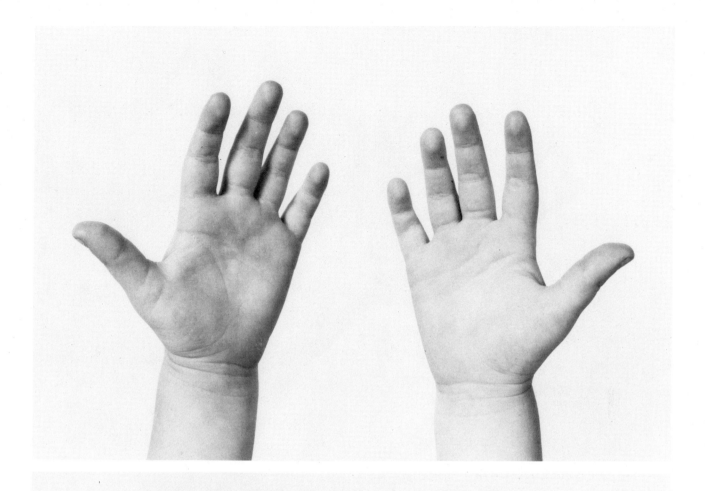

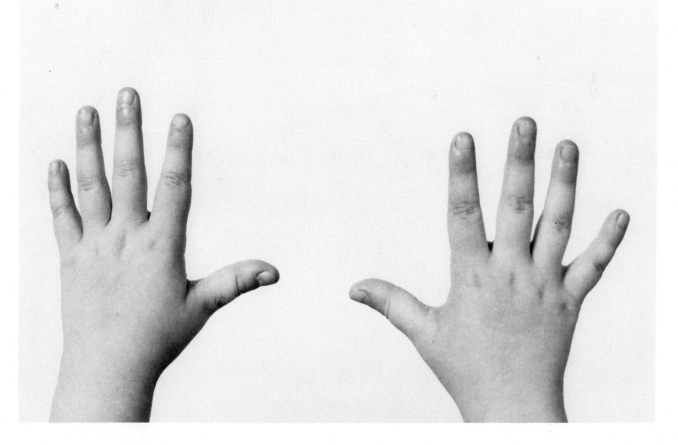

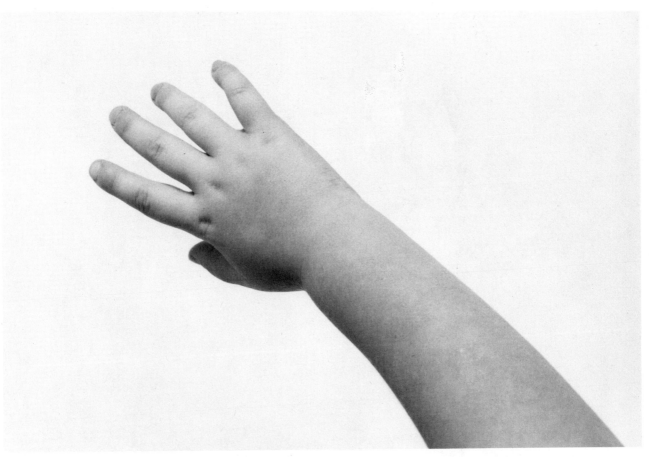

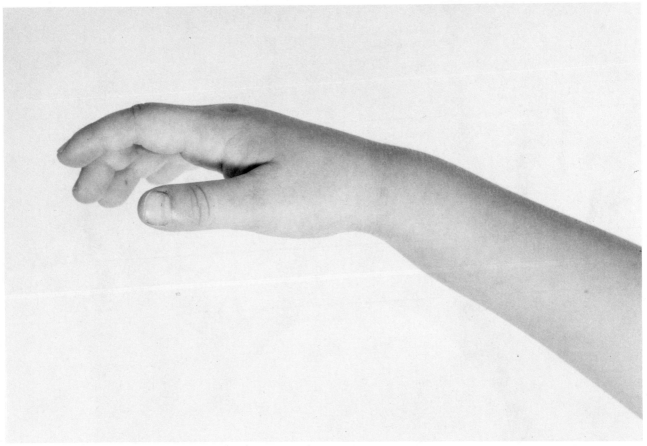

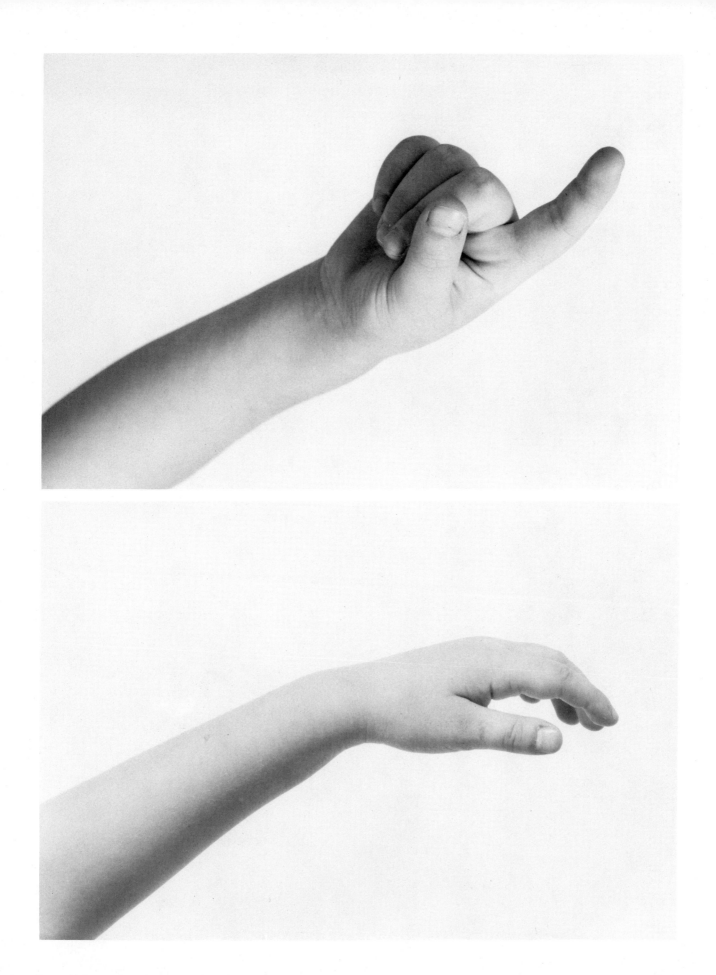

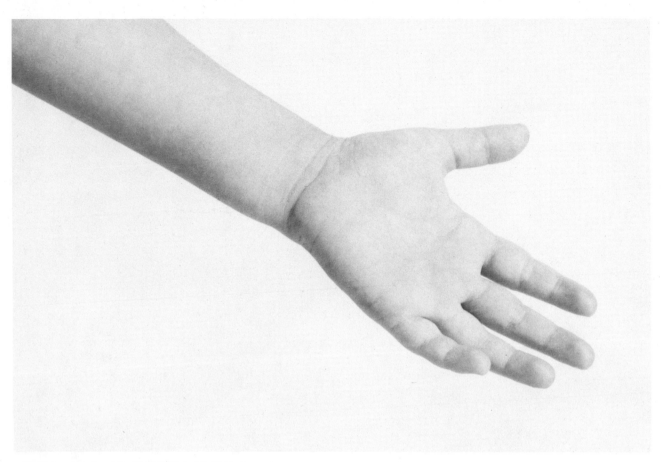

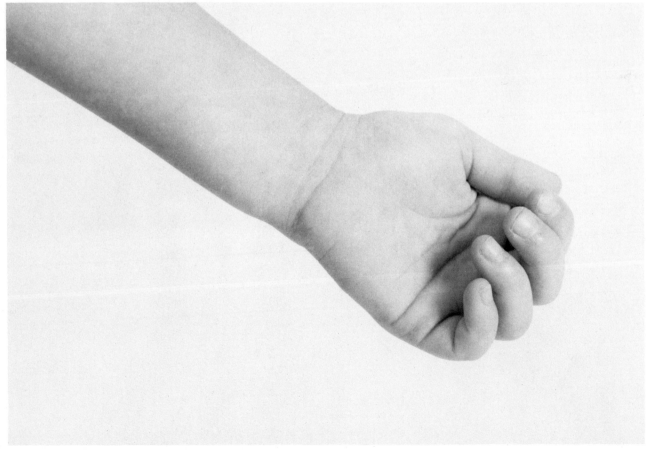

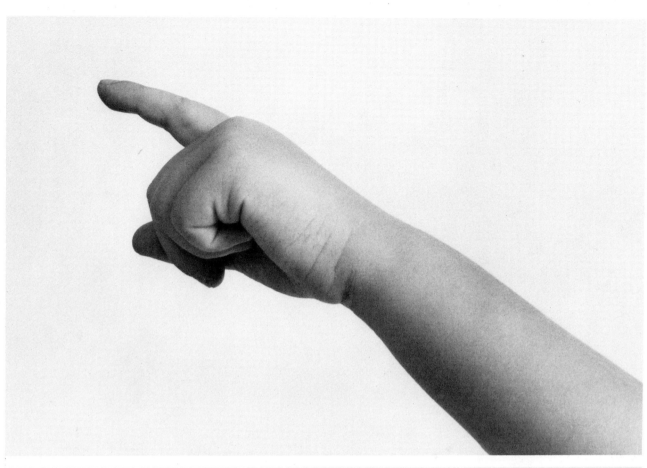

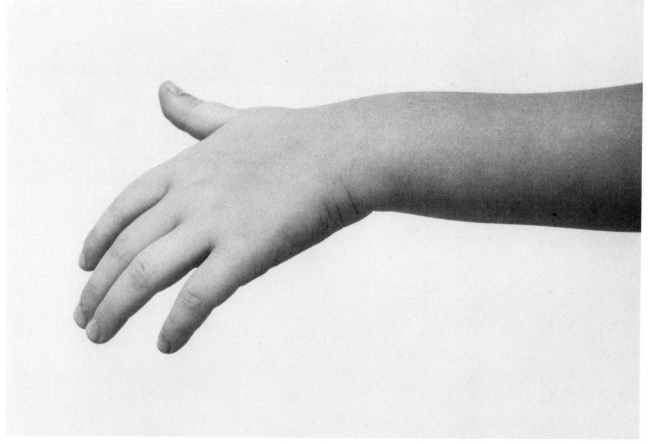

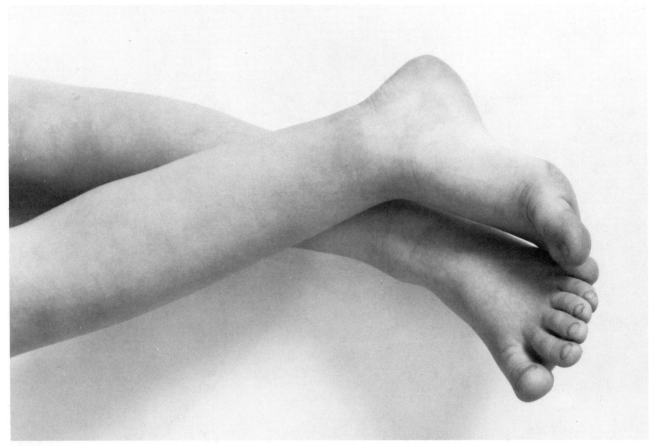

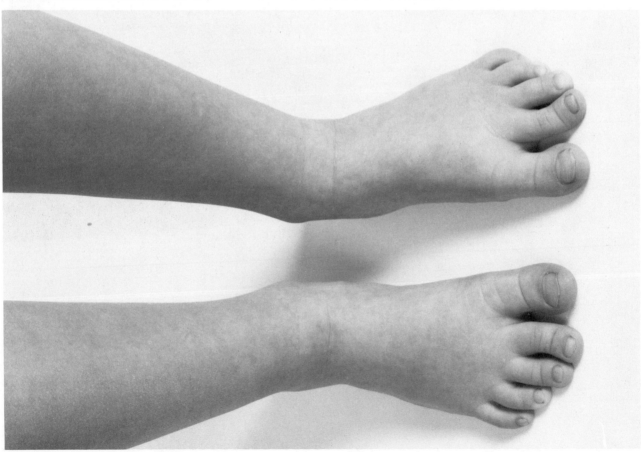

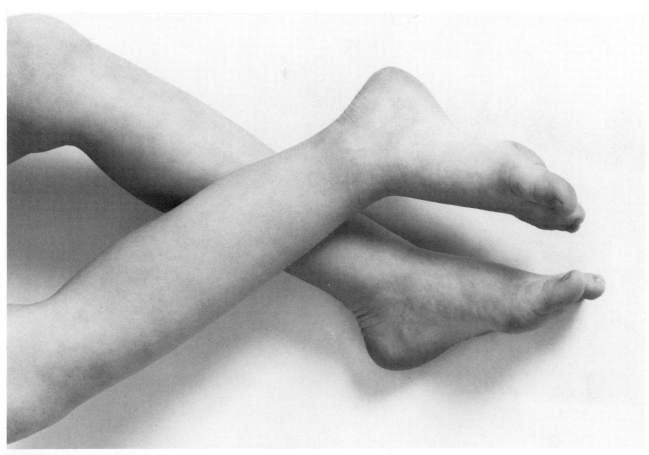

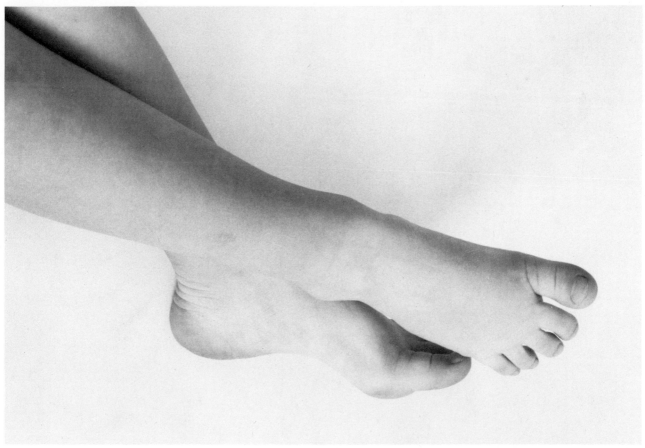

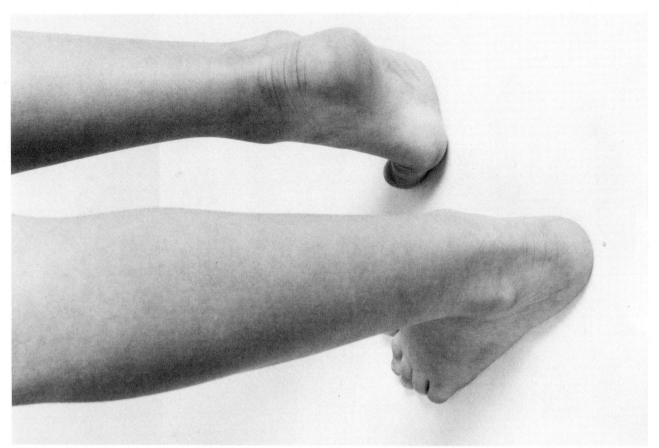

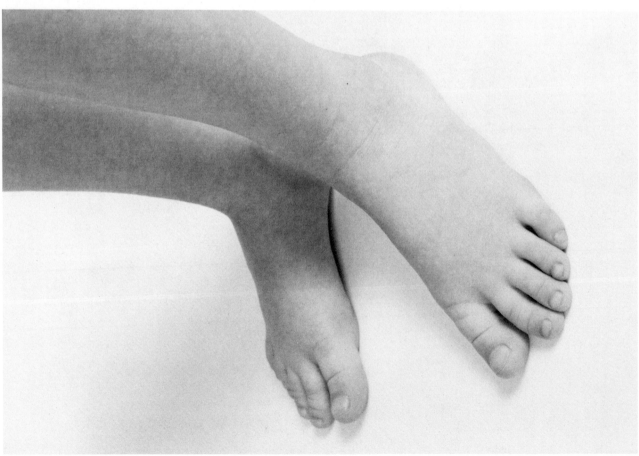

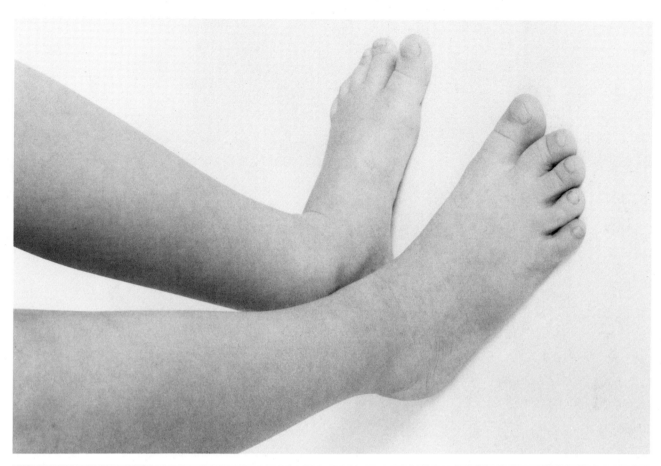

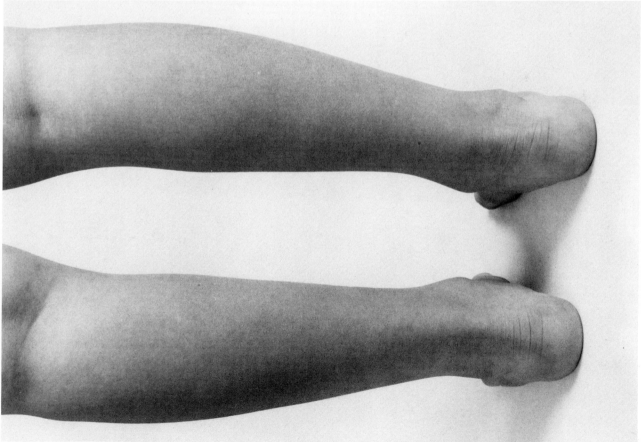

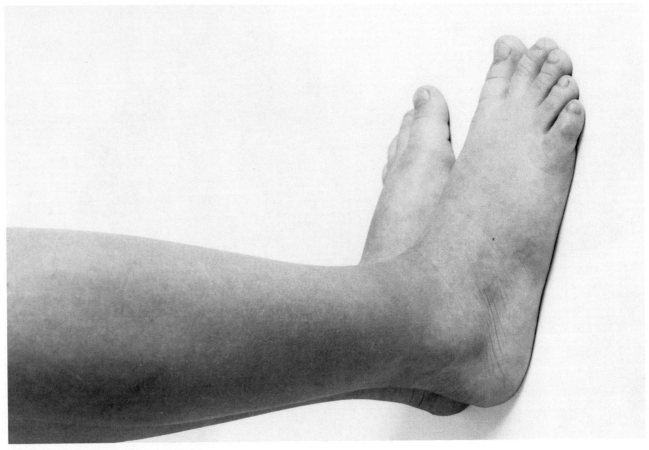

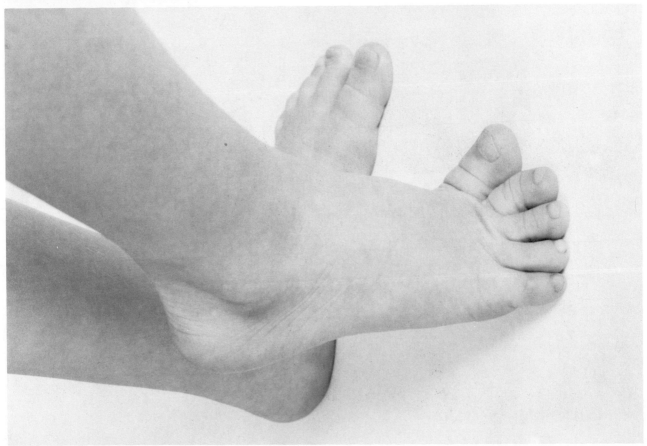